INTRODUCTION

What This Book Is

This is a reference book for decorative painters. Instructions given are for using *acrylic paints* and *fabric paints*. This book was written especially with the beginner in mind, in that I chose to over-explain rather than under-explain. For those of you with more experience, please don't be offended if it seems that I'm stating the obvious. What's "obvious" to you may seem like a foreign language to a beginner.

Two years have passed since the second edition of this book was released, and over four years since the original edition. I've learned once again that there is always something new to learn. I've taken many classes with wonderful, knowledgeable teachers and I'm anxious to share what I've learned with you.

The idea to write this type of book was born out of the frustration I felt as a beginner when I was unable to easily locate information I needed. When I couldn't find what I was looking for, I started doing research, and the notes I compiled became the foundation for this book.

I've researched the field of decorative painting for about six years now. The information included in this book represents the expertise of many different people—artists and manufacturers alike. These "pearls of wisdom" are what I feel make this book especially valuable. As with the second edition, I will continue to use some "untraditional" footnotes to give credit to some of the unpublished artists who shared their knowledge with me.

Changes In This Edition

In previous editions, Chapter 1 included descriptions of basic painting supplies as well as providing in-depth information on a variety of paints. Because of the wide range of information provided, we felt it would be more convenient for you if paints were described in a separate chapter. Therefore, Chapter 1 now describes only supplies and Chapter 2 provides in-depth information on standard acrylic paints, acrylic gloss enamels, and fabric paints. Color conversion charts are found at the end of Chapter 2.

With this edition, there are two types of color charts—those for regular acrylic paints (seven brands), and those for acrylic gloss enamels (six brands). **Fabric charts are no longer included because most of the readers I polled said they didn't use them.**

I'm very pleased that there is a new chapter, Chapter 7, included in this edition. It's called "Color Choices." Its purpose is to help you to change color schemes in your painting projects by offering suggestions for basecoat, shading, and highlight colors for nine different color categories with at least five choices per category. For example, if you're painting a design that calls for a dress to be yellow and you would like to change the dress to pink ⋯⋯ ⋯ⁱⁿ⋯ are offered for the basecoat, shading⋯

Des⋯

I wa⋯ to use. With this goal in mind, ⋯ ⋯rs, except Chapter 8, are in alphabetical order. This, along with the Index, Table of Contents, and Glossary, should make it easy for you to quickly find what you need. Main headings are in **bold** print and words I want to emphasize are in *italics*.

I have numbered the pages of each chapter with the chapter number as a prefix. For example, the first three pages of Chapter 1 are numbered 1-1, 1-2, 1-3. Therefore, if you know that the subject you are looking for is somewhere in Chapter 1, you can quickly thumb through the pages prefixed with "1-." The thumb index on the back cover is also a quick, easy reference tool. The Glossary defines commonly used decorative painting terms. Often, more than one word is used to describe the same thing. This can be very frustrating, especially for beginners. I'm sure I didn't find all such words, but the ones I did find are included and cross-referenced.

What This Book Isn't

This is not a pattern book. There are already hundreds of these on the market. Experienced painters can usually recreate the projects in these books easily. Unfortunately, for beginners, this is not the case. My hope is that the information provided here will help beginners to understand, use, and enjoy the many beautiful pattern books available.

Why Should You Buy This Book?

This is intended to be your one-source reference book. No matter how many pattern books you add to your library, my hope is that this book will become an old friend that provides you with needed information throughout your painting experience. I have heard that some craft stores recommend this as a decorative painting "text book" for their beginning students. Needless to say, this is music to my ears!

For beginners especially, this book can save you time and money by helping you avoid buying unneeded supplies, and steering you away from making some of the costly mistakes beginners often make.

What Is Tole/Decorative Painting

Traditionally, "Tole" meant painting on tin surfaces. However, today, it is used in a much broader sense and is called "Tole/Decorative Painting," or more recently simply "Decorative Painting." Tole Painting classes now gener-

ally teach beginners to paint on wood, frequently venturing to other surfaces such as fabric, ceramic, tin, pottery, glass, plastic, or candles. Throughout this book, it will be referred to as "Decorative Painting."

Decorative Painting is not an exact or perfect art. The more you learn, the more you will find this to be true. You will see painted roses that look nothing like those found in Nature's garden, yet they are beautiful.

Not all authorities in the field do things the same way or agree on the "right" way to do something. The end result, however, is what counts. It's good to learn some "tried and true" methods. However, experimenting can sometimes result in developing methods that suit you even better.

Though terminology sometimes varies, one thing remains constant—the desire that each artist has to create something of beauty. When this is accomplished, the inconsistencies seem relatively unimportant.

Can You Do Decorative Painting?

Yes, you *can* learn Decorative Painting—whether you feel you have natural artistic abilities or not. You don't have to be able to draw. (I, of all people, should know this.) What is required are three very important things: a positive attitude, perseverance, and practice.

The beauty of decorative painting is that you don't have to draw anything without a pattern if you don't want to—that's why there are so many pattern books and pattern packets available. It's just, plain fun. If you enjoyed coloring as a child, you'll probably love this type of painting.

The hours you spend learning the craft will be more than compensated for when you are able to paint decorations for your home, gifts for friends and relatives, and just be able to say "I did it." I'm sure you'll agree the effort to learn was worth it.

If you are a beginner, I suggest you read this book in its entirety. This will help familiarize you with the field and give you an overview before you "dive in" and get your feet wet. If you can take decorative painting lessons while studying this book, it's even better. With practice, you should soon be able to use the available pattern books and easily recreate the projects they present.

Throughout the book I sometimes give my own opinion on how to do something. An example is recommending that you wait 24 hours for one type of sealer to dry rather than the eight hours suggested in the product instructions. Please remember, these are my personal opinions reflecting methods that worked best for me. They may not represent the common practice of other painters.

Writing this and previous editions of this book has been a labor of love and a tremendous learning experience. I met or corresponded with many helpful people who were willing to share their knowledge with me. I learned, first-hand, that the majority of people in this industry enjoy a wonderful camaraderie that is based on their love of decorative painting.

I think the greatest failure is never to try. No matter what you want to learn, whether it's to paint, play the piano, or anything else, you owe it to yourself to give it your best shot. Keeping a positive attitude makes learning anything new a lot easier.

Your Comments Are Welcome

If you would like to write to me, please feel free to do so. Though time may not permit me to answer your letters personally, I welcome your comments. Write to me at 15876 East La Floresta Drive, Hacienda Heights, CA 91745.

Creating things of beauty is a real joy. My sincerest hope is that this book will help you accomplish this.

Susan Adams Bentley

Chapter 1

SUPPLIES

The purpose of this chapter is to provide as much information as possible about the many wonderful decorative painting products that are available. Detailed descriptions are provided for a broad range of basic supplies, such as brushes, varnishes, stains, special tools, etc. (Descriptions of paints and color conversion charts are found in Chapter 2.) The "Bare Essentials Shopping List" at the end of the chapter is especially for beginners. I hope it will guide you in your first purchases as well as keep your costs to a minimum.

Supplies are arranged in alphabetical order to help you quickly find what you're looking for. Most are available at your local craft or hardware store. If you can't find them locally, one of the mail order catalogs listed at the end of the chapter will most likely carry what you're looking for. For those products that are sold mainly by one distributor, the source name and address are given with the product description.

With the growing interest in decorative painting, new companies and supplies appear almost daily and established companies are constantly adding to their product lines. Please keep this vigorous growth in mind as you read this chapter. This lively market place is a good indication of how popular decorative painting has become.

There is no way I could describe every decorative painting supply in this chapter. The omission of any products is by no means an indication that they aren't popular or of good quality. It means I was unaware of them or simply didn't have space to include them all.

Caution Regarding Supplies

Every day, we become aware of new hazards that exist in our environment. Many products we use around our homes can cause health problems if used incorrectly, and painting supplies are no exception.

Be sure to read and follow the instructions on each product container before you use it. Due to the wide variety of products to choose from, it isn't practical to include warnings for all the products described in this book. Avoid putting any supplies in containers where they might be mistaken for food unless they are well labeled; and keep them out of reach of children and pets. For example, rubbing alcohol put in a cup for cleaning your brushes, *could* be mistaken for water.

Descriptions

Acrylic Spray, Clear

There are many uses for clear acrylic spray. Use one with a matte finish to prepare slick surfaces, such as ceramic, for painting. This enables the paint to adhere better than it would to the same surface without the spray. It is also used to protect basecoats before applying a faux finish, and to protect decorated surfaces before antiquing, etc. Use it when painting is complete to protect it.

Some available brands are: Accent® Acrylic Sealer, DecoArt™ Acrylic Sealer/Finisher (matte and gloss finish), Delta® Ceramcoat® Clear Spray Finishes (satin and gloss), FolkArt™ Clear Cote™ (matte & "Hi-Shine"), Krylon® Crystal Clear.

Caution: Read the warnings on the can. Some brands warn pregnant women not to use the product.

Alcohol (Rubbing)

Alcohol can be used to clean brushes that won't clean up with soap and water alone. It is also useful for removing painting mistakes. However, rinse the area with water to remove alcohol residue, and make sure the area has dried before repainting. Add about 1/4 cup of rubbing alcohol to a container of baby wipes to make them more effective in removing paint from your hands.

Antiquing Mixtures

There are premixed products you can purchase for antiquing if you don't want to mix your own. Often, acrylic wood stains are also used to antique. Refer to "Wood Stains" in this chapter. See Chapter 6 for information on antiquing.

Some suggested products are:

Delta® Delta® Home Decor/Ceramcoat® Antiquing Gel is non-toxic and water-based. It is available in the browns and blacks usually used for antiquing plus Patina, which gives the blue-green color of weathered copper or bronze. Available in 2-ounce squeeze bottles as well as 8-ounce jars.

FolkArt® Antiquing This is a non-toxic, water-based formula available in 5 colors. It comes in both 2 and 4-ounce squeeze bottles and can be used on a wide variety of surfaces, such as wood, canvas, plaster, bisque, clay, primed metal, non-fired ceramic, and paper.

Apron

Unless you're able to paint in clothes you really don't care about, I suggest you wear some type of apron. Cloth ones are generally available in craft stores and look nice just as they are, or you can "spiff" them up with a little decorative painting. If they aren't available locally, they may be ordered through the Viking Mail Order catalog.

Baby Wipes

These come in handy for removing paint from your hands or for quickly wiping off painting mistakes from your project before they dry. To save money, I suggest you purchase a generic brand. Most brands no longer contain alcohol, which is the ingredient needed to remove paint. However, this isn't a problem. Before you use the baby wipes, just pour some rubbing alcohol into the container (around 1/4 cup), put the lid back on and shake it a bit to distribute the alcohol.

Note: There are some artists who do not recommend using these on surfaces because they contain lanolin and feel it will affect paint adhesion. Though this is a valid concern, I have never encountered this problem.

Basecoat Acrylics

FolkArt® Basecoat formula is a combination of sealer and paint which enables you to seal and basecoat in one step. It dries to the touch in about 15 minutes and cleans up easily with soap and water. It's available in 36 colors which are packaged in 8-ounce squeeze bottles. It can be used on wood, artist canvas, baskets, non-fired ceramic, watercolor paper, plaster, bisque, clay, leather, non-washable fabric, or primed metal.

Jo Sonja® Though this isn't a pre-mixed product, I'm listing it in this category because it is an effective basecoat/sealer combination. Mix approximately equal parts of Jo Sonja's® Artist Colors and Jo Sonja's® All-Purpose Sealer and apply it as you would any basecoat. Cleanup is with soap and water. See Chapter 6 under "Basecoating Wood Without Sealing–Jo Sonja's Method" for details.

Bronzing Powder

This comes in vials and is available in gold shades, silver, and other colors. It is either mixed directly into paints or, for some fabric painting techniques, brushed onto wet paint. Venus® Bronze Powder by United States Bronze Powders, Inc. is one possible brand for you to try.

Caution: Read the warning on the label. Misuse of this product can cause serious health problems. Keep any tools you use for this product with your craft supplies—not in the kitchen. Wash your hands (and any tools you use to mix it) thoroughly after each use.

Pour out the desired amount of paint onto your palette. Hold the bronzing powder container as close to the puddle of paint as possible. Use a palette knife and carefully lift a bit of the powder out and place it on top of the paint. Mix it into the paint immediately. Avoid creating any bronzing powder dust. This must *not* be inhaled, so you might consider wearing a disposable mask.

Brush Basin

This is also referred to as a water basin and can be anything from a bowl, glass, or mug you have around the house, to a product especially designed for decorative painters. The one I prefer is plastic and has holes for holding brushes around the top edge and ridges in the bottom. The ridges make cleaning your brushes easier.

I suggest using two separate basins—one for brush cleaning, the other for floating, etc. Having separate basins will assure you that no soap from your newly cleaned brushes will be mixed in with the paint.

Loew-Cornell® now makes the "Easy Traveler Water Bucket" which was designed for artists on the go. It takes up little space when not inflated. It inflates to a 6" basin and has a convenient handle to make it easy to carry when filled with water.

Brush Cleaners

Though a bar of Ivory® soap works adequately, there are good brush cleaners/conditioners on the market that you might prefer to use. Examples are:

Acrylic Brush Cleaner #387 This Loew-Cornell® product cleans and restores brushes used with acrylic, latex, and water-based products.

Brush Plus™ This Plaid Enterprises water-based product provides brush care to clean all your brushes after using acrylics, oils, alkyds, watercolor paints, varnishes, stains, glues, and painting mediums.

daVinci Brush Cleaner & Renewer This removes all types of paint from brushes, from acrylics to oils, (even paint that's dried in the bristles). It contains powerful cleaners

that get down to the ferrule, lifting binders and pigments from the bristles. It also contains softeners and conditioners to help keep brushes in good shape. It removes fresh or dried-on paint from fabric; however, it is recommended that you test it on a small piece of the fabric from an inconspicuous area before cleaning to make sure it is safe for that type of fabric. If you can't find this locally, call (800) 84BRUSH or (402) 494-2538, or write to daVinci Inc., 1402 Fifth Avenue, #3, South Sioux City, NE 68776.

Note: This product contains acetone, so keep it off the brush handles because it will take the paint off them as well as your fingernail polish.

DecoMagic™ Brush & Hand Cleaner This DecoArt™ product is a concentrated, water-based formula that cleans and reconditions paint brushes and works well for acrylic and oil-based paints. It cleans brushes with dried-in paint. It also acts as an excellent hand cleaner and removes fresh acrylic paint from fabric.

J.W. Etc. Formula II Creme Brush Cleaner A non-petroleum, non-toxic brush cleaner produced with natural solvents derived from citrus fruit aromatic oils. It removes both wet and dried oil and acrylic paints, and revitalizes old brushes. Repeated use will not harm your brushes.

The Masters® Brush Cleaner and Preserver This is used with water to clean and preserve brushes and can restore old, stiff brushes as well. It removes acrylics, watercolor, varnishes, oil paints, stains, and alkyds from brushes.

Pink Soap™ Artist Brush Cleaner This is a Houston Art & Frame product used as a brush, hand, and fabric cleaner. Contains no chlorides, alkalis, phosphates, alcohol, or solvents.

Stencil Magic® Brush Cleaner This Delta® product was designed to remove Stencil Magic® Paint Creme from stencil brushes.

Brush Holders

A mug or similar container will safely hold your brushes when you're at home, but it's nice to have a container that will protect them when you take them to classes. Examples are the Brush Well (Loew-Cornell®), Brush Mate™ (Plaid Ent.), or the Brush Quiver™ (Mastersons).

Brush-Up Paper

This is a Loew-Cornell® product used for practicing brush strokes using water only. Like Raphaél's® Magic Paper, it can be reused many times. The water dries quickly, enabling you to practice on the same sheet of paper for as long as you wish.

Brushes

Traditionally, brushes were made using natural fibers such as sable. Modern technology, however, has given us a wide choice of man-made fibers, which offer distinct advantages when used with acrylic paints. Synthetic brushes are chemically similar to acrylic paint, and, therefore, will last longer. Additionally, synthetic brush fibers are less expensive, resist insect damage, and are custom designed for acrylic paints to simulate the feel of natural fiber brushes.[1]

Brushes are usually sized by determining the width of a *flattened* ferrule, (the metal part that holds the bristles), in either inches or millimeters. For example, a #6 brush would be about 6 millimeters across. Though you may run into slight variations between manufacturers, this will at least give you an idea of how brushes are sized. Another variation is that a French brush size will be twice that of other equivalent brushes. For example, an American size 4 would be a French size 8.[2]

There are many good brushes available. It's not my intention to advertise any particular brand. I have used Loew-Cornell® "La Corneille"™ Golden Taklons almost exclusively because of their excellent quality, complete line, and because they are readily available. Whatever brand you select, choose quality brushes and take good care of them. Remember that the brush becomes an extension of your hand, and a bad brush will hinder the quality of your painting.

When you purchase a new brush, look it over carefully before you buy it. Make sure the bristles have not been damaged in any way. Liner and round brushes should come to a point with no bristles protruding away from the other bristles. Flat and angle brushes should have a good chisel edge. That is, all the bristles should neatly line up to form a narrow row.

Fabric painting on sweat shirts, T-shirts, etc., sometimes requires using fabric brushes, which have stiffer bristles than regular decorative painting brushes do. They are sold separately, as well as in sets, (e.g., the "FolkArt® Fabric Painting Basic Set"). Keep in mind that fabric brushes are not required for all fabric painting. Refer to the "Fabric Paints" section in this chapter to find out the type of brush recommended for the brand of paint you plan to use.

Shapes

I recommend that beginners start with just three brush shapes—flat, liner, and round. Learn to master the various brush strokes described in Chapter 5. After you have accomplished this, venture into new territory and try some of the other available shapes.

Here is a brief description of some of the available brush shapes. The Loew-Cornell® Company was kind enough to provide samples for the photographs.

Angular Shader A flat brush cut diagonally so that one side has short bristles that gradually lengthen to longer bristles on the other side. Also referred to as a "Rose Petal" brush.

Bright Similar to a flat brush, but has shorter bristles that come to a fine chisel edge. Sometimes called a "Chisel Blender."

Cat's Tongue See "Filbert."

Chisel Blender See "Bright."

Dagger Striper A flat brush with long, full bristles cut in a quarter oval (dagger) shape. Used to make long, sweeping strokes without reloading. Thick to thin strokes are created by the amount of pressure applied to the downward stroke. This makes it excellent for painting ribbons, borders, and such. Also called a "Sword Striper.[3]

Deerfoot A short, full-bristled round brush used to stipple. It is similar to a stencil brush except the bristles are cut at an angle. Excellent for textured strokes used to create shrubbery, fur, etc.

Dusty Brush See "Mop."

Egbert See "Filbert."[4]

Fan The bristles are shaped like a fan. Often used for special effects, such as flecking or dry brushing.

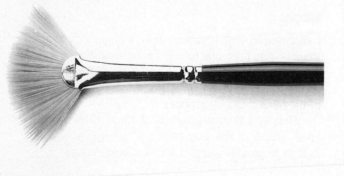

Filbert A flat brush, with bristles cut in an oval (fingernail shape). Sometimes called "Cat's Tongue," "Egbert," or "Oval."

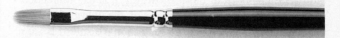

Flat This has squared-off bristles that form a fine chisel edge. It's similar to a Bright but has longer bristles. Sometimes referred to as a "Shader."

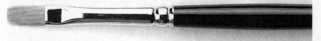

Glaze/Wash A very large, flat brush that is useful in applying washes, basecoating, or varnishing.

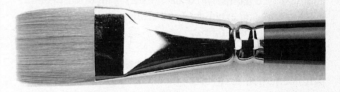

Liner A thin-bristled brush that forms a fine point. Has shorter bristles than a Script Liner.

Melinda's Magic Brush This is a #3 round sable brush created by the Royal Brush Company especially for Melinda Neist. It has a well-defined point and snaps back to a point easily and quickly, making it ideal for the multiloading technique Melinda has mastered. See "Round Brush."

Mop Brush Sometimes called a "Dusty Brush," this soft, large, full-bristled brush is used to soften the edges of floats and the effects of antiquing.

Oval See "Filbert."

Rake A brush with bristles that are thinned and uneven at the edge. Its "rake-like" shape, when wet, is ideal for creating interesting line work. Excellent for dry brushing grass, fur, and hair, as well as woodgraining.

Rose Petal Brush See "Angular Shader."

Round A round, full-bristled brush that is capable of creating a stroke which varies from thick to very thin. Bristles come to a fine point.

Script Liner A liner brush that has longer bristles than a regular liner. Has thin bristles that form a fine point.

Scumbler See "Stippler."

Scrubber See "Stippler."

Shader See "Flat."

Spotter A round, thin, short-bristled brush. Because bristles come to a very fine point, it is excellent for detail work.

Stencil A round, heavily bristled brush, cut straight across, with coarse, stiff bristles. Appropriate for pushing paint into cut-out areas of stencils.

Stippler A full, round, stiff bristled brush. Used for stippling and is also effective for scrubbing paint into fabric. Sometimes referred to as a "Scumbler" or "Scrubber." A stippler with softer bristles that are cut at an angle is called a "Deerfoot."

Sword Striper See "Dagger."

Tight Spot A spotter brush with a handle that is bent to a 120 degree angle by the ferrule. Excellent for detail work in hard-to-reach places.

Triangle Wedge As the name implies, there are three sides to the bristles. It can be single, double, and triple loaded for its own unique stroke work. Effective for easily creating borders, leaves, and ribbons. In the Loew-Cornell® brush line, this is called a "Miracle Wedge™."

Ultra Round This is designed for sign work and scrolling. Its filaments are tapered to create a reservoir in the middle and an ultra-fine point. The tip is the functional part of the brush. The reservoir allows the painter to work without frequent reloading.

Care of Brushes

Good brushes can range in price from around $3.00 to over $100, depending on the type and style. This adds up quickly. Their shape is vital to your painting success. Here are some hints to help you keep your brushes at their best for a long time. Treat your brushes with tender loving care—it will pay off in the long run.

1. The plastic protector covering brush bristles is used to protect them as they travel from the factory to you. Remove it and throw it away. It is not intended to be put back on once it has been removed and could damage the bristles if you try.

2. Sizing must be removed from new brushes. Rinse the brush in cool water and blot it on a paper towel. Sizing, just as the plastic protector described above, is used to protect the bristles as the brush travels from the factory to you.

3. Never load a flat-ferruled brush with paint up to the ferrule because it's very difficult to remove the paint. If you do, when the paint dries, it will spread the bristles,

3. Never load a flat-ferruled brush with paint up to the ferrule because it's very difficult to remove the paint. If you do, when the paint dries, it will spread the bristles, causing the brush to permanently lose its original shape.

Liner and round brushes, however, can be loaded to the ferrule because, by their design, paint is more easily removed from this area. Clean them often and well.

Don't throw away your ruined brushes. These "scruffy" brushes are excellent to use for dry brush blending, stippling, or scruffing.

4. Always use *cool* water for cleaning your brushes. Warm or hot water can harden the paint before you get it out of the bristles.

5. Never rest your brushes on the bristles. Even if you will be using them again in a few minutes, rinse them off, reshape the bristles, and lay them flat. Also, avoid resting a brush with the bristles touching another object.

6. Change the water in your basin often. Keep rinsing your brushes as you paint to avoid paint build-up.

7. When you are finished painting, clean your brushes thoroughly. Either a commercial brush cleaner or a bar of Ivory® soap will do the trick.

To clean your brushes with soap, first rinse them in cool water. Then stroke the bristles gently back and forth over a bar of Ivory® soap. Rinse often. Do this until no paint color remains. Use your fingers to rub the soap in thoroughly. Avoid smashing the bristles so they go in all directions.

8. Once cleaned, reshape bristles to their original shape. Flat brushes should be shaped to a good chisel edge, round and liner brushes to a point. Before storing them, blot brush bristles thoroughly to keep water from settling in the ferrule.

9. Store your brushes in a container, bristles up. A coffee mug or a glass works fine, or you may purchase a container designed especially for brush storage.

Caution: Brushes made with natural fibers (such as Sable) can be damaged by insects. When I'm not going to paint with my sable brushes in the immediate future, I store them (laying flat) in an air-tight box with a piece of cedar to repel moths. Make sure the bristles are completely dry before you do this. The cedar pieces are usually sold in the closet accessory section of department and discount stores. As mentioned earlier, insects are not a problem with synthetic brushes.

10. When using brushes that have been cleaned with soap, rinse them well. Reshape the bristles using plain water. Soap in the bristles may diminish the adhesion of paint.

11. A damaged liner brush (bristles not straight) can sometimes be repaired by the following method. Boil water in a small kettle. Carefully hold the brush straight up and down over the water and dip the bristles (about half way up) into the boiling water. Make sure the bristles don't touch the bottom or sides of the kettle and *don't get any water on the metal ferrule because this can*

loosen the glue. Remove after about 30 seconds and reshape the bristles.

Bubble Palette See "Palette, Bubble."

Chacopaper®, (Super)

Though the actual name of this product is "Super Chacopaper®," it is most commonly referred to as "Chacopaper®." It is a Houston Art & Frame product that can be used in place of standard graphite and other transfer papers. Transfer markings are instantly removed with a damp cloth, paper towel, or brush. It comes in two colors, blue and white, and can be reused many times to transfer patterns onto paper, fabric, leather, wood, plastic, china, or metal.

Because the transfer marks come off with water, this is not appropriate for using with any technique that requires dampening the surface before painting.

If you are unable to locate Chacopaper® in your area, it may be ordered directly from Houston Art & Frame, Box 56146, Houston, TX 77256-6146, Telephone: (713) 622-7042.

Chalk

Chalk is used in one of the methods to transfer a pattern onto a painting surface. U.S.A. General's® Multi-Pastel Chalks are in pencil form and available in a variety of colors. You may also purchase ordinary chalk sticks, the kind you would buy for a child's blackboard, *not* artists' chalk. Use white (or light) chalk for transferring onto dark backgrounds, colored chalk for lighter ones.

Cleaners for Hands and Fabrics

There are products made to handle the difficult task of cleaning painters' hands and clothes. Here are some suggestions:

Citri-Clean™ This J.W. Etc. product safely removes paints, grease, printer's ink, felt marker ink, ball-point pen ink, and other stains from both hands and fabrics. It is non-toxic and biodegradable. It contains no mineral spirits or other petroleum solvents and is produced from by-products of the citrus concentrate industry.

DecoMagic This DecoArt™ product is a hand cleaner that also removes fresh acrylic paint from fabric and is used for cleaning and conditioning brushes.

Kiss-Off™ Stain Remover This B&J product removes stains from fabrics without laundering or dry cleaning. It is conveniently packaged in a 7-ounce applicator stick.

Pink Soap™ This Houston Art & Frame product is used as a hand, fabric, and brush cleaner. It contains no chlorides, alkalis, phosphates, alcohol, or solvents.

Spoto® This Mark Enterprises product is a non-flammable, easy-to-use liquid cleaner that removes most paint from clothes if used before the paint has dried.

Clear-Tex™

This DecoArt™ product is a water-based, non-toxic texturizing medium that can be mixed with any water-based acrylic color to create textured colors. It is designed for use on solid surfaces, such as wood, ceramic, paper, tin, cardboard, etc. Mix equal parts of Clear-Tex™ and acrylic color. If a rougher texture is desired, use less acrylic paint. Apply to the surface with a brush, palette knife, sponge, or craft stick. Additional coats can be applied after the first coat is dry to the touch if additional dimension is desired.

Color Value Reader

This DecoArt™ product (DAS32), is a red, transparent plastic sheet. When held over your painting, it nullifies the color so that all you see through the sheet are the values. This is very helpful because it makes it easy to see if you have good value changes within your painting.

Color Wheel

If you want to learn about color theory, it will be to your advantage to have a color wheel. There is a very special one available by Johannes Itten called "The Color Star." It comes with discs (black on one side, white on the other), which may be easily attached on top of the Color Star. Each disk has areas which are cut out for a specific type of color scheme: Complementary, Triadic, Split Complementary, etc.

For example, if you want a complementary color scheme (colors directly opposite each other on the color wheel), remove that disk from the box and attach it on top of the Color Star. Because of the way the cut-out areas were designed, you'll only be able to see the colors that are directly opposite each other on the color wheel, i.e. red and green, blue and orange, etc. Spin the disk around to see all the possible complementary color scheme choices you have.

If you can't find this at your local craft store, ask if they can order it for you. You may order this by mail by writing to Barb Watson, P.O. Box 1467, Moreno Valley, CA 92556 or call her for more information at (909) 653-3780. She is the author of an excellent color theory book called *"The ABC's of Color."*

Crackle Medium

This product is used to create an aged, weathered, crackled appearance on surfaces. Some of the available brands are DecoArt™ Weathered Wood™, FolkArt® Crackle Medium, Jo Sonja's® Crackle Medium, and Wally R.™ Crinkle Medium.

There is now crackle medium designed for fabrics. Delta's® Fabric Crackle Medium is available in 4-ounce jars and is used to create tie-dye, stone washed, quick and easy batik, or antique crackle patterns on fabric. It is non-toxic and water-based.

Crow Quill Pen

"Crow Quill Pen" has become a generic name in the industry for a quill pen. It refers to the Hunt's Crow Quill Pen, which is a particular brand, and is most commonly found in craft stores. This may be used in place of a fine liner to do outlining. The pen is comprised of three parts, a nib, grip, and handle. Refer to Chapter 6, "Crow Quill Pen, Use of," for detailed information on how to use it.

Cubbyware

These are reusable, stackable, nonbreakable one-ounce containers with resealable snap-on lids. They are a Plaid® Enterprises product and are ideal to use for storing mediums or paint mixes. I've stored paint mixes in them for months and the paint remained fresh and usable.

Decowriter Tip™ and DecoArt™ Fine-liner

Decowriter Tips™ come in two sizes and are used to convert either 1 or 2-ounce universal-size bottles into writers. They are intended for use with DecoArt™ Hot Shots™, Dazzling Metallics™, Americana™, and So-Softs™. The tips have a small opening which is just the right size for doing liner work, making dots, etc. The tips come with a protective cover. After every use, or when changing paint colors, clean them in water and wipe dry with a paper towel. Replace the protective cover on the tips to keep your paints from drying out.

The DeccArt™ Fine-Liner (DAS80) is a super-fine paint writer which is effective for detailing and outlining. When you first purchase it, you'll find a metal tip and a wire inside the bottle. Remove them, fill the bottle with paint, and replace the lid. Screw the metal tip onto the lid. The wire is used to clean the metal point. This is not intended for use with glitter paints because the particles are too large to flow through the tiny point.

Deli-Wrap

This is used to make an inexpensive wet-palette. It can be purchased in restaurant supply stores and warehouse stores, such as Price Club, etc. The brand I use is made by Papercraft® Inc., and is called "Interfolded Dry Waxed Paper With Wet Strength." It comes in a box of 500 folded sheets that measure 10" X 10-3/4" (unfolded size).

To make your wet palette, unfold the deli wrap. Dampen a paper towel, squeeze out some of the excess water, then fold it and put it on a half of the deli wrap. Fold down the other half of the deli wrap on top (like a sandwich). Turn under the outside edges of the deli wrap, so no paper towel is exposed. This will help the paper towel stay damp longer. Place it in a small container. I use a Tupperware® Freezermate that's about 5-1/2" X 8-1/2" and 1-3/4" inches deep. If you need to leave your painting for awhile, just mist the paints lightly with water and cover the container.

Note: Avoid using the blue "shop towels" that are sold in the automotive section of hardware stores. They tend to absorb too much moisture and keep your paints too wet.[5]

Dressmaker Carbon Tracing Paper

This is used with a tracing wheel to transfer patterns onto fabric, and can be purchased at fabric stores in various colors.

Dry-It™ Board

This is a great helper for decorative painters. It is a washable, plastic drying board. One side is smooth and the other side is covered with short, sharp, tiny points. You can paint all sides of your project, place it on the Dry-It™ Board to dry or to continue painting. The tiny points will not mar or stick to wet paint or varnish. It comes in two sizes: 9" x 12" and 12" x 15".

Caution: Because the points are sharp, the board comes with a piece of protective plastic foam which is the same size as the board. Store the board with the points against the foam. The manufacturer also recommends hanging it up for storage.

If you are unable to find this at your local craft store, contact The Folk Art Cottage, P.O. Box 2107, Fallbrook, CA 92088. Telephone: (619) 728-3211.

Etching Cream

Because glass and mirrors are such smooth surfaces, etching cream can be used very effectively to "add tooth" to the areas you want to paint. Paint adheres better to etched glass and this treated surface is also easier to paint on.

I have used B&B Etching Creme™ with good results.

It has a creamy texture without any grit or liquid separation. See "Glass" category in Chapter 3 for in-depth instructions on use.

If you can't find this in your local craft store, it is available by mail. Address your inquiry to B&B Etching Products, Inc., 18700 N. 107th Avenue, Suite 9, Sun City, Arizona 85373. Telephone: (602) 933-2962.

When using etching creme, regular contact paper (available at your local variety store), a squeegee, swivel knife, and straight knife (such as an X-Acto®) are also necessary. The swivel knife and squeegee are available from B&B Etching Products. Pre-cut self-adhesive stencils may also be used.

Note: Etching Creme darkens in hot climates, but the darkening doesn't affect its performance.

Etching Liquid

This product, similar to Etching Cream described above, is used to roughen a glass surface so that paint adheres better and the glass is easier to paint on.

Dip 'n Etch™ by B&B Etching Products, Inc. is a reusable liquid for two-sided etching. Complete instructions for its use are found in Chapter 3 in the "Glass" category. If you can't find this at your local craft store, write to B&B Etching Products, Inc., 18700 N. 107th Avenue, Suite 9, Sun City, Arizona 85373. Telephone: (602) 933-2962.

Note: This darkens in hot climates; however, this has no effect on its performance.

Extender

This product is used to extend the drying time of paint. It is also used instead of water to vary the transparency while maintaining the consistency of paint. Every brand of acrylic paint described in Chapter 2 has an equivalent product. However, some brands have named their equivalent product differently. For example: DecoArt™ (Brush 'n Blend), Delta® (Acry-Blend), Liquitex® (Acrylic Retarding Medium), Jo Sonja® (Retarder), or Wally R™ (Blending Medium).

Fabric Pens

There are pens available for designing and outlining on all types of fabric. Make sure that the pen indicates it is washable and permanent. Suggested brands: DEKA's® Fabric Marker pens or FabricMate™ Brush Tip Markers (formerly Niji Fabricolor Superfine Markers).

Fashion Tape

This DecoArt™ product is a self-adhesive stencil tape. It's available in 12 different precut designs, such as Victorian hearts, stars, teardrops, etc., on 1" to 1-1/2" x 12 ft. rolls.

It is used on fabric as well as paper maché and hard surfaces such as wood. See Chapter 6 under "Stenciling With Fashion Tape" for information on its use.

Flow Medium

This is a Jo Sonja® product that is used with Jo Sonja's® Artist Colors to: (1) make paint flow smoothly and evenly for liner work; (2) remove brush marks from newly painted surfaces; (3) improve floating techniques; and (4) make basecoating easier. It can be mixed directly into Jo Sonja's® Artist Colors (3 parts paint to 1 part medium), or brush mixed on your palette.

Fluid Writer Pen

This Kemper Tool Inc. product is used to easily make fine lines. It is recommended for pen & ink drawings, fabric painting, and signing artwork. It comes with a metal cup attached to a fine metal pen point. Thin the paint and load the cup using an eye dropper. It's best to test it first on your palette so you can adjust the thickness of the line. If the pen clogs, use the metal plunger that comes with the pen to clear it. It comes in a large and small size.

Folk Art Design Tools

These tools are used to paint clear, consistent patterns. They are available in dot patterns of varying size, hearts, commas, teardrops, as well as letters. They are especially handy for painting borders.

Note: Practice on paper first, holding the tool in an upright position, before using it on your actual surface.

French Wash™ Sponging Paint

This Plaid Enterprises product is an easy-to-apply wash that is used to create a soft, delicate, cloud-like finish on walls, ceilings, floors, fabrics, and a variety of decorative painting surfaces. It is water-based, non-toxic, and cleans up with soap and water. It is available in 8 colors and may be applied with a sponge, spray bottle, or synthetic brush, to name just a few. Refer to Chapter 8, under the "Suggested Reading" category for a reference book that will instruct you in a variety of ways to use this product.

Gel Medium

This acrylic medium is used to increase the translucency of acrylic paints without changing their consistency. It's ideal for thick, transparent painting.

Gesso

This is an acrylic primer ideal for use on almost any surface except shiny ones. It is an effective sealer for wood, clay pots, and absorbent surfaces, such as canvas, hardboard, plaster, and masonry. Gesso is generally sold in jars; however, it is also found in squeeze bottles as well as spray cans. Acrylic paint can be mixed with white gesso when you want a tint of color. Depending on the brand, gesso dries in 15 to 30 minutes.

Suggested brands are Winsor & Newton, Bob Ross, or Liquitex® gesso (which is available in white as well as 7 intermixable colors).

Glitter

Glitter is available in dry form or suspended in a liquid.

Dry Glitter This is used in "diamond dusting," a technique used to add sparkle to your painting. Glitter can be used on a variety of surfaces, including fabric, and is particularly effective on Christmas projects. Examples are Prisma™ Glitter by Gick Publishing Inc. which is available in several colors in medium, fine, and ultra-fine grades. Also available is DecoArt™ Glamour Dust™. This is a finely-ground, sprinkle-on, non-toxic glitter that adds a rainbow of iridescent sparkle to most any surface.

Liquid Glitter This can be brushed on surfaces. Use one of your old brushes, as glitter is sometimes difficult to remove. Some examples are: DecoArt's™ Craft Twinkles™, Liquitex® Liquigems™, and Delta's® Sparkle Glaze which is glitter in a varnish base.

Gloss Medium

This medium is used to thin acrylics and to produce a glossy effect, greater translucency, and smoother paint flow.

Gloves, Disposable Plastic

These are inexpensive and extremely effective in protecting your hands while staining, antiquing, or sealing your projects. They should be available at craft or hardware stores, as well as through the Viking catalog.

Note: Some brands are not intended for use with oil-based products.

Glue

There will be times when a glue gun, tacky glue, or wood glue is needed to assemble projects you have painted. Aleene's Thick Designer Tacky Glue by Artis, Inc. was designed to be used in place of a glue gun and it is very effective. You'll find this in most craft stores.

Glue, Substitute for

A clear tub and tile sealer is an effective substitute for wood glue when more flexibility after setting is needed. I use it almost exclusively for such tasks as attaching angel wings, halos, etc. The added flexibility is a real help—the wings and halo aren't as easily knocked off as they are if attached with glue. One possible brand for you to try is DAP® Clear '230'® Premium Kitchen & Bath Sealant. Make sure the product package indicates that it dries *clear*, not white.

Graphite Transfer Paper

Graphite paper is the decorative painters' carbon paper, and is used in one method of transferring a pattern onto your project surface. It can be purchased in single sheets or in packets at art or craft stores.

Graphite is a gray-black color—like the color of pencil lead. One sheet of graphite paper should last a long time. New graphite should be used carefully because tracings can easily become too dark and tend to smear.

Graphite comes in only one color—gray/black. However, graphite has almost become a generic name for any color of transfer paper. For accuracy's sake, remember that transfer paper comes in assorted colors, including a graphite (gray/black) color.

When you purchase new graphite paper, wipe it with a soft rag or tissue to remove all the excess graphite. To get the longest wear, don't fold it. One convenient place to store it is in the back of your palette or transfer pad. However, if you must fold it, have the shiny side facing in. When you are ready to use it again, place the paper on your surface with the shiny side down.

India Ink

This is used in Rapidograph® and crow quill pens for "pen and ink" projects. Make sure the ink you purchase is waterproof. It is available at most craft and artist supply stores as well as mail-order catalogs.

An acceptable, less expensive substitute, is to use a water-proof permanent marker with a fine point instead of the Rapidograph® Pen and India ink. Check the ink for permanency by writing on a sample piece of paper, allowing the ink to dry, then dampening it with water. If the ink doesn't run, it should be suitable for your project.

Iron-On Transfer Pencil

This pencil is used for transferring a pattern onto fabric and is available at most fabric stores. The pattern is traced with the pencil, then ironed onto the fabric to be painted.

Kleister Medium

Kleister is an old term for faux finishes. This is a Jo Sonja® product used for creating various faux finishes and simulated woodgraining techniques. Adding this to the Jo Sonja® Artist Colors gives you more open time.

Kneaded Rubber Eraser

This is used to erase graphite and other transfer markings from your painted surface. Before doing any erasing, make sure the paint has dried completely. The eraser is available at craft and stationary stores, as well as through craft mail order catalogs.

It is so soft that it doesn't keep its shape for very long. However, even when out of shape, it remains effective.

Light Box

This is a wonderful tool to use for tracing patterns, transferring patterns onto surfaces such as watercolor paper, and for viewing slides and negatives without a projector. The box has a top made of translucent glass (or frosted Plexiglas) with a light under it. I use mine mainly for transferring patterns onto watercolor paper for pen and ink designs. It's easy to use. Put the pattern on the glass (facing up), then put the watercolor paper on top of it. Carefully ink the pattern lines. Because you don't need to use any transfer paper, you won't have the problem of messy transfer lines to contend with. You should be able to find this in your local tole shop.

Magic™ Transparent Tape

This Scotch® product is used to secure tracings to a surface or for masking areas when painting line trim. When using it for any of these applications, make sure the area is completely dry before applying the tape.

Manila Folders

These are an excellent surface to have on hand for practice painting. If you are a beginning painter, you may feel uncomfortable painting directly on your project surface without a bit of practice. If this is the case, transfer your pattern onto a manila folder and paint the project on this first. You may need to add a little water to your paint so it will flow evenly.

Mask

When you're doing a lot of sanding, or working with products that emit harmful vapors, it's a good idea to wear a mask to protect your lungs. A variety of types are available at most hardware stores. Check the label on the

package to make sure the one you purchase will provide the desired protection. A mask that protects you from dust will not necessarily provide adequate protection from harmful vapors.

Masking Tape

This can be used instead of Magic™ Mending Tape to secure tracings for pattern transferring. Surfaces already basecoated must be completely dry before using masking tape on them. If some of the adhesive should adhere to your project surface, carefully wipe it off with a damp cloth. Don't rub too hard or you may begin to rub off some of the basecoat.

Matte Medium

This acrylic medium is used with acrylic paints to improve the flow of the paint and to dry with a matte finish.

Metal Primer

This is used to seal out moisture and prevent rust on metal surfaces. It's available in both brush-on and spray-on types and is applied to the metal surface before any decorative painting is done. Suggested products are Krylon® All-Purpose Primer, Rusticide, or Rustoleum®. Your local craft or hardware store should carry at least one brand of metal primer.

Multimedia Artboard®

This is a unique, combination of paper and resin. You can paint on both sides of the board. One side is textured, the other side is smooth. It is available in a variety of sizes. Teachers will find it an excellent surface on which to demonstrate. When soaked in water, it can be formed into jewelry, baskets, etc. and painted. For free samples and information call (800) 701-2781, or write to Multimedia Artboard, 15727 N.E. 61st Court, Redmond, WA 98052.

Neutral Gel (Delta® Home Decor/Ceramcoat®)

This product is added to acrylic paints to make them transparent and has several uses. Mix with Delta® Ceramcoat® acrylic paints when you want to achieve a wash-/watercolor look on wood for pen and ink designs. Mix with the paint to make a transparent stain for pickling or staining. Add to the paints when doing wall glazing. Use for glazing on painted pieces. Add to paints for faux finishes.

Norwegian Painting Medium

This Cabin Craft Inc. product is a combination of varnish, paint thinner, and linseed oil. When mixed with oil paint, it is used for antiquing.

Oil Paint

Oil paint, when mixed with McCloskey® Clear Stain Controller & Wood Sealer, makes an excellent stain. When mixed with Norwegian Painting Medium, it makes an antiquing mixture.

For both staining or antiquing, one tube of Liquitex® Burnt Umber Artist Oil Color, or an equivalent brand, is all you need. Though Burnt Umber is a popular color to use, any color of oil paint may be used.

Some companies make both oil and acrylic tube paints. Make sure you purchase *oil paints* for doing the techniques described above as acrylics won't give the same results and should not be mixed with petroleum-based products because they are not compatible.

Paint, Aerosol

For those who prefer sprays, using an aerosol paint is a quick and effective way to apply basecoats, especially on smooth surfaces, such as metals, where brush strokes tend to show more.

Some of the available brands are Accent® and Country Colors® Matte Craft Sprays, Carnival Arts™ Village Classic Matte Sprays, and FolkArt® Color Aerosol Spray Paint. Because products vary, be sure to read the entire label for directions and any warnings before using.

Paint Caddy (Color Wheel)

This is a very handy way to store your paints. There are two types available. One is designed to store 57 standard 2-ounce squeeze bottles of regular acrylic paints—the other one is for Jo Sonja® Artist Colors (holds 56 tubes). Each one is like a "Lazy Susan" with a color wheel design on top. Paints are placed in the caddy according to their place on the color wheel. The caddy comes with some definitions and suggestions for mixing colors. They may be stacked on top of each other to store additional colors. Just spin the caddy around to find the desired color. For information, write or call Georgetowne, Inc., 121 Bashford Drive, Coraopolis, PA 15108. Telephone: (800) 947-6690.

Paint Stripers

The one I'm familiar with is made by the Embee Corporation (552 West State Street, Springfield, Ohio 45501). They make a variety of Master® Paint Stripers that are used for making straight or curved lines. They have

interchangeable wheel assemblies so you can vary the line widths.

Palette, Bubble

This is a plastic plate with "bubble"-shaped depressions over the surface. It is especially useful when painting watercolor designs with regular acrylics. A different color of thinned paint is placed in each bubble so you don't have a problem with colors running into each other. Some bubble palettes come with a plastic cover.

Palette, Disposable

Paints are blended on a palette before applying to a surface. The Morilla Company makes pads that contain 50 disposable plastic-coated sheets that are appropriate for use with acrylics or oils. They are available in a 9" x 12" and 12" x 16" size. Other brands are available, but make sure the one you buy is suitable for acrylic paints.

In a pinch, try using Styrofoam® plates or glazed ceramic tile of an appropriate size.

Palette Knife

This is used for mixing paints on a palette, taking paint out of jars, adding bronzing powder, and for achieving textured effects. They're available in both plastic and metal. In a pinch, use a plastic knife or wooden craft stick.

Clean the palette knife after each use since it's difficult to remove paint once it has dried.

Palette, Sta-Wet

This is an air-tight storage box that keeps paints fresh for days. It comes with a sponge and specially treated palette paper. Some varieties also have air-tight containers for paint storage.

To use the "sta-wet" feature, saturate the sponge with water and place it in the palette box; soak a sheet of the treated paper for 3 to 5 minutes, then place it on top of the sponge.

Sta-Wet palettes are very convenient for painting classes. When class is over, just put the lid on and keep the box in an upright position. Your paints will stay fresh and you will not be wasting paint.

The one I'm familiar with is made by Masterson. There are several types available, but I recommend #912 "Painter's Pal" because everything you need is in one box.

If you don't have a Sta-Wet palette, you can make your own. See "Deli-Wrap" category in this chapter for details.

Paper Towels

You will use a lot of these. They are great for blotting your brush before floating as well as clean-up jobs. The blue paper towels, (available in most auto supply stores), work especially well because they absorb more moisture than regular paper towels.

Pencil, Pastel

Conté pastel pencils are used in one method of transferring a pattern to both fabric and solid surfaces. The pencil is used in place of chalk to retrace the back of the pattern.

Permanent Marker Pen

Used to mark the color names on the plastic tops of acrylic paint bottles, pen and ink work, etc. Make sure the marker is *waterproof*. One possible brand is Sanford Sharpie® extra-fine point permanent marker. Permanent markers are available in black as well as colors.

Petifours

These are unique, reusable sponge applicators by Plaid Enterprises. They are about 1-1/2" square with three layers of sponge. The top (yellow layer), can be folded so that it makes a little handle. Try them for banding the sides of a box, or edges of a picture frame. I've found banding is easier, quicker, and the results better when I've used Petifours instead of a brush. See Chapter 6, under "Edging" for details.

Pickling Stains

For those who choose not to mix their own pickling stains, pre-mixed ones are available. The one I'm familiar with is called "Susan Goans Driggers Pickling Stain™" and is a Plaid Enterprises product available in 4 colors in both half pint and pint sizes. It is water-based, non-toxic, and seals as it stains.

You can make your own pickling stain by mixing J.W. Etc. White Lightning™ with a dab of regular acrylic paints. This will pickle and seal in one step. See Chapter 6, "Pickling."

Plastic Wrap

Products, such as Saran or Reynolds® Wrap, are used in creating some types of "faux finishes."

Poly Brush See Sponge Brush.

Q-Tips®

These are used for quickly cleaning off mistakes in small areas. Just slightly dampen the Q-tip® with water (or alcohol if the paint has dried), and remove the problem area. If you used alcohol, use another Q-tip® with water on it to remove any excess alcohol.

Rags

Rags are used for tacking, antiquing, and various other tasks. I like to use the Scott® "Rags In A Box" with convenient pop-up dispensing. They are 10" x 14" rags that have the strength of cloth and the absorbency of a sponge. They are clean, white, and lint free and are available in large hardware stores, such as Home Base or Home Depot. If you can't find them in your area, the Scott® Paper Company Consumer Hot Line telephone number is (800) 835-7268. Old T-shirts, sheets, etc., work well too.

Rapidograph® Pen

This pen is used with India ink or special technical pen inks and is very good for doing techniques such as "pen and ink."

Renaissance Foil

This is a Delta® product that is used in place of traditional gold leafing sheets to add metallic accents to plaster, bisque, wood, and other surfaces. Because the foil is attached to a thin layer of Mylar, it is much easier and tidier to use than traditional gold leafing sheets, which tend to scatter in every direction when you work with them. The foil is non-tarnishing and is available in gold, copper, and silver. The line also includes a sealer, basecoat, adhesive, and antiquing products to be used with the foil.

See Chapter 6, under "Gold Leafing With Renaissance Foil" for complete instructions on its use.

Resist

Resist for fabric is a medium most commonly used in silk painting techniques to outline pattern areas. The resist lines act as barriers to keep dyes from spreading beyond the line of resist. It is available in a variety of colors as well as clear (colorless). DEKA® Resist and Delta® Fabric Color Resist are possible brands to try.

Now you can do the Resist technique on wood using Delta® Home Decor/Ceramcoat® Stain Resist. It comes in a 1-ounce squeeze bottle with an applicator tip. For instructions on how to use it, see Chapter 6 under "Resist on Wood Technique."

Note: Since Delta® carries two types of resist, be sure to choose the appropriate type, depending on whether you're painting on fabric or wood.

Retarder and Antiquing Medium

This is a Jo Sonja® medium that is used whenever you want to retard the drying time of the Artist Colors. Other uses are for making an antiquing glaze, various blending techniques, added to water in a squirt bottle for misting paints to keep them fresh longer, added to textile medium for fabric painting, simulating oil painting techniques, or for wet-on-wet painting techniques.

When using Retarder with Jo Sonja's® Artist Colors, allow up to 5 days to cure before varnishing. In their "Tech Data Booklet" they caution that although the paint containing Retarder may appear to be dry, it can be reactivated unless it is force dried with a hair dryer.

Sandpaper

You will use this before and after sealing to smooth the wood or after basecoating to smooth out the surface. It's necessary to have several grades on hand, varying from medium to a very fine grade (such as #600). If you have trouble finding a fine enough grade in a hardware store, try your craft store. Plaid Enterprises Inc. Craft Sandpaper is available in an assortment that includes 3 each of #400 and #600 grades.

I often sand basecoats with pieces of unprinted, brown paper grocery bags. You might want to try this.

Saral®

This is a brand name for a reusable, greaseless, wax-free transfer paper that is available in the following colors: graphite, blue, red, yellow, and white. It can be used to transfer patterns onto paper, wood, glass, acetate, metal, and cloth.

It's available in economy rolls of 12 ft. x 12-1/2 inches, "Sampler" packages which contain one sheet of each color, or a "Tole & Craft Kit" which contains 3 white, 1 graphite, and 1 yellow sheet.

Scissors

These are handy to keep with your painting supplies for cutting tracings to a more convenient size.

Scottie's Antiquing Patina

This is a Cabin Craft Inc. product used with oil paint for antiquing.

Screwdriver

Some projects require hinges or screws for assembling. A common and a Phillips screwdriver are advisable to have on hand.

Scruffy Brush

This is the name given to any old, beat-up brush. It's very useful for stippling and dry brush blending.

Sea Sponge

This is sold in most craft stores and in drugstores in the cosmetics department. The sponge has large holes in it and is used for such things as applying sponged or pickled backgrounds, stippling, etc.

Sealers

Most project surfaces need to be sealed before doing any decorative painting. This is discussed in depth in Chapter 3. There are many products to choose from. I suggest you wear gloves when applying any sealers that aren't water-based. Here is a description of some available sealers:

Accent® "Start" Sealers Available in a brush-on, water-based formula. It is non-yellowing and quick drying and is available in an 8-oz bottle. It is appropriate for preparing wood, paper, and other porous surfaces for painting. There is also a "Start" Sealer available in a 6-ounce spray.

DecoArt™ Wood Sealer A non-toxic, water-based, fast-drying, easy to apply sealer that is appropriate for use on most surfaces. It has a thin viscosity that allows it to penetrate wood without raising the grain. Clean up is with soap and water. Available in 2-ounce and 8-ounce flip-top bottles.

Delta® Ceramcoat® Wood Sealer A water-based, non-toxic wood sealer that is appropriate for any porous surface. It is available in 2-ounce and 8-ounce squeeze bottles as well as 8-ounce jars.

Hint: If you plan to stain the surface using a Delta® Home Decor/Ceramcoat® *gel* wood stain, *don't* seal the wood first because the stain won't penetrate. After the stain has dried, then seal the surface. However, if you are using the Delta® liquid wood stains, seal the wood *first* before staining.[6]

Designs From The Heart Wood Sealer™ This is a petroleum product that dries in only 30 minutes. Read cautions on the label and do not mix with oil paint. I don't recommend using this with Jo Sonja's® Artist Colors because the products are not compatible.

Gesso A water-based, fast-drying acrylic primer. Described in detail under "Gesso."

Jo Sonja's® All-Purpose Sealer This is a water-based, pure acrylic sealer with good adhesive powers. It is used to seal wood, granite, metal of any kind, tin, (including tin that has already been painted), slick glass, or porous glass (frosted, porcelain, pottery with a porous surface). Mix with the Jo Sonja's® Artist Colors for basecoating and sealing in one step.

McCloskey® Clear Stain Controller & Wood Sealer This is available in most hardware stores, or stores that carry painting supplies. Per instructions on the can, it requires an 8 hour drying period; however, I recommend waiting 24 hours. Purchase the smaller size can because, as the sealer ages, it turns to a gel-like substance that must be discarded. The more times the can is opened, the quicker this will happen.

 Caution: Be sure to read all the warnings on the label. Wear gloves when using this sealer. Work in a well-ventilated area—outdoors if at all possible, because the vapors are harmful. Use a sponge or sponge brush for applying the sealer and discard all trash in an outdoor trash can. Keep the newly sealed surface away from people and pets because the fumes remain strong during the drying period.

Tannin Blocking Sealer Pitch or knots in wood can cause a brownish stain to bleed through the paint. This special sealer by Jo Sonja® is designed to prevent this problem.

 Note: Shellac can also be used to prevent this.

White Lightning™ See "White Lightning" category later in the chapter.

Shade Cloth

This is a painting surface which is made out of window shade material. It's relatively inexpensive, commonly available, and, therefore, is a good surface for beginners to practice on.

Shoe Paint (Color Step®)

Color Step® Shoe Paint is a Plaid® Enterprises product designed especially for use on leather and vinyl shoes and accessories. (Do not use this on suede or patent.) Old shoes and accessories can be repaired using Color Step® "Shoe Repair" and then painted to look like new. Whether new or old, shoes and accessories can be enhanced with your decorative painting. Once the paint has dried, it is water resistant and won't crack or peel. It is water-based and is available in 12 colors. The 1-ounce container covers up to 3 pairs of shoes. See Chapter 3, "Shoes" category for information on how to use this

product.

Shrink-it™ Plastic

Aleene's Shrink-It™ Plastic, (formerly called "Shrink-Art Plastic"), was first introduced in the early '70's. It is particularly popular when made into jewelry or sewn onto sweat shirts. See "Shrink-It™" category in Chapter 3 for instructions.

If you can't find Shrink-It™ in your local craft store, write or call Aleene's, 85 Industrial Way, Buellton, CA 93427. Telephone: (805) 688-7339.

Snow-Tex™

Snow-Tex™ is a DecoArt™ medium that is used to give texture and dimension to your designs. To name a few applications, it can be used to create the appearance of snow on rooftops, pine cones, or to use as stucco for backgrounds.

There are two types available—one for use on hard surfaces, and another for fabric. Though both types come in white, each can be tinted to create subtle colors. Tint regular Snow-Tex™ by adding up to 50% DecoArt™ Americana™ acrylic paint. Tint Fabric Snow-Tex™ with up to one-third DecoArt™ So-Soft™ Fabric Acrylics, Shimmering Pearls™, or Heavy Metals™.

Each type can be applied with a brush, sponge, or palette knife and remains workable for 20 minutes. It will dry to a hard finish in 2 to 3 hours. Additional layers can be applied if desired after the first coat has dried. Fabric Snow-Tex™ is machine washable. Hang painted fabric up to dry. Do not machine dry because the heat may crack the Snow-Tex™.

Soap

Though I prefer using one of the commercial brush cleaners, a bar of Ivory® soap works adequately for cleaning brushes. Also, see "Brush Cleaners."

Soft Flock®

This non-toxic product is used to put a lovely, soft, yet extremely durable, velvety finish on almost any surface. Decorative painters will find it a quick and easy product to use to "line" drawers on jewelry cabinets, painted boxes, and similar objects. It can be used on fabric and becomes washable and dryable after heat setting. Cleanup is easy with soap and water.

Soft Flock® is available in 20 colors. Each package includes 1/2-ounce flock fibers in an easy applicator bottle, 1-ounce water-based, color coordinated adhesive, and a detailed instruction sheet which also gives you many project ideas. The rayon fibers have been precision cut to a uniform length of 1/32".

To help you decide which color would match your project, I've included the color name, brand, and product number of an acrylic paint that is a close match. This should be especially helpful for those of you who will be ordering this by mail. To make the matches, the flocking was done on top of a basecoat that was the same color as the adhesive. Keep in mind that a darker, lighter, or different basecoat color will slightly alter the color of the flocking.

 Black (use any Black)
 Brown (Brown Iron Oxide, Wally R™ #1016)
 Cranberry (Crimson Tide, DecoArt™ #DA21)
 Gold (English Mustard, FolkArt® #959)
 Hunter Green (Hunter Green, FolkArt® #406)
 Ivory (Antique White, DecoArt™ #DA58)
 Kelly Green (Christmas Green, Delta® #2068)
 Lt. Blue (Blue Heaven, Delta® #2037)
 Mauve (Rose Garden, FolkArt® #754)
 Orange (Autumn Leaves, FolkArt® #920)
 Peach (Cherub, Wally R™ #1165)
 Pink (Lisa Pink, Delta® #2084)
 Purple (Dioxazine Purple, FolkArt® #558)
 Red (Fire Red, Delta® #2083)
 Royal Blue (Ultra Blue Deep, DecoArt™ #DA100)
 Silver (Slate Grey, DecoArt™ #DA68)
 Slate Blue (Stoneware Blue, Accent #2440)
 Tan (Territorial Beige, Delta® #2425)
 White (use any White)
 Yellow (Luscious Lemon, Delta® #2004)

If you can't find this locally, it is available in several mail order catalogs, or directly from the manufacturer (DonJer Products Corp., Ilene Court, Bldg. 8J, Belle Mead, NJ 08502. Telephone: (908) 359-7726.)

Soft Tints

These Delta® Ceramcoat® products are transparent acrylic paints in a creamy, gel-like consistency. They are water-based, non-toxic, and take longer to dry than regular acrylic colors, giving you more time for blending, shading, highlighting, antiquing, etc. They were designed to be used on bisque, plaster, and ceramic (for example the Christmas villages that are quite popular now). Use them to create a soft, matte, chalked look, or for translucent stained effects. Very effective when used as transparent glazes for decorative painting. They are available in 24 colors plus a matte and gloss glaze and are packaged in 1-ounce jars. See Chapter 6 under "Tinting Plaster Castings" for instructions on their use.

Spatter Brush

This is a product made by Kemper Tools® used for flecking. It is designed so your fingers remain paint free. It can be used with acrylics, oils, fabric paints, and watercolors. For information on its use, see Chapter 6, under "Flecking."

Sponge Brushes

These are also called poly brushes. They are available in 1", 2", 3", and 4" sizes and are used for applying sealers, basecoats, and varnishes.

When used with water-based products, the brushes can be washed with soap and water. Rinse well, then allow to dry. Many people use them once and toss them out because they are relatively inexpensive.

Stencils

Pre-cut stencils are available in a wide variety of designs. The medium weight plastic ones are recommended because they are strong yet pliable, so they'll bend to make it easier to work on curved areas or corners.[7] With the increased popularity of stenciling, you'll have a variety of stencils to choose from. Examples: Delta's® Stencil Magic® stencils and Plaid's® Stencil Decor®. (Each brand has over 100 designs available.)

Stencil Adhesives

Stencil adhesives are used to attach a stencil to a surface with a secure—but not a permanent—bond. Use of these products reduces the risk of paint seeping under the edges of the stencil cutouts. Spray stencil adhesive is convenient to use and dries quickly.

Delta® Stencil Adhesive Spray is available in 4-3/4 ounce and 11-ounce cans. It is convenient to use and dries quickly.

Delta® Liquid Stencil Adhesive is applied to the reverse side of the stencil using the dauber applicator tip on the 1-ounce bottle. It takes about 10 minutes to dry. The adhesive is non-toxic.

Stencil Paints

With the ever increasing popularity of stenciling, paint companies are coming up with new, improved products to make the job a lot easier.

Dry Brush™ Stencil Paint This is from the Plaid® Stencil Decor® product line. It has a creamy consistency, so drips or runs are no problem. There are 24 colors that are non-toxic, fade-resistant, permanent, and washable. They are appropriate for use on walls, wood, paper, plaster, and fabric.

Easy Blend Stencil Paint™ This is a DecoArt™ product which is available 1-ounce jars. It is available in 35 intermixable colors, which includes 2 metallics. They adhere to most surfaces, including walls, furniture, and fabric (no heat setting required.). They are water-based and non-toxic. The dry-brush formula makes drips and runs a thing of the past.

Stencil Paint Creme This is from the Delta® Stencil Magic® line. Stencil Paint Creme is an oil-based, concentrated, permanent color suitable for walls, fabric, wood, or paper–virtually any surface. While it may look like a solid cake of paint, it is creamy when applied to the stenciling surface. It's registered as AP Non-toxic. Because of the cream-like texture, you are able to stencil without drips, and it won't run under the stencil. It's available in 48 colors (of which 3 are metallics). Cleans up with detergent or Stencil Magic® Brush Cleaner. See Chapter 6, under "Stenciling with Stencil Paint Creme" for details on how to use it.

Stencil Palette

This Delta® product was designed to hold up to 10 Stencil Magic® Paint Creme containers or stencil brushes in one place. It makes it easier when you're painting walls because all your paints will be handy. It is made of sturdy, durable, corrugated board that has been fitted with foam pieces that grip and hold the Paint Creme or brushes in place. There is a cut-out section at the top of the palette so you can hold it securely in the palm of your hand as it rests on your forearm.

Steel Wool

This is used for fine sanding metal and wood. A fine grade, such as 000 or 0000, is commonly used.

Stylus, Double-Ended

This is used in transferring a pattern to your design or for applying dots to your painting. This type of stylus has a wooden handle and a small bulb-like piece of metal at each end. The bulbs are two different sizes...one for making very small dots, the other for slightly larger ones. (I recommend using the smallest end when transferring patterns.)

A stylus is also handy to use for fabric painting. When using dimensional fabric paint, bubbles sometimes appear, or the paint looks too "globby." The stylus easily pops bubbles and evens out lines.

In a pinch, a toothpick, pencil point, or knitting needle can be substituted for a stylus.

Clean the stylus with a paper towel after each use. Avoid unnecessary pressure on the bulbs to keep them from breaking off. When you break a stylus, save it for

fabric painting. It will still work for popping bubbles and smoothing out uneven lines.

Tack Cloth

These cloths are treated with substances that make it easy to remove sanding residue. They can be purchased in most craft or hardware stores. See Chapter 6, "Techniques," for instructions on the proper way to use a tack cloth.

Textile Medium

This is used with regular acrylic paints to make them penetrate into fabric fibers better than the paint would if it were used without the medium. It is also used to thin some fabric paints/dyes. Though most companies refer to it as "textile medium," the DecoArt™ equivalent product is "Fabric Painting Medium" and for Liquitex®, it is "Fabric Medium." Refer to the "Fabrics" category in Chapter 3 for more information on its use.

Texturizing Mediums

Following are some mediums that will create texture in your painted designs.

DecoArt™ Sparkling Sandstones™ is a stone-like textured acrylic with glitter and is available in 24 colors. It can be used on wood, papier maché, ceramic, bisque, plaster, wall board, cardboard, Styrofoam®, resin, or virtually any other hard craft surface. DecoArt™ Clear-Tex™ and Snow-Tex™ (described in Chapter 2), are also texture mediums.

Delta® Decorative Snow adds realistic snow-like texture to the same surfaces as "Fantasy Snow." It will dry to a durable, rough, white finish without any glitter. Regular acrylic paint may be mixed in to give it a tint of color or you may paint on top of it.

Delta® Fantasy Snow is used to add tiny snowballs with an icy glitter texture to Christmas decorations, miniatures, painted designs, woodcrafts, florals, plastercrafts, and fabrics that won't be washed. A good companion product to use is *Sparkle Glaze*, which adds a clear, protective, glittery finish to both of the texture mediums described or may be used alone over acrylic paints.

Liquitex® Texturizing Mediums are dense, opaque gels. *Natural Sand* has a low viscosity, glossy sheen, and fine texture. *Resin Sand* has a high viscosity, semi-gloss sheen, and a course texture. *Blended Fibers* has a medium viscosity, semi-gloss sheen, and a fibrous texture. *Black Lava* has a high viscosity, semi-gloss sheen, and a black speckled texture. *Glass Beads* has a high viscosity and a "bubbly" texture. *White Opaque Flakes* has a high viscosity, random, irregular texture, with white speckles.

Thickener

This is added to acrylic paints to create a textured effect. It is also used in some marbleizing and other faux finish techniques.

Tracing Paper

This is a thin, almost transparent paper used for tracing patterns. There are a number of brands available. The Morilla Company Tower Tracing Paper No. 82 is the one I'm most familiar with. It's available in 9" x 12", 11" x 14", and 19" x 24" sizes as well as in rolls.

Tracing Wheel

This is used with Saral®, regular dressmaker's carbon tracing paper, or graphite paper to transfer a pattern onto fabric.

Transfer Paper

This is used under tracing paper to transfer a pattern onto a project surface. There are a variety of types available. Regular graphite is available in single sheets or packets at craft stores. Saral® is a brand name for transfer paper that is available in a variety of colors. (See "Saral®" in this chapter.) "Super Chacopaper®," by Houston Art & Frame is another type of transfer paper. See "Chacopaper®" in this chapter for a complete description.

Tru-Color™ System Discs

Bobbie's Tru-Color™ System Discs are hand-painted with colors from leading paint manufacturers. They are used to find equivalent paint colors between the various brands. For example, if you are taking a class that is doing a project using FolkArt® acrylics, but you have mostly Delta® Ceramcoat® acrylics, you can use the appropriate disc to find the Delta® color that comes closest to the FolkArt® color.

They are also helpful for choosing alternate color schemes for class or pattern book projects or choosing colors for your own designs. It's a lot easier than hauling out all your bottles of paint. If you can't find these locally, write to Bobbie's Tru-Color System, 64 East Marion Street, Danville, Indiana 46122-1824 or telephone (317) 745-7535.

Varnish

Varnish is used to protect a finished painting. There are both brush-on and spray-on types available in matte, satin, semi-gloss, and gloss finishes.

Brush-on Water-based Water-based varnish is easy to apply with a wide, soft-bristled flat brush, giving a smooth, ripple-free finish. Brush cleanup is easy, requiring just soap and cool water.

There is a large selection to chose from. Here are some possibilities. Be sure to read the package instructions carefully, as different brands have different requirements.

> Accent® Acrylic Varnish (matte, satin, and gloss)
> Delta® Ceramcoat® Water-based Varnish (matte, satin and gloss)
> Delta® Ceramcoat® Exterior Varnish
> FolkArt® Water-Based Varnish (satin)
> J.W. Etc. Right-Step™ (matte, satin, or gloss)
> Jo Sonja's® Polyurethane Water-Based Varnish (satin)
> Liquitex® Varnish (Satin or High Gloss)
> Wally R.™ Super Lustre™ Acrylic Varnishes (Satin or Gloss)

Unlike the varnishes listed above, Liquitex® Soluvar Varnish is a *removable* varnish in matte or gloss finishes. It is to be used as a final coat after your final permanent varnish. All acrylic is porous and will allow dirt to collect in the pores of the top layer of a painting over the years. Soluvar® is resoluble at any time with mineral spirits so you can wash away the dirt without hurting your work. After the dirt is removed, apply a fresh coat of Soluvar® varnish.

Spray-on Varnishes For those of you who prefer a spray-on type of varnish, here are some of the possibilities:

> Accent® Acrylic Varnish (matte, satin, and gloss)
> Blair Satin Tole #810
> DecoArt™ Americana™ Acrylic Sealer/Finisher (gloss or matte)
> Delta® Clear Finish (satin or gloss)
> FolkArt® Clear Cote™ Extra-Thick Glaze, Hi-Shine Brilliant Glaze, or Matte Acrylic Sealer

Caution: Use all spray varnishes in a well-ventilated area and avoid breathing the fumes. Read the warnings on the can.

Water/Brush Basin See "Brush Basin."

Watercolor Paper[8]

Watercolor paper is made from linen and cotton rag that goes through a cutting, boiling, and beating process to create pulp that is pressed into thin layers. The "Watercolor with Acrylics" technique, described in Chapter 6, is very popular. Choosing what kind of paper to use, when there is such a wide variety available, can sometimes be confusing. Perhaps the following will help:

Sizes Watercolor paper is available in pads, blocks in which several sheets are glued at the edges to keep it flat while painting, and single sheets. When you purchase single sheets, you will most likely find them in the standard size, 22" x 30", which can be cut to suit.

Surfaces There are three types: (1) cold pressed, which is medium coarse (a popular type with decorative painters); (2) hot pressed, which is smooth; and (3) rough, which gives your paintings a textured appearance.

Weight The weight of watercolor paper refers to the weight of a ream, which is 500 sheets. Therefore, when you purchase 125 lb. paper, a ream would weigh 125 lbs. Though weights vary, the 140 lb. weight is most often used for the "Watercolor With Acrylics" technique.

Right And Wrong Side The manufacturer's name or a watermark will be embossed on one corner of the paper. This indicates the right side of the paper (which is smoother). However, when you purchase better quality paper, either side will work well. If you paint on the wrong side of less expensive paper, you may notice flaws in the paper that you didn't see before it was painted.

Sizing Watercolor paper contains a sizing that controls its absorbency. It is a mixture of glue and gelatin which is pH (acid/alkaline) balanced to control yellowing of the paper.

Weathered Wood™

This is a DecoArt™ crackle medium that is used to create a very old, crackled effect in any color. It is appropriate for use on all solid surfaces that will hold a coat of acrylic paint. Either DecoArt™ Americana™, Heavy Metals™, Heavy Metals Light™, or Dazzling Metallics™ may be used as the basecoat.

It is available in 2 and 4-ounce squeeze bottles. This is not recommended for use on fabric. For specific information on its use, refer to Chapter 6, under "Crackling With Weathered Wood™."

White Lightning™

This J.W. Etc. product is a water-based, white sealer. Though it is often used for pickling wood, that is not the only use for this product. It's an excellent sealer for practically all surfaces, including candles and glass. It prevents bleeding through of the sap and knots in wood, (including green wood). It can be mixed with any acrylic paint to basecoat and seal in one step.

If you would like more information on ways to use White Lightning™, send your request for information,

along with a stamped, self-addressed envelope to J.W. Etc., 2205 First Street, #103, Simi Valley, CA 93065-1981. Telephone: (805) 526-5066.

Wipe out Tool

A Kemper Tools® product used to remove painting mistakes. One end has a chisel edge, the other has a fine point which makes it easy to get to hard-to-reach areas.

Wood Filler

When you work on wood pieces that have nail holes, or other areas that need filling, it is advisable to use a wood filler before you sand, seal, or paint the surface. There are wood fillers available in both craft and hardware stores. They come in a variety of wood types. Purchase the type that is appropriate for the type of wood you're using.

J.W. Etc. Professional Wood Filler is non-toxic, non-flammable, water-based, and cleans up with soap and water. It is appropriate for all wood types, so you don't need to have more than one wood filler on hand.

In addition to being used as a wood filler, this J.W. Etc. product can be mixed with acrylic paints to achieve special colors or effects (such as stippling on Santa's beard). It can be thinned with water if necessary. It adheres to wood, metal, glass, stone, or pottery. It can be stained, antiqued, painted, varnished, lacquered, drilled, cut, or planed, and is easy to sand.

If you can't find this in your local craft store, call or write to J.W. Etc., 2205 First Street, #103, Simi Valley, CA 93065-1981, or call (805) 526-5066.

Wood Stains

There are pre-mixed wood stains available for those who want to avoid mixing their own. Cleanup is easy with soap and water. Here are a few of the available brands:

DecoArt™ Wood 'n Resin Gel Stains These are water-based, non-toxic, translucent gel stains. They are used for staining, antiquing, and pickling. This product *does not* seal the wood. It's available in 6 colors. Any color pickling stain can be made by adding DecoArt™ Americana™ colors to "Unbleached Pine (DS25)."

Delta® Home Decor/Ceramcoat® Gel Wood Stains These are water-based, non-toxic stains in a thick and creamy gel

formula. This *does not* seal the wood. The *Gel Wood Stains* come in 8 wood colors. The *Neutral Gel*, which has the same formula, is colorless and intended to be mixed with any Delta® Ceramcoat® acrylic paint. The *Pickling Gel* is used to add a little color to wood while allowing the grain to show through. It is available in one color, Desert White.

Note: Seal the wood *after* the staining is complete and dry using Delta's® Wood Sealer. Then proceed with your decorative painting. If you seal the wood before applying the gel, the gel stain will not penetrate the wood properly.

Delta® Home Decor/Ceramcoat® Liquid Wood Stain This is water-based, non-toxic, and is for those who prefer the liquid consistency of oil-based stains. This *does not* seal the wood. Brush it on and wipe it off just like traditional stains. It is available in 8 wood colors.

Note: Seal the wood with Delta® Wood Sealer *before* applying the Home Decor/Ceramcoat® *liquid* stains.

J.W. Etc. Acrylic Wood Stain This water-based, acrylic wood stain is available in 6 wood tones plus Teal Blue. It *does not* seal the wood. The stains may be mixed to produce new colors or diluted with J.W. Etc.'s Right Step varnish to achieve lighter colors. The stains may also be used as antiquing or opaquing stains over J.W. Etc.'s White Lightning™ or painted surfaces. For in-depth instructions on using this product, refer to Chapter 6 under "Staining With J.W. Etc. Acrylic Wood Stains."

Liquitex® Acrylic Wood Stains This is a stain and sealer in one that has a gel-like consistency and is water repellent when dry. It is available in 12 colors, any of which may be tinted with Liquitex® Concentrated Artist Colors for antiquing, pickling, and faux finish applications. Clean up is with soap and water. Available in 4-ounce squeeze bottles.

Wally R.™ Benchmark™ Acrylic Stains These are non-toxic liquid acrylic stains that can be used on wood as well as most surfaces, such as plaster castings, non-fired clay, ceramic bisque, leather, and paper. May also be used as an antiquing medium. This *does not* seal the wood. Available in 13 wood tones plus a White Pickling color. These are most commonly available in 2-ounce squeeze bottles with flip-top lids. However, larger sizes may be special ordered.

Mail Order Catalogs

If you have difficulty finding any supplies, here are the names of some of the mail order companies I've dealt with. Most companies charge a fee for their catalog and reimburse you on your first order.

When a company deals mainly in one type of product, I will indicate this in parentheses after their telephone number. Otherwise, assume that the company carries a variety of decorative supplies, including books, wood, paints, and such.

Artists' Club
5750 NE Hassalo Street, Bldg. C., Portland, OR 97213. Telephone: (800) 845-6507

Art 'n Craft Supply
P.O. Box 5070, Slidell, LA 70469. Telephone: (800) 642-1062

Cabin Craft Midwest, Inc.
1225 W. 1st St., P.O. Box 270, Nevada, IA 50201. Toll-free order line: (800) 669-3920

Cabin Craft Southwest, Inc.
1500 Westpark Way, Euless TX 76040
P.O. Box 876, Bedford, TX 76095

Toll-free order line: (800) 877-1515

Decorative Porcelain Ltd.
1515 Evergreen Place, Tacoma, WA 98466. Telephone: (206) 565-3051

Georgetowne, Inc.
121 Bashford Drive, Coraopolis, PA 15108. Telephone: (800) 947-6690
(An excellent source for in-depth instructional books for painting song birds and waterfowl as well as the resin castings to paint on.)

Prime Arts Ltd. (Mats by Pal)
8911 Rossash Drive, Cincinnati, OH 45236. Telephone: (513) 793-0313
(A source for good quality, yet relatively inexpensive, mats.)

Viking Woodcrafts, Inc.
1317 8th St. S.E., Waseca, MN 56093. Telephone: (507) 835-8043

Zim's Inc.
Box 7620, Salt Lake City, UT 84107. Telephone: (801) 268-2505. Toll-free order line: (800) 453-6420.

Bare Essentials Shopping List

Here are the basic supplies you will need to get started painting. Brand names are given as guidelines only. For the brush stroke practice described in Chapter 5, you only need one color of paint, Magic or Brush-Up Paper, and the liner and flat shader brushes listed below.

Acrylic paint
Alcohol, rubbing
Baby Wipes, generic variety to which you add 1/4 cup rubbing alcohol
Brushes (the following, or their equivalents):
 Loew-Cornell® #1 Script Liner, series 7050
 Loew-Cornell® #8 Flat Shader, series 7300
 Loew-Cornell® 1-1/2" or 2" Sky Wash brush, series 7750 (for basecoating, varnishing, etc.)
Brush basins (2): one to hold water for rinsing brushes cleaned with soap, another to use for floating, etc. A cup or jar will work.
Brush holder (a mug will do)
Brush-Up Paper (Loew-Cornell®) or Magic Paper (Raphaél®)

Gloves, disposable plastic
Kneaded rubber eraser
Magic™ Transparent Tape
Palette, disposable type suitable for acrylic paints
Paper towels
Pencil or felt tip marker for tracing
Rag or tack cloth
Sandpaper, grades varying from medium to very fine (#400 or #600)
Scissors
Scrap paper for brush stroke practice
Sealer (such as Delta® or DecoArt™ Wood Sealer)
Soap, Ivory®, or a brush cleaner
Sponge brush (to apply sealer)
Stylus, double-ended
Tracing paper, 9" x 11" pad
Transfer paper, (suggest blue Chacopaper®, as well as one piece of graphite and one white)
Varnish, brush-on water-based such as J.W. Etc. Right Step™ in Satin finish.

Chapter 2

PAINTS

This chapter provides you with in-depth information for some of the leading brands of regular acrylic paints, acrylic gloss enamels, and brush-on as well as dimensional fabric paints/dyes. This information was generously provided by the manufacturers, and I think you will find it useful. Color conversion charts (located at the end of the chapter) are included for seven brands of regular acrylic paints and six brands of acrylic enamels.

The paints are arranged in alphabetical order by the type of paint. For example, "Acrylic Paints" are listed first. After the general information that applies to all acrylic paints, the brands are alphabetized within this category.

Paint companies are continually reviewing their colors to keep current with the latest design trends. When I say a certain paint is available in 90 colors, you might find 100 available by the time you read this book.

Acrylic Paints

Acrylics differ from oil paints in several ways. Generally speaking, acrylics are non-toxic. They dry much faster and are easy to clean up using soap and water—harsh solvents aren't necessary. Also, acrylics retain their brilliance with age. Some brands have so many colors to choose from that you never need to mix your own color unless you want to. Recently, a number of paint companies have added colors to their lines that are similar to those found in oil paints. These are pure, clean, and intense pigments with an artist quality viscosity.

How to Tell When Acrylic Paints Are Dry

As you read the instructions throughout this book, you will see that it's very important for paints to be dry before progressing from one step to another. The following tips, plus the drying times given for the various paints should help you.

1. Standard acrylic paints have a shine when they are wet. When dry, the shine disappears and the color looks almost dull. Enamels, however, such as Liquitex® Glossies™ or DEKA®-Gloss, maintain the gloss when dry.

2. Paint feels cold before it has dried because moisture is still evaporating from it.

How to Care for Acrylic Paints

The following pointers will help keep your acrylic paints at their best.

1. Shake the jar or bottle before using. If using tube acrylics, gently squeeze the tube with the cap tightly in place to mix the pigments. Do this over a paper towel, just in case the tube is faulty and leaks.

Note: Avoid hitting the jar or bottle against your palm to shake it. Use of this technique over time could result in injury to your hand.

2. Because soap diminishes the adhesive quality of acrylic paints, make sure you rinse your brushes thoroughly in water before painting. Do not use the cleaning water for rinsing brushes while you paint because it will contain soap residue.

3. If you use squeeze bottles, wipe off the spout after use and keep the bottle cap closed to prevent paint from drying out.

For tube acrylics, hold with the cap side up. Remove the cap and carefully press the tube to remove any air, then replace the cap. This makes it easy for you to tell how much paint is left in the tube.

4. Don't expose your paints to extreme heat or cold. For example, leaving them in your car for any length of time on a hot (or freezing cold) day could shorten their shelf life.

5. If your paints travel with you and are subjected to changes in elevation, here's a safeguard to use before you begin painting. Take the cap off of the squeeze bottles first. This will remove any pressure that might have built up within the bottles. Then replace the cap and squeeze out the paint. I've heard "horror stories" about paint that's actually squirted across the room due to the pressure that built up within the container.

6. Because acrylic paints dry faster than oils, there are some things you can do to help them stay fresh longer on your palette: (a) Use a product such as a "Sta-Wet Palette," or make your own wet palette. (b) Spray a fine mist of water over the paints on your palette. (c) Cover

the puddle of paint with a small plastic cap and press it down firmly. (d) If you are using thick tube acrylics, such as Jo Sonja's®, dampen a paper towel and put the paints directly on the towel. (e) Add extender to the paint to slow down the drying time. Add Retarder when using Jo Sonja's® colors.

Characteristics by Brand

The following information represents data given to me by the manufacturers of each acrylic paint described below. This chapter is intended to inform, not to recommend one brand over another.

All of the manufacturers were able to provide me with "ball-park" numbers for drying time between coats, before varnishing, or before the paint is 100-percent cured. You will need to adjust these times depending upon temperature, humidity, air flow, how thick you apply the paint, or if you added Retarder or Extender to the paints. For example:

Increase drying time when: Humidity is high, weather is cold, you have added Retarder or Extender to the paint, the paint is applied heavily, such as for painting dots or heavy, textured strokes.

Decrease drying time when: Weather is hot and dry, or you are "force drying" the surface.

The heading "Time Before 100 Percent Cured" means how long it takes for the paint to reach its maximum state of hardness.

Many manufacturers make other products for decorative painting. However, unless they are *mixed into the paint*, they are not shown in the category "Possible Additives Used To Modify Paint Characteristics." Any additives listed are made by the manufacturer of the acrylic paints being described.

Accent®

Description: Highly concentrated, smooth flowing, non-toxic, water-based acrylic paints. The line includes Accent® Country Colors®, Acrylic Blending Colors™, and Crown Jewel™ Metallics.

Packaging: Available in 2-ounce squeeze bottles. Some colors are available in 1-ounce jars, 8-ounce squeeze bottles, or 6-ounce spray cans.

Colors: 99 Accent® Country Colors®, 18 Acrylic Blending Colors™, and 13 Crown Jewel™ Metallics (130 total).

Drying Time Between Coats: 20 minutes or more, depending on temperature, humidity, etc.

Drying Time Before Varnishing: 20 minutes (same as drying time between coats).

Time Before 100 Percent Cured: 24 hours.

Possible Additives Used To Change Paint Characteristics

✦ **Extender** aids in blending while slowing the drying time of paint.

✦ **Fabric Painting Medium** used with the acrylic paints to make them penetrate into, rather than just coating the surface of the fabric. Mix 1 to 2 parts Medium to 1 part of paint to create a more permanent bond to fabric.

Surfaces Use on any clean surface, such as wood, metal, canvas, fabric, plaster, foam, ceramic, etc. It is recommended that the application be tested on a surface sample prior to use.

Address Accent Products Div. HPPG, Borden, Inc., 300 East Main St., Lake Zurich, IL 60047. Telephone: (708) 540-1615.

DecoArt™

Description DecoArt™ Americana™ is a smooth flowing, highly pigmented, cream textured, non-toxic, artist-quality acrylic paint. Included in the Americana™ line are TrueColors, which are pure, clean, intense pigments of artist quality viscosity and Enid's Colors which were created for the Multi-Loading technique.

Though DecoArt™ Dazzling Metallics™, Heavy Metals™ and Heavy Metals Light™, Hot Shots™, Liquid Sequins™, and Pastel Liquid Sequins are considered to be part of their fabric paint line, they are also appropriate (and very effective) when used on solid surfaces. However, when used on solid surfaces, apply thin coats because if the application is too thick, it will remain sticky.

Note: Never add mediums (Fabric Medium, Brush 'n Blend, Control Medium, etc.) to Dazzling Metallics™ because they will dull the metallic glow. The Metallics look best on black or other very dark backgrounds whether they be wood, fabric, etc.

Packaging Most commonly found in 2-ounce squeeze bottles. Some colors are also available in 8-ounce squeeze bottles.

Colors 128 Americana™, which includes 23 TrueColors, and 5 Enid's Colors. Fifteen of the Americana™ colors are transparent. They are labeled as transparent to let the painter know that these particular colors are intended to be

used for glazing, transparent washes, and pen and ink, but are not recommended for basecoats. Also included in the Americana™ color line are three Toning Colors: Warm Neutral, Cool Neutral, and Neutral Grey.

Drying Time Between Coats Varies depending on thickness and surface, but will generally dry in 15-20 minutes.

Drying Time Before Varnishing Same as drying time between coats.

Time Before 100 Percent Cured 24 hours.

Possible Additives Used To Change Paint Characteristics

✦ **Brush 'N Blend Extender** Add to the Americana™ acrylics to thin the paint and slow down the drying time. Used with Control Medium for marbleizing.

✦ **Control Medium** A thick medium that slows down the drying time of paint. (It slows down the drying time more than using Brush 'n Blend.) Used for glazing in colors, emulating techniques used in oil painting, and marbleizing. Use a small amount since a little bit goes a long way.

✦ **Fabric Painting Medium** Add to DecoArt™ Americana™ acrylics when painting on fabric. Mix 2 parts paint to 1 part Fabric Painting Medium. Apply with a stiff (fabric) brush and scrub paint/medium into the fibers. The medium helps the paint penetrate the fabric more easily. After the fabric is painted, allow 24-48 hours to dry, then heat set.
 Note: None of DecoArt's™ fabric paints require heat setting. However, the Americana™ paints were *not* developed as fabric paints and, therefore, *do* require it. To do this, set the iron to the hottest temperature appropriate for the type of fabric you've painted. Lay a clean, soft cloth over the painted area (on the painted side), then press one area at a time for 20 to 30 seconds, lift the iron, and go to the next area until the entire painted area has been heat set. For extra protection, heat set the wrong side as well.

✦ **Glo-It™ Luminescent Paint Medium** This is a cream colored paint that can be used alone or added to Hot Shots™ or *transparent* DecoArt™ Americana™ acrylic paints to create colors that glow in the dark. It may be used on fabric as well as other surfaces. (You cannot achieve the glowing effect when mixed with non-transparent colors.) You may add up to 50% Glo-It™ to your paint.

Surfaces Wood, ceramics, plaster, fabric, prepared metal, wallpaper, canvas, paper, dry wall, poster paper, etc.

Address DecoArt, Customer Service, Box 360, Stanford, KY 40484. Telephone: (800) 367-3047. A "DecoArt™ Mini Facts" booklet is available that is filled with information on how to use DecoArt™ products. Write or call them for ordering information.

Delta®

Description Delta® Ceramcoat® is a smooth flowing, durable, non-toxic, water-based acrylic paint. In addition to the standard acrylics, the line includes "Gleams" in metallic and pearl-like colors as well.

Packaging Available in 1-ounce jars, and 2 and 8- ounce squeeze bottles with flip-top lids in all colors.

Colors 214, which includes 8 Metallic and 8 Pearl "Gleams."

Drying Time Between Coats 30 minutes or longer, depending on temperature, humidity, etc.

Drying Time Before Varnishing 2 hours minimum.

Time Before 100 Percent Cured 12-24 hours.

Possible Additives Used To Change Paint Characteristics

✦ **Acry-Blend** Extends the drying time of paints, allowing for longer blending time.

✦ **Artist Gel** a colorless thickener used to create textured effects.

✦ **Textile Medium** Helps the paint penetrate fabric fibers for better permanency and easier application.

Surfaces Any porous surface, such as wood, plaster, fabric, canvas, tin, plastic, leather, ceramics, and paper. Though Delta's Chemical Director does not recommend it for slick or waxy surfaces, such as glass or candles, they have had success using it on glass that has been varnished with their water-based varnish before painting.

Address Delta Technical Coatings, Inc. 2550 Pellissier Place, Whittier, CA 90601. Telephone in California: (213) 686-0678; outside California: (800) 423-4135. Please enclose a stamped, self-addressed envelope when you write and request brochures.

FolkArt®

Description Rich, creamy, non-toxic artist's quality acrylic paint. Heavily pigmented for maximum coverage and longer open time for increased blending. The Pure

ACRYLICS

Pigment Colors™ included in their line are clean and intense, with universal color names that are easy to relate to oil palettes.

Packaging Available in 2-ounce squeeze bottles. Individually color coded labels and exclusive FolkArt® color dot lids provide you with at-a-glance color identification.

Colors 223 (which includes 26 Pure Pigment Colors™ and 26 Metallics.)

Drying Time Between Coats 1 hour (at dry room temperature).

Drying Time Before Varnishing 24 hours (at dry room temperature).

Time Before 100 Percent Cured At dry room temperature, dry to handle cure is 2 hours; dry to maximum hardness cure is 24 hours.

Possible Additives Used To Change Paint Characteristics

✦ **Extender** Mix with FolkArt® acrylic colors to increase the drying time and transparency when floating, blending, and washing colors. For brush strokes, extender creates effects from transparent to opaque without color reduction. Also used as a faux finish and fabric painting medium.

✦ **Textile Medium** Mix with any FolkArt® color to create permanent, washable, painted effects on almost any fabric—cotton, polyester, denim, and wool. Nontoxic, water-based. Maintains "soft hand" of fabric while allowing paint to penetrate fibers and become a part of the fabric. Appropriate for all painting effects—opaque, transparent, color washes, and detail work.

 Mix 2 parts FolkArt® acrylic color to 1 part Textile Medium. Paint, air dry 24 hours. Heat set using pressing cloth over painted area, iron 30 seconds per area at correct heat setting for type of fabric used, air dry 24 more hours.

✦ **Thickener** Added to paints to create more transparency while maintaining the color, a thick flow, and consistency. Also used as a faux finish and fabric painting medium.

Surfaces Plaster, wood, bisque, clay, leather, fabric, primed metal, canvas, watercolor paper, and any porous surface.

Address Direct requests for information to: Plaid Enterprises Inc., Consumer Affairs, P.O. Box 7600, Norcross, GA 30091-7600. Telephone: (404) 923-8200.

Jo Sonja®

Description Jo Sonja's® (Chroma Acrylics) Artist Colors are velvet matte acrylic gouache. Highly pigmented, nontoxic tube acrylics that are tough and flexible. The line includes basic colors, metallics, and iridescents (which can be mixed with all the colors to create an iridescent effect).

Packaging 2-1/2 ounce tubes; some colors available in an 8-ounce size.

Colors 60 total, which includes 50 basic colors, 5 metallics, and 5 iridescents.

Drying Time Between Coats From 10 to 15 minutes, or until it feels dry to the touch.

Drying Time Before Varnishing From 10 to 15 minutes. Jo Sonja's® Polyurethane Varnish and other mediums will cure through each other.

Time Before 100 Percent Cured 80 percent cured in 24 hours, 100 percent cured in 2 weeks (under normal drying conditions).

Possible Additives Used To Change Paint Characteristics

✦ **All-Purpose Sealer** Mixed with the paints for basecoating and sealing in one step; use any time you want to make the paint more durable. Seals wood, glass, metal, and tin.

✦ **Clear Glazing Medium** a versatile, transparent acrylic glazing medium which makes it possible to use the highly pigmented Jo Sonja's® Artist Colors for glazing, creating wood stains, or for special glaze painting techniques. Used to emulate egg tempera, pickling, etc.

✦ **Flow Medium** Add to the paints to increase the flow without diluting the color. If you wish to thin Jo Sonja's® varnish, add Flow Medium, not water, as water will cause streaking. Flow Medium also levels the textural properties of the color. One part medium mixed with two parts paint produces an extraordinary leveling effect. Use for applying paints with an airbrush. Appropriate for all techniques requiring a smooth finish without brush marks.

✦ **Kleister Medium** Add to the paints to create wood grains and translucent textural effects. Ideal for many faux finishes. The addition of this medium gives you more open time, so you can work the paint longer

without it pulling or grabbing.

+ **Retarder and Antiquing Medium** A medium added to the paint to extend the open time (drying time). Also used to make an antiquing glaze. Keep in mind that paint containing retarder may look dry, but it can be reactivated and can take up to 5 days to cure unless it's been force dried with a hair dryer. Therefore, wait 5 days before varnishing. Crackle Medium won't adhere to a surface containing any traces of retarder.

+ **Tannin Blocking Sealer** A special sealer for use on wooden surfaces where the knots, tannin, or pitch contained in them may come through your painting. It may be mixed with the Artist Colors for sealing and basecoating in one step. However, for best results, apply straight sealer to the wood, then basecoat after sealer has dried.

+ **Textile Medium** Mix equal parts of any Jo Sonja's® Artist Colors, (including the metallics) with the Textile Medium for fabric painting. Painted fabric requires heat setting.

+ **Texture Paste** A flexible, brushable, translucent modeling compound. For textured brush strokes, add up to equal parts Texture Paste to Jo Sonja's® colors.

Surfaces Paper, canvas, wood, metals, glass, ceramics, and some plastics. Appropriate for fabric when mixed with Textile Medium.

Address For information, write or call Chroma Acrylics, Inc., 205 Bucky Drive, Lititz, PA 17543. Telephone: (800) 257-8278 or, in Pennsylvania, (717) 626-8866

Comments Jo Sonja's® *Color Selector System* is an excellent tool to help you mix just the right color. This compact, fan deck contains 166 large size color swatches (including the Metallics and Iridescents) on heavy cards with easy-to-follow mixing recipes shown on the back of each card. Order it directly from Chroma Acrylics. This definitely helps take the mystery out of mixing colors!

A very helpful video cassette is available called "A Guide For The Use of Jo Sonja's® Artist Colors and Mediums." It should be available at your local craft store, or order it directly from Chroma Acrylics.

Jo Sonja has this recommendation for those who are accustomed to painting with Delta® or other similar bottled acrylics. Mix approximately equal parts of Jo Sonja's® All-Purpose Sealer with Jo Sonja's® Artist Colors. This will give a similar consistency to bottled acrylics. However, she encourages you to use the paints as they come from the tube so you can appreciate the qualities of these paints.

Liquitex®

Though Liquitex® acrylic paint is available in both squeeze jars and tubes, the manufacturer recommends the Concentrated Artist Colors (packaged in squeeze jars) for decorative painting. Therefore, it is the *squeeze jar* colors that will be described here.

Description A versatile, concentrated, yet fluid acrylic paint. Color and viscosity (thickness of paint) are consistent from batch to batch. The jar colors are of a medium viscosity (similar to the consistency of heavy cream). Check each label to determine opacity. It is possible to emulate oil painting techniques by adding various Liquitex® mediums.

The Concentrated Artist Color line also includes the following specialty paints: Fluorescents, Iridescents (metallics), Liquigems™ (liquid glitter paints), Interference (formerly called Opalescents), and the Glossies™ Acrylic Enamels (which are described separately in this section). The Interference paints are shimmering colors that change as the light changes. The colors refract their complementary color. They may also be mixed with the Liquitex® mediums to use as a glaze.

Packaging All the types described above are packaged in 2-ounce squeeze jars with flip-top lids, with the exception of the Liquigems™ which come in a 2-ounce jar with an applicator tip. Some colors are available in 8, 16, and 32-ounce sizes.

Colors 83 regular and 24 Specialty colors. In the Specialty paints there are: 6 Liquigems™, 6 Interference, 6 Iridescents (metallics), and 6 Fluorescents. The "Liquitex® Color Conversion Chart & Mixing Guide" and the book *"How to Mix and Use Color"* will make it easy to mix other colors.

Drying Time Between Coats Varies from 10 to 45 minutes, depending on the thickness of the coats of paint.

Drying Time Before Varnishing Wait 24 to 36 hours to allow all layers of paint to dry thoroughly.

Time Before 100 Percent Cured 24 to 48 hours.

Possible Additives Used To Change Paint Characteristics

+ **Blending and Painting Medium** Mix with the Concentrated Artist Colors to thin them for most painting techniques while retaining body. Will improve flow and slightly extend drying time. Ideal medium for blending colors, floating color, and over-painting techniques. Load brush well with Medium, blot brush on paper towel. Single or double load paint into

brush then work paint into the bristles by blending on a palette. For transparent color, use equal parts of Medium and paint.

✦ **Fabric Medium** Mix with Concentrated Artist Colors to thin them to a dye-like consistency. Controls bleeding on fabric. Eliminates the stiffness of using acrylics directly from the jar, and gives you a smooth flow of paint.

For fabric painting, begin by adding equal parts of Medium to the Concentrated Artist Colors. More Medium can be added directly on your fabric to blend colors. For transparent, dye-like washes, use 5 parts Medium to 1 part paint. This Medium can also be used for a wet-on-wet technique on fabric. Heat setting is optional. However, if you feel more confident heat setting, place your garment in the clothes dryer at a permanent press setting for 10 minutes. Wait 48 hours before cleaning. For in-depth information on fabric painting with Liquitex®, write and ask for their Technique Sheet for painting on cloth.

✦ **Flow Aid™** A flow enhancer and water tension breaker for any water soluble paint, medium, ink, or dye. It causes better absorption of the medium into a painting surface. Mix 1 part Flow Aid™ to 20 parts of water. May be used with either the jar or tube colors.

✦ **Gel Medium** A gloss medium that gives more transparency and thickness to the paint. Start by adding about 25% Medium to the paint, and increase the amount as needed. May be used as a resist. When used alone, it dries clear and makes an excellent glue that can be used for heavy objects as well as for delicate applications, such as applying jewels and sequins to fabric.

✦ **Gelex® Extender Medium** An extender that is a thick, heavy, translucent white gel. When added to the paints, it produces a heavy, opaque paint, which is ideal for impasto techniques. Add up to 50 percent by volume to the paint to double the amount of usable paint. Reduces gloss of colors to a semi-matte surface sheen.

✦ **Gloss Medium and Varnish** An all-purpose mixing medium for the Concentrated Artist Colors as well as a final permanent gloss varnish. Mix with the colors to increase flow, transparency, and gloss; to produce more flexibility and adhesion to a surface; and to enhance the depth of color intensity. Best for flexible surfaces. When used to thin paint, use equal parts of Gloss Medium and water as a thinning medium for all colors. Using water alone will cause the colors to

dull and lose some of their flexibility. Add large amounts of the Medium to the colors for transparent glazes. May also be used separately as a varnish that dries to a clear gloss sheen, that is flexible, and non-yellowing.

✦ **Heavy Gel Medium** A heavy-bodied gloss gel that extends the drying time of the Concentrated Artist Colors longer than the other gels and also thickens the paint. This enables you to emulate oil painting techniques, such as heavy impasto, crisp knife, and brush strokes.

✦ **Iridescent Tinting Medium** A special effects medium containing titanium-coated mica flakes. For best results, mix with transparent or translucent colors.

✦ **Jarpaque™ Extender Medium** An extender for jar colors that may be added to increase paint volume economically. It can increase the paint volume at least 50% with little or no noticeable loss in intensity or change in hue. It has the same viscosity as jar colors and all the properties of Gelex Medium. This medium affects the surface sheen, giving it a matte appearance. It acts as a gouache medium, giving the color an opaque look and a matte sheen.

✦ **Liquithick™** A very thick gel medium that offers a full range of viscosities from oil-like handling of acrylic paint to "cake" or sculptural paint. Add small amounts at a time to each color of paint until desired thickness is achieved.

✦ **Marble Ease®** A thin, colorless medium that is mixed with the Concentrated Artist Colors for marbleizing. It is flammable and should be used in a well-ventilated area away from sparks or flame.

✦ **Matte Gel Medium** The same as Gel Medium except that it dries to a satin matte finish. It extends the drying time of the Concentrated Artist Colors and increases the body of the paint while reducing the gloss. The more you add, the more transparent the color will become. The result is a thick matte or semi-matte glaze.

✦ **Matte Medium** Mix with the Concentrated Artist Colors to create a flat matte surface sheen. It increases the transparency of paint and may be used for matte glazes. Maintains a matte or flat, dull finish when added to colors. Mix with Gloss Medium and Varnish to vary paint sheen from matte to gloss.

✦ **Painter's Pearl® (Pearlescent) Medium** Used to create rich, luminous effects when mixed with the

Concentrated Artist Colors. Add very small amounts of color to this medium to create a pastel, iridescent, or metallic effect. Add more paint gradually until the desired affect is achieved. Most effective when used with transparent or translucent colors. However, opaque colors may also be used. It is appropriate for wood, raw canvas, acrylic primed canvas, porcelain, walls, paper, plaster, masonry, etc.

✦ **Retarder Medium** Add to the Concentrated Artist Colors to slow their drying time, allowing more time for blending.

✦ **Slow-dri® Extender Medium** Add to the Concentrated Artist Colors and mediums to slow the drying time. (When this is added to the paint, you'll have an average of twice as long to work with the paint.) Used to create transparent colors or washes. Use it in place of water for smoother floats and liner work. Do not add over 20 percent Medium because larger amounts will cause shrinkage, poor adhesion, and paint skins to form.

✦ **Smooth Texture Medium** A heavy bodied, glossy gel used to add texture to any painted surface. It may be mixed into the Concentrated Artist Colors to increase density, or painted directly on any surface to build up texture before adding color. Ideal for oil-like brush and knife work. Mix with Painter's Pearl® Medium to simulate snow or other pearlescent effects. May be rolled, brushed, or knifed on and will hold detail when used for an impression. An excellent glue for attaching heavy objects to a surface, or as a binder for sand, gravel, etc.

✦ **Texture Mediums** These are dense, opaque gels that can be mixed with any Liquitex® Acrylic Color to create a variety of special effects or techniques. The available gels are: Ceramic Stucco, Natural Sand, Resin Sand, Blended Fibers, Black Lava, Glass Beads, and Opaque Flakes.

Surfaces Appropriate for wood, raw canvas, acrylic primed canvas, porcelain, walls, paper, plaster, masonry, etc. May also be used on a variety of fabric, including cotton/polyester blends, burlap, suede, leather, terry cloth, silk, velvet, corduroy, flannel, to name a few. For best results, use Fabric Medium (described earlier in this section).

Note: Acrylics will not be permanent on any surfaces that are oily, greasy, or hard-shiny and non-porous, such as glass, shiny metals, Formica, or on unsanded hardboards, over oil-primed canvas, or oil colors. Also, glue sizing should not be used under Liquitex® acrylic materials because the paint will peel off or blister when water is applied.

Address For promotional brochures, write to: Consumer Affairs Department, Binney & Smith, 1100 Church Lane, P.O. Box 431, Easton, PA 18044-0431.

Wally R.™

Description Wally R.™ Premium Acrylic Artist's Paint is smooth flowing, rich and creamy, highly pigmented, non-toxic bottled acrylics. Water-based for easy cleanup.

Packaging 2 and 8-ounce squeeze bottles. Also, 16 and 32-ounce, 1-gallon, and 5-gallon containers.

Colors 233, which includes 200 basic colors, 12 Southwest, 8 fluorescents, 5 metallics, and 8 pearls.

Drying Time Between Coats The manufacturer recommends waiting 2-3 hours between coats. However, if you don't care to wait that long, the *minimum* time between coats should be at least 30 minutes. Waiting longer is better.

Drying Time Before Varnishing 30 minutes minimum. Again, if you can wait longer, do so.

Time Before 100 Percent Cured Partially cured in 12 hours; it is 100 percent cured in 3-4 days, depending on thickness of coats, temperature, humidity, etc.

Possible Additives Used To Change Paint Characteristics

✦ **Blending Medium** Slows down drying time. Extender is an equivalent product.

✦ **Textile Medium** Added to the acrylics to make them appropriate for fabric painting.

Surfaces Unfinished wood, prepared tin, fabric, leather, plaster, paper, ceramic bisque, non-fired clay. It can also be used on shiny surfaces, such as candles and glass. However, on slick surfaces, better coverage is achieved when designs are painted with heavy stroke work.

Address For information, write to the Wally R. Company, Inc., 16366 Valley Blvd., La Puente, CA 91744. Telephone: (818) 333-2033.

Acrylic High-Gloss Enamels

These differ from standard acrylics in that they have a durable, high-gloss finish. They also take longer to dry. Because of their durability, they are ideal for painting objects to be used outdoors, such as mail boxes, birdhouses, etc. Some of the brands described may be "home-oven fired" to increase their durability—others may not. Be sure to read the details pertaining to the brand you plan to use.

Accent®

Description Accent® Hobby Craft High-gloss Enamels are durable, high-gloss, non-toxic, water-based brush-on paint that cleans up with soap and water.

Packaging Available in 1/2-ounce and 2-ounce jars.

Colors 25 intermixable colors, which includes 4 metallics, and 4 fluorescents.

Drying Time Between Coats 20-30 minutes, depending upon thickness, temperature, and humidity.

Drying Time Before Varnishing Same as drying time between coats.

Time Before 100 Percent Cured 24 hours.

Possible Additives Used to Change Paint Characteristics None required.

Surfaces Wood, metal, plaster, unglazed porcelain, and glass.

How to Heat Harden For increased durability on any surface that can tolerate a home oven temperature of 325°F, allow the paint to cure for 24 hours before oven baking. Do not preheat the oven. Place the object in the oven, turn the setting to 325°F, and bake for 1 hour.

Comments These enamels are also available in a satin finish, and both the gloss and satin enamels are available in 3-ounce sprays in matching colors.

Address Accent Products Div. HPPG, Borden, Inc., 300 East Main St., Lake Zurich, IL 60047. Telephone: (708) 540-1615.

Apple Barrel®

Description Apple Barrel® Gloss Enamels are water-based, weather resistant enamels with enhanced durability for indoor and outdoor use. Clean up with soap and cool water.

Packaging 2-ounce squeeze bottles with non-clog, flip-top lids.

Colors 46 intermixable colors.

Drying Time Between Coats 4 hours.

Drying Time Before Varnishing 48 hours.

Time Before 100 Percent Cured 48 hours.

Possible Additives Used to Change Paint Characteristics None required.

Surfaces Wood, plaster, bisque, clay, foam, primed metal, canvas, and most porous materials.

Comment For maximum gloss, apply two coats. This paint is *not* intended to be "oven fired" as some of the other gloss enamels described.

Address Direct requests for information to: Plaid Enterprises Inc., Consumer Affairs, P.O. Box 7600, Norcross, GA 30091-7600. Telephone: (404) 923-8200.

DecoArt™

Description DecoArt™ Ultra Gloss™ Acrylic Enamels are durable, high-gloss acrylic enamels that can be "home oven baked" for dishwasher-safe durability. Non-toxic, weather resistant for outdoor use, and clean up is with soap and water. Apply with a very soft brush.

Packaging 1-ounce squeeze bottles.

Colors 45 intermixable colors, which includes 4 metallics and 6 glitters. The glitters do not "dull" when oven baked or if dried in a dishwasher.

Drying Time Between Coats 1 hour.

Drying Time Before Varnishing 24 hours.

Time Before 100 Percent Cured After heat hardening. If not heat hardened, at last one week.

Possible Additives Used to Change Paint Characteristics

✦ *Clear Medium* Added to the paint to create soft tints, do glazing techniques, or for painting over Ultra Gloss™ applications to achieve additional shine. Used to thin the paint for translucent effects. Water should *not* be used to thin the paint because it will reduce the bonding of the paint to the surface. You may use as much Clear Medium as you like without affecting the permanence of the paint. How much to use depends on how pastel you want the colors to be.

Surfaces Wood, jewelry, clean glass, prepared metal, ceramic, or hard plastic, resin, Styrofoam™, leather, paper, and poster board. Unlike regular acrylics, these adhere very well to slick surfaces of all kinds.

How to Heat Harden To obtain a dishwasher-safe finish on any surface that can tolerate a home oven temperature of 325°F, allow the paint to cure for 24 hours before oven baking. Do not preheat the oven. Place the object in the oven, turn the setting to 325°F, and bake for 30 minutes. After the time has elapsed, turn the oven off, keep the oven door closed, and allow it to cool down before removing.

Note: When you wash the object in the dishwasher, allow the paint to thoroughly cool and dry first before handling.

For items that are too big to harden in the oven, you may "heat set" them by using a hair dryer or, for exterior items, placing them in the hot sun.

Comment[1] The amount of gloss you achieve with Ultra Gloss™ will vary depending on the surface. Paint applied to dull surfaces will have much less shine than when applied to shiny ones. Though not required, you may apply a coat of Ultra Gloss™ Clear Medium to the completed object, which acts as a varnish. Wait at least 24 hours after the object has been "baked" and cooled to do this. This would especially be appropriate when using Ultra Gloss™ over a dull or porous surface when you want to achieve maximum gloss.

DecoArt's™ Super-Fine Line Paint Writer (Product DG50), is very effective for doing detailed line work and personalizing with Ultra Gloss™ paints.

Caution Even though this is a non-toxic product, place your design on eating utensils where your mouth, the food, or beverage, will not come in contact with the painting.

Address DecoArt, Customer Service, P.O. Box 360, Stanford, KY 40484. Telephone: (800) 367-3047.

Deka®

Description Deka®-Gloss Enamels are opaque enamels that are durable, fade resistant, water-based, easy to blend, have a high gloss, and can be applied with a brush or airbrush. May be "oven fired" for added durability. Clean up is with soap and water.

Packaging 1 fl. ounce and 4 fl. ounce squeeze bottles.

Colors 17 intermixable colors.

Drying Time Between Coats 20-30 minutes, depending on thickness of coats.

Drying Time Before Varnishing 12 hour minimum. Varnish with either DEKA®-Gloss Finish #361 or Matte Finish #362. Though the finishes do add some protective coating, their main function is to add or remove some of the glossiness. After varnish has dried 20-30 minutes, you *may* heat harden again, although this is optional.

Drying Time Before Heat Hardening 48 hours (minimum).

Time Before 100 Percent Cured Cured after heat hardening process. If not heat hardened, 100% curing time will be *at least* one week.

Possible Additives Used To Change Paint required.

Surfaces Wood, paper, glass, metal, plastic, leather, stone, plaster, clay, ceramics; non-washable fabric items, such as backpacks, tents, windsocks, kites, or umbrellas; also ideal for sign painting.

How To Heat Harden This process improves the adhesive strength, scratch resistance, and water resistance of the paint. Allow the paint to dry at least 48 hours. Put the painted object in a cold oven, turn the oven on to 200°F. After 1 hour, turn the oven off and leave the object in the oven to cool. Do not heat harden any surfaces which are sensitive to heat, such as plastic, leather, etc.

After the object has cooled, you *may* varnish with either of the DEKA® finishes mentioned above and heat harden the object again if desired.

Caution DEKA®-Gloss is not recommended for eating or drinking utensils where the painting will come in contact with food. Decorative tableware can be painted with DEKA®-Gloss. Heat harden these pieces, and wash them in cool water with gentle detergents. Do not leave them soaking in water.

Address For product information, write or call Decart Inc., Lamoille Industrial Park, Box 309, Morrisville,

Vermont 05661. Telephone: (802) 888-4217.

Delta®

Description Delta® Hi-Gloss Enamels are glossy, water-based, durable, scuff resistant, non-toxic enamel paints for use outdoors as well as indoors. They are compatible with Delta® Ceramcoat® regular acrylics. Clean up is with soap and water.

Packaging 1-ounce wide-mouth jar.

Colors 39, which match regular Delta® Ceramcoat® acrylics with the same names.

Drying Time Between Coats 1 hour.

Drying Time Before Varnishing 1 hour. Varnishing is not necessary, however if you want to increase the durability, varnish with Delta® Ceramcoat® water-based *gloss* Exterior Varnish. This varnish takes about 1 hour to dry to the touch and cures overnight.

Time Before 100 Percent Cured 24 hours.

Possible Additives Used to Change Paint required.

Surfaces Wood, plaster, plastic, primed metal, and most porous surfaces.
 Note: Raw wood or plaster should be sealed before applying the paint. Use a soft brush for painting. This paint is *not* intended to be "oven fired" as some of the other gloss enamels described.

Liquitex®

Description Liquitex® Glossies™ are non-toxic acrylic enamel which provides a high gloss, dishwasher-proof color on any non-porous surface that can be baked in your home oven. Glossies™ may also be used on porous surfaces and will be permanent. Paintings will maintain their beauty even after repeated washings in a dishwasher. Cleans up with soap and water.
 See Chapter 2, "Glass," for in-depth information on the use of Liquitex® Glossies™.

Packaging 2-ounce squeeze jars with flip-top lids.

Colors 24 intermixable colors.

Drying Time Between Coats 2 hours.

Drying Time Before Varnishing 2 hours when painting on ceramic tiles that will get heavy use. Apply 2 coats of Liquitex® High-Gloss Varnish (or Satin Varnish) *after* baking. Allow 30 minutes between each coat.

Drying Time Before Baking 30 minutes.

Time Before 100 Percent Cured After baking process.

Possible Additives Used To Change Paint Characteristics Up to 25% water may be added to the paints to thin them or make them more transparent. Keep in mind the more medium or water you add to the paint, the more you will break down the special adhesives that make it adhere to glass and other non-porous surfaces.

Surfaces Any surface that can be baked in your home oven. Examples: glass, ceramic tile, crockery, tin, or other primed metal decorative plates.

How To Bake Bake in a 325° oven for 45 minutes. To avoid breakage, put painted glass in a cold oven, then turn the oven to 325°. Heat-safe objects may be placed in a preheated oven. Open a window or leave the room while object is baking because there will be some fumes. Baking at a higher temperature may cause excessive fumes as well as over-baking your paint, causing it to flake off. Baking at a lower temperature or for less time may not ensure dishwasher safeness. At the end of the baking time, turn off the oven, *open the oven door*, and allow the object to cool completely before removing.

Address Consumer Affairs Department, Binney & Smith, 1100 Church Lane, P.O. Box 431, Easton, PA 18044-0431. Write to them if you are interested in receiving a Technical Data Sheet on Glossies™.

Fabric Paints

Regular acrylic paints, when mixed with textile medium, can be used for fabric painting. However, there are paints designed specifically for fabric that require no additives. In most cases, these specially formulated fabric paints/dyes allow your fabric to remain softer than if they were painted with regular acrylics plus textile medium.
 "Dimensional" fabric paint sits on top of the fabric. The types I'm familiar with are all packaged in bottles

dimensional paints are stiffer than paints or dyes that penetrate into the fabric. The dimensional quality makes them ideal for applying sequins, fabric appliqués or other decorations, accenting designs painted with the dyes, or simply left plain.

There is also a softer type of paint that is used to accent or outline designs in much the same way as the stiffer, dimensional paints. An example is DEKA®-Flair liners. Because they are softer, they tend to spread out more on the fabric than the stiffer dimensional paints.

Fabric dyes sink down into the fabric. Some companies refer to them as "paints," others as "dyes," or "liquid paint." Whether fabric is painted with dyes, fabric paints, or liquid paints, it will generally have a lovely, soft touch when dried. This is sometimes referred to as the "soft hand" of fabric. For most of us, this is all we really need to know.

However, some of you may also be interested in knowing that chemically, dyes and paints are different. Paint contains an ingredient that enables it to bond with the fabric. It surrounds each fabric fiber. Dyes, on the other hand, actually penetrate each fabric fiber.

To illustrate this, let's assume you were looking at cross sections of fabric fibers under a microscope. One had been painted with fabric paint, the other with a fabric dye. The cross section painted with the dye would be the same color as the dye *throughout* the fiber. The one painted with the paint would be the color of the paint *around* the fiber, but the inside would remain the color of the original, unpainted fiber.

Characteristics by Brand

Following is a description of some of the various fabric paints and dyes that are available. I've included as much information about each brand as possible. If I've provided more information for one brand than another, it in no way means I recommend that brand over another. It simply indicates that more information was available, and I thought you would like to have it.

For in-depth information on the basics of fabric painting, see Chapter 2, under the "Fabric, Washable" or "Silk Painting" categories.

Accent®

For product information or to receive their newsletter, contact Accent Products Division, HPPG, Borden, Inc., 300 East Main Street, Lake Zurich, IL 60047. Telephone: (708) 540-1615.

The following books (available through Accent), will give you ideas for using the Elegance™ dyes: "Soft 'n Silky Fabric Painting," "Elegance Home Decorating," or "Pipka's Painting With Elegance."

Elegance™ Soft 'N Silky Fabric Painting Dyes

Description Water-based, non-toxic, permanent, machine washable, and dry cleanable. May be used as a silk paint without the use of a resist.

Packaging 2-ounce squeeze bottles

Colors 18, which includes 2 metallics.

Special Instructions Dyes may be brushed on with either a soft-bristled brush or fabric brushes (for heavier fabrics). Dry painted fabric flat at room temperature for five hours. Drying time may be reduced by using a blow dryer on the lowest setting. Wait four days before washing. Dry cleaning is recommended for silks and rayons. All other fabrics should be hand or machine washed at a gentle cycle using cool water. Dry flat and iron at an appropriate setting for the type of fabric used.

Crown Jewel™ Metallics may be mixed with the Elegance™ dyes to create a wide range of colors.

Heat Setting Heat setting is required *only* if (1) you are painting with Opaque White, (2) dyes are mixed with Pearlizer, or (3) when painting on 100% cotton. Iron at a dry setting on the back side of the fabric. Iron in a circular motion for about 2 minutes, never leaving the iron in one permanent position.

Additives

✦ *Extender* (formerly called Pastelizer & Extender) Use at least 1 part Extender to 1 part dye to create a more pastel shade of dye. For blending and shading, apply Extender to fabric pattern section first, then brush on the dye(s) to shade and highlight.

✦ *Pearlizer Medium* Mix equal parts of dye and Pearlizer to create beautiful pearlized colors. This may also be used alone to create pearlescent effects.

✦ *Gold and Silver Metallics* These may be used alone or added to the dyes to create metallic effects. Add gold to make a color warmer; add silver to make it cooler.

✦ *Crystal Sparkle Glaze* Mix with any of the dyes to transform them into sparkle tints. Use equal parts of dye and Crystal Sparkle Glaze.

Surfaces For all fabric—silk, rayons, synthetics, and cotton.

FABRIC

FABRIC

DecoArt™

The following points apply to all the DecoArt™ fabric paints described in this section:

1. No fabric medium is required.
2. Paint doesn't need to be scrubbed into the fabric because the paints are self-bonding.
3. For best results, *generously* apply any of the DecoArt™ fabric paints using a *soft-bristled brush*, not a fabric brush.
4. Use a wet-on-wet technique, working small areas at a time. As soon as the area is based, bring in your shading and highlighting colors. It is important that they be blended while the paint is *wet* so they will dry together and bond properly.
5. No heat setting is required or recommended.
6. Do not use regular acrylic colors along with So-Soft™ colors. Regular acrylics require fabric medium and heat-setting, but So-Softs™ do not.
7. They are certified non-toxic.
8. If you've used cardboard in back of your fabric, remove it immediately after the painting is complete.
9. If inking is desired, do this *before* applying the paints because inking will not bond permanently when applied on top of the paints.

For promotional brochures, write or call DecoArt, P.O. Box 360, Stanford, KY 40484. Telephone: (800) 367-3047.

So-Soft™ Fabric Acrylics

Description Bright and opaque fabric paints that provide excellent coverage on fabric regardless of fabric color. Retains "soft hand" of fabric.

Packaging 1-ounce and 4-ounce squeeze bottles with flip-top lids.

Colors 35 intermixable colors. They match the DecoArt™ Americana™ regular acrylics of the same name. This enables you to paint designs on fabric that were intended to be painted on wood or other hard surfaces with the Americana™ acrylics. Just use the So-Soft Fabric Acrylics of the same name.

Special Instructions Allow painted fabric to dry 24-48 hours before washing. Wash on gentle cycle. Do not use bleach or a detergent that contains special additives, such as whitener or lemon scents. Dry on low heat or hang to dry. Also refer to the instructions at the beginning of the "DecoArt™ Fabric Paint" section that apply to all their fabric paints.

Additives DecoArt™ Transparent Medium may be used to thin the paints for creating transparent effects (as with shaded iron-ons). They may also be thinned with water to create watercolor effects. Thinning the paint will not diminish the bonding power and it will remain permanently on the fabric.

Surfaces Most fabrics, including 100% acrylic or silk.

So-Soft™ Metallics

Description Bright and opaque metallics that give excellent coverage on fabrics of all colors. Retains "soft hand" of fabric.

Packaging 1-ounce squeeze bottles with flip-top lids.

Colors 24 intermixable.

Special Instructions Dry painted fabric 24-48 hours before washing. Wash gently with unscented, non-harsh detergent. See special instructions at beginning of "Deco-Art™ Fabric Paint" section.

Additives None required.

Surfaces Most fabrics, including 100% acrylic or silk.

So-Soft™ Shimmering Pearls

Description Pearlescent fabric acrylics with a hint of glitter.

Packaging 1-ounce and 4-ounce squeeze bottles with flip-top caps.

Colors 24 intermixable

Special Instructions Dry for 24-48 hours. Wash on a gentle cycle with a mild, unscented detergent. Tumble dry on low heat. Heavily glittered fabric should hang or lie flat to dry. See special instructions at the beginning of the "DecoArt™ Fabric Paint" section.

Heat Setting None required or recommended.

Additives Add Transparent Medium, *not water*, to create more transparent colors. Use up to 2 parts Transparent Medium to 1 part Shimmering Pearls™.

Surfaces Most fabrics, including 100% acrylic or silk.

So-Soft™ Dimensionals

Description Dimensional paint that won't crack, peel or

harden when laundered. Designed for color coordination with DecoArt's™ So-Softs™, Shimmering Pearls™, and Heavy Metals™.

Packaging 1-ounce and 4-ounce soft, easy to squeeze bottles with applicator tips.

Colors 36 total, which includes: 15 Shiny (match So-Soft™ Fabric Acrylics), 12 Pearlescent (match So-Soft™ Shimmering Pearls™), 9 Glittering (match Heavy Metals™).

Special Instructions To use, place tip directly on surface and squeeze gently for dimensional lines and beads. Finished design should dry flat for 2 hours. Dries to the touch in 4-6 hours and is wearable in 24 hours. Allow 4 days before washing. Turn garment inside out and wash on a delicate cycle. Lay flat or hang garment up to dry for the first 4 washings. Machine drying is not recommended during this period to avoid lint adhesion. See special instructions at the beginning of the "DecoArt™ Fabric Paint" section.

Additives None required or recommended.

Surfaces All fabrics, including stretchable ones. May also be used on hard surfaces, such as wood, Lycra, glass, plastic, etc. When used on hard surfaces, you may seal with either a brush-on or spray gloss or matte sealer.

Heavy Metals™ and Heavy Metals Light™

Description Heavy Metals™ are bright liquid glitter fabric paints in a clear base and are recommended for dark fabrics. Heavy Metals Light™ are glitter paints in a colored base for light-colored fabrics.

Packaging 2-ounce and 8-ounce squeeze bottle.

Colors 12 Heavy Metals™, 12 Heavy Metals Light™.

Special Instructions May be applied using a soft brush or a palette knife. Apply two generous coats. Apply highlights, shading, or an additional coat before the first coat dries (within 1 hour).

May be used as an accent over Shimmering Pearls™ or So-Soft™ fabric paints. Apply as soon as the undercoat is dry to the touch. Don't wait more than 1 hour to apply. Allow to dry 48 hours. Hand wash using a mild, unscented detergent. Hang garment to dry. Do not dry in a clothes dryer because the heat will affect the colors and brilliance of the Heavy Metals™. See special instructions at beginning of "DecoArt™ Fabric Paint" section.

Heat Setting None required or recommended.

Additives None recommended. Adding water or other mediums will reduce the bonding qualities.

Surfaces Most fabrics, including 100% acrylic or silk. May be used on wood, tin, glass, metals, paper. However, for best results, basecoat piece first with regular acrylic paint. Apply a thin coat of Heavy Metals™ or Heavy Metals Light™ because if the application is too thick, it will remain sticky.

Liquid Sequins™ and Pastel Liquid Sequins™

Description Bright fabric paint containing large glitter particles. With Liquid Sequins™, the glitter particles are suspended in a cloudy base that dries clear and does not yellow. They are appropriate for dark and light fabrics. The Pastel Liquid Sequins™ are in a tinted base and were especially created for white or light-colored fabrics.

Packaging 2-ounce and 8-ounce squeeze bottles with flip-top lids.

Colors 18 Liquid Sequins™, 12 Pastel Liquid Sequins™

Special Instructions Apply two coats, using a *soft bristled brush*. Apply the first one heavily so it saturates the fabric. Apply the second coat before the first coat has dried completely. Do not scrub paint into the fabric. Paint out to the edge of your design, even exaggerating the application at the edges. Wait at least 48 hours before washing (longer is better). Hand wash in a mild, unscented detergent. Hang to dry. See special instructions at beginning of "DecoArt™ Fabric Paint" section.

Heat Setting None required.

Additives None recommended.

Surfaces Most fabrics. Liquid Sequins™ may also be used on hard surfaces, such as wood, tin, glass, metals, and paper. On hard surfaces, basecoat the area first with regular acrylics before applying Liquid Sequins™.

Hot Shots™

Description Bright, neon, fluorescent colors.

Packaging 2-ounce squeeze bottles with flip-top lids.

Colors 6

Special Instructions See special instructions at beginning of "DecoArt™ Fabric Paint" section.

Heat Setting None required

Additives Glo-It™ Luminescent Paint Medium may be added to create a glow-in-the-dark effect. Mix at a 50/50 ratio for the brightest glow in the dark. Glo-It™ recharges with exposure to light.

Surfaces Most fabrics, including 100% acrylic or silk.

Fabric Snow-Tex™

This is described in this section because it is included in the DecoArt™ fabric paint line.

Description A textural fabric acrylic designed to create the look of real textural snow on fabric. Use it alone or sprinkle with glitter or mix with any So-Soft™ fabric acrylic. It will not crack or peel.

Packaging 2-ounce and 4-ounce jars.

Colors 1, white.

Special Instructions Apply with a brush, sponge, or palette knife. Additional layers can be applied if desired after the first coat has dried. Use alone or sprinkle with Glamour Dust™ or mix it with any So-Soft™ Fabric Acrylic to create a variety of colors. This is machine washable. Hang painted fabric up to dry. Do not machine dry because the heat may cause the Snow-Tex™ to crack.

Heat Setting None required.

Additives None required. However, it may be tinted with up to 1/3 part of So-Softs™ Shimmering Pearls™, or Heavy Metals™ fabric acrylics to create soft tints of color.

Surfaces Most effective on sweat shirts, T-shirts, and other materials of similar thickness.

DEKA®

Before I describe the various DEKA® fabric paints available, I encourage you to write to them and ask for their promotional brochures for any of the products that interest you. Address your request for information to Decart Inc., Lamoille Industrial Park, Box 309, Morrisville, Vermont 05661, or call (802) 888-4217.

DEKA®-Permanent Fabric Paint

Description DEKA®-Permanent Fabric Paint is water-based, easily blended, non-stiffening, non-fading, machine washable, and dry cleanable. It may be brushed, stenciled, stamped, or airbrushed on. For airbrushing, thin with 15-25% water.

Packaging Available in 1 fl. ounce, 2-1/4 fl. ounce, 8 fl. ounce, and 1 qt. bottles.

Colors 69 colors, which includes 45 Basic shades, 10 Opaques, 8 Metallics, and 6 Fluorescents.

Special Instructions Shake paint well. Whether you brush it on or apply it in a different manner, avoid creating a heavy buildup of paint because it will affect the washfastness of your painted piece. Use just enough paint to achieve the color intensity desired. Generally, you should be able to see the weave of the fabric through the finished painting. Allow painting to dry thoroughly (overnight is best) then heat set.

Heat Setting Use *dry heat* and iron the wrong side of the painted piece at the hottest temperature suitable for the type of fabric used. Generally, iron for 1 minute at a hot setting, 2 minutes at medium, or 4 minutes at a warm setting. Heat setting in a home clothes dryer isn't effective because it doesn't reach a high enough temperature.

 Note: If you have blended fluorescent and non-fluorescent shades, *do not exceed a medium heat setting temperature* because hotter temperatures will alter the colors.

Additives Use DEKA®-Permanent Colorless Extender to reduce the intensity of the colors. Paint may be thinned with water to achieve desired consistency.

Surfaces All types of synthetic and natural fabric. Do not use on water-repellent fabric.

DEKA®-Permanent Glitter

Description Soft, water-based brush-on glitter that is opaque, non-fading, machine washable, dry cleanable, and non-toxic.

Packaging 1 fl. ounce jars and 8-ounce bottles.

Colors 10

Special Instructions Apply a medium-thick coat using a soft brush, smoothing with your brush to distribute the glitter evenly. Avoid thick blobs and don't apply multiple coats. After heat setting, wait one week before washing. May be washed in machine at delicate cycle with warm water and mild soap, or dry cleaned.

Heat Setting When dry, iron on wrong side for 2 minutes with iron on permanent press setting.

Surfaces All types of synthetic and natural fabric. Do not use on water-repellent fabric.

DEKA®-Flair

Description Fashion Outliners that are soft, water-based, opaque, non-fading, machine washable, dry cleanable, and non-toxic. May be used as a resist with DEKA®-Silk paints.

Packaging 1-ounce squeeze bottles with applicator tips.

Colors 10

Special Instructions Shake very well. Poke a hole in the applicator tip with a pin. Use a fine tip applicator for fine lines. Hold applicator vertically with the tip pressed firmly against the fabric, squeeze gently while drawing the lines. This may also be spread on with a brush. After heat setting, wait 5 days before machine washing or dry cleaning. Allow the painted fabric to dry completely before ironing. Do not iron painted fabric while it is still wet. If necessary, iron with iron at steam setting.

Heat Setting Use pressing cloth and iron for 3 minutes at a temperature appropriate for the type of fabric used.

Surfaces All types of synthetic and natural fibers except for those treated with water-repellent.

Additives None

DEKA®-Silk

Description For silk painting techniques on nearly any fine-weave fabric. This is a water-based, non-toxic, permanently machine washable and dry cleanable paint that may be applied by brush, dropper, cotton ball, or airbrush.

Packaging 2 fl. oz and 8 fl. ounce bottles. DEKA®-Silk Resist is available in 1 fl. ounce and 8 fl. ounce bottles.

Colors DEKA®-Silk is available in 20 colors that are intermixable. For more pastel shades, just add water. DEKA®-Silk Resist is available in 10 colors.

Special Instructions Applied using either the "Resist," "Watercolor," or "Stop-Flow Method." See Chapter 3, "Silk Painting Techniques" in the "Fabric" section for more information on silk painting.

Heat Setting Heat set when the project is thoroughly dry. Use a pressing cloth and iron the painting on the wrong side for 3 minutes at a temperature that is appropriate for the type of fabric used. An alternate method is to wrap the painted fabric in aluminum foil and put it in a *pre-heated* 300°F oven for 10 minutes.

Additives Add water to create more pastel shades. DEKA®-Silk Salt may be used to create starburst effects. It is not added to the paint, but is sprinkled on the painted area while the paint is still wet.

Surfaces For silk, fine cotton, and synthetic fabrics.

DELTA®

For product information, contact Delta Technical Coatings, Inc., 2550 Pellissier Place, Whittier, CA 90601. Telephone inside California: (213) 686-0678; outside California: (800) 423-4135. If you would like brochures describing the use of any of their products, send your request to them and include a stamped, self-addressed envelope.

Delta® Permanent Fabric Color

Description The Brush-On Fabric Colors are richly pigmented fabric paints that are non-toxic, water-based, provide one-coat coverage, create a soft feel on the fabric, and are permanent when heat set. The Shimmering Fabric Colors (Starlite™) offer the same features with a pearlized look that is especially impressive on dark fabrics.

Packaging 1-ounce and 2-ounce squeeze bottles with flip-top lids.

Colors 24 Permanent Fabric Colors and 32 Starlites™.

Special Instructions Apply using either a soft-bristled brush, fabric brush, stencil brush, or air brush. To achieve the strongest bonding, paint with a wet-on-wet technique. Work small areas at a time, applying shading and highlights while base colors are still damp. If you wish to accent your design with Dimensionals or Dazzlers, apply them to the first coat before it has dried. To apply the Dazzlers, carefully brush them out so the shapes don't cluster together.

Heat Setting Allow an hour or more for the fabric paints to dry before heat setting. Apply a press cloth over the design and iron with either a dry or steam setting for 20-30 seconds. An alternate method of heat setting is to put painted fabric in the clothes dryer for 10-15 minutes at a setting appropriate for the fabric.

If your painting includes the fabric paints and Dimensionals, first allow them to air dry together. Then iron at a steam or dry setting and press the *back* of the painted area using very light pressure for 30 seconds. An alternate method is to turn the garment inside out and put it in the clothes dryer for 20 minutes at an appropriate setting for the type of fabric used.

FABRIC

Additives

✦ *Fabric Gel Medium* A thick, colorless medium that can be mixed with the Delta® Fabric Colors to create transparent colors and to give you more "open time" for optimum blendability. (This gives you a longer open time than Textile Medium.) It is very effective for watercolor techniques as well as for shading and highlighting. Allows greater control and prevents fabric paints from bleeding outside the pattern lines. Dress the brush with Gel, then pick up paint on the brush and apply. Another method is to brush Gel on the pattern area first, then apply the paint while the Gel is still wet.

✦ *Sta-Set Spritzer™* This may be used for thinning the fabric paints to an appropriate consistency for lightweight fabrics, such as polyesters and silk. Mix equal parts of water and Sta-Set Spritzer™ in a jar, then tint with the fabric paints until the desired shade is obtained. Shake well to mix thoroughly. Brush mixture directly onto the fabric.

Sta-Set™ helps keep diluted pigments brighter over several washings. It is also used for tie dying and creating watercolor effects.

For silk painting techniques, mix 1 part Sta-Set Spritzer™, 1 part water, and 2 parts fabric paint.

✦ *Textile Medium* A water-based, colorless medium used to thin Delta® fabric paints (as well as Delta® Ceramcoat® Acrylics) to prevent bleeding and to help blend paints on fabric.

Surfaces Most washable fabrics. If possible, test paints by painting a small area on a similar type of material before starting a big project. Not recommended for use on non-porous fabric, such as nylon for "wind breakers" or nylon banners.

Delta® Dimensionals

Description Non-toxic, water-based, dimensional paints that come in two types: Glitter Liners (sparkling colors in a milk-colored base that dries clear so only the glitter shows), and Shiny Liner (opaque, looks shiny and wet when dry).

Packaging 2-oz. squeeze bottle with applicator tip.

Colors 8 Glitter and 6 Shiny.

Special Instructions Remove outer cap, cut back the top of the inner applicator tip to the size opening you want. You'll need a larger opening for the Glitter Liners. If you paint very fine lines, remember that they will only have a few fibers to adhere to and, therefore, may not be as washfast as thicker lines. Applicator tips should be washed free of paint after each application.

Heat Setting None required; however, Dimensionals won't be damaged if combined with fabric paints that do require heat setting.

Additives None.

Surfaces Fabrics containing natural fibers are recommended. The paints may also be used on other surfaces, such as wood, ceramics, paper, etc.

Delta® Dazzlers

Description Water-based, non-toxic, transparent, brush-on fabric specialty paints that feel soft and flexible on fabric. They are filled with glitter and other sparkling glitter shapes.

Packaging 1-ounce jars.

Colors 11 Liquid Stars, 11 Liquid Hearts, 3 Liquid Confetti, 1 Liquid Diamonds, and 5 Miscellaneous (Celestial, wedding/anniversary, western, tropical waters, and patriotic).

Special Instructions Carefully brush them out so the shapes don't cluster together. May be applied on top of Delta® Ceramcoat® acrylics or the Delta® Fabric Colors. For best bonding, apply them over the first paint while it is still damp. Dazzlers may still feel tacky to the touch, even when dry; however, tackiness lessens after washing.

Heat Setting None. Do not heat set or put in the dryer. Hang fabric to dry.

Additives None.

Surfaces Fabrics containing natural fibers are recommended. The paints may also be used on other surfaces, such as wood, ceramics, paper, etc.

Plaid®

For product information, contact Plaid Enterprises, P.O. Box 7600, Norcross, GA 30091-7600. Telephone: (404) 923-8200.

Fashion™ Dimensional Fabric Paint

Description Permanent, machine washable, non-toxic dimensional paint that is flexible; therefore, it will not crack, warp, fall off, or permanently stick to itself.

FABRIC

Available in Glitter, Metallic, Neon, Pearl, Shiny, and Sparkle.

Note: Plaid® no longer makes Fashion Show™ Soft Paint (brush-on).

Packaging 1.1 fl. ounce soft, squeezable bottles with ultra fine-line applicator tip.

Colors 66 total, which includes: 9 Glitter, 5 Metallic, 5 Neon (one glows in the dark), 18 Pearl, 18 Shiny, and 11 Sparkle.

Special Instructions Turn the bottle upside down and firmly tap on a table to force paint into the tip. For maximum adhesion, place the tip on the surface, squeeze, and move forward slowly. If the tip becomes clogged, remove the tip by pushing it up until it comes off the bottle. Unclog it with a toothpick, then flush with water.

As you're painting, store the paints upside down on the caps (which act as a stand). Use a toothpick to smooth bumps or bubbles on the painted surface. Allow the paint to air dry 72 hours before washing. Wash in cool water on gentle cycle. Dry on low heat. Do not dry clean painted object.

Heat Setting None required.

Surfaces Most fabrics except 100% acrylic and slick fabric such as Rayon.

Scribbles®

These paints are available in both brush-on and dimensional types. Each is described separately. Both types of paint are matched to a standard which ensures consistent color matching from batch to batch. For information, call or write: Duncan Crafts, 5673 E. Shields Avenue, Fresno, CA 93727. Telephone: (800) 438-6226.

Scribbles® Brush 'n Soft Fabric Paint

Description These are formulated to brush on smoothly and come in the following types: Matte (rich, basic colors); Crystal (translucent colors filled with tiny color crystals); Glittering (glitter particles in a clear base); Iridescent (shimmering, pearlescent colors); and Metallics. The fabric remains soft after painting. Colors are permanent, washable, and non-toxic. Cleanup is easy with soap and water.

Brush 'n Soft colors match the 3-Dimensional Fashion Writer colors exactly. The paint color order number is the same as the matching 3-Dimensional paint.

Packaging 1-ounce squeeze bottles with flip-top cap.

Colors 72 total, which includes 35 Matte, 20 Iridescent, 3 Glittering, 10 Crystal, and 4 Metallic.

Special Instructions Shake bottle well. Use a soft-bristled flat brush and apply one even coat of paint. Use a wet-on-wet technique, working small areas at a time. As soon as the area is based, bring in your shading and highlighting. If you will be outlining your design with 3-Dimensional Fabric Writers, paint one area at a time and apply the outlining *before* the brushed-on paint is completely dry. This creates a strong bond between the two types of paint.

Heat Setting None required. Allow to dry flat for 4-6 hours. It will dry completely in 24 hours. Wait 72 hours before the first washing.

Additives None required.

Surfaces Fabrics containing natural fibers are recommended. The paints may also be used on a variety of craft surfaces.

Scribbles® 3-Dimensional™ Fashion Writers

Description These are ideal for outlining or accenting designs painted with Scribbles® Brush 'n Soft Fabric Paints, or used by themselves. They are available in the same colors as the Brush 'n Soft Fabric Paints making color matching easy.

Packaging 1 and 4.5-ounce squeeze bottles with no-drip writing tip.

Colors 106 total, which includes 36 Shiny, 25 Iridescent, 6 Ultra Iridescent, 16 Glittering, 13 Crystal, 4 Neon, and 6 Glow-in-the-Dark.

Special Instructions Shake paint toward tip of bottle. Place writer tip directly on surface and gently squeeze. To create a strong bond, keep the writer tip in contact with the fabric as you apply the paint. For consistent flow, use steady pressure on the bottle while applying the paints. Slow movement creates a wider line; quick movement creates a thinner one.

As you are painting, occasionally shake the bottle as well as wipe the writer tip with a soft tissue. If the tip becomes clogged, remove the tip and immerse it under running, warm water or insert a pin to clear it.

Heat Setting None required. Allow to dry flat 4-6 hours. Dries completely in 24 hours.

Special Instructions Wait 72 hours before the first washing. Turn the garment inside out and wash separately

on the delicate cycle. Do not expose to extremely cold temperatures. Machine dry on a low setting or air dry.

Surfaces Fabrics containing natural fibers are recommended. The paints can also be used on a variety of craft surfaces.

Tulip®

For information or promotional brochures, write to Tulip, 24 Prime Park Way, Natick, MA 01760. Telephone: (800) 458-7010.

Tulip® Brush-On Fabric Paints

There are a number of Tulip® brush-on fabric paints, and the following information applies to them all. They are non-toxic, water-based, and permanent when dry; brushes clean up easily with soap and water. Thin them with water or Soft Lite™ Clear Extender. They are recommended for use on cotton and cotton/polyester blends which contain at least 50% cotton. All are available in 1-ounce jars.

Allow 24 hours for finished painting to dry completely. In humid weather, allow more time. If you have used a heavy application of paint, or applied embellishments, the garment should be dried flat. Wait 72 hours before washing. Wash in a gentle cycle with warm water. Air dry–do *not* dry clean.

+ **Soft Covers All™** This is an opaque paint that covers completely on light or dark fabrics and stays soft to the touch. It is available in 24 blendable colors. Heat setting is required. Place a cloth over your fully dry design and heat set for 60 seconds with a *dry* iron set at the appropriate temperature for the type of fabric used.

+ **Soft Glitter** This has a smooth, glittering appearance when dry. There are 13 colors available, which may be brushed, layered, or spread onto fabric. Contains large glitter crystals, some with crystalline flakes for added shimmer. No heat setting required.

+ **Soft Lite Paint™** This is a translucent paint that dries soft. There are 23 colors (plus a clear extender) available. Best when used on white or light colored fabrics. Should be applied with a soft, artist-style brush. The shadings and details of iron-on transfer designs will show through the paint. Heat setting is required. Place a cloth over your fully dry design and heat set for 60 seconds with a *dry* iron set at the appropriate temperature for the type of fabric used.

+ **Soft Metallics™** These contain a liquid metal additive

to create rich, smooth metallic effects, and are available in 16 colors. They can be brushed, layered, or spread onto fabric. No heat setting required.

+ **Soft Sparkling Tints™** These are used when you want a tint of color with a soft sparkle. The 12 translucent colors may be mixed together. Most effective when used on white or pastel fabrics. Specially designed for use on iron-on transfers. Can be stamped or brushed onto fabric. No heat setting required.

Tulip® Dimensional Fabric Paints

The paints are non-toxic, water-based, permanent when dry, and brushes clean up easily with soap and water. They are recommended for use on cotton and cotton/polyester blends which contain at least 50 percent cotton. None of the paints require heat setting except the Puffy and Colorpoint® "Stitch" paints.

Most of the paints are available in the following sizes: 5/8-ounce, 1.25-ounce (Easy-Flow™ bottle), and 4-ounce applicator bottles.

Allow 24 hours for paints to dry completely. In humid weather, allow more time. Wait 72 hours before laundering. Turn garment inside out for washing. Wash in warm water using a mild detergent and fabric softener. The garment should be air dried (lay it flat). Do not dry clean.

+ **Crystals®** Paint that has a frosted, glittering appearance when dry. Available in 13 colors. They will bond to almost any surface.

+ **Glitter** This has a raised, glittery appearance when dry. It is composed of opaque colored polyester glitter flakes suspended in a transparent base. May be brushed, squirted, layered, sponged, spread, or spattered on. Available in 12 colors.

+ **Pearl™** This is a pearlescent additive, giving a shimmering effect when dry. May be applied directly from the bottle, sponged, stenciled, or brushed on. Available in 30 colors.

+ **Puffy®** This has a raised, matte finish when dry. Available in 12 colors (including 3 fluorescents). The paint swells when heat is applied. For best results, allow paint to dry 24 hours before "puffing," as follows: Place design face down on a smooth, cushioned surface. Iron with a steam iron on the reverse side until the paint "puffs."

+ **Slick®** This paint has a glossy, wet appearance when dry. The 36 colors (which includes 6 fluorescents), can be applied directly from the bottle, brushed,

layered, sponged, or spread on.

✦ **Sparkles™** Contain a multi-prismatic glitter flake with a colored hue in a clear acrylic base. Available in gold and crystal. Paints may be squeezed on directly from the bottle or brushed or spread on. The paint is often used to add shimmering highlights. Most effective when used on dark fabrics.

✦ **Tulip® Treasures™** The Treasures™ line consists of dimensional paint, design books, See-Thru Stones, Lamé Appliqués, and Shake-On Holographic Glitter. The Tulip® Treasures™ paint is available in 17 "Brilliant Jewels" (luminescent colors that create the effect of sparkling gems), and 7 "Precious Metals" (earth tones with a metallic sheen to create the effect of polished metals). The See-Thru Stones are clear, unbacked stones that are transformed into colorful jewels when combined with Treasures™ paint. The paints are also ideal for use with the Lamé. They are available in 2-5/8-ounce Easy Flow™ bottles.

The Lamé appliqués have fusible web backings that iron on easily. They are available in 12 non-seasonal, and 6 Christmas designs. The Holographic Glitter is available in gold, silver, and icicle.

✦ **Tulip® ColorPoint® Paint Stitching** This line includes products that allow you to create the look of needlecrafts. The ColorPoint® "Bead" Paint is applied using the applicator bottle and is specially formulated to allow you to form perfect self-rounding beads with a lustrous finish. It is available in 62 colors (including 5 fluorescents and 1 glow-in-the-dark), and is packaged in 1.1-ounce squeeze bottles with applicator tips. Use with patterns from the ColorPoint® Original and EasyPoint™ Design Books to create a needle-crafted look.

The ColorPoint® "Stitch" Paint is used to replicate 10 of the most popular needlework stitches. It comes in a 1.1-ounce bottle with a patented applicator with a micro-fine tip that maintains controlled paint flow. This specially formulated paint expands with heat for a soft, yarn-like finish. To expand the paint, place design face down on a smooth, cushioned surface. Iron with a steam iron on the reverse side until the paint expands. It is available in 54 colors (including 5 fluorescents and 1 glow-in-the dark). Use with patterns from the ColorPoint® Stitch and EasyPoint™ Design Books. The books contain iron-on patterns with easy-to-paint "stitches."

Wally R.™

The Wally R.™ fabric painting line includes dimensional fabric paints as well as fabric dyes.

Instructions for the type of fabric to use, fabric preparation, and washing information that follows applies to both the paints and dyes.

Fabric Works best with natural fabrics and blends: cotton, cotton/polyester blends, and silk.

Fabric Preparation Pre-wash material to remove sizing. Use a detergent that doesn't contain a soil resistant additive or fabric softener. Dry at an appropriate setting for the type of fabric used. Again, don't use fabric softener sheets. If necessary, iron fabric before painting it.

Special Instructions For maximum adhesion, *allow seven days* to cure before washing. The manufacturer recommends hand washing painted items with a mild laundry soap. For best results, wash in warm (never hot) water. Avoid using harsh laundry detergents or fabric softeners. Dry flat on a towel or hang to dry. Do not wring.

Note: Layering fabric dyes or paints is not recommended because if you overload the fabric, you may get some cracking or peeling.

Address For information, write to the Wally R. Company, Inc., 16366 Valley Blvd., La Puente, CA 91744. Telephone inside California: (818) 333-2033; outside California: (800) 458-0570.

Wally R.™ Permanent Fabric Dyes

This information applies *only* to the fabric dyes. Please refer to the basic instructions given above that apply to both Wally R.™ brush-on dyes and dimensional paints.

Description Permanent Fabric Dyes have a soft touch when dried. They are easy to clean up with soap and water. Heat setting keeps them as brilliant and supple as the day they were applied. The line includes Opaques, Lite Line (pastels), Fluorescents, and Galaxy™ (shimmering colors that are appropriate for both dark and light fabric).

Packaging 1-ounce squeeze bottles.

Colors There are 58 total. This includes 21 Galaxy™, 20 Opaque, 12 Lite Line, 5 Fluorescents.

Drying Time Normal painting applications take 20-30 minutes to dry to the touch. Allow dyes to dry completely before heat setting.

FABRIC

FABRIC

Additives

✦ **Fab Fixative** This is a medium designed to extend the properties of the fabric dye without breaking down the ingredients or affecting the permanency. This was designed to be used with the fabric dyes only, *not* with the dimensional fabric paints.

✦ **Textile Medium** This is an additive to mix with the dyes for better penetration of color on tightly woven fabrics. It can also be used for various painting effects, (i.e. watercolor), or simply as a basecoat to keep dye from bleeding outside the pattern lines.

Heat Setting To ensure permanence of colors, fabric dyes must be heat set. Waiting overnight is recommended; however, in a pinch you could heat set after about 4 hours. Use a dry iron at a setting appropriate for the fabric. Place a pressing cloth or plain brown paper bag (no printing) on the *wrong* side of the fabric. Heat must be evenly applied over the painted area for *4 minutes*.

Special Instructions Super Hide White may be used alone as an undercoat on darker fabrics or to make dyes opaque. This may lighten the colors slightly.

The dyes may be accented with Wally R.™ Dimensional Fabric Paints. Be sure to heat set the dye *before* you begin decorating because unlike the dyes, dimensional fabric paints do not require heat setting. Decorate with the fabric paints as soon as possible after heat setting the dyes so they can cure together.

Wally R.™ Dimensional Fabric Paints

The following information applies *only* to the Dimensional Fabric Paints. Please read the basic instructions shown earlier in this section that apply to the Wally R™ dyes *and* dimensional paints.

Types There are a number of different types. The following paints are all packaged in 1-ounce applicator bottles. If you plan to use them to decorate designs already painted with fabric dyes, remember to heat set the dyes *before* accenting with the paints.

✦ **Fluorescents** Very intense (neon-like), in 5 colors.

✦ **Meteorites** Glitter paints which contain metal flakes in a clear base. Available in 9 colors.

✦ **Moonbeams** Pearlescent opaque paints in 17 colors.

✦ **Moondust** Sparkling paints which contain iridescent flakes in a translucent colored base. Available in 19 colors. May be used directly from the bottle or brushed on by itself or over fabric dye colors.

✦ **Raindrops** See-through paints for setting jewels. Available in 7 colors.

✦ **Sunbeams** This is a traditional, slick, opaque, dimensional paint, available in 18 colors.

Use On Other Surfaces Though designed for fabric, these can be used on non-fabric surfaces such as wood. I accented a fireworks scene on a wooden picnic basket using the Meteorites. I waited for the initial painting to dry, then brushed on the glitter. To ensure permanence, I varnished the design when the paint was completely dry.

Drying Time Light applications will dry in 4-6 hours. For maximum adhesion, allow 5 days to cure.

Additives None required or recommended.

Heat Setting None required.

Special Instructions Trim nozzle evenly, according to desired thickness of line. Turn bottle upside down and shake before using to remove air bubbles from solution. Keep a toothpick handy to pop any bubbles or to smooth out lines when necessary.

Color Conversion Charts

Color conversion charts are used to guide you in selecting comparable colors in different brands of paint. When instructions call for a particular color and you don't have it, look up the color on the chart to see if you already have a comparable color in another brand. It's a way to save money on purchasing unnecessary paints.

I hope you enjoy the color conversion charts in this edition. They include the new colors as of Spring 1994, and believe me, there have been a lot of colors added and, in some lines, a number of them discontinued. There are two sections of charts. The first includes charts for seven brands of regular acrylic paints. The second section (new with this edition) contains charts for six brands of Acrylic Gloss Enamels. No fabric conversion charts are included in this edition because the majority of those poled didn't use them.

The more time I spend working on color comparison charts, the more I realize that it's rare to find an exact match for any particular color. Please keep in mind that these charts reflect how I perceive the colors–we all perceive them somewhat differently.

There are also other things that affect perceived color, such as the light that the color is viewed in, the background color it is painted on, or variations from batch to batch, to name a few. However, when the originally suggested color isn't available for direct comparison, you will, in all likelihood, be satisfied with the substitute color.

Many of us like to avoid mixing colors. With the wide range of colors available in bottled acrylics, mixing isn't really necessary. That's why no mix recipes are included for Accent®, DecoArt™, Delta®, FolkArt®, or Wally R.™ acrylics. However, Jo Sonja® Artist Colors and Liquitex® Concentrated Artist Colors have fewer colors available, so mixing is often necessary. Therefore, I've included recipes for a number of these.

How the Charts Were Compiled

The paint companies graciously provided me with samples of their complete color lines, which enabled me to paint my own color swatches. I prepared a white file card for each color and painted 1-inch squares showing one-coat and two-coat coverage. For these swatches, nothing was added to the paint. Then I thinned the paint with water for the third square to create a "wash" or float of color.

Having paint swatches of this size was a big help, and being able to see how the paint looked when thinned with water was very beneficial, especially with reds. For example, some reds appear pinker, while others have more of an orange tone when thinned with water. Undiluted applications of the same color make it difficult to see this.

When a manufacturer's color comparison chart was available, I first compared their recommended matches using my swatches. If I agreed with their match, I included it in my chart. If I disagreed, I compared all my painted swatches to see if there was a better match. There are many cases where I have not used the color recommended by the manufacturer because I felt another color was closer or there was no adequate match. Many of the color mixes for Liquitex® acrylics were those recommended in the wonderful Binney & Smith booklet *"Color Conversion Chart & Mixing Guide."*

In comparing my hand-painted swatches, I chose what I believed to be the best matches by using the two-coat coverage swatch as well as the washes. When all I show is "-----", it means I didn't feel there was an appropriate match. If you see any of the following symbols in parentheses after a color name, it indicates the matches aren't what I'd consider "ideal," but they would do in a pinch.

Symbols used in the charts

"+" The color is darker than the reference color (first column).

"-" The color is lighter than the reference color (first column).

"*" The "washes" or floats don't match; however, the color would probably suit your needs if you are simply basecoating with it.

In each case, the left-most column of the chart is the reference column. The other columns show the different brands of paint. When you see a color listed in one of these columns, it indicates this is the nearest equivalent color to that shown in the reference column.

Note that the best match is *only* indicated between the color in the reference column compared to any of the other columns. For example, if the reference column is Delta® acrylics, and you are looking for a substitute for Delta's® "Crimson," then Accent's® "Razzle Red," or DecoArt's™ "Berry Red" are close matches. However, it is not necessarily true that DecoArt's™ "Berry Red" is the best substitute for Accent's® "Razzle Red."

It's important for you to be aware that there will be cases such as the one described above where one color would be an appropriate substitute for one brand but not for another simply because of the slight variations.

Sometimes you will find the same color name in more than one brand. For example, "Leaf Green" is available in both Delta® and DecoArt™, but the colors don't match. Therefore, when you're purchasing paints, make sure you know the brand name as well.

For clarification, product numbers are listed after the color names on the conversion charts. This is done for two reasons. Many craft stores stock their paints in order by product number instead of color name. Secondly, two

brands have two colors with the same name. (There are two Accent® "Burnt Siennas" and two "Burnt Umbers"; there are two FolkArt® "Pure Oranges.") Hopefully, if you know the product number, there shouldn't be any confusion. Though you may not always agree with my choices, hopefully, these charts will be a good starting point.

Color Key—Jo Sonja's® Artist Colors

AM ...	Amethyst	GRNOX	Green Oxide	ROSE ..	Rose Pink
AQ ...	Aqua	IRO ...	Indian Red Oxide	RS	Raw Sienna
BE	Brown Earth	JADE ..	Jade Green	RU	Raw Umber
BG	Brilliant Green	MOSS .	Moss Green	SAPH ..	Sapphire
BS	Burnt Sienna	NC	Napthol Crimson	SP	Smoked Pearl
BU	Burnt Umber	NIM ...	Nimbus Gray	STRM .	Storm Blue
BUR ..	Burgundy	NOR ..	Norwegian Orange	TEAL ..	Teal Green
CB	Carbon Black	NRL ...	Napthol Red Light	TM ...	Transparent Magenta
COBH .	Cobalt Blue Hue	OPL ...	Opal	TW ...	Titanium White
COBL .	Colony Blue	PB	Provincial Beige	TY	Turner's Yellow
CS	Cad. Scarlet	PBH ...	Prussian Blue Hue	UBD ..	Ultra. Blue Deep
CYL ...	Cad Yellow Lt.	PG	Payne's Gray	UMB ..	Ultramarine
CYM ..	Cad. Yellow Mid	PINE ..	Pine Green	VER ...	Vermilion
DP	Dioxazine Purple	PLUM .	Plum Pink	WW ...	Warm White
FB	French Blue	PTHBL .	Pthalo Blue	YL	Yellow Light
FWN ..	Fawn	PTHGR	Pthalo Green	YO ...	Yellow Oxide
GO ...	Gold Oxide	RE	Red Earth		

Color Key—Liquitex® Concentrated Artist Colors

ALIZ ..	Alizarine Crimson Hue	DPP ...	Deep Portrait Pink	PTHGR	Phthalocyanine Green
AP	Apricot	DVR ..	Dark Victorian Rose	PV	Prism Violet
BAG ..	Bright Aqua Green	FGB ...	French Gray/Blue	RAS ...	Raspberry
BAL ...	Baltic Blue	FLOR ..	Fluorescent Orange	RO	Red Oxide
BB	Brilliant Blue	FLPI ..	Fluorescent Pink	RS	Raw Siena
BG	Baltic Green	IB	Ivory Black	RT	Real Teal
BP	Brilliant Purple	LBV ...	Light Blue Violet	RU	Raw Umber
BS	Burnt Siena	LPP ...	Light Portrait Pink	SAP ...	Sap Green (Permanent)
BU	Burnt Umber	MB ...	Mars Black	SCR ...	Scarlet
BUR ..	Burgundy	MM ...	Medium Magenta	SDL ...	Sandalwood
BY	Bronze Yellow	NC	Naphthol Crimson	SW ...	Soft White
CG	Christmas Green	NG5 ...	Neutral Gray, Value 5	SWBL .	Swedish Blue
CO	Cad. Orange	NRL ...	Naphthol Red Light	TP	Taupe
COBH .	Cobalt Blue Hue	OL	Olive	TW ...	Titanium White
COG ..	Chromium Oxide Green	PAR ...	Parchment	TWI ...	Twilight
COH ..	Cad. Orange Hue	PG	Payne's Gray	TY	Turner's Yellow
CRLH .	Cad. Red Light Hue	PGL ...	Permanent Green Light	UBT ...	Unbleached Titanium
CRM ..	Cad. Red Medium	PHGH .	Perm. Hooker's Green Hue	UMB ..	Ultramarine Blue
CRMH .	Cad. Red Medium Hue	PLB ...	Permanent Light Blue	VR	Venetian Rose
CYLH .	Cad. Yellow Light Hue	PLV ...	Permanent Light Violet	WIS ...	Wisteria
CYMH .	Cad. Yellow Med. Hue	PPP ...	Pale Portrait Pink	YLH ..	Yellow Light Hansa
DP	Dioxazine Purple	PTHBL .	Phthalocyanine Blue	YO ...	Yellow Oxide

Color Conversion Chart

ACCENT®

Acrylic Paints

ACRYLICS

Accent® Acrylics (See Notes 6, 7)	DecoArt™ Americana™ (See Notes 1 - 3, 6, 7)	Delta® Ceramcoat® (See Notes 1 - 3, 6, 7)	FolkArt® (Plaid) (See Notes 1 - 3, 6, 7)	Jo Sonja® (Chroma Acrylics) ("t" = Tad in recipes below) (See Notes 1 - 4)	Liquitex® Concentrated Artist Colors ("t" = Tad in recipes below) (See Notes 1 - 7)	Wally R.™ (See Notes 1 - 3, 6, 7)
Adobe Wash 2311	-----	Antique White 2001	Taffy (+) 902	WW+TY (1:t)	SW+YO (6:1)	Creamette 1024
Antique White 2429	Sand(+) 4	Ivory(-) 2036	Taffy(-) 902	WW+YO (1:t)	PAR+BY (2:1)	Oatmeal(+) 1054
Apache Red 2303	-----	Deep Coral 2479	-----	ROSE+NC+TW (3:1:1)	CRMH+MM+UBT (1:1:1)	-----
Apricot Stone 2448	-----	Rosetta Pink(-) 2430	Peach Perfection (+) 617	WW+NOR+PINE (4:1:t)	AP+HIB+BU (4:1:t)	Cherub(+) 1165
April Showers 2510	Gray Sky(-) 111	Drizzle Gray 2452	Dove Gray 708	TW+NG+STRM (1:1:t)	SW+NG5+FGB (4:1:t)	Pelican 1223
Avon On The Green 2316	Viridian Green(+) 108	-----	Phthalo Green(+) 563	Pthalo Green(+)	Phthalocyanine Green(-) 317	Pthalo Green(+) 1001
Barn Red 2424	Brandy Wine(-) 79	-----	Barnyard Red 611	IRO+RE+NC (4:1:t)	BUR+RO (2:1)	Aztec 1145
Baroque Pearl CJ 2532	White Pearl 117	Pearl Finish Gleams 2601	Pearl White Met. 659	Pearl White Metallic	Iridescent White 238	Pearl White 1520
Black Green 2342	-----	-----	-----	TEAL+RU (2:1)	PHGH+TWI (3:1)	-----
Blonde 2582	-----	-----	-----	TW+GO+TY (7:1:t)	UBT+AP+TW (3:1:1)	-----
Blue Bonnet 2309	-----	-----	-----	TW+DP+UMB (1:t:t)	PLV+LBV+TW (3:1:1)	-----
Bordeaux 2322	Cranberry Wine 112	Mendocino Red(-) 2406	Raspberry Wine 935	BUR+BU (1:t)	BUR+RAS+BU (3:1:1)	Burgundy(+) 1181
Burgundy 2605	-----	-----	Maroon(+) 415	BUR+OPL+BU (2:1:t)	BUR+MM+BU (2:1:t)	-----
Burgundy Deep 2338	-----	Black Cherry 2484	Alizarine Crimson(+) 556	BUR+UBD (1:t)	BUR+MM (2:1)	Cranberry(+) 1083
Burnt Sienna 2614	Burnt Sienna(+) 63	Burnt Sienna(-) 2030	Burnt Sienna(-) 568	RE+BU (1:t)	Burnt Siena 127	Burnt Sienna(-) 1022
Burnt Sienna 2435	-----	-----	Maple Syrup 945	BS+BU+OPL (3:1:t)	BU+BS (1:1)	-----
Burnt Umber 2613	-----	Walnut 2024	Raw Umber(-) 571	Burnt Umber	BU+IB (3:1)	Raw Umber 1017
Burnt Umber 2437	Dark Chocolate(+) 65	Burnt Umber(-) 2025	Chocolate Fudge 950	RU+BE (1:1)	Burnt Umber(+) 128	Burnt Umber(-) 1018
Cactus Flower 2306	Pineapple 6	Pale Yellow 2005	-----	TW+YL (1:t)	SW+CYM (2:1)	Cotton Seed 1099
Chesapeake Blue 2438	Blue Haze(+) 115	-----	Township Blue(-) 606	COBL+RU+TW (2:1:t)	BAL+RT+BU (3:1:t)	Astro Blue(-) 1025
Clear Blue 2336	-----	-----	-----	COBH+TW+BU (3:1:t)	BB+LBV+BU (3:1:t)	-----
Cool Neutral 2615	Warm Neutral 90	-----	Milkshake(+) 704	Opal	SDL+SW+BU (2:1:t)	Burnt Almond(-) 1214
Coral Blush 2333	Coral Rose(+) 103	-----	-----	ROSE+TY+TW (2:1:1)	AP+CRMH (4:1)	-----
Coronation Russet CJ2521	Royal Ruby Met.(+) 74	Red Copper Gleams(+) 2605	Regal Red Metallic 657	N/A	-----	-----
Cottage Rose 2313	Coral Rose(-) 103	Fiesta Pink(+) 2045	Salmon(+) 747	VER+ROSE+OPL (1:1:1)	SCR+SDL+HIB (6:1:1)	Festive Pink 1029
Crimson 2604	True Red 129	Berry Red 2056	Napthol Crimson 555	Napthol Crimson(+)	NC+RAS (3:1)	Pthalo Crimson(+) 1147
Crown Red Velvet CJ2520	-----	-----	-----	N/A	Pearl+BUR (See Note 5.)	-----
Dark Flesh 2332	Shading Flesh(+) 137	Desert Sun Orange(+) 2444	-----	OPL+RE (5:1)	RO+SW+YO (2:1:t)	-----
Deep Forest Green 2444	Black Forest Green 83	Hunter Green(-) 2471	Hunter Green(-) 406	PTHGR+CB (3:1)	PTHGR+BU (4:1)	-----
Devonshire Cream 2312	Moon Yellow 7	Maple Sugar Tan(+) 2062	Moon Yellow(+) 409	WW+TY (3:1)	SW+RW+CYMH (7:1:1)	Margarine(-) 1062
Dijon Gold 2318	-----	Empire Gold 2412	-----	Turner's Yellow(+)	Turner's Yellow(+) 730	Spun Gold 1087
Dioxazine Purple 2606	Dioxazine Purple(-) 101	Purple 2015	Dioxazine Purple 558	Dioxazine Purple	Dioxazine Purple 186	Purple(-) 1106

ACRYLICS

Color Conversion Chart

ACCENT®

Acrylic Paints

Accent® Acrylics "CJ"™ = Crown Jewels (See Notes 6, 7)	DecoArt™ Americana™ (See Notes 1 - 3, 6, 7)	Delta® Ceramcoat® (See Notes 1 - 3, 6, 7)	FolkArt® (Plaid) (See Notes 1 - 3, 6, 7)	Jo Sonja® (Chroma Acrylics) ("t" = Tad in recipes below) (See Notes 1 - 4)	Liquitex® Concentrated Artist Colors ("t" = Tad in recipes below) (See Notes 1 - 7)	Wally R.™ (See Notes 1 - 3, 6, 7)
Duchess Rose CJ2522	Rose Pearl(-) 119	Fuchsia Pearl Gleams 2622	-----	N/A	Pearl+NC (See Note 5.)	Pearl Fuchsia(+) 1526
Ebony Black 2612	Ebony Black 67	Black 2506	Ivory Black 576	Carbon Black	Mars Black 276	Black 1006
Eggplant 2337	-----	Vintage Wine 2434	Purple Passion(-) 638	UMB+NC (2:1)	WIS+DP+BU (1:1:t)	Brandy(-) 1169
Empress Blue CJ2524	Ice Blue Met.(+) 75	-----	Blue Sapphire Met. 656	N/A	Pearl+PTHBL (See Note 5.)	-----
English Marmalade 2315	-----	-----	-----	VER+OPL (2:1)	SCR+UBT+BU (3:1:t)	Fresh Tangerine(+) 1027
Faberge Purple CJ2523	Purple Pearl 124	Violet Pearl Gleams 2623	Amethyst Metallic 654	N/A	Pearl+DP (See Note 5.)	Pearl Violet 1527
Fingerberry Red 2425	Russett 80	Candy Bar Brown 2407	Dark Brown 416	IRO+BU (3:1)	BUR+BU (1:1)	Cinnabar 1084
Forest Green 2341	-----	Forest Green 2010	Sap Green 565	PINE+SAPH+BU (4:1:t)	OL+PHGH+BU (1:1:t)	Terrestrial Green 1011
Fuschia 2335	-----	Fuchsia(-) 2481	-----	TM+TW+NC (2:1:1)	MM+RAS (2:1)	-----
Golden Harvest 2433	-----	Straw(-) 2078	Yellow Ochre(+) 572	WW+YO (1:1)	YO+SW+BU (2:1:t)	Caribou(-) 1049
Golden Oxide 2339	-----	Raw Sienna(+) 2411	Trans. Oxide Yellow 573	Raw Sienna	RS+TY (2:1)	Raw Sienna(+) 1156
Green Olive 2442	-----	-----	Old Ivy(+) 927	GRNOX+OPL+CB (5:1:t)	COBH+YO (1:1)	Terrestrial Green(+) 1011
Holiday Green 2577	Holly Green(-) 48	Green Isle 2008	-----	BG+TEAL (2:1)	CG+PHGH (2:1)	Erin Green 1009
Holiday Red 2421	-----	Berry Red 2056	Holiday Red(+) 612	NC+BUR (4:1)	NC+RAS (3:1)	Valentine 1065
Imperial Antique Gold CJ2528	Emperor's Gold Met.(+) 148	-----	-----	-----	-----	-----
Indian Sky 2308	-----	-----	-----	TW+UBD (1:t)	TW+LBV (4:1)	-----
Jo Sonja® Red 2449	Naphthol Red 104	Fire Red 2083	Napthol Crimson 555	Napthol Crimson(+)	Cadmium Red Med Hue 151	Fire Truck Red 1050
King's Gold CJ2527	-----	-----	-----	-----	-----	-----
Larkspur Blue 2563	-----	-----	-----	PTHBL+COBL+TW (2:1:t)	SWBL+SW+BU (2:1:t)	-----
Liberty Blue 2439	-----	Dark Night Blue(+) 2414	Indigo 908	STRM+PG (2:1)	NVY+NG5+MB (2:2:1)	Velvet Night 1089
Lt. Cactus Flower 2462	Pineapple 6	Pale Yellow(+) 2005	Lemonade(+) 904	TW+CYL (20:1)	SW+CYMH (4:1)	Maize 1189
Lt. Flesh 2330	-----	Santa's Flesh(+) 2472	Dusty Peach(+) 615	TW+GO (6:1)	SW+PPP+AP (5:3:1)	Cornflower 1185
Lt. Peaches N' Cream 2465	-----	-----	-----	WW+GO+TY (6:1:t)	SW+AP+UBT (2:2:1)	Chamisa(+) 1192
Lt. Roseberry 2464	-----	Sachet Pink 2464	Berries 'n Cream 752	OPL+PLUM+BU (3:1:t)	TW+DVR (2:1)	Apache Dawn 1191
Lt. Seafoam Green 2460	-----	-----	-----	TW+AQ+YL (7:1:1)	SW+BAG+YLH (4:1:t)	Hollyhock(+) 1186
Lt. Stoneware Blue 2463	-----	Tide Pool Blue(+) 2465	Porcelain Blue 765	TW+FB+BU (4:1:t)	FGB+TW (1:1)	Santa Fe Blues 1190
Lt. Tumbleweed 2467	-----	Western Sunset Yellow 2454	-----	WW+YO (4:1)	UBT+AP+YO (7:1:1)	Desert Tea(+) 1194
Lt. Village Green 2466	-----	Cactus Green 2463	-----	JADE+WW+BU (1:1:t)	SW+COG+BAL (4:1:1)	Pine Cone 1193
Lt. Yellow Green 2340	Hauser Lt. Green(+) 131	-----	Fresh Foliage(+) 954	YL+GRNOX (2:1)	YLH+COG (4:1)	-----
Marina Blue 2507	Desert Turquoise 44	Laguna(+) 2418	-----	WW+GO (5:1)	PLB+RT (1:1)	Breezy Turquoise(+) 1039
Medium Flesh 2331	Flesh Tone(+) 78	Medium Flesh(+) 2126	Skintone(+) 949	WW+GO (5:1)	AP+TW+BS (1:1:t)	Chamisa 1192
Mellow Yellow 2410	Lemon Yellow 11	Luscious Lemon 2004	Lemon Custard(+) 735	CYL+WW (1:t)	CYL+TW (4:1)	Juicy Lemon 1098

© 1994 Susan Adams Bentley

Color Conversion Chart

ACCENT®

Acrylic Paints

ACRYLICS

Accent® Acrylics "CJ" = Crown Jewels (See Notes 6, 7)	DecoArt™ Americana™ (See Notes 1-3, 6, 7)	Delta® Ceramcoat® (See Notes 1-3, 6, 7)	FolkArt® (Plaid) (See Notes 1-3, 6, 7)	Jo Sonja® (Chroma Acrylics) ("t" = Tad in recipes below) (See Notes 1-4)	Liquitex® Concentrated Artist Colors ("t" = Tad in recipes below) (See Notes 1-7)	Wally R.™ (See Notes 1-3, 6, 7)
Monet Blue 2321	-----	-----	-----	-----	LBV+COBH (1:1)	-----
Napthol Red Lt. 2603	Brilliant Red(+) 145	-----	Red Light 554	NRL+VER (3:1)	CRMH+SCR (1:1)	-----
Nevada Turquoise 2307	-----	Avalon Blue 2417	-----	PTHBL+PTHGR+NIM (1:1:1)	RT+FGB (2:1)	Pacifica(+) 1157
New Leaf 2511	-----	-----	-----	BG+YL+TW (1:1:1)	UBT+YLH+PGL (2:2:1)	-----
Off White 2428	Buttermilk(-) 3	-----	Tapioca 903	TW+SP (2:1)	PAR+UBT (3:1)	Antique Lace 1007
Painted Desert 2300	-----	Hydrangea Pink 2449	Sweetheart Pink(+) 955	TW+NRL (20:1)	SW+HIB (6:1)	Carnation(+) 1219
Paradise Blue 2508	-----	Salem Blue(+) 2121	-----	TW+PTHBL (20:1)	SW+PLB+SWBL (5:1:1)	Gentle Blue 1104
Payne's Gray 2609	-----	-----	-----	PG+FB (1:1)	PG+TWI (1:1)	-----
Peaches N' Cream 2420	Medium Flesh(+) 102	Island Coral(-) 2433	-----	WW+GO+YL (5:1:t)	AP+HIB+OL (4:1:t)	Peachee 1168
Pennsylvania Clay 2423	Georgia Clay(-) 17	Red Iron Oxide 2020	Rusty Nail(+) 914	NOR+RE (1:1)	HIB+RO (2:1)	Red Iron Oxide(+) 1014
Pine Needle Green 2445	Plantation Pine 113	Dark Forest Green 2096	Thicket 924	PINE+SAPH+RU (2:1:t)	IB+CYMH (1:1)	Bay Leaf 1073
Pink Blossom 2409	-----	Pink Frosting 2461	-----	TW+CS (20:1)	PPP+HIB (8:1)	Hopi Pink(-) 1184
Prairie Green 2310	Deep Teal(-) 116	-----	-----	JADE+TEAL+OPL (2:2:1)	COG+UMB+UBT (2:1:t)	-----
Princely Pewter CJ2531	-----	-----	Gunmetal Gray Met.(-) 667	N/A	Pearl+IB (See Note 5.)	-----
Pthalo Green 2610	Viridian Green 108	Pthalo Green 2501	Phthalo Green 563	Pthalo Green(+)	Phthalocyanine Green 317	Pthalo Green 1001
Pueblo Red 2302	Crimson Tide 21	Tomato Spice(+) 2098	Brick Red(-) 631	RE+NC+SP (3:1:t)	NC+RO (2:1)	Ripe Tomato(-) 1059
Pure Blue 2472	Blue Violet(+) 141	Ultra Blue 2038	Ultramarine Blue 560	-----	Ultramarine Blue(+) 380	Electric Blue 1115
Pure Red 2470	Berry Red 19	Bright Red 2503	Christmas Red 958	Napthol Red Light(+)	CRMH+COH (2:1)	Toluidine Red 1003
Pure Yellow 2471	Yellow Light(-) 144	Bright Yellow 2027	Sunny Yellow 918	Yellow Light(+)	CYMH+TW (2:1)	Hansa Yellow 1020
Purple Canyon 2304	-----	-----	-----	DP+OPL+BU (2:1:t)	WIS+UBT+TWI (4:1:t)	-----
Queen's Emerald CJ2525	Crystal Green Met.(-)76	-----	Emerald Green Met.(-) 653	N/A	Pearl+PTHGR (See Note 5.)	Pearl Aqua(-) 1523
Raw Sienna 2436	Lt. Cinnamon(-) 114 *	Dark Brown 2053	Coffee Bean 940	BE+RS (1:1)	RS+BU (2:1)	Dark Brown Sugar 1119
Raw Umber 2427	-----	-----	Raw Umber(-) 571	Raw Umber(*-)	RU+MB (3:1)	-----
Razzle Red 2579	Napthol Red 104	Napthol Crimson 2408	Christmas Red 958	Napthol Red Light	Acra Red(-) 112	Persian Red 1130
Real Black 2477	Ebony (Lamp) Black 67	Black 2506	Licorice 938	Carbon Black	Mars Black 276	Black 1006
Real White 2476	Snow (Titanium) White 1	White 2505	Wicker White 901	Titanium White	Titanium White 432	White 1005
Regency Silver CJ2530	Shimmering Silver Met. 70	Silver Gleams 2603	Silver Sterling Met. 662	Silver Metallic	Iridescent Silver(-) 236	Silver Metallic 1511
Rose Blush 2334	-----	-----	Pink(-) 413	ROSE+TW+NC (3:2:1)	HIB+SW (2:1)	-----
Roseberry 2450	Mauve(+) 26	Bouquet Pink 2132	Potpourri Rose 624	OPL+PLUM+BU (4:1:t)	Venetian Rose(+) 149	Zinfandel(+) 1151
Royal Blue 2565	-----	-----	-----	SAPH+DP (1:1)	UMB+SDL+DP (3:1:t)	-----
Royal Copper CJ2529	-----	-----	Copper Metallic 664	Super Copper Metallic	Iridescent Copper 233	Copper Metallic(+) 1512
Sapphire 2607	Sapphire 99	Denim Blue 2477	Blue Ribbon(-) 719	Sapphire(+)	TWI+BB (3:1)	-----

© 1994 Susan Adams Bentley

ACRYLICS

Acrylic Paints

Color Conversion Chart

Accent® Acrylics "CJ" = Crown Jewels (See Notes 6, 7)	DecoArt™ Americana™ (See Notes 1 - 3, 6, 7)	Delta® Ceramcoat® (See Notes 1 - 3, 6, 7)	FolkArt® (Plaid) (See Notes 1 - 3, 6, 7)	Jo Sonja® (Chroma Acrylics) ("t" = Tad in recipes below) (See Notes 1 - 4)	Liquitex® Concentrated Artist Colors ("t" = Tad in recipes below) (See Notes 1 - 7)	Wally R.™ (See Notes 1 - 3, 6, 7)
Seafoam Green 2506	Sea Aqua(-) 46	-----	-----	TW+AQ+YL (7:3:t)	SW+BAG+YL (2:1:t)	-----
Sedona Clay 2301	Burnt Orange (-) 16	Georgia Clay(*) 2097	Cinnamon(-) 913	RE+RS+OPL (2:1:t)	BS+COH (3:1)	Russet 1058
Soft Black 2447	Ebony Black 67	Black 2506	Licorice 938	Carbon Black	Ivory Black 244	Soft Black 1201
Soft Blue 2562	-----	-----	-----	TW+COBL+BU (2:1:t)	TW+BB+BU (3:1:t)	-----
Soft Gray 2400	-----	-----	-----	NIM+RU (1:t)	UBT+NG5+TWI (4:2:1)	-----
Soft White 2561	White Wash 2	White 2505	Wicker White 901	Titanium White	Titanium White 432	White 1005
Soldier Blue 2441	Uniform Blue(+) 86	-----	Heartland Blue(+) 608	FB+SAPH+BU (2:1:t)	PG+FGB (3:1)	Phantom Blue(+) 1078
Spring Pink 2504	-----	-----	-----	TW+ROSE (1:t)	PPP+LM (3:1)	-----
Stoneware Blue 2440	French Gray/Blue 98	Cape Cod Blue 2133	Settler's Blue 607	FB+TW (1:1)	French Gray/Blue 243	Dover Blue(-) 1079
Sunkiss Yellow 2432	Cadmium Yellow(+) 10	Bright Yellow(-) 2027	Yellow Medium(+) 552	Cadmium Yellow Mid(+)	Cad. Yellow Med. Hue(+) 830	Hansa Yellow 1020
Sunsational Yellow 2500	-----	Crocus Yellow 2459	-----	TW+YL+TY (3:2:1)	CYMH+UBT (2:1)	Sungold 1197
Sweet Chocolate 2408	Burnt Umber(-) 64	Brown Velvet 2109	Chocolate Fudge 950	BE+RU+OPL (3:2:1)	BU+RS (2:1)	Chestnut(-) 1067
Teal Deep 2611	Deep Teal(-) 116	Deep River Green 2419	-----	-----	COG+UMB (2:1)	Deep Sea(+) 1092
Telemark Green 2443	Deep Teal(-) 116	-----	Plantation Green(-) 604	TEAL+OPL (2:1)	RT+PHGH+NG5 (2:1:1)	Emeraude(-) 1199
Tiara Ruby CJ2526	-----	-----	-----	N/A	Pearl+CRMH (See Note 5.)	-----
Titanium White 2617	Snow White 1	White 2505	Titanium White 574	Titanium White	Titanium White 432	White 1005
True Green 2474	-----	Christmas Green(+) 2068	-----	Brilliant Green(+)	PGL+PHGH (4:1)	Holly Green 1043
True Orange 2473	-----	Pumpkin(-) 2042	Pure Orange 628	VER+CYL (1:1)	SCR+CYMH (1:1)	-----
True Purple 2475	-----	Purple(+) 2015	Purple 411	TM+DP+TW (1:1:t)	PV+DP (6:1)	-----
Tumbleweed 2305	Raw Sienna 93	Raw Sienna 2411	English Mustard(-) 959	Raw Sienna	RS+YO (2:1)	Raw Sienna 1156
Ultra. Blue Deep 2608	Ultra Blue Deep(+) 100	-----	Ultramarine(+) 720	Ultramarine	COBH+FGB (1:t)	-----
Ultramarine Blue 2412	True Blue(+) 36	Copen Blue 2051	-----	Sapphire(-)	SWBL+TWI (1:1)	Sapphire Blue 1034
Vermilion 2502	Cadmium Orange 14	Orange 2026*	Red Orange(+) 629	Vermilion	SCR+CYMH (5:1)	Fresh Tangerine(-) 1027
Victorian Mauve 2452	-----	Normandy Rose(-) 2432	-----	OPL+BS (5:1)	SW+VR+SDL (4:1:1)	Opal 1167
Village Green 2451	-----	Green Sea(+) 2445	Poetry Green(+) 619	-----	BG+PHGH (1:t)	-----
Warm Neutral 2616	Antique White 58	Sandstone(+) 2402	Vanilla Cream 703	TW+YO+BU (1:t:t)	UBT+PAR (2:1)	-----
White Wash 2454	White Wash 2	White 2505	Wicker White 901	Titanium White	Titanium White 432	White 1005
Wicker 2453	-----	-----	Country Twill(+) 602	PB+WW (2:1)	TP+PAR (1:1)	-----
Wild Heather 2314	-----	GP Purple(-) 2091	-----	TW+DP (5:1)	BP+TW (1:1)	Lavender(+) 1031
Wild Hyacinth 2505	-----	Lilac(+) 2060	-----	TW+AM+STRM (3:1:t)	SW+PV (5:1)	-----
Windsor Blue 2317	Midnite Blue 85	Manganese Blue(+) 2124	-----	PBH+PTHBL (1:1)	Navy 832	Manganese Blue(+) 1146
Wineberry 2426	-----	Dusty Purple(+) 2128	Plum Pudding(-) 934	UMB+NC (2:1)	WIS+RAS+BU (1:1:t)	Mulberry(+) 1149

ACCENT®

Color Conversion Chart

ACCENT®

Acrylic Paints

Accent® Acrylics "CJ" = Crown Jewels (See Notes 6, 7)	DecoArt™ Americana™ (See Notes 1 - 3, 6, 7)	Delta® Ceramcoat® (See Notes 1 - 3, 6, 7)	FolkArt® (Plaid) (See Notes 1 - 3, 6, 7)	Jo Sonja® (Chroma Acrylics) ("t" = Tad in recipes below) (See Notes 1 - 4)	Liquitex® Concentrated Artist Colors ("t" = Tad in recipes below) (See Notes 1 - 7)	Wally R.™ (See Notes 1 - 3, 6, 7)
Yellow Light 2600	Lemon Yellow 11	Luscious Lemon 2004	Yellow Light 551	Cadmium Yellow Light(+)	Cadmium Yellow Light 160	Juicy Lemon 1098
Yellow Ochre 2601	True Ochre 143	Antique Gold 2002	Yellow Ochre 572	YO+TW (2:1)	Yellow Oxide 416	Yellow Oxide 1008

© 1994 Susan Adams Bentley

NOTES

(1) A "+" indicates darker (or a "-" lighter) than first column color.
(2) An asterisk "*" indicates floats or washes don't match, though regular basecoats do.
(3) "N/A" indicates there is no comparable product in this brand.
(4) Refer to the Color Keys for these brands. Numbers shown in parentheses after the color name abbreviations equal "parts." For example, "RAS+SW+BU (2:1:t)" means to mix 2 parts of Raspberry with 1 part Soft White, and just a touch of Burnt Umber.
(5) "Pearl" = "Liquitex® Painter's Pearl Medium": Add small amount of paint to Medium. The more Medium added, the lighter and more pearlescent the color will become.
(6) Product numbers are for the 2-ounce size. DecoArt™ numbers will be preceded by a "DA" (for DecoArt™ Americana™) on the bottles.
(7) Accent® has two Burnt Siennas and two Burnt Umbers. Burnt Sienna #2614 and Burnt Umber #2613 are in their "Acrylic Blending Color" line. Burnt Sienna #2435 and Burnt Umber #2437 are in their "Country Color" line. Though the names are the same, the colors are different.

ACRYLICS

Color Conversion Chart

ACRYLICS

Acrylic Paints

DECOART™

DecoArt™ Americana™ (See Note 6)	Accent® Acrylics "CJ" = Crown Jewels (See Notes 1-3, 6)	Delta® Ceramcoat® (See Notes 1-3, 6)	FolkArt® (Plaid) (See Notes 1-3, 6)	Jo Sonja® (Chroma Acrylics) ("t" = Tad in recipes below) (See Notes 1-4)	Liquitex® Concentrated Artist Colors ("t" = Tad in recipes below) (See Notes 1-6)	Wally R.™ (See Notes 1-3, 6)
Antique Gold 9	Yellow Ochre(-) 2601	Antique Gold(-) 2002	Teddy Bear Tan(+) 419	YO+TW (2:1)	Yellow Oxide(-) 416	Oak(-) 1097
Antique Gold Deep 146	-----	-----	-----	-----	-----	-----
Antique Green 147	-----	Avocado(+) 2006	-----	PINE+YO+RU (2:1:1)	CYMH+IB (2:1)	-----
Antique White 58	Warm Neutral 2616	-----	Clay Bisque 601	SP+TW+MOSS (2:1:t)	UBT+PAR (2:1)	-----
Avocado 52	-----	Seminole Green 2009	Ripe Avocado 952	GRNOX+SAPH+BE (1:t:t)	PHGH+RS (1:1)	Terrestrial Green(+) 1011
Baby Blue 42	-----	-----	Light Blue(+) 402	TW+COBH+BE (7:2:1)	-----	Wedgewood Blue(-) 1044
Baby Pink 31	-----	Lisa Pink(+) 2084	Baby Pink(-) 633	TW+NC (10:1)	TW+NC (10:1)	-----
Base Flesh 136	-----	Indiana Rose(-) 2018	Portrait Medium(-) 422	WW+BS+NOR (11:2:1)	PPP+DPP (2:1)	-----
Berry Red 19	Pure Red 2470	Bright Red 2503	Christmas Red 958	Napthol Red Light	Cadmium Red Med Hue 151	Persian Red 1130
Black Forest Green 83	Deep Forest Green 2444	Deep River Green(-) 2419	Hunter Green(-) 406	PTHGR+CB (3:1)	Perm. Viridian Hue 398	Deep Sea(+) 1092
Black Pearl 127	-----	-----	Sequin Black Met.(+) 661	N/A	-----	-----
Blue Green 142	-----	-----	-----	PTHGR+PTHBL (1:1)	Real Teal 903	-----
Blue Haze 115	Chesapeake Blue 2438	-----	Township Blue(-) 606	COBL+CB (2:1)	Baltic Blue(-) 379	Astro Blue(-) 1025
Blue Violet 141	Pure Blue(-) 2472	Ultra Blue(-) 2038	Brilliant Blue(+) 641	COBH+DP (1:t)	Ultramarine Blue(-) 380	Electric Blue(-) 1115
Blue/Gray Mist 105	-----	-----	-----	-----	-----	-----
Blueberry 37	Soldier Blue(*-) 2441	-----	Blueberry Pie 963	COBH+RU+WW (2:1:t)	-----	-----
Bluegrass Green 47	-----	Emerald Green(+) 2482	-----	AQ+PTHGR (1:1)	BAG+PTHGR (4:1)	-----
Blush Flesh 110	-----	Persimmon(-) 2480	Poppy Red(-) 630	CS+OPL (4:1)	HIB+CRLH+UBT (3:1:t)	-----
Boysenberry Pink 29	-----	-----	-----	-----	-----	-----
Brandy Wine 79	Barn Red(+) 2424	Burgundy Rose 2123	Huckleberry(+) 745	IRO+RE+WW (4:1:t)	BUR+RO (2:1)	Aztec(-) 1145
Bright Green 54	-----	-----	Kelly Green 407	BG+TW (8:1)	PGL+UBT (1:1)	-----
Brilliant Red 145	Napthol Red Lt. 2603	Bright Red(*) 2503	-----	Napthol Red Lt.(+)	SCR+CRMH (4:1)	-----
Bronze Metallic 73	-----	Copper Gleams(-) 2607	Solid Bronze Metallic 663	-----	Iridescent Copper(+) 233	Copper Metallic(*-) 1512
Burgundy Wine 22	-----	Maroon(+) 2075	Burgundy(+) 957	NC+IRO (5:1)	HIB+BUR (3:1)	Raspberry(*) 1077
Burnt Orange 16	Sedona Clay(+) 2301	Georgia Clay 2097	Persimmon(-) 919	Norwegian Orange(-)	COH+RO (1:1)	Russet 1058
Burnt Sienna 63	Burnt Sienna(-) 2614	Candy Bar Brown(+) 2407	-----	IRO+RE (4:1)	BS+DVR (3:1)	-----
Burnt Umber 64	Sweet Chocolate(+) 2408	Brown Velvet(-) 2109	Coffeebean(-) 940	RU+RE+OPL (4:1:t)	TP+BU (1:1)	Brown Iron Oxide(-) 1016
Buttermilk 3	Off White(+) 2428	Lt. Ivory(-) 2401	Warm White 649	TW+SP (2:1)	SW+UBT (2:1)	Creamette(-) 1024
Cadmium Orange 14	Vermillion(+) 2602	Orange(*) 2026	Red Orange(*) 629	CS+VER (1:1)	SCR+CYMH (3:1)	Fresh Tangerine(*-) 1027
Cadmium Red 15	Napthol Red Lt.(*) 2603	Napthol Crimson(*+) 2408	Christmas Red 958	NRL+VER (4:1)	CRMH+COH (2:1)	-----
Cadmium Yellow 10	Sunkiss Yellow(-) 2432	Yellow(+) 2504	School Bus Yellow(+) 736	CYM+TY (3:1)	Cadmium Yellow Med 161	School Bus Yel.(+) 1004
Calico Red 20	Crimson 2604	Napthol Red Lt. (+) 2409	Calico Red(-) 932	-----	COH+NC (1:1)	Napthol Red Lt. 1086

Color Conversion Chart

DECOART™ Acrylic Paints

ACRYLICS

DecoArt™ Americana™ (See Note 6)	Accent® Acrylics "CJ" = Crown Jewels (See Notes 1-3, 6)	Delta® Ceramcoat® (See Notes 1-3, 6)	FolkArt® (Plaid) (See Notes 1-3, 6)	Jo Sonja® (Chroma Acrylics) ("t" = Tad in recipes below) (See Notes 1-4)	Liquitex® Concentrated Artist Colors ("t" = Tad in recipes below) (See Notes 1-6)	Wally R.™ (See Notes 1-3, 6)
Cashmere Beige 91	----	----	----	----	----	----
Charcoal Gray 88	----	----	Dark Gray(-) 426	----	RU+1B+NG5 (2:2:1)	----
Colonial Green 81	----	----	----	TW+TEAL+CB (12:2:1)	BAG+NG5+TW (2:2:1)	----
Cool Neutral (Toning) 89	----	Sandstone 2402	----	----	UBT+BG+BU (20:2:1)	Desert Sand(-) 1081
Coral Rose 103	Coral Blush(-) 2333	Fiesta Pink(*+) 2045	Salmon(+) 747	ROSE+TY+TW (2:1:1)	AP+CRMH (4:1)	Festive Pink(+) 1029
Country Blue 41	----	Periwinkle Blue(-) 2478	----	TW+COBH+DP (4:3:1)	LBV+COBH (1:1)	----
Country Red 18	----	Cardinal Red 2077	----	----	NC+HIB+BU (3:1:1)	Coronado Red 1048
Cranberry Wine 112	Bordeaux 2322	Mendocino Red(-) 2406	Raspberry Wine 935	BUR+TM (2:1)	BUR+RAS+BU (3:1:1)	Cranberry 1083
Crimson Tide 21	Pueblo Red(*) 2302	----	Brick Red(-) 631	NC+BUR (4:1)	DVR+RO+NC (3:1:1)	Bing Cherry(-) 1047
Crystal Green Met. 76	Queen Emerald(+) CJ2525	----	Emerald Green Met.(-) 653	N/A	Pearl+PTHGR (See Note 5.)	Pearl Aqua(+) 1523
Dark Chocolate 65	Burnt Umber(-) 2437	Burnt Umber 2025	Burnt Umber(-) 570	RU+BE (1:1)	Burnt Umber(+) 128	Burnt Umber(-) 1018
Dark Pine 49	----	----	Tartan Green(-) 725	----	----	----
Deep Burgundy 128	----	Maroon(+) 2075	Burgundy 957	NC+BE (1:t)	BUR+MM (2:1)	----
Deep Teal 116	Prairie Green(+) 2310	Woodland Night Gm(+)2100	Plantation Green(*-) 604	JADE+TEAL (1:1)	BAL+PHGH (2:1)	Forest Night(+) 1060
Desert Sand 77	Warm Neutral(-) 2616	Sandstone(-) 2402	Clay Bisque 601	Smoked Pearl(+)	UBT+NG5 (6:1)	----
Desert Turquoise 44	Marina Blue 2507	Colonial Blue(-) 2058	----	AQ+TW+UMB (3:2:2:)	RT+PLB (2:1)	Breezy Turquoise(-) 1039
Dioxazine Purple 101	Dioxazine Purple(+) 2606	Purple 2015	Purple 411	Dioxazine Purple(+)	Dioxazine Purple(+) 186	Purple 1106
Dove Gray 69	----	----	Light Gray 424	----	----	----
Dusty Rose 25	----	Normandy Rose(-) 2432	----	WW+BS+NOR (9:2:t)	DPP+TW (2:1)	Opal(-) 1167
Ebony (Lamp) Black 67	Ebony Black 2612	Black 2506	Licorice 938	Carbon Black	Mars Black 276	Black 1006
Electric Blue DHS6	N/A	N/A	N/A	N/A	Fluorescent Blue 984	Fluor. Blue(+) 1504
Emperor's Gold 148	Imp. Ant. Gold(+) CJ2528	----	----	----	----	----
Evergreen 82	Pine Needle Green(*+) 2445	----	Thicket(-) 924	PINE+SAPH (2:1)	Perm. Hooker's Green Hue(+) 224	Everglade 1093
Fiery Red DHS4	N/A	N/A	N/A	N/A	Fluorescent Red 983	Fluor. Flame(+) 1508
Flesh (Hi-Lite) 24	----	----	Portrait Light(-) 421	TW+CS+BE (1:t:t)	TW+LPP+UBT (4:1:1)	----
Flesh Tone 78	Medium Flesh(-) 2331	----	Skintone(+) 949	WW+GO (1:t)	AP+DPP (2:1)	----
Forest Green 50	----	----	----	TEAL+MOSS (1:1)	Perm. Hookers Green Hue(+) 224	----
French Gray/Blue 98	Stoneware Blue 2440	Cape Cod Blue 2133	Settler's Blue(+) 607	FB+TW (1:1)	French Gray/Blue 243	Dover Blue(-) 1079
Georgia Clay 17	Pennsylvania Clay(+) 2423	----	Red Clay(-) 931	Norwegian Orange	HIB+RO (2:1)	----
Glorious Gold Met. 71	----	Kim Gold Gleams 2602	Pure Gold Met. 660	Rich Gold Metallic(+)	----	Gold Metallic(+) 1510
Gooseberry Pink 27	----	Gypsy Rose(+) 2129	Cherokee Rose(-) 956	OPL+ROSE+BE (4:1:t)	UBT+DVR+RO (5:2:1)	Rose Dawn(-) 1150

Color Conversion Chart

DECOART™

ACRYLICS

Acrylic Paints

DecoArt™ Americana™ (See Note 6)	Accent® Acrylics "CJ" = Crown Jewels (See Notes 1-3, 6)	Delta® Ceramcoat® (See Notes 1-3, 6)	FolkArt® (Plaid) (See Notes 1-3, 6)	Jo Sonja® (Chroma Acrylics) ("t" = Tad in recipes below) (See Notes 1-4)	Liquitex® Concentrated Artist Colors ("t" = Tad in recipes below) (See Notes 1-6)	Wally R.™ (See Notes 1-3, 6)
Green Pearl 122	-----	-----	Mint Pearl Met.(-) 672	N/A	-----	-----
Gray Sky 111	April Showers(+) 2510	Drizzle Gray(+) 2452	Dove Gray 708	TW+NIM+UBD (3:1:t)	SW+NG5+FGB (4:1:t)	-----
Hauser Dark Green 133	Teal Deep(+) 2611	Deep River Green 2419	-----	TEAL+RU+OPL (3:2:t)	-----	-----
Hauser Lt. Green 131	Lt. Yellow Green(-) 2340	-----	-----	YL+GRNOX+BE (2:1:T)	YLH+COG (4:1)	-----
Hauser Med. Green 132	-----	-----	Old Ivy(+) 927	GRNOX+PINE+WW (2:1:t)	Chromium Oxide Green(+) 166	-----
Holly Green 48	Holiday Green(+) 2577	Christmas Green(+) 2068	Green 408	BG+PTHGR (3:1)	CG+RT (1:t)	Holly Green(+) 1043
Ice Blue 135	-----	Blue Wisp(+) 2455	Teal Blue(+) 717	-----	-----	-----
Ice Blue Metallic 75	Empress Blue(-) CJ2524	-----	Blue Sapphire Met. 656	N/A	Pearl+PTHBL (See Note 5.)	-----
Indian Turquoise 87	-----	-----	-----	AQ+UMB+TW (1:1:1)	PLB+SW (1:1)	Cool Blue(-) 1074
Jade Green 57	-----	Stonewedge Green(-) 2442	Basil Green(-) 645	-----	OL+BG+PAR (3:1:1)	Sage 1177
Kelly Green 55	-----	-----	Green 408	BG+PTHGR (3:1)	Christmas Green(-) 902	-----
Lavender 34	-----	-----	Lavender(+) 410	TW+DP (3:1)	BP+DP (1:t)	-----
Leaf Green 51	-----	Green Isle(+) 2008	Shamrock 926	BG+TEAL (3:1)	PHGH+BG (2:1)	Erin Green 1009
Lemon Yellow 11	Yellow Lt. 2600	Luscious Lemon 2004	Yellow Lt. 551	Cadmium Yellow Lt.	Yellow Light Hansa 411	Juicy Lemon 1098
Lilac 32	-----	-----	-----	-----	PV+TW (2:t)	-----
Lt. Avocado 106	-----	Vibrant Green(-) 2007	-----	GRNOX+YO (5:1)	OL+PAR (1:t)	Garland(-) 1101
Lt. Cinnamon 114	Raw Sienna(*+) 2436	Spice Brown(-) 2049	Nutmeg(*) 944	RS+BE (2:1)	RS+BU (2:1)	Warm Brown(-) 1032
Mauve 26	Roseberry(-) 2450	Bouquet Pink 2132	Potpourri Rose(-) 624	OPL+PLUM+BU (2:1:t)	Venetian Rose 149	Zinfandel(-) 1151
Medium Flesh 102	Peaches n' Cream(-) 2420	Medium Flesh(+) 2126	Skintone(-) 949	WW+GO+TY (4:1:t)	AP+DPP (2:1)	HB Medium Flesh(+) 1076
Midnite Blue 85	Windsor Blue 2317	Manganese Blue 2124	Thunder Blue 609	PBH+PTHBL (1:1)	Navy 832	Manganese Blue(+)1146
Midnite Green 84	-----	Black Green(+) 2116	Wrought Iron 925	TEAL+CB (3:1)	PHGH+MB (1:1)	Kohl Green(*) 1071
Mink Tan 92	-----	Bambi Brown(+) 2424	-----	Fawn(+)	TP+SW (4:1)	Doeskin(+) 1095
Mint Julep Green 45	-----	-----	-----	WW+BG+BE (12:1:t)	-----	-----
Mississippi Mud 94	-----	-----	-----	FAWN+BU (1:1)	TP+IB (3:1)	-----
Mistletoe 53	-----	Kelly Green 2052	Evergreen 724	BG+NIM (5:1)	-----	Chrome Green Lt.(+) 1102
Mocha 60	-----	Dunes Beige(-) 2466	Skintone 949	WW+GO (4:1)	AP+SDL+TW (1:1:1)	Toast(-) 1208
Moon Yellow 7	Devonshire Cream 2312	-----	Moon Yellow 409	TW+TY+BU (3:1:t)	TW+AP+BY (2:1:1)	Margarine 1062
Napthol Red 104	Napthol Red Lt.(-) 2603	Napthol Crimson(+) 2408	Christmas Red 958	Napthol Red Light	Napthol Red Light 294	Fire Truck Red(+) 1050
Navy Blue 35	Windsor Blue(-) 2317	Prussian Blue 2413	Navy Blue(+) 403	PBH+PTHBL (1:1)	Navy(-) 832	-----
Neutral Gray (Tone) 95	-----	-----	Medium Gray(+) 425	-----	NG5+BU (8:1)	-----
Olive Green 56	-----	-----	-----	WW+GRNOX+YL (5:2:2)	OL+YLH+TW (2:2:1)	-----
Orchid 33	-----	-----	Orchid(-) 637	AM+TW (1:1)	PLV+MM (2:1)	-----

Color Conversion Chart

DECOART **Acrylic Paints**

DecoArt Americana™ (See Note 6)	Accent Acrylics "CJ" = Crown Jewels (See Notes 1-3, 6)	Delta Ceramcoat® (See Notes 1-3, 6)	FolkArt (Plaid) (See Notes 1-3, 6)	Jo Sonja® (Chroma Acrylics) ("t" = Tad in recipes below) (See Notes 1-4)	Liquitex® Concentrated Artist Colors ("t" = Tad in recipes below) (See Notes 1-6)	Wally R.™ (See Notes 1-3, 6)
Orchid Pearl 123	----	----	----	N/A	Pearl+PLV (See Note 5.)	----
Oxblood 139	Pennsylvania Clay(-)2423	----	----	NOR+RE (1:1)	HIB+RO (2:1)	----
Peaches 'n Cream 23	----	----	----	----	AP+TW+SCR (2:2:1)	----
Pineapple 6	Lt. Cactus Flower 2462	Pale Yellow 2005	Lemonade(+) 904	TY+CYL (10:1)	TW+CYMH (2:1)	Maize 1189
Pink Satin Pearl 118	----	----	----	N/A	----	----
Plantation Pine 113	Pine Needle Green 2445	Gamel Green(+) 2120	Southern Pine 730	PINE+SAPH+RU (2:1:t)	IB+CYMH (2:1)	Bay Leaf 1073
Plum Pearl 120	----	Violet Pearl Glms 2623	Plum Metallic 668	N/A	----	----
Prussian Blue 138	----	Prussian Blue 2413	Prussian Blue 559	PBH+PTHBL (1:1)	Prussian Blue(-) 318	Prussian Blue(+) 1088
Pumpkin 13	----	Pumpkin(*+) 2042	----	YL+VER (3:1)	Cadmium Orange Hue(-) 720	----
Purple Pearl 124	Faberge Purple CJ2523	----	Amethyst Metallic 654	N/A	Pearl+DP (See Note 5.)	Pearl Violet 1527
Raspberry 28	----	----	----	----	DVR+SCR+TW (1:1:1)	Winter Wine(+) 1082
Raw Sienna 93	Tumbleweed 2305	Raw Sienna 2411	Buckskin Brown 418	RS+RE (5:1)	RS+YO (2:1)	Raw Sienna(-) 1156
Raw Umber 130	----	----	----	BU+RS (5:1)	Raw Umber(+) 331	Raw Umber(+) 1017
Red Iron Oxide 96	Sedona Clay(-) 2301	Burnt Sienna(+) 2030	Rusty Nail(+) 914	NOR+RE (1:1)	Red Oxide 335	Brick 1144
Red Violet 140	----	----	Fuchsia(-) 635	----	----	----
Rookwood Red 97	Fingerberry Red(+) 2425	Candy Bar Brown(+) 2407	----	BUR+PINE+TW (3:1:t)	BUR+RU (1:1)	Burgundy 1181
Rose Pearl 119	Duchess Rose(+) CJ2522	----	Rose Shimmer Met. 652	N/C	Pearl+NC (See Note 5)	----
Royal Ruby Met. 74	Coronation Russet(-) 2521	Red Copper Glms(*) 2605	----	N/A	----	----
Russett 80	Fingerberry Red 2425	Candy Bar Brown 2407	Dark Brown 416	IRO+BU (3:1)	BU+BUR (1:1)	Cinnabar 1084
Sable Brown 61	----	Toffee Brown(-) 2086	----	----	TP+UBT (2:1)	Hazelnut(-) 1132
Salem Blue 43	----	Salem Blue(-) 2121	----	TW+COBL (3:1)	SW+PLB+SWBL (5:1:1)	----
Sand 4	Antique White(+) 2429	Antique White(-) 2001	Taffy(-) 902	WW+YO (1:t)	TW+YO (10:1)	Flesh(+) 1113
Sapphire 99	Sapphire 2607	Denim Blue(-) 2477	Blue Ribbon(-) 719	UMB+SAPH+WW (2:1:t)	TWI+BB (3:1)	Sapphire Blue(+) 1034
Scorching Yellow DHS1	N/A	N/A	N/A	N/A	Fluorescent Yellow 981	Fluor. Chartreuse 1506
Sea Aqua 46	Seafoam Green(+) 2506	----	----	TW+AQ+YL (12:4:1)	TW+PLB+CG (1:1:1)	----
Shading Flesh 137	Dark Flesh(-) 2332	----	----	OPL+RE (4:1)	RO+SW+YO (2:1:t)	Lt. Rose(+) 1202
Shimmering Silver Met. 70	Regency Silver CJ 2530	Silver Met. Gleams 2603	Silver Sterling Metallic 662	Silver Metallic	Iridescent Silver(-) 236	Silver Metallic(+) 1511
Sizzling Pink DHS3	N/A	N/A	N/A	N/A	Fluorescent Pink 987	----
Sky Blue Pearl 121	----	----	----	N/A	----	----
Slate Gray 68	----	Bridgeport Gray(+) 2440	----	NIM+PG (4:1)	PAR+FGB+NG5 (2:1:1)	Pilgrim Gray(+) 1175
Snow (Titanium) White 1	Real White 2476	White 2505	Wicker White 901	Titanium White	Titanium White 432	White 1005
Spice Pink 30	----	----	----	TW+ROSE+TM (3:1:t)	SW+HIB+SCR (2:1:1)	----

© 1994 Susan Adams Bentley

ACRYLICS

Color Conversion Chart

DECOART™

Acrylic Paints

DecoArt™ Americana™ (See Note 6)	Accent® Acrylics "CJ" = Crown Jewels (See Notes 1-3, 6)	Delta® Ceramcoat® (See Notes 1-3, 6)	FolkArt® (Plaid) (See Notes 1-3, 6)	Jo Sonja® (Chroma Acrylics) ("t" = Tad in recipes below) (See Notes 1-4)	Liquitex® Concentrated Artist Colors ("t" = Tad in recipes below) (See Notes 1-6)	Wally R.™ (See Notes 1-3, 6)
Taffy Cream 5	-----	-----	Lemonade 904	TW+TY (20:1)	TW+TY (4:1)	Lemon Meringue 1221
Tangerine 12	-----	-----	Tangerine 627	YL+VER (4:1)	Cadmium Orange Hue(+) 720	-----
Taupe 109	-----	Taupe(-) 2470	-----	OPL+IRO (12:1)	-----	Lilac Gray 1212
Teal Green 107	-----	-----	Seafoam(+) 734	-----	RT+BG (1:1)	-----
Teal Pearl 126	-----	-----	-----	N/A	-----	-----
Terra Cotta 62	-----	Mocha Brown(-)2050	Buckskin Brown 418	GO+RS (1:1)	RS+SCR+UBT (3:1:1)	Jamocha(-) 1033
Thermal Green DHS5	N/A	N/A	N/A	N/A	N/A	-----
Toffee 59	-----	AC Flesh 2085	Almond Parfait(+) 705	OPL+GO+TY (9:1:t)	UBT+SDL (1:t)	Warm Beige(+) 1131
Torrid Orange DHS2	N/A	N/A	N/A	N/A	-----	-----
True Blue 36	Ultra. Blue(-) 2412	Copen Blue(-) 2051	True Blue 401	UMB+SAPH (2:1)	SWBL+TWI (1:1)	-----
True Ochre 143	Yellow Ochre 2601	Antique Gold(+) 2002	Yellow Ochre 572	Turner's Yellow(-)	Yellow Oxide 416	Yellow Oxide 1008
True Red 120	Crimson(+) 2604	Napthol Red Lt. 2409	Calico Red(+) 932	NC+NRL (2:1)	Cadmium Red Medium Hue(+) 151	Napthol Crimson 1085
Turquoise Pearl 125	-----	-----	-----	N/A	-----	-----
Ultra Blue Deep 100	Ultra. Blue Deep(-) 2608	Phthalo Blue(+) 2502	Ultramarine 720	Cobalt Blue Hue(-)	Cobalt Blue Hue 381	Pthalo Blue 1002
Uniform Blue 86	Soldier Blue(-) 2441	Nightfall Blue(+) 2131	Heartland Blue 608	SAPH+PBH+BE (1:1:t)	UMB+NG5 (1:1)	Phantom Blue(-) 1078
Venetian Gold Met. 72	Imp. Antique Gold(-)CJ2528	-----	-----	Rich Gold Metallic(+)	-----	Gold Metallic(-) 1510
Victorian Blue 39	-----	-----	-----	SAPH+OPL+BE (6:1:t)	NVY+FGB (2:1)	-----
Viridian Green 108	Pthalo Green 2610	Phthalo Green(-) 2501	Pthalo Green(-) 563	Pthalo Green(+)	Phthalocyanine Green(-) 317	Pthalo Green 1001
Warm Neutral (tone) 90	Cool Neutral 2615	Wild Rice(-) 2453	Milkshake 704	Opal(-)	SDL+TW (1:1)	Burnt Almond(-) 1214
Wedgewood Blue 38	-----	-----	Blueberry Pie 963	SAPH+PBH (1:1)	SAPH+PBH (1:1)	-----
White Pearl 117	Baroque Pearl CJ2532	Pearl Finish Gleams 2601	Pearl White Met. 659	Pearl White Metallic	Iridescent White 238	Iridescent White 238
White Wash 2	White Wash 2454	White 2505	Wicker White 901	Titanium White	Titanium White 432	White 1005
Williamsburg Blue 40	-----	-----	Prairie Blue(-) 766	SAPH+CS+TW (5:1:1)	NG5+UMB+TW (3:2:1)	Dover Blue(+) 1079
Yellow Green 134	-----	Lima Green(-) 2072	-----	WW+YL+GRNOX (5:2:1)	-----	-----
Yellow Light 144	Yellow Light 2600	Bright Yellow 2027	Yellow Light(+) 551	Yellow Light	Cadmium Yellow Lt. 160	Hansa Yellow 1020
Yellow Ochre 8	-----	-----	Buttercrunch(-) 737	WW+TY+RU (2:1:t)	YO+PAR (1:1)	Chamois(-) 1040

See Notes on next page

ACRYLICS

Color Conversion Chart

DECOART™

NOTES

(1) A "+" indicates darker (or a "-" lighter) than first column color.
(2) An asterisk "*" indicates floats or washes don't match, though regular basecoats do.
(3) "N/A" indicates there is no comparable product in this brand.
(4) Refer to the Color Keys for these brands. Numbers shown in parentheses after the color name abbreviations equal "parts." For example, "RAS+SW+BU (2:1:t)" means to mix 2 parts of Raspberry with 1 part Soft White, and just a touch of Burnt Umber.
(5) "Pearl" = "Liquitex® Painter's Pearl Medium": Add small amount of paint to Medium. The more Medium added, the lighter and more pearlescent the color will become.
(6) Product numbers are for the 2-ounce size. DecoArt™ numbers will be preceded by a "DA" (for DecoArt™ Americana™) on the bottles, unless a "DHS" (for Hot Shots) is shown.

Color Conversion Chart

ACRYLICS

DELTA®

Acrylic Paints

Delta® Ceramcoat® (See Notes 6-8)	Accent® Acrylics "CJ" = Crown Jewels (See Notes 1-3, 6)	DecoArt™ Americana™ (See Notes 1-3, 6)	FolkArt® (Plaid) (See Notes 1-3, 6)	Jo Sonja® (Chroma Acrylics) ("t" = Tad in recipes below) (See Notes 1-4)	Liquitex® Concentrated Artist Colors ("t" = Tad in recipes below) (See Notes 1-6)	Wally R.™ (See Notes 1-3, 6)
AC Flesh 2085	-----	Toffee 59	-----	TW+RS+RU (6:2:1)	Unbleached Titanium(-) 434	Warm Beige(+) 1131
Adobe Red 2046	-----	-----	-----	RE+NC+OPL (2:1:1)	HIB+RO (2:1)	Chimney 1030
Adriatic Blue 2438	-----	-----	-----	FB+TW+CB (2:1:t)	FGB+IB (1:1)	Caspian (-) 1173
Alpine Green 2439	-----	-----	-----	JADE+TEAL+WW (1:1:t)	NG5+CG (2:1)	Solvang 1174
Antique Gold 2002	Yellow Ochre 2601	Antique Gold(+) 9	Harvest Gold(-) 917	YO+TW (2:1)	TY+YO (2:1)	Yellow Oxide 1008
Antique Rose 2469	-----	-----	Rose Chiffon(-) 753	-----	DPP+ALIZ (4:1)	Madder Rose 1211
Antique White 2001	Adobe Wash 2311	Sand(+) 4	Taffy 902	WW+TY (1:t)	SW+YO (6:1)	Cotton Candy(-) 1108
Apple Green 2065	-----	-----	-----	WW+CYM+GRNOX (5:1:1)	CYMH+TW+PGL (5:2:1)	Pippin Green 1041
Aqua Cool Pearl Gleams 2614	-----	-----	Aquamarine Met. 655	N/A	Pearl+BAG (See Note 5.)	Pearl Aqua 1523
Autumn Brown 2055	-----	Lt. Cinnamon(+) 114	Teddy Bear Brown(-) 417	RS+IRO (2:1)	TP+BU (2:1)	Nutmeg 1037
Avalon Blue 2417	Nevada Turquoise 2307	-----	Bavarian Blue(+) 907	COBL+BU (1:t)	RT+FGB(2:1)	Pacifica 1157
Avocado 2006	-----	Antique Green(-) 147	-----	PINE+YO+RU (2:1:1)	CYMH+IB (2:1)	Green Olive 1100
Azure Blue 2483	-----	-----	Azure Blue(+) 643	COBL+PTHBL+TW (1:1:1)	Brilliant Blue(-) 570	-----
Bambi Brown 2424	-----	Mink Tan(-) 92	-----	Fawn	SW+TP (1:1)	Doeskin 1095
Berry Red 2056	Crimson 2604	-----	Cardinal Red 414	TM+CS (3:1)	NC+RAS (3:1)	Pthalo Crimson 1147
Bittersweet Orange 2041	-----	-----	-----	YL+VER (3:1)	COH+RO (1:t)	Duck Bill (*) 1117
Black 2506	Real Black 2477	Ebony (Lamp) Black 67	Licorice 938	Carbon Black	Mars Black 276	Black 1006
Black Cherry 2484 (Note 8.)	Burgundy Deep 2238	Deep Burgundy(-) 128	Alizarin Crimson(+)556	BUR+UBD (1:t)	BUR+MM (2:1)	Cranberry 1083
Black Green 2116	-----	Midnite Green(-) 84	Wrought Iron 925	TEAL+CB (3:1)	PG+YLH (2:1)	Kohl Green 1071
Blue Danube 2013	-----	-----	Lt. Blue(+) 402	TW+COBH+NIM (8:2:1)	TW+SWBL (3:1)	Gentle Blue 1104
Blue Haze 2122	-----	-----	-----	-----	BAL+SW (1:1)	Gray Dawn 1075
Blue Heaven 2037	-----	-----	-----	TW+COBH (3:1)	-----	Heavenly Blue 1114
Blue Jay 2059	-----	-----	-----	UMB+WW (2:1)	-----	Blue Birds 1121
Blue Mist 2400	-----	-----	Icy White(-) 701	TW+FB (1:t)	TW+BAL+FGB (2:1:1)	Misty Blue 1152
Blue Spruce 2115	-----	-----	-----	TEAL+OPL+BE (3:1:t)	RT+IB (1:1)	Eucalyptus(-) 1070
Blue Wisp 2455	-----	Ice Blue(-) 135	Teal Blue(-) 717	OPL+JADE+SAPH (5:2:1)	-----	Pamadour Green(+) 1216
Bobby Blue Prl. Glms 2609	-----	-----	Blue Pearl Metallic 670	N/A	N/A	Pearl Blue 1521
Bonnie Blue 2106	-----	-----	Prairie Blue(+) 766	TW+FB+BU (3:2:t)	FGB+PLB (1:1)	Aegean Blue 1064
Boston Fern 2110	-----	Antique Green(-) 147	-----	PINE+YO+RU (2:1:1)	PGL+RS (1:1)	Artichoke 1140
Bouquet Pink 2132	Roseberry 2450	Mauve(+) 26	Potpourri Rose(-) 624	OPL+PLUM+BU (2:1:t)	Venetian Rose 149	Zinfandel(-) 1151
Bridgeport Gray 2440	-----	Slate Gray(-) 68	-----	NIM+PG (3:1)	PAR+FGB+NG5 (2:1:1)	Pilgrim Gray 1175
Bright Red 2503	Pure Red 2470	Berry Red 19	Christmas Red(-) 958	Napthol Red Lt. (-)	CRMH+COH (2:1)	Toluidine Red 1003

© 1994 Susan Adams Bentley

Color Conversion Chart

DELTA Acrylic Paints **Wally R.™** ACRYLICS

Delta® Ceramcoat® (See Notes 6-8)	Accent® Acrylics "CJ" = Crown Jewels (See Notes 1-3, 6)	DecoArt™ Americana™ (See Notes 1-3, 6)	FolkArt® (Plaid) (See Notes 1-3, 6)	Jo Sonja® (Chroma Acrylics) ("t" = Tad in recipes below) (See Notes 1-4)	Liquitex® Concentrated Artist Colors ("t" = Tad in recipes below) (See Notes 1-6)	Wally R.™ (See Notes 1-3, 6)
Bright Yellow 2027	Pure Yellow 2471	Yellow Lt. 144	Sunny Yellow 918	Yellow Lt.(+)	Yellow Medium Azo(-) 412	Hansa Yellow 1020
Bronze Gleams 2606	-----	Bronze Metallic(+) 73	Solid Bronze Met.(+) 663	-----	-----	-----
Brown Iron Oxide 2023	-----	Burnt Umber 64	Maple Syrup(-) 945	BE+RS (2:1)	BU+BS+RS (3:2:1)	Brown Iron Oxide 1016
Brown Velvet 2109	Sweet Chocolate 2408	Burnt Umber(+) 64	Huckleberry 745	BE+RU (1:1)	TP+BU (1:1)	Chestnut 1067
Burgundy Rose 2123	Barn Red 2424	Brandy Wine 79	-----	IRO+RE+NC (4:1:t)	BUR+RO (2:1)	Aztec(-) 1145
Burnt Sienna 2030	Burnt Sienna(+) 2614	Red Iron Oxide(-) 96	Burnt Sienna 568	RE+BU (1:t)	Burnt Siena(+) 127	Burnt Sienna 1022
Burnt Umber 2025	Burnt Umber(+) 2437	Dark Chocolate 65	Burnt Umber 570	RU+BE (1:1)	Burnt Umber 128	Burnt Umber 1018
Butter Yellow 2102	Golden Harvest(+) 2433	-----	Buttercup(-) 905	TY+SP+BE (2:1:t)	TY + SW (2:1)	Caribou(-) 1049
Cactus Green 2463	Lt. Village Green 2466	-----	-----	JADE+WW+BU (1:1:t)	SW+COG+BAL (4:1:1)	Cypress Green(+) 1188
Cadet Gray 2426	-----	-----	-----	NIM+TW (4:1)	TW+UBT+NG5 (1:1:1)	Rebel Gray 1096
Candy Bar Brown 2407	Fingerberry Red 2425	Rookwood Red(-) 97	Dark Brown(*) 416	IRO+BU (1:t)	BUR+BU (1:1)	Cinnabar 1084
Cape Cod Blue 2133	Stoneware Blue 2440	French Gray/Blue 98	Settler's Blue 607	FB+TW (1:1)	French Gray Blue 243	Dover Blue 1079
Cardinal Red 2077	Jo Sonja® Red(-) 2449	Country Red 18	-----	NC+NRL (3:1)	Perm. Alizarin Crimson Hue 116	Coronado Red 1048
Caucasian Flesh 2029	-----	-----	-----	GO+WW+NC (1:1:t)	-----	Spiced Peach 1021
Cayenne 2428	-----	Portrait Dark 423	Portrait Dark 423	-----	RO+SDL(2:1)	Red Pepper 1163
Charcoal 2436	-----	-----	-----	CB+SP (3:1)	IB+SW (3:1)	Soft Kohl 1171
Christmas Green 2068	True Green(-) 2068	Holly Green(-) 48	Shamrock(+) 926	BG+TEAL (3:1)	PGL+PHGH (2:1)	Holly Green 1043
Chrome Green Lt. 2011	-----	-----	-----	Green Oxide	Chrom. Oxide Green(+) 166	Chrome Green Lt.(-) 1102
Cloudberry Tan 2112	-----	-----	-----	-----	BY+SW (1:1)	Apache 1141
Colonial Blue 2058	-----	Desert Turquoise(+) 44	-----	AQ+TW+UMB (2:1:1)	PLB+RT (1:1)	Breezy Turquoise 1039
Copen Blue 2051	Ultramarine Blue 2412	True Blue(+) 36	Blue Ribbon(-) 719	UMB+SAPH (2:1)	SWBL+TWI (1:1)	Sapphire Blue 1034
Copper Pearl Gleams 2607	-----	Bronze Met. (-) 73	-----	-----	-----	Copper Metallic(+) 1512
Coral 2044	-----	-----	Salmon(-) 747	ROSE+TY+TW (2:1:1)	SCR+SDL (2:1)	Cashmere Rose 1028
Crimson 2076	Razzle Red 2579	Berry Red 19	Christmas Red 958	Napthol Red Lt.	COH+NC (1:1)	Toluidine Red 1003
Crocus Yellow 2459	Sunsational Yellow 2500	Cad. Yellow(+) 10	-----	TW+YL+TY (3:2:1)	CYMH+UBT (2:1)	Sungold 1197
Custard 2448	-----	Taffy Cream 5	Lemonade(+) 904	-----	TW+TY (4:1)	Lemon Meringue(+) 1221
Dark Brown 2053	Raw Sienna 2436	Lt. Cinnamon(-) 114	Maple Syrup 945	BE+RS (2:1)	BU+BS+RS (3:2:1)	Dark Brown Sugar 1119
Dark Chocolate 2021	-----	Charcoal Gray(+) 88	Raw Umber(-) 571	BU+IB (1:1)	BU+IB (1:1)	Espresso 1109
Dark Flesh 2127	-----	-----	-----	OPL+TY+RE+RU (2:1:1:t)	BS+SDL (2:1)	Pottery(-) 1148
Dark Forest Green 2096	Pine Needle Green 2445	Plantation Pine(*-) 113	Thicket(-) 924	PINE+SAPH+RU (2:1:t)	IB+PHGH+NG5 (3:1:1)	Ivy 1057
Dark Jungle Green 2420	-----	-----	Green Meadow(-) 726	PINE+GRNOX (4:1)	PHGH+RS (1:1)	Everglade(*) 1093
Dark Night Blue 2414	Liberty Blue(-) 2439	-----	Indigo(-) 908	PG+CB (4:1)	UMB+IB+NG5 (4:4:1)	Velvet Night 1089

© 1994 Susan Adams Bentley

Color Conversion Chart — DELTA® — Acrylic Paints

Delta® Ceramcoat® (See Notes 6-8)	Accent® Acrylics "CJ" = Crown Jewels (See Notes 1-3, 6)	DecoArt™ Americana™ (See Notes 1-3, 6)	FolkArt® (Plaid) (See Notes 1-3, 6)	Jo Sonja® (Chroma Acrylics) ("t" = Tad in recipes below) (See Notes 1-4)	Liquitex® Concentrated Artist Colors ("t" = Tad in recipes below) (See Notes 1-6)	Wally R.™ (See Notes 1-3, 6)
Darkest Red - See Note 8.						
Deep Coral 2479	Apache Red 2303	-----	-----	ROSE+NC+TW (3:1:1)	CRM+MM+UNBL (1:1:1)	-----
Deep River Green 2419	Teal Deep 2611	Hauser Dark Green 133	Wintergreen(+) 962	TEAL+OPL (5:1)	RT+BU+NG5 (2:2:1)	Deep Sea 1092
Denim Blue 2477	Sapphire 2607	Sapphire(+) 99	Paisley Blue(+) 967	-----	TWI+BB (3:1)	-----
Desert Sun Orange 2444	Dark Flesh(-) 2332	-----	-----	OPL+RE (4:1)	AP+RO (1:1)	Santa Fe(-) 1179
Dolphin Gray 2457	-----	-----	Amish Blue(+) 715	OPL+FB (4:1)	LBV+NG5 (1:1)	Oxford Gray(-) 1195
Dresden Flesh 2033	-----	-----	-----	OPL+RS (5:1)	-----	Ivory Cream 1112
Drizzle Gray 2452	April Showers 2510	Gray Sky(-) 111	Dove Gray(-) 708	TW+NIM+STRM (1:1:t)	SW+NG5+FGB (4:1:t)	Pelican(-) 1223
Dunes Beige 2466	-----	Mocha(+) 60	Almond Parfait(+) 705	OPL+GO+TW (5:1:1)	AP+SDL+TW (1:1:t)	Toast 2466
Dusty Mauve 2405	-----	-----	Raspberry Sherbert(-) 966	Plum Pink	DVR+UBT (3:1)	Winter Wine(+) 1082
Dusty Plum 2456	-----	-----	-----	-----	NG5+MM+UBT (2:1:1)	-----
Dusty Purple 2128	Wineberry(-) 2426	-----	-----	NC+SAPH (1:1)	DVR+TWI (1:1)	Mulberry(-) 1149
Emerald Green 2482	-----	Bluegrass Green(-) 47	Teal(+) 405	AQ+PTHGR (2:1)	BG+PTHGR (4:1)	-----
Empire Gold 2412	Dijon Gold 2318	-----	-----	Turner's Yellow	Turner's Yellow 730	Spun Gold(-) 1087
English Yew Green 2095	-----	Plantation Pine(+) 113	Southern Pine(*+) 730	PINE+MOSS+CB (4:1:t)	Olive(-) 907	Shrub 1136
Fiesta Pink 2045	Cottage Rose 2313	Coral Rose(*-) 103	-----	VER+ROSE+OPL (1:1:1)	SCR+SDL+HIB (6:1:1)	Festive Pink(-) 1029
Fire Red 2083	Jo Sonja® Red 2449	Berry Red 19	Napthol Crimson 555	NC+NRL (2:1)	Perm. Alizarin Crimson Hue 116	Fire Truck Red 1050
Fjord Blue 2104	-----	-----	-----	FB+CB+SP (4:2:1)	IB+FGB (2:1)	Smoky Blue 1063
Flesh Tan 2035	-----	-----	-----	WW+YO+BU (4:1:t)	PAR+YO (2:1)	Creamy Beige(-) 1023
Fleshtone 2019	-----	-----	Almond Parfait(+) 705	TW+GO+TY (1:t:t)	PPP+RS (3:1)	Skin Tone 1013
Fleshtone Base 2082	-----	-----	-----	WW+SP+BE (4:1:t)	-----	-----
Forest Green 2010	Forest Green 2341	-----	-----	PINE+SAPH+BE (2:1:t)	OL+PHGH+BU (1:1:1)	Terrestrial Green(*-) 1011
Fuchsia 2481	Fuchsia(+) 2335	-----	Hot Pink(+) 634	TM+WW+CS (4:4:1)	MM+RAS (2:1)	-----
Fuchsia Pearl Gleams 2622	Duchess Rose CJ2522	-----	-----	N/A	Pearl+NC. (See Note 5.)	Pearl Fuchsia 1526
GP Purple 2091	Wild Heather(+) 2314	-----	-----	TW+DP (5:1)	BP+TW (1:1)	Iris 1135
Gamel Green 2120	-----	Plantation Pine 113	Southern Pine(-) 730	PINE+RU (2:1)	YLH+MB (3:1)	Bay Leaf(*) 1073
Georgia Clay 2097	Sedona Clay 2301(*)	Burnt Orange 16	-----	Norwegian Orange (+)	RO+BS (1:1)	Russet 1058
Gold (14K) Gleams 2604	-----	-----	Inca Gold Metallic 676	Pale Gold Metallic	-----	49'er Gold 1513
Golden Brown 2054	Tumbleweed(+) 2305	-----	English Mustard 959	-----	RS+YO (2:1)	Brown Sugar(-) 1036
Grape 2048	-----	-----	Plum Pudding(-) 934	DP+BUR+OPL (3:3:1)	RAS+TWI (2:1)	Velvet Plum 1118
Green Isle 2008	Holiday Green 2577	Leaf Green(-) 51	Shamrock(+) 926	BG+TEAL (2:1)	PHGH+BG (2:1)	Erin Green 1009
Green Sea 2445	Village Green(-) 2451	-----	-----	JADE+OPL (2:1)	BG+TY (2:1)	Tranquil Green(-) 1180

ACRYLICS

Color Conversion Chart — Acrylic Paints

Delta® Ceramcoat® (See Notes 6 - 8)	Accent® Acrylics "CJ" = Crown Jewels (See Notes 1 - 3, 6)	DecoArt™ Americana™ (See Notes 1 - 3, 6)	FolkArt® (Plaid) (See Notes 1 - 3, 6)	Jo Sonja® (Chroma Acrylics) ("t" = Tad in recipes below) (See Notes 1 - 4)	Liquitex® Concentrated Artist Colors ("t" = Tad in recipes below) (See Notes 1 - 6)	Wally R.™ (See Notes 1 - 3, 6)
Gypsy Rose 2129	-----	Gooseberry Pink(-) 27	-----	ROSE+OPL+IRO (4:2:1)	UBT+DVR+RO (5:2:1)	Rose Dawn 1150
Hammered Iron 2094	-----	-----	-----	-----	-----	Iron Clad(-) 1056
Heritage Blue 2415	-----	-----	Denim Blue 721	FB+DP (4:1)	TWI+NG5 (2:1)	Charcoal Blue(-) 1090
Hippo Gray 2090	-----	-----	-----	-----	-----	Rhino Gray 1053
Hunter Green 2471	Deep Forest Grn(+) 2444	-----	Hunter Green(-) 406	PTHGR+CB (3:1)	Permanent Viridian Hue 398	Forest Night(+) 1060
Hydrangea Pink 2449	Painted Desert 2300	-----	Sweetheart Pink(+) 955	TW+CS (1:1)	SW+HIB (6:1)	Carnation(-) 1219
Ice Storm Violet 2468	-----	-----	-----	WW+BS+ROSE (7:1:t)	UBT+PLV (2:1)	Soft Lilac 1210
Indiana Rose 2018	-----	Base Flesh(+) 136	Rose Blush(+) 621	-----	PPP+DPP (2:1)	Faded Rose(-) 1220
Island Coral 2433	Peaches 'n Cream(+) 2420	-----	Peach Cobbler(+) 738	WW+CS+YL (1:1:t)	AP+HIB+OL (4:1:t)	Peachee 1168
Ivory 2036	Adobe Wash(-) 2311	Sand(+) 4	Taffy 902	WW+YO (1:t)	SW+UBT (1:1)	Sweet Cream(-) 1203
Jade Green 2475	-----	-----	-----	AQ+BG (2:1)	-----	-----
Jubilee Green 2421	Holiday Green 2577	Holly Green(*+) 48	-----	BG+CYL (4:1)	Christmas Green(*) 902	Teal Green 1094
Kelly Green 2052	-----	Mistletoe 53	Evergreen 724	-----	-----	Irish Green 1035
Kim Gold Met Gleams 2602	-----	Glorious Gold Met. 71	Pure Gold Metallic 660	Rich Gold Metallic	-----	Gold Metallic 1510
Laguna Blue 2418	Marina Blue(-) 2507	Desert Turquoise(+) 44	-----	Aqua(+)	PLB+RT (1:1)	Blue Lagoon 1158
Lavender 2047	-----	-----	-----	TW+BUR+COBH (2:1:1)	SW+WIS (2:1)	-----
Lavender Lace 2016	-----	-----	-----	TW+AM+FB (4:1:t)	-----	Shy Violet(-) 1107
Leaf Green 2067	-----	-----	-----	GRNOX+YL (1:1)	CYMH+PHGH (4:1)	Blade 1042
Leprechaun 2422	-----	-----	-----	JADE+OPL (3:1)	BG+PHGH (3:1)	Blarney 1159
Liberty Blue 2416	-----	-----	-----	-----	UMB+SDL (2:1)	Freedom Blue(-) 1091
Lichen Gray 2118	-----	-----	Barn Wood 936	NIM+BE+PINE (4:1:t)	UBT+NG5 (3:1)	Sterling Gray 1072
Light Chocolate 2022	-----	-----	-----	-----	-----	Milk Chocolate 1015
Lilac 2060	Wild Hyacinth(-) 2505	-----	Heather(+) 933	TW+AM+STRM (2:1:t)	SW+PV (5:1)	Amethyst 1122
Lilac Dusk 2403	-----	-----	-----	Amethyst(+)	MM+PLV (2:1)	Pink Begonia 1153
Lima Green 2072	-----	-----	-----	-----	-----	Spring Green(-) 1127
Lisa Pink 2084	-----	Baby Pink(-) 31	-----	-----	LPP+MM (3:1)	Lisa's Blush(-) 1051
Lt. Ivory 2401	-----	Buttermilk(+) 3	Warm White(+) 649	Warm White	Soft White 904	Tusk(-) 1080
Lt. Jade Green 2476	-----	-----	-----	AQ+BG+WW (4:2:1)	-----	-----
Luscious Lemon 2004	Yellow Lt. 2600	Lemon Yellow 11	Yellow Lt. 551	Cadmium Yellow Lt.(+)	Cad. Yellow Lt.(+) 160	Juicy Lemon 1098
Manganese Blue 2124	Windsor Blue(-) 2317	Midnite Blue 85	-----	PBH+PTHBL (1:1)	-----	Manganese Blue 1146
Maple Sugar Tan 2062	Devonshire Cream(-)2312	-----	Buttercrunch(-) 737	WW+TY (3:1)	SW+RS+CYMH (7:1:1)	Chamois(+) 1040
Maroon 2075	-----	Burgundy Wine(-) 22	Burgundy(-) 957	BUR+TM (3:1)	RAS+BUR (2:1)	Bing Cherry 1047

ACRYLICS

Color Conversion Chart

DELTA®

Acrylic Paints

Delta® Ceramcoat® (See Notes 6 - 8)	Accent® Acrylics "CJ" = Crown Jewels (See Notes 1 - 3, 6)	DecoArt™ Americana™ (See Notes 1 - 3, 6)	FolkArt® (Plaid) (See Notes 1 - 3, 6)	Jo Sonja® (Chroma Acrylics) ("t" = Tad in recipes below) (See Notes 1 - 4)	Liquitex® Concentrated Artist Colors ("t" = Tad in recipes below) (See Notes 1 - 6)	Wally R.™ (See Notes 1 - 3, 6)
Medium Flesh 2126	Medium Flesh(-) 2331	Medium Flesh(-) 102	Apricot Cream(-) 911	WW+GO (1:t)	AP+DPP (2:1)	HB Medium Flesh(-) 1076
Mendocino Red 2406	Burgundy Deep 2338	Cranberry Wine(+) 112	Raspberry Wine(+) 935	BUR+BU (1:t)	BUR+RAS+BU (3:1:1)	Cranberry 1083
Metallic Gold Gleams 2600	-----	-----	-----	-----	-----	-----
Midnight Blue 2114	-----	-----	Payne's Gray(+) 575	STRM+PG (2:1)	PG+NG5 (3:1)	Kohl Blue 1069
Misty Mauve 2441	Cool Neutral(-) 2615	-----	-----	SP+BS (1:1)	UBT+VR (2:1)	Dusty Rose 1176
Mocha Brown 2050	Golden Oxide(-) 2339	Terra Cotta(+) 62	Buckskin Brown(+) 418	RS+GO+WW (4:4:1)	Raw Siena(-) 330	Jamocha(-) 1033
Napa Wine 2443	-----	-----	Plum Chiffon(+) 761	AM+IRO (2:1)	WIS+DVR (2:1)	Plum Wine(-) 1178
Naphtol Crimson 2408	Razzle Red 2579	Berry Red(-) 19	Christmas Red 958	Napthol Red Lt.	SCR+NC (3:1)	Fire Truck Red(+) 1050
Naphtol Red Light 2409	Crimson 2604	True Red 129	Napthol Crimson 555	NC+NRL (2:1)	Naphthol Crimson(+) 292	Napthol Red Lt. 1086
Navy Blue 2089	-----	Ultra Blue Deep(-) 100	-----	PBH+PTHBL (1:1)	-----	Blazer Blue(+) 1052
Nectar Coral 2458	-----	-----	-----	WW+ROSE+YL (8:1:t)	SCR+HIB+UBT (2:1:1)	Rouge(-) 1196
Nightfall Blue 2131	-----	Uniform Blue(-) 86	-----	FB+TW+BU (1:t:t)	PG+FGB (3:1)	Phantom Blue(-) 1078
Normandy Rose 2432	Victorian Rose(+) 2452	Dusty Rose(+) 25	-----	BS+WW+SP (2:2:1)	SW+VR+SDL (4:1:1)	Opal(+) 1167
Norsk Blue 2111	-----	-----	-----	-----	FGB+BAL (1:1)	Nordic Blue 1068
Ocean Reef Blue 2074	-----	-----	-----	UMB+TW (2:1)	SWBL+TW+UMB (5:1:t)	Reef Blue 1129
Old Parchment 2092	-----	-----	Buttercrunch(+) 737	WW+TY+RU (3:1:t)	PAR+YO (2:1)	Creamy Beige 1023
Orange 2026	Vermillion(*) 2602	Cadmium Orange(*) 14	Red Orange(+) 629	CS+VER (1:1)	SCR+CYMH (5:1)	Orange 1019
Orange Pearl Gleams 2617	-----	-----	-----	N/A	Pearl+FLOR (See Note 5.)	Pearl Orange 1525
Pale Gold Glms 2624	-----	-----	-----	-----	-----	-----
Pale Mint Green 2473	-----	-----	-----	TW+BG (20:1)	-----	Mellow Marsh 1133
Pale Yellow 2005	Cactus Flower 2306	Pineapple 6	Lemonade(-) 904	TW+YL (1:1)	SW+CYMH (4:1)	Cotton Seed 1099
Palomino Tan 2108	-----	-----	Camel(-) 953	PB+SP+OPL (2:1:1)	COH+NG5+TW (2:2:1)	Sonora(-) 1066
Pearl Finish Gleams 2601	Baroque Pearl CJ2532	White Pearl 117	Pearl White Met. 659	Pearl White Metallic	Iridescent White 238	Pearl White 1520
Periwinkle Blue 2478	-----	Country Blue(+) 41	-----	TW+COBH+DP (4:3:1)	LBV+BU (9:1)	-----
Persimmon 2480	Cottage Rose(-) 2313	Blush Flesh(+) 110	Poppy Red(+) 630	ROSE+VER+WW (1:1:t)	-----	Tropicana(+) 1154
Pigskin 2093	-----	-----	-----	-----	-----	Tigereye(-) 1055
Pineapple Yellow 2101	Cactus Flower(-) 2306	-----	Lemon Custard(+) 735	TW+CYM (6:1)	CYMH+TW (1:1)	Banana Cream 1061
Pink Angel 2061	Apricot Stone(+) 2448	-----	-----	WW+NOR (5:1)	PPP+RO (6:1)	Maiden Blush(-) 1123
Pink Frosting 2461	Pink Blossom 2409	-----	-----	TW+CS (1:t)	PPP+HIB (8:1)	Cameo Pink(-) 1198
Pink Quartz 2474	-----	-----	-----	WW+BUR (14:1)	TW+ALIZ+SWBL (5:1:t)	-----
Pinkie Pearl Gleams 2612	-----	-----	-----	N/A	Pearl+Fluor Pink (Note 5)	Pearl Pink(+) 1522
Pretty Pink 2088	-----	-----	-----	TW+TM+CS (10:4:1)	-----	Flamingo(-) 1134

Color Conversion Chart DELTA Acrylic Paints

ACRYLICS

Delta® Ceramcoat® (See Notes 6 - 8)	Accent® Acrylics "CJ" = Crown Jewels (See Notes 1 - 3, 6)	DecoArt™ Americana™ (See Notes 1 - 3, 6)	FolkArt® (Plaid) (See Notes 1 - 3, 6)	Jo Sonja® (Chroma Acrylics) "t" = Tad in recipes below (See Notes 1 - 4)	Liquitex® Concentrated Artist Colors "t" = Tad in recipes below (See Notes 1 - 6)	Wally R.™ (See Notes 1 - 3, 6)
Prussian Blue 2413	Windsor Blue(-) 2317	Navy Blue 35	Prussian Blue 559	PBH+PTHBL (1:1)	NVY+PG (1:1)	Manganese Blue 1146
Pthalo Blue 2502	-----	Ultra Blue Deep(-) 100	Pthalo Green 563	Pthalo Blue	Phthalocyanine Blue(+) 316	Pthalo Blue 1002
Pthalo Green 2501	Pthalo Green 2501	Viridian Green(+) 108	Pthalo Green 563	Pthalo Green	Phthalocyanine Green(-) 317	Pthalo Green 1001
Pumpkin 2042	True Orange(+) 2473	Pumpkin(*) 13	-----	YL+VER (3:1)	Cad Orange Hue(-) 150	Mango(-) 1026
Purple 2015	Dioxazine Purple 2606	Dioxazine Purple 101	Dioxazine Purple 558	Dioxazine Purple	Dioxazine Purple(+) 186	Purple(-) 1106
Putty 2460	-----	-----	Georgia Peach(-) 615	TW+GO+TY (15:1:t)	-----	Ecru(-) 2460
Quaker Gray 2057	-----	-----	-----	Nimbus Gray(*+)	NG5+SW (1:1)	Dove Gray 1038
Queen Anne's Lace 2017	-----	-----	Georgia Peach 615	TW+GO+TY (20:1:t)	-----	Corn Flower 1185
Rainforest Green 2462	-----	-----	Bluegrass(+) 916	TEAL+OPL+TW (1:1:t)	BAL+SW (2:1)	Emeraude(+) 1199
Raw Sienna 2411	Golden Oxide(-) 2339	Raw Sienna 93	Raw Sienna(-) 569	RS+RE (5:1)	Raw Siena 330	Raw Sienna(-) 1156
Red Copper Gleams 2605	Coron. Russet(-) CJ2521	Royal Ruby Met.(*) 74	Regal Red Metallic 657	Red Earth	-----	-----
Red Iron Oxide 2020	Pennsylvania Clay(-) 2423	Red Iron Oxide(-) 96	Rusty Nail 914	Red Earth	Red Oxide(-) 335	Red Iron Oxide(-) 1014
Rose Cloud 2450	-----	-----	-----	OPL+PLUM+BU (9:1:t)	TW+VR (2:1)	-----
Rose Mist 2437	-----	-----	-----	OPL+IRO+PLUM (2:2:1)	DVR+NG5 (1:1)	Grecian Rose(-) 1172
Rosetta Pink 2430	Apricot Stone(+) 2448	-----	Portrait Medium(-) 422	WW+NOR+PINE (4:1:t)	AP+HIB+BU (4:1:t)	Cherub(+) 1165
Rouge 2404	Cottage Rose(-) 2313	-----	-----	ROSE+VER (2:1)	SCR+HIB+UBT (2:1:1)	Tropicana 1154
Sachet Pink 2464	Lt. Roseberry 2464	-----	Berries 'n Cream 752	OPL+PLUM+BU (7:1:t)	TW+DVR (2:1)	Terra Rosa(+) 1206
Salem Blue 2121	Paradise Blue(-) 2508	Salem Blue(+) 43	-----	TW+COBL+BU (4:1:t)	SW+PLB+SWBL (5:1:1)	-----
Salem Green 2099	-----	-----	Plantation Green(-) 604	TEAL+OPL+BU (1:1:1)	BAL+SW (2:1)	Lichen Green 1137
Sandstone 2402	Warm Neutral(-) 2616	Cool Neutral Toning 89	Clay Bisque 601	SP+TW+MOSS (2:1:t)	UBT+NG5 (6:1)	Desert Sand 1081
Santa's Flesh 2472	Lt. Flesh(-) 2330	-----	Dusty Peach(+) 616	TW+GO (6:1)	SW+PPP+AP (5:3:1)	-----
Seminole Green 2009	-----	Avocado(+) 52	Clover(-) 923	GRNOX+PINE (2:1)	PGL+RS+NG5 (1:1:1)	Moss 1010
Silver Met. Gleams 2603	Regency Silver CJ2530	Shimmering Silver Met. 70	Silver Sterling Met. 662	Silver Metallic	Iridescent Silver 236	Silver Metallic(+) 1511
Sonoma Wine 2446	Fingerberry Red(*) 2425	Russett(*) 80	-----	IRO+BU (1:t)	BUR+BU (1:1)	Burgundy(-) 1181
Spice Brown 2049	-----	Lt. Cinnamon(+) 114	Maple Syrup 945	BE+RS (1:1)	BS+RS (1:1)	Warm Brown 1032
Spice Tan 2063	-----	-----	Teddy Bear Tan(*-) 419	RS+YO+WW (5:1:1)	-----	Cappucino 1124
Stonewedge Green 2442	-----	Jade Green(+) 57	-----	GRNOX+OPL+BE (6:4:1)	OL+PAR (6:1)	Sage(-) 1177
Straw 2078	Golden Harvest(+) 2433	-----	-----	WW+YO (1:1)	YO+CYMH (2:1)	Caribou 1049
Sunbright Yellow 2064	Mellow Yellow 2410	-----	Lemon Custard(+) 735	WW+CYM (6:1)	UBT+CYMH (2:1)	Banana Cream 1061
Sunshine Pearl Gleams 2615	-----	-----	-----	N/A	Pearl+YLH (See Note 5.)	Pearl Yellow 1524
Sweetheart Blush 2130	Burgundy Deep 2338	Burgundy Wine(*-) 22	Burgundy(-) 957	TM+BUR (5:1)	-----	Raspberry 1077
Tangerine 2043	Vermillion (*) 2602	Cad. Orange (*) 14	-----	VER+CYL (2:1)	COH+CRMH (3:1)	Fresh Tangerine 1027

Color Conversion Chart

DELTA® Acrylic Paints

ACRYLICS

Delta® Ceramcoat® (See Notes 6 - 8)	Accent® Acrylics "CJ" = Crown Jewels (See Notes 1 - 3, 6)	DecoArt™ Americana™ (See Notes 1 - 3, 6)	FolkArt® (Plaid) (See Notes 1 - 3, 6)	Jo Sonja® (Chroma Acrylics) ("t" = Tad in recipes below)(See Notes 1 - 4)	Liquitex® Concentrated Artist Colors ("t" = Tad in recipes below)(See Notes 1 - 6)	Wally R.™ (See Notes 1 - 3, 6)
Taupe 2470	-----	Taupe(+) 109	-----	OPL+IRO (12:1)	-----	Lilac Gray(+) 1212
Terra Cotta 2071	-----	-----	-----	Gold Oxide(+)	COH+RO (1:1)	Indian Clay(+) 1046
Territorial Beige 2425	-----	-----	-----	Provincial Beige	RS+BAL+VR (3:1:1)	Soil 1161
Tide Pool Blue 2465	Lt.Stoneware Blue(-) 2463	-----	Porcelain Blue(-) 765	TW+FB+BU (3:1:t)	FGB+TW (1:1)	Delft Blue 1207
Toffee Brown 2086	-----	Sable Brown(+) 61	-----	-----	TP+SDL (5:1)	Hazelnut(-) 1132
Tomato Spice 2098	Pueblo Red(-) 2302	Country Red(-) 18	-----	RE+NC (3:1)	NC+RO (1:1)	Ripe Tomato(-) 1059
Tompte Red 2107	Holiday Red(-) 2421	Deep Burgundy(+) 128	-----	NC+BUR (4:1)	NC+RAS (1:1)	Valentine 1065
Trail Tan 2435	-----	-----	Country Twill 602	PB+WW (2:1)	UBT+RU (2:1)	Taupe(-) 1170
Tropic Bay Blue 2451	-----	-----	-----	TW+AQ+PTHGR (11:2:1)	-----	Aqua(+) 1222
Turquoise 2012	-----	-----	Aqua Bright 731	AQ+TW+TY (5:3:1)	BAG+SW (2:1)	Hawaiian Green(-) 1103
Ultra Blue 2038	Pure Blue 2472	Blue Violet(+) 141	Ultramarine Blue 560	Ultra Blue Deep(+)	Cobalt Blue Hue 381	Electric Blue 1115
Vibrant Green 2007	-----	Lt. Avocado(+) 106	Clover 923	BG+YO+BE (1:1:t)	OL+PAR (1:t)	Garland 1101
Village Green 2447	-----	-----	-----	WW+JADE+OPL (2:1:1)	BG+TW (1:1)	Myrtle Green 1217
Vintage Wine 2434	Eggplant 2337	-----	Purple Passion(-) 638	UMB+NC (2:1)	WIS+DP+BU (1:1:1)	Brandy 1169
Violet Pearl Gleams 2623	Faberge Purple CJ2523	Plum Pearl 120	Amethyst Met.(-) 654	N/A	Pearl+DP (See Note 5.)	Pearl Violet 1527
Walnut 2024	Burnt Umber 2613	Dark Chocolate(-) 65	Raw Umber 571	Raw Umber	BU+IB (3:1)	Raw Umber 1017
Wedgewood Blue 2069	-----	-----	-----	TW+FB (3:1)	TW+FGB+UMB (2:1:t)	-----
Wedgewood Green 2070	-----	-----	-----	GRNOX+OPL+BE (7:3:1)	UBT+SAP+IB (2:1:t)	Wedgewood Green(-)1045
Western Sunset Yellow 2454	Lt. Tumblewood 2467	-----	-----	WW+YO (4:1)	UBT+AP+YO (7:1:1)	Desert Tea(+) 1194
White 2505	Real White 2476	Snow Titanium White 1	Wicker White 901	Titanium White	Titanium White 432	White 1005
Wild Rice 2453	Cool Neutral(+) 2615	Warm Neutral Tone(+) 90	Milkshake(+) 704	OPL+SP (3:1)	SDL+SW+BU (2:1:t)	Burnt Almond(+) 1214
Wisteria 2467	-----	-----	-----	AM+IRO (2:1)	-----	Hortense Violet 1209
Woodland Night Green 2100	-----	Deep Teal(-) 116	Hunter Green(-) 406	TEAL+OPL (4:1)	COG+UMB+UBT (2:1:t)	Forest Night(-) 1060
Yellow 2504	-----	Cad. Yellow(-) 10	School Bus Yellow(+) 736	CYM+TY (3:1)	Cad Yel. Med. Hue(+) 830	School Bus Yellow 1004

See notes on next page.

Color Conversion Chart

DELTA

Acrylic Paints

NOTES

(1) A "+" indicates darker (or a "−" lighter) than first column color.

(2) An asterisk "*" indicates floats or washes don't match, though regular basecoats do.

(3) "N/A" indicates there is no comparable product in this brand.

(4) Refer to the Color Keys for these brands. Numbers shown in parentheses after the color name abbreviations equal "parts." For example, "RAS+SW+BU (2:1:t)" means to mix 2 parts of Raspberry with 1 part Soft White, and just a touch of Burnt Umber.

(5) "Pearl" = "Liquitex® Painter's Pearl Medium": Add small amount of paint to Medium. The more Medium added, the lighter and more pearlescent the color will become.

(6) Product numbers are for the 2-ounce size. DecoArt™ numbers will be preceded by a "DA" (for DecoArt™ Americana™) on the bottles.

(7) Some of Delta's® color names have been slightly changed by the addition of the color family name. This was done for clarity only. For example, "Adobe Red" was formerly called "Adobe." The actual colors remain the same.

(8) Delta's® "Black Cherry" was mislabelled "Darkest Red" when the color was first released. The colors are the same.

Color Conversion Chart

FOLKART®

Acrylic Paints

ACRYLICS

FolkArt® (Plaid) (See Notes 6, 7)	Accent® Acrylics "CJ" = Crown Jewels (See Notes 1-3, 6, 7)	DecoArt™ Americana™ (See Notes 1-3, 6, 7)	Delta® Ceramcoat® (See Notes 1-3, 6, 7)	Jo Sonja® (Chroma Acrylics) ("t" = Tad in recipes below) (See Notes 1-4)	Liquitex® Concentrated Artist Colors ("t" = Tad in recipes below) (See Notes 1-6)	Wally R.™ (See Notes 1-3, 6, 7)
Acorn Brown 941	-----	-----	Dark Flesh(+) 2127	-----	BS+SDL (2:1)	Hazelnut(+) 1132
Alizarin Crimson 556	Burgundy Deep(-) 2338	-----	Black Cherry(-) 2484	BUR+BU (1:1)	Burgundy 834	Cranberry(-) 1083
Almond Parfait 705	-----	Toffee(-) 59	Fleshtone(-) 2019	TW+GO+TY (1:t:t)	UBT+SDL (1:t)	Skin Tone 1013
Amethyst Metallic 654	Faberge Purple CJ2523	Purple Pearl 124	Violet Prl. Glms (+) 2623	N/A	Pearl+DP (See Note 5.)	Pearl Violet(+) 1527
Amish Blue 715	-----	-----	Dolphin Gray(-) 2457	OPL+FB (4:1)	LBV+NG5 (1:1)	Oxford Gray(-) 1195
Antique Copper Met. 666	-----	-----	-----	Rich Gold Metallic(+)	-----	-----
Antique Gold Metallic 658	-----	-----	Kim Gold Met. Glms 2602	-----	-----	Gold Met.(+) 1510
Apple Spice 951	Barn Red(+) 2424	Brandy Wine(+) 79	Burgundy Rose(+) 2123	BUR+RE+SP (1:t:t)	BUR+RO (3:1)	Aztec(+) 1145
Apricot Cream 911	Medium Flesh(-) 2331	Medium Flesh(+) 102	Medium Flesh(+) 2126	WW+GO+TY (5:1:t)	AP+LPP (1:1)	Chamisa(-) 1192
Aqua Bright 731	-----	-----	Turquoise 2012	-----	BAG+SW (2:1)	Hawaiian Green(-) 1103
Aquamarine Metallic 655	-----	-----	Aqua Cool Prl Glms 2614	N/A	Pearl+BAG (See Note 5.)	Pearl Aqua(+) 1523
Aspen Green 646	-----	-----	-----	-----	BAL+OL+UBT (4:4:1)	-----
Autumn Leaves 920	-----	-----	-----	CYL+VER+BE (3:1:t)	COH+CRMH (8:1)	Fresh Tangerine(*+) 1027
Azure Blue 643	-----	-----	Azure Blue(-) 2483	-----	RT+BB (1:1)	-----
Baby Pink 633	-----	Baby Pink(+) 31	Hydrangea Pink(-) 2449	TW+NC (1:1)	TW+ALIZ (10:1)	-----
Barn Wood 936	-----	-----	Lichen Gray 2118	NIM+BE+PINE (4:1:t)	UBT+NG5 (3:1)	Sterling Gray 1072
Barnyard Red 611	Barn Red(+) 2424	-----	-----	RE+NC (3:1)	-----	Bing Cherry(*) 1047
Basil Green 645	-----	Jade Green(+) 57	-----	-----	-----	-----
Bavarian Blue 907	-----	-----	Avalon Blue(-) 2417	COBL+BU (4:1)	BU+PTHBL+TW (2:1:1)	Astro Blue(-) 1025
Bayberry 922	-----	-----	-----	-----	OL+BG+PAR (3:1:1)	Wedgewood Green(*+)1045
Berries 'n Cream 752	Lt. Roseberry 2464	-----	Sachet Pink 2464	OPL+PLUM+BU (7:1:t)	TW+DVR (2:1)	Terra Rosa 1206
Blue Ink 642	-----	-----	-----	UBD+FB (2:1)	Twilight(-) 910	-----
Blue Pearl Metallic 670	-----	-----	Bobby Blue Prl Glms 2609	N/A	-----	Pearl Blue Met.(-) 1521
Blue Ribbon 719	Sapphire(+) 2607	Sapphire(+) 99	Copen Blue(+) 2051	Sapphire(+)	Swedish Blue(+) 906	Sapphire Blue 1034
Blue Sapphire Met. 656	Empress Blue CJ2524	Ice Blue Metallic 75	-----	N/A	-----	-----
Blue Topaz Met. 651	-----	-----	-----	N/A	-----	-----
Bluebell 909	-----	-----	Bonnie Blue(+) 2106	WW+STRM (9:1)	FGB+PLB (1:1)	Aegean Blue(+) 1064
Blueberry Pie 963	-----	Blueberry 37	-----	COBH+RU+WW (2:1:t)	-----	-----
Bluebonnet 711	-----	-----	-----	COBH+RU+WW (6:4:1)	-----	-----
Bluegrass 916	-----	-----	Salem Green(+) 2099	TEAL+OPL+TW (1:1:t)	BAL+SW (2:1)	Emeraude(-) 1199
Brick Red 631	Pueblo Red(+) 2302	Crimson Tide(+) 21	-----	-----	BS+TW (4:1)	Ripe Tomato(+) 1059
Brilliant Blue 641	-----	Blue Violet(-) 141	-----	COBH+DP (1:t)	-----	-----

Color Conversion Chart

FOLKART®

Acrylic Paints

FolkArt® (Plaid) (See Notes 6, 7)	Accent® Acrylics "CJ" = Crown Jewels (See Notes 1 - 3, 6, 7)	DecoArt™ Americana™ (See Notes 1 - 3, 6, 7)	Delta® Ceramcoat® (See Notes 1 - 3, 6, 7)	Jo Sonja® (Chroma Acrylics) ("t" = Tad in recipes below) (See Notes 1 - 4)	Liquitex® Concentrated Artist Colors ("t" = Tad in recipes below) (See Notes 1 - 6)	Wally R.™ (See Notes 1 - 3, 6, 7)
Brown Sugar 707	-----	-----	Dark Flesh(-) 2127	-----	-----	Pottery(-) 1148
Buckskin Brown 418	-----	Terra Cotta 62	Mocha Brown(-) 2050	RS+GO (1:1)	RS+SCR+UBT (3:1:1)	-----
Burgundy 957	Burgundy(+) 2605	Deep Burgundy 128	Maroon 2075(+)	BUR+TM (1:1)	BUR+MM (2:1)	Raspberry (+) 1077
Burnt Carmine 567	-----	-----	-----	BU+BUR+TM (3:1:t)	Maroon(+) 501	-----
Burnt Sienna 568	Burnt Sienna(+) 2614	-----	Burnt Sienna 2030	-----	Burnt Siena(+) 127	Burnt Sienna 1022
Burnt Umber 570	Burnt Umber 2437	Dark Chocolate(+) 65	Burnt Umber 2025	RU+BE (2:1)	Burnt Umber(+) 128	Burnt Umber 1018
Butter Pecan 939	-----	-----	-----	-----	-----	Taupe(-) 1170
Buttercream 614	-----	Taffy Cream(+) 5	-----	TW+TY (20:1)	TW+CYMH (4:t)	-----
Buttercrunch 737	Devonshire Crm(-) 2312	Yellow Ochre(+) 8	Maple Sugar Tan 2062	WW+TY+RU (3:1:t)	UBT+YO (4:1)	Chamois(+) 1040
Buttercup 905	-----	-----	Butter Yellow(+) 2102	TW+TY+BU (3:1:t)	TY+UBT (1:1)	Margarine(-) 1062
Butterscotch 648	-----	-----	-----	-----	-----	-----
Calico Red 932	Jo Sonja® Red 2449	Calico Red 20	Berry Red 2056	NRL+NC (2:1)	Naphthol Crimson(+) 292	Fire Truck Red 1050
Camel 953	-----	-----	Cloudberry Tan(+)2112	-----	UBT+OL (2:1)	Golden Gourd(+) 1162
Cardinal Red 414	Holiday Red(+) 2421	-----	Berry Red 2056	NC+NRL (2:1)	Naphthol Crimson(-) 292	Valentine 1065
Cerulean Blue Hue 562	-----	-----	-----	-----	Cerulean Blue(+) 164	-----
Champagne Met. 675	-----	-----	-----	N/A	Pearl+UBT (See Note 5.)	-----
Charcoal Gray 613	-----	-----	-----	-----	-----	-----
Cherokee Rose 956	-----	Gooseberry Pink(+) 27	-----	OPL+ROSE+BE (4:1:t)	PAR+MM+RO (2:1:1)	-----
Cherry Royale 758	-----	Deep Burgundy 128	Maroon(+) 2075	NC+IRO (5:1)	BUR+MM (2:1)	Bing Cherry 1047
Chocolate Fudge 950	Sweet Chocolate(+) 2408	Dark Chocolate(+) 65	Burnt Umber(-) 2025	BE+RU+WW (1:1:t)	BU+RS (2:1)	Espresso(+) 1109
Christmas Red 958	Pure Red 2470	Napthol Red 104	Crimson 2076	Napthol Red Light(+)	Cadmium Red Medium 154	Persian Red 1130
Cinnamon 913	Sedona Clay(+) 2301	-----	Cayenne 2428	-----	SDL+RO (1:1)	Red Pepper(+) 1163
Clay Bisque 601	-----	Antique White 58	Sandstone 2402	Smoked Pearl(+)	UBT+NG5 (6:1)	-----
Clover 923	-----	-----	Vibrant Green 2007	BG+YO+BE (1:1:t)	OL+PAR (1:t)	Garland(+) 1101
Coastal Blue 713	-----	-----	-----	TW+PTHBL (15:1)	-----	-----
Cobalt Blue 561	Ultra. Blue Deep(-) 2608	Ultra. Blue Deep 100	-----	Cobalt Blue Hue(-)	-----	-----
Coffee Bean 940	Raw Sienna 2436	Burnt Umber(+) 64	Dark Brown(+) 2053	-----	UBT+BU+BS (2:2:1)	Dark Brown Sugar 1119
Copper Metallic 664	Royal Copper CJ2529	-----	-----	Super Copper Metallic	Iridescent Copper 233	Copper Met.(+) 1512
Cotton Candy 929	-----	-----	-----	TW+CS+NIM (1:t:t)	TW+PPP (1:1)	-----
Country Twill 602	Wicker(-) 2453	-----	Trail Tan 2435	PB+WW (2:1)	UBT+RU (2:1)	Taupe(-) 1170
Dapple Gray 937	-----	-----	-----	-----	-----	Iron Clad(+) 1056
Dark Brown 416	Fingerberry Red 2425	Russet 80	Candy Bar Brown(*)+2407	-----	BUR+BU (1:1)	-----

Color Conversion Chart

FOLKART®

ACRYLICS

Acrylic Paints

FolkArt® (Plaid) (See Notes 6, 7)	Accent® Acrylics "CJ" = Crown Jewels (See Notes 1 - 3, 6, 7)	DecoArt™ Americana™ (See Notes 1 - 3, 6, 7)	Delta® Ceramcoat® (See Notes 1 - 3, 6, 7)	Jo Sonja® (Chroma Acrylics) ("t" = Tad in recipes below) (See Notes 1 - 4)	Liquitex® Concentrated Artist Colors ("t" = Tad in recipes below) (See Notes 1 - 6)	Wally R.™ (See Notes 1 - 3, 6, 7)
Dark Gray 426	-----	Charcoal Gray(+) 88	-----	-----	RU+IB+NG5 (2:2:1)	-----
Delicate Rose 623	-----	-----	-----	WW+BS (20:1)	-----	-----
Denim Blue 721	-----	-----	Heritage Blue 2415	FB+DP (4:1)	TWI+NG5 (2:1)	Charcoal Blue 1090
Dioxazine Purple 558	Dioxazine Purple 2606	Dioxazine Purple(-) 101	Purple 2015	Dioxazine Purple	Dioxazine Purple 186	-----
Dove Gray 708	April Showers 2510	Gray Sky 111	Drizzle Gray(+) 2452	TW+NIM+UBD (4:1:t)	TW+NG5 (2:1)	-----
Dusty Peach 616	Lt. Flesh 2330	-----	Santa's Flesh(-) 2472	TW+GO+TY (7:1:t)	-----	Cornflower(-) 1185
Earthenware 610	-----	-----	-----	-----	-----	Paprika(-) 1155
Emerald Green Met. 653	Queen Emerald(+) CJ2525	Crystal Green Met.(+)76	-----	N/A	Pearl+PTHGR (See Note 5.)	-----
Emerald Isle 647	Deep Forest Green(+)2444	Viridian Green 108	-----	Pthalo Green(+)	-----	-----
English Mustard 959	Tumbleweed(+) 2305	-----	Golden Brown 2054	Raw Sienna(+)	RS+YO (2:1)	Brown Sugar 1036
Evergreen 724	-----	Mistletoe 53	Kelly Green 2052	GRNOX+BG (1:1)	-----	Chrome Green Lt.(+) 1102
French Blue 639	-----	-----	-----	-----	-----	-----
Fresh Foliage 954	Lt. Yellow Gm (-) 2340	-----	-----	CYL+GRNOX (2:1)	CYMH+TW+PHGH (6:2:1)	-----
Fuschia 635	-----	Red Violet(+) 140	-----	TM+NIM+BU (1:1:t)	-----	-----
Garnet Red Metallic 665	-----	-----	-----	N/A	Pearl+NC (See Note 5.)	-----
Georgia Peach 615	Lt. Flesh(+) 2330	-----	Queen Anne's Lace 2017	TW+GO+TY (20:1:t)	-----	Corn Flower 1185
Glazed Carrots 741	-----	-----	-----	YL+VER (3:1)	COH+SCR+PAR (4:3:1)	Mango(-) 1026
Grass Green 644	-----	-----	Kelly Green(+) 2052	MOSS+BG (1:1)	-----	-----
Gray Flannel 709	-----	-----	-----	-----	PPP+WIS (1:1)	-----
Gray Mist 702	-----	-----	Lilac(-) 2060	-----	-----	-----
Green 408	-----	Kelly Green 55	-----	BS+PTHGR (3:1)	Emerald Green 450	-----
Green Meadow 726	-----	Evergreen(+) 82	Dark Jungle Green(+) 2420	PINE+GRNOX (3:1)	-----	Everglade(*+) 1093
Gunmetal Gray Met. 667	Prince Pewter(+) CJ2531	-----	-----	N/A	Pearl+IB (See Note 5.)	-----
Harvest Gold 917	Yellow Ochre 2601	True Ochre(+) 143	Antique Gold(+) 2002	Turner's Yellow(-)	YO+TW (2:1)	Yellow Oxide 1008
Heartland Blue 608	Soldier Blue(-) 2441	Uniform Blue 86	-----	FB+SAPH+BU (2:1:t)	UMB+NG5 (1:1)	Phantom Blue(-) 1078
Heather 933	-----	-----	Lilac(-) 2060	-----	PPP+WIS (1:1)	-----
Holiday Red 612	Napthol Crimson 555	-----	-----	-----	HIB+RAS (3:1)	Pthalo Crimson(-) 1147
Honeycomb 942	-----	-----	-----	PB+YO+SP (4:1:1)	TP+YO (2:1)	-----
Hot Pink 634	-----	-----	Fuchsia(-) 2481	TM+WW+CS (4:4:1)	-----	-----
Huckleberry 745	Barn Red 2424	Brandy Wine(-) 79	Burgundy Rose 2123	RE+IRO (1:1)	BUR+RO (1:1)	Aztec(*-) 1145
Hunter Green 406	Deep River Green(+) 2444	Black Forest Green(+) 83	Hunter Green(+) 2471	BG+TEAL (1:1)	PTHGR+BU (1:1)	-----
Icy White 701	-----	-----	Blue Mist(+) 2400	TW+FB (1:t)	TW+SWBL (10:t)	Misty Blue(+) 1152

© 1994 Susan Adams Bentley

Color Conversion Chart

FOLKART®

Acrylic Paints

FolkArt® (Plaid) (See Notes 6, 7)	Accent® Acrylics "CJ" = Crown Jewels (See Notes 1 - 3, 6, 7)	DecoArt™ Americana™ (See Notes 1 - 3, 6, 7)	Delta® Ceramcoat® (See Notes 1 - 3, 6, 7)	Jo Sonja® (Chroma Acrylics) ("t" = Tad in recipes below) (See Notes 1 - 4)	Liquitex® Concentrated Artist Colors ("t" = Tad in recipes below) (See Notes 1 - 6)	Wally R.™ (See Notes 1 - 3, 6, 7)
Inca Gold Metallic 676	-----	-----	14K Gold Gleams 2604	Pale Gold Metallic(+)	Iridescent Gold 234	49'er Gold 1513
Indigo 908	Liberty Blue 2439	-----	Dark Night Blue(+) 2414	STRM+JADE (1:t)	NVY+NG5+MB (2:2:1)	Velvet Night(+) 1089
Ivory Black 576	Ebony Black 2612	Ebony (Lamp) Black 67	Black 2506	Carbon Black	Ivory Black 244	Black 1006
Kelly Green 407	-----	Bright Green 54	-----	BG+WW (9:1)	PGL+UBT (1:1)	-----
Lavender 410	-----	Lavender(-) 34	-----	DP+AM (3:1)	BP+DP (1:t)	-----
Lavender Sachet 625	-----	-----	-----	-----	-----	-----
Lemon Custard 735	Mellow Yellow(-) 2410	Lemon Yellow 11	Luscious Lemon 2004	TW+CYM (6:1)	YLH+BY (1:1)	Banana Cream 1061
Lemonade 904	Lt Cactus Flower(-) 2462	Taffy Cream 5	Pale Yellow(+) 2005	TW+CYL (1:t)	TW+TY (4:1)	Cotton Seed(+) 1099
Licorice 938	Real Black 2477	Ebony (Lamp) Black 67	Black 2506	Carbon Black	Mars Black 276	Black 1006
Light Blue 402	-----	Baby Blue(-) 42	Blue Danube(-) 2013	TW+COBH+BE (7:2:t)	TW+SWBL (3:1)	Wedgewood Blue(+) 1044
Light Gray 424	-----	Dove Gray 69	-----	-----	-----	-----
Light Periwinkle 640	-----	-----	-----	COBH+WW+AM (3:3:1)	-----	-----
Linen 420	-----	-----	-----	SP+PB (2:1)	-----	-----
Magenta 412	-----	-----	-----	Transparent Magenta(+)	Raspberry(-) 901	-----
Maple Syrup 945	Burnt Sienna 2435	Lt. Cinnamon(-) 114	Spice Brown(*) 2049	BE+OPL (3:1)	BU+BS+RS (3:2:1)	Dk Brown Sugar(+) 1119
Maroon 415	Burgundy(-) 2605	Cranberry Wine 112	-----	BUR+OPL+BU (3:1:t)	Burgundy(+) 834	-----
Medium Gray 425	-----	Neutral Gray Tone(-) 95	-----	-----	-----	-----
Midnight 964	-----	-----	-----	-----	Twilight(-) 910	-----
Milkshake 704	Cool Neutral(-) 2615	Warm Neutral Tone 90	Wild Rice(-) 2453	Opal(+)	SDL+TW (1:1)	Burnt Almond(-) 1214
Mint Pearl Metallic 672	-----	Green Pearl(+) 122	-----	N/A	-----	-----
Molasses 943	-----	-----	-----	BS+IRO (1:1)	BU+RO+TP (3:1:1)	-----
Moon Yellow 409	Devonshire Cream(-) 2312	Moon Yellow 7	Spice Brown(+) 2049	WW+TY (3:1)	TW+AP+CYMH (2:1:1)	Margarine(-) 1062
Mystic Green 723	-----	-----	-----	-----	BG+CG (1:1)	-----
Napthol Crimson 555	Crimson 2604	Calico Red(-) 555	Napthol Red Lt. 2409	Napthol Crimson(+)	Naphthol Crimson 292	Napthol Crimson 1085
Navy Blue 403	Liberty Blue(-) 2439	Navy Blue(-) 35	-----	PBH+SAPH+BU (4:1:t)	-----	-----
Nutmeg 944	-----	Lt. Cinnamon(*) 114	Spice Brown(+) 2049	BS+RS (1:1)	BS+TP (1:1)	Warm Brown(+) 1032
Old Ivy 927	Green Olive(-) 2442	Hauser Med. Green(-) 132	-----	Green Oxide(-)	OL+PHGH (3:1)	Terrestrial Green(+)1011
Orchid 637	-----	Orchid(+) 33	-----	AM+TW (1:1)	-----	-----
Paisley Blue 967	-----	Sapphire(-) 99	Denim Blue(-) 2477	Sapphire(+)	UMB+SDL (2:1)	Freedom Blue(-) 1091
Payne's Gray 575	Payne's Gray(-) 2609	-----	Midnight Blue(-) 2114	PG+CB (4:1)	PG+NG5 (3:1)	Velvet Night 1089
Peach Cobbler 738	-----	-----	Island Coral(-) 2433	WW+VER+YL+BE (9:2:2:t)	AP+PPP (1:1)	Pearl Orange(+) 1525
Peach Pearl Metallic 674	-----	-----	-----	N/A	-----	-----

ACRYLICS

Color Conversion Chart

FOLKART® Acrylic Paints

FolkArt® (Plaid) (See Notes 6, 7)	Accent® Acrylics "CJ" = Crown Jewels (See Notes 1-3, 6, 7)	DecoArt™ Americana™ (See Notes 1-3, 6, 7)	Delta® Ceramcoat® (See Notes 1-3, 6, 7)	Jo Sonja® (Chroma Acrylics) ("t" = Tad in recipes below) (See Notes 1-4)	Liquitex® Concentrated Artist Colors ("t" = Tad in recipes below) (See Notes 1-6)	Wally R.™ (See Notes 1-3, 6, 7)
Peach Perfection 617	Apricot Stone(-) 2448	-----	Rosetta Pink(-) 2430	WW+VER+YL+BU (11:2:2:t)	LPP+AP (2:1)	Cherub(-) 1165
Pearl White Metallic 659	Baroque Pearl CJ2532	White Pearl 117	Pearl Finish Gleams 2601	Pearl White Metallic	Iridescent White 238	Pearl White 1520
Peridot Metallic 671	-----	-----	-----	N/A	-----	-----
Periwinkle 404	-----	-----	-----	STRM+DP+WW (1:1:1)	Pearl+LBV (See Note 5.)	-----
Periwinkle Metallic 669	-----	-----	-----	N/A	N/A	-----
Persimmon 919	-----	Burnt Orange(+) 16	-----	-----	CYMH+ RO (1:1)	Mesa 1143
Phthalo Green 563	Pthalo Green 2610	Viridian Green(+) 108	Pthalo Green 2501	Pthalo Green	Phthalocyanine Green(-) 317	Pthalo Green 1001
Pink 413	Rose Blush(-) 2334	-----	-----	-----	LM+NC (6:1)	-----
Plantation Green 604	Telemark Green(+) 2443	Deep Teal(*+) 116	Salem Green(+) 2099	TEAL+TW (2:1)	COBH+YO (2:1)	Lichen Green(+) 1137
Plum Chiffon 761	-----	-----	Napa Wine(-) 2443	IRO+AM (2:1)	DVR+TWI (1:1)	-----
Plum Metallic 668	-----	Plum Pearl 120	-----	N/A	Pearl+PV (See Note 5.)	-----
Plum Pudding 934	Wineberry(+) 2426	-----	Grape(+) 2048	-----	PV+BU+TW (2:1:1)	Velvet Plum(+) 1118
Poetry Green 619	Village Green(-) 2451	-----	-----	-----	BG+PHGH (1:t)	Tranquil Green(*+) 1180
Poppy Red 630	-----	Blush Flesh(+) 110	Persimmon(-) 2480	CS+OPL (4:1)	-----	-----
Porcelain Blue 765	Lt Stoneware Blue 2463	-----	Tide Pool Blue(+) 2465	TW+AM+FB (5:1:1)	FGB+SW (1:1)	Santa Fe Blues(-) 1190
Portrait Dark 423	-----	Flesh, Hi-Lite(+) 24	Cayenne 2428	OPL+TY+RE (2:1:1)	RO+SDL (2:1)	-----
Portrait Light 421	-----	Flesh(+) 24	-----	TW+CS (1:1)	TW+LPP+UBT (4:1:1)	Cameo Pink(+) 1198
Portrait Medium 422	Apricot Stone(+) 2448	Base Flesh(+) 136	Rosetta Pink(-) 2430	OPL+VER (7:1)	LPP+AP (3:1)	Sandy Peach(-) 1204
Potpourri Rose 624	Roseberry 2450	Mauve(+) 26	Bouquet Pink(+) 2132	OPL+PLUM+BU (3:1:t)	Venetian Rose(+) 149	Zinfandel(+) 1151
Prairie Blue 766	-----	Williamsburg Blue(+) 40	Bonnie Blue(-) 2106	WW+STRM+CB (9:1:t)	FGB+PLB (1:1)	Aegean Blue(-) 1064
Primrose 930	-----	-----	-----	ROSE+NC (5:1)	-----	-----
Promenade 912	-----	-----	Coral(+) 2044	OPL+NOR (3:2)	TW+HIB+RO (2:1:1)	Cashmere Rose(-) 1028
Prussian Blue 559	-----	Prussian Blue 138	Prussian Blue 2413	PBH+PTHBL (1:1)	NVY+PG (1:1)	Manganese Blue 1146
Pure Gold Metallic 660	-----	Glorious Gold Met. 71	Kim Gold Met. 2602	Rich Gold Metallic(+)	-----	-----
Pure Orange 553 (Note 7)	True Orange(+) 2473	-----	-----	CYL+VER (3:1)	COH+CRLH (4:1)	Fresh Tangerine 1027
Pure Orange 628 (Note 7)	True Orange 2473	-----	-----	VER+CYL (1:1)	SCR+CYMH (1:1)	-----
Purple 411	True Purple 2475	Dioxazine Purple 101	Purple(+) 2015	DP+TM+TW (1:1:t)	PV+DP (6:1)	Purple 1106
Purple Passion 638	Eggplant(+) 2337	-----	Vintage Wine(+) 2434	-----	UMB+NC (2:1)	Brandy(*) 1169
Raspberry Sherbet 966	-----	-----	Dusty Mauve(+) 2405	Plum Pink(+)	DVR+TW (2:1)	Winter Wine(-) 1082
Raspberry Wine 935	Bordeaux 2322	Cranberry Wine 112	Mendocino Red(-) 2406	BUR+BU (1:t)	Burgundy(+) 834	Cranberry 1083
Raw Sienna 569	Golden Oxide 2339	-----	Raw Sienna(+) 2411	GO+RS (1:1)	Raw Sienna(+) 330	-----
Raw Umber 571	Raw Umber(+) 2613	-----	Walnut 2024	RU+RS (7:1)	Raw Umber(+) 331	Raw Umber 1017

ACRYLICS

Color Conversion Chart

FOLKART® Acrylic Paints

Wally R.™

FolkArt® (Plaid) (See Notes 6, 7)	Accent® Acrylics "CJ" = Crown Jewels (See Notes 1 - 3, 6, 7)	DecoArt™ Americana™ (See Notes 1 - 3, 6, 7)	Delta® Ceramcoat® (See Notes 1 - 3, 6, 7)	Jo Sonja® (Chroma Acrylics) ("t" = Tad in recipes below) (See Notes 1 - 4)	Liquitex® Concentrated Artist Colors ("t" = Tad in recipes below) (See Notes 1 - 6)	Wally R.™ (See Notes 1 - 3, 6, 7)
Red Clay 931	-----	Georgia Clay(+) 17	-----	-----	NC+RO (1:1)	-----
Red Light 554	Napthol Red Lt 2603	-----	-----	VER+CS (2:1)	Naphthol Red Light(+) 294	-----
Red Orange 629	Vermillion(*) 2602	Cad Orange(*) 14	Orange(-) 2026	CS+VER (1:1)	SCR+COH (2:1)	Orange(-) 1019
Red Violet 636	-----	-----	Vintage Wine(+) 2434	TM+DP (1:1)	Prism Violet(-) 391	Brandy(+) 1169
Regal Red Metallic 657	Coronation Russet CJ2521	-----	Red Copper Gleams 2605	N/A	-----	-----
Ripe Avocado 952	-----	Avocado 52	-----	BG+YO+BE (1:1:t)	PHGH+RS (1:1)	-----
Robin's Egg 915	-----	-----	-----	WW+JADE+SAPH (6:3:1)	UBT+BAL (3:1)	Cypress Green(+) 1188
Rose Blush 621	-----	-----	Indiana Rose(-) 2018	WW+BS+CS (7:1:t)	PPP+DPP (2:1)	Damsel Rose(+) 1012
Rose Chiffon 753	-----	-----	Antique Rose(+) 2469	WW+BS+NC (5:2:t)	-----	Madder Rose(+) 1211
Rose Crimson 557	-----	-----	-----	-----	-----	-----
Rose Garden 754	-----	-----	Dusty Mauve(+) 2405	PLUM+OPL+RU (1:1:t)	VR+BUR (1:1)	-----
Rose Pearl Metallic 673	-----	-----	-----	N/A	Pearl+CRMH (See Note 5.)	-----
Rose Pink 632	-----	-----	-----	OPL+PLUM+NIM (4:1:t)	-----	-----
Rose Shimmer Met 652	-----	Rose Pearl 119	-----	NA	-----	-----
Rusty Nail 914	Pennsylvania Clay(-) 2423	Red Iron Oxide(-) 96	Red Iron Oxide 2020	Red Earth(+)	Red Oxide 335	Red Iron Oxide 1014
Salmon 747	Cottage Rose(-) 2313	Coral Rose(-) 103	Coral(+) 2044	ROSE+VER+OPL (2:1:1)	SCR+SDL (2:1)	Cashmere Rose(-) 1028
Sap Green 565	Forest Green 2341	Hauser Med. Green(-) 132	Dark Jungle Green(+) 2420	-----	PHGH+RS (1:1)	Terrestrial Green(+)1011
School Bus Yellow 736	Sunkiss Yellow 2432	Cadmium Yellow(-) 10	Yellow(+) 2504	CYM+TY (3:1)	Cadmium Yellow Med. Hue 830	School Bus Yellow 1004
Seafoam 734	-----	Teal Green(*-) 107	-----	-----	RT+BG (1:1)	-----
Sequin Black Metallic 661	-----	Black Pearl(-) 127	-----	N/A	-----	-----
Settler's Blue 607	Stoneware Blue(+) 2440	French Gray/Blue(-) 98	Cape Cod Blue 2133	FB+TW (2:1)	French Gray/Blue 243	Dover Blue(+) 1079
Shamrock 926	-----	Leaf Green 51	Green Isle(-) 2008	BG+TEAL (2:1)	PHGH+BG (2:1)	Erin Green(*-) 1009
Silver Sterling Metallic 662	Regency Silver CJ2530	Shimmering Silver Met.70	Silver Gleams(-) 2603	Silver Metallic	Iridescent Silver 236	Silver Met.(+) 1511
Skintone 949	Medium Flesh(-) 2331	Flesh Tone(-) 78	-----	WW+GO (1:1)	AP+SDL+TW (1:1:1)	Chamisa(-) 1192
Slate Blue 910	-----	-----	-----	FB+TW+BE (1:1:t)	FGB+IB (1:1)	Caspian(+) 1173
Solid Bronze Metallic 663	-----	Bronze Metallic 73	-----	-----	Copper Metallic(+) 233	Copper Metallic 1512
Southern Pine 730	Pine Needle Green(+) 2445	Plantation Pine 113	Gamel Green(+) 2120	PINE+SAPH+RU (2:1:t)	OL+IB (6:1)	Bay Leaf(+) 1073
Spice Pink 750	-----	-----	-----	OPL+RE (4:1)	Deep Portrait Pink(-) 838	Light Rose(+) 1202
Spring Rose 767	-----	-----	-----	WW+PLUM+BU (10:1:t)	TW+DVR+NG5 (8:2:1)	-----
Strawberry Parfait 751	-----	-----	-----	TW+ROSE+TY (3:2:1)	UBT+SCR+CRMH(3:2:1)	-----
Summer Sky 906	-----	-----	-----	SP+SAPH+GRNOX (8:2:1)	-----	Parnadour Green(-) 1216
Sunny Yellow 918	Pure Yellow 2471	Cadmium Yellow(+) 10	Bright Yellow 2027	Yellow Light	Yellow Medium Azo(+) 412	Hansa Yellow 1020

© 1994 Susan Adams Bentley

ACRYLICS

Color Conversion Chart

FOLKART®

Acrylic Paints

FolkArt® (Plaid) "CJ" = Crown Jewels (See Notes 1-3, 6, 7)	Accent® Acrylics (See Notes 1-3, 6, 7)	DecoArt™ Americana™ (See Notes 1-3, 6, 7)	Delta® Ceramcoat® (See Notes 1-3, 6, 7)	Jo Sonja® (Chroma Acrylics) ("t" = Tad in recipes below) (See Notes 1-4)	Liquitex® Concentrated Artist Colors ("t" = Tad in recipes below) (See Notes 1-6)	Wally R.™ (See Notes 1-3, 6, 7)
Sweetheart Pink 955	Painted Desert(-) 2300	-----	Hydrangea Pink(-) 2449	TW+ROSE (8:1)	SW+HIB (2:1)	Lisa's Blush(+) 1051
Taffy 902	Antique White(+) 2429	Sand(+) 4	Ivory 2036	WW+TY (1:t)	SW+UBT(1:1)	Sweet Cream 1203
Tangerine 627	-----	Tangerine 12	Bittersweet Orange(+) 2041	YL+VER (5:1)	COH+L (3:1)	-----
Tapioca 903	Off White 2428	Buttermilk(-) 3	Antique White(+) 2001	TW+SP (2:1)	Soft White(-) 904	Antique Lace(-) 1007
Tartan Green 725	-----	Dark Pine(+) 49	-----	JADE+TEAL (1:1)	-----	-----
Teal 405	-----	-----	Emerald Green(-) 2482	PTHGR+NIM+PTHBL (3:1:1)	-----	-----
Teal Blue 717	-----	Ice Blue(-) 135	Blue Wisp(+) 2455	-----	-----	Pamadour Green(+) 1216
Teal Green 733	-----	-----	Rainforest Green(-) 2462	TEAL+OPL (1:1)	-----	-----
Teddy Bear Brown 417	-----	-----	Autumn Brown(+) 2055	-----	TP+RO+UBT (6:1:1)	-----
Teddy Bear Tan 419	-----	Antique Gold(-) 9	Spice Tan(+) 2063	RS+YO+WW (5:1:1)	TY+RS (2:1)	Cappucino(-) 1124
Thicket 924	Pine Needle Green 2445	Evergreen(+) 82	Dark Forest Green 2096	PINE+SAPH (2:1)	PHGH+RS (1:1)	Everglade 1093
Thunder Blue 609	-----	Midnite Blue 85	Prussian Blue(*) 2413	STRM+PG (2:1)	-----	-----
Titanium White 574	Titanium White 574	Snow (Titanium) White 1	White 2505	Titanium White	Titanium White 432	White 1005
Township Blue 606	Chesapeake Blue(+)2438	Blue Haze(+) 115	-----	COBL+CB (6:1)	BAL+SW (1:1)	Astro Blue(-) 1025
Trans. Oxide Red 566	-----	-----	-----	-----	-----	-----
Trans. Oxide Yellow 573	Golden Oxide 2339	-----	Mocha Brown(+) 2050	RS+GO (2:1)	-----	-----
True Blue 401	-----	True Blue 36	-----	UMB+SAPH (2:1)	-----	-----
Turquoise 961	-----	-----	-----	AQ+TW+TY (6:2:1)	BAG+PTHGR (10:1)	-----
Ultramarine 720	Ultra. Blue Deep(-) 2608	True Blue 36	-----	Ultramarine(+)	Ultramarine Blue(+) 380	-----
Ultramarine Blue 560	Pure Blue 2472	-----	Ultra Blue 2038	Ultra Blue Deep(+)	Cobalt Blue Hue 381	Electric Blue 1115
Vanilla Cream 703	Warm Neutral 2616	Antique White(+) 58	Sandstone(+) 2402	SP+TW (2:1)	UBT+PAR (2:1)	-----
Victorian Rose 620	-----	-----	-----	TW+NOR (20:1)	Pale Portrait Pink(-) 837	-----
Viridian 564	Phthalo Green 2610	Viridian Green(+) 108	Pthalo Green(+) 2501	PTHGR+SP (7:1)	Phthalocyanine Green 317	Pthalo Green(+) 1001
Warm White 649	Adobe Wash(+) 2311	-----	Lt. Ivory(-) 2401	Warm White	SW+UBT (3:1)	Antique Lace(+) 1007
Whipped Berry 759	-----	-----	-----	-----	-----	-----
Wicker White 901	Real White 2476	Snow (Titanium) White 1	White 2505	Titanium White	Titanium White 432	White 1005
Wintergreen 962	-----	Viridian Green(*-) 108	Deep River Green(-) 2419	TEAL+PTHGR (1:1)	PTHGR+BU (3:1)	Pthalo Green(-) 1001
Wrought Iron 925	-----	Midnite Green 84	Black Green 2116	TEAL+CB (3:1)	PHGH+MB (1:1)	Kohl Green 1071
Yellow Light 551	Yellow Light 2600	Yellow Light 144	Luscious Lemon 2004	Cadmium Yellow Light	CYMH+SW (1:1)	Juicy Lemon 1098
Yellow Medium 552	Sunkiss Yellow(-) 2432	Cadmium Yellow(+) 10	Bright Yellow 2027	Cadmium Yellow Mid(+)	Cadmium Yellow Med.(+) 161	Hansa Yellow 1020
Yellow Ochre 572	Yellow Ochre(+) 2601	Antique Gold(+) 9	Antique Gold 2002	YO+TW (2:1)	Yellow Oxide 416	Yellow Oxide 1008

© 1994 Susan Adams Bentley

Color Conversion Chart

FOLKART®

Acrylic Paints

NOTES

(1) A "+" indicates darker (or a "-" lighter) than first column color.

(2) An asterisk "*" indicates floats or washes don't match, though regular basecoats do.

(3) "N/A" indicates there is no comparable product in this brand.

(4) Refer to the Color Keys for these brands. Numbers shown in parentheses after the color name abbreviations equal "parts." For example, "RAS+SW+BU (2:1:t)" means to mix 2 parts of Raspberry with 1 part Soft White, and just a touch of Burnt Umber.

(5) "Pearl" = "Liquitex® Painter's Pearl Medium": Add small amount of paint to Medium. The more Medium added, the lighter and more pearlescent the color will become.

(6) Product numbers are for the 2-ounce size. DecoArt™ numbers will be preceded by a "DA" (for DecoArt™ Americana™) on the bottles.

(7) There are two FolkArt® colors with the name "Pure Orange." The one numbered 553 is a Pure Pigment Color; #628 is a Designer Jewel Color.

ACRYLICS

Color Conversion Chart

JO SONJA®

Acrylic Paints

Jo Sonja® (Chroma Acrylics)	Accent® Acrylics "CJ" = Crown Jewels (See Notes 1 - 3, 6)	DecoArt™ Americana™ (See Notes 1 - 3, 6)	Delta® Ceramcoat® (See Notes 1 - 3, 6)	FolkArt® (Plaid) (See Notes 1 - 3, 6)	Liquitex® Concentrated Artist Colors ("1" = Tad in recipes below) (See Notes 1 - 6)	Wally R.™ (See Notes 1 - 3, 6)
Amethyst	-----	-----	Lilac Dusk(-) 2403	-----	PAR+RAS+PV (2:1:1)	Pink Begonia 1153
Aqua	Marina Blue(-) 2507	Desert Turquoise(-) 44	Laguna Blue(-) 2418	-----	BAG+NVY (8:1)	Blue Lagoon(-) 1158
Blue Iridescent	N/A	N/A	N/A	N/A	Interference Blue 42	N/A
Brilliant Green	True Green(-) 2474	Holly Green 48(*)	Jubilee Green 2421	-----	Christmas Green(*-) 902	Teal Green(-) 1094
Brown Earth	-----	-----	-----	-----	BU+BS (2:1)	Burnt Umber(*-) 1018
Burgundy	-----	Cranberry Wine(+) 112	Black Cherry(-) 2484	Alizarine Crimson 556	Burgundy 834	Cranberry(-) 1083
Burnt Sienna	-----	Burnt Sienna(*) 63	Burnt Sienna(-) 2030	-----	Burnt Siena 127	-----
Burnt Umber	Burnt Umber 2613	-----	Walnut(-) 2024	Raw Umber(-) 571	BU+IB (3:1)	Raw Umber 1017
Cadmium Scarlet	Napthol Red Lt. 2603	Cadmium Red 15	-----	Red Lt.(-) 554	SCR+CRMH (10:1)	-----
Cadmium Yellow Lt.	Yellow Lt. 2600	Lemon Yellow 11	Luscious Lemon(-) 2004	Yellow Lt. 551	Yellow Lt. Hansa(-) 411	Juicy Lemon 1098
Cadmium Yellow Mid	Sunkiss Yellow(-) 2432	Cadmium Yellow(+) 10	Bright Yellow(-) 2027	Yellow Medium 552	Cad. Yellow Medium Hue(+) 830	Hansa Yellow(-) 1020
Carbon Black	Ebony Black 2612	Ebony (Lamp) Black 67	Black 2506	Licorice 938	Mars Black 276	Black 1006
Cobalt Blue Hue	Ultra. Blue Deep(-) 2608	Ultra. Blue Deep(+) 100	-----	Cobalt Blue(+) 561	Cobalt Blue Hue 381	-----
Colony Blue	Nevada Turquoise(-) 2307	-----	Avalon Blue(+) 2417	-----	BB+BU (2:1)	Pacifica(+) 1157
Dioxazine Purple	Diox. Purple(-) 2606	Diox. Purple(-) 101	Purple 2015	Diox. Purple 558	Dioxazine Purple 186	-----
Fawn	-----	Mink Tan(-) 92	Bambi Brown 2424	-----	SW+TP (1:1)	Doeskin(-) 1095
French Blue	-----	-----	Nightfall Blue 2131	Denim Blue(*) 721	PG+NG5+UMB (2:2:1)	-----
Gold Oxide	-----	-----	Terra Cotta 2071	-----	RS+SCR+UBT (3:1:1)	Jamocha(+) 1033
Green Iridescent	N/A	N/A	N/A	N/A	Interference Green 44	N/A
Green Oxide	-----	-----	Chrome Green Lt. 2011	Old Ivy(+) 927	PHGH+BG (2:1)	-----
Indian Red Oxide	Fingerberry Red(+) 2425	Rookwood Red(*-) 97	Candy Bar Brown 2407	-----	BUR+BU (1:1)	-----
Jade	-----	-----	Leprechaun 2422	-----	BG+PHGH (3:1)	Blarney 1159
Moss Green	-----	-----	-----	-----	YO+OL (1:1)	Olive Branch(-) 1160
Napthol Crimson	Crimson 2604	-----	Napthol Red Lt.(-) 2409	Napthol Crimson 555	Napthol Crimson 292	Napthol Crimson 1085
Napthol Red Light	Razzle Red 2579	Berry Red 19	Napthol Crimson 2408	Christmas Red(-) 958	SCR+CRMH (4:1)	Toluidine Red 1003
Nimbus Gray	-----	-----	Cadet Gray(-) 2426	-----	UBT+NG5 (1:1)	Dove Gray(-) 1038
Norwegian Orange	-----	Georgia Clay(-) 17	Georgia Clay(-) 2097	-----	RO+SCR (1:1)	Russet(*-) 1058
Opal	Cool Neutral 2615	Warm Neutral Tone(+) 90	Wild Rice 2453	Milkshake 704	PAR+VR+SDL (6:1:1)	-----
Orange Iridescent	N/A	N/A	N/A	N/A	Interference Orange 36	N/A
Pale Gold Metallic	-----	-----	14K Gold Gleams 2604	Inca Gold Met.(-) 676	Iridescent Gold 234	49'er Gold(-) 1513
Payne's Grey	Payne's Grey(-) 2609	-----	Midnight Blue(-) 2114	Payne's Gray 575	Payne's Gray 310	Prussian Blue(-) 1088
Pearl White	Baroque Pearl CJ2532	White Pearl 117	Pearl Finish Gleams 2601	Pearl White 659	Iridescent White 432	Pearl White 1520

Color Conversion Chart

JO SONJA®

Acrylic Paints

ACRYLICS

Jo Sonja® (Chroma Acrylics)	Accent® Acrylics "CJ" = Crown Jewels (See Notes 1 - 3, 6)	DecoArt™ Americana™ (See Notes 1 - 3, 6)	Delta® Ceramcoat® (See Notes 1 - 3, 6)	FolkArt® (Plaid) (See Notes 1 - 3, 6)	Liquitex® Concentrated Artist Colors ("t" = Tad in recipes below) (See Notes 1 - 6)	Wally R.™ (See Notes 1 - 3, 6)
Pine Green	-----	-----	Dark Jungle Green 2420	Southern Pine(*-) 730	YLH+MB (5:1)	Bay Leaf(-) 1073
Plum Pink	Burgundy(+) 2605	-----	Dusty Mauve 2405	Raspberry Sherbert(-) 966	DVR+NG5 (2:1)	-----
Provincial Beige	-----	-----	Territorial Beige 2425	-----	RS+BAL+VR (3:1:1)	Soil 1161
Prussian Blue Hue	-----	Midnite Blue(-) 85	Prussian Blue 2413	Prussian Blue(*-) 559	UMB+BU (2:1)	Manganese Blue(-)1146
Pthalo Blue	-----	Ultra. Blue Deep 100	Pthalo Blue 2502	-----	Phthalocyanine Blue 316	Pthalo Blue 1002
Pthalo Green	Pthalo Green 2610	Viridian Green 108	Pthalo Green 2501	Pthalo Green 563	Phthalocyanine Green(-) 317	Pthalo Green 1001
Raw Sienna	Tumbleweed 2305	Raw Sienna 93	Raw Sienna 2411	English Mustard(-) 959	BY+BS (4:1)	Raw Sienna 1156
Raw Umber	Raw Umber(*) 2427	Raw Umber(-) 571	Walnut 2024	Raw Umber(-) 571	Raw Umber(*) 331	Raw Umber 1017
Red Earth	-----	Red Iron Oxide(-) 96	Red Iron Oxide(-) 2020	Rusty Nail(-) 914	Red Oxide(-) 335	Red Iron Oxide 1014
Red Iridescent	N/A	N/A	N/A	N/A	Interference Red 38	N/A
Rich Gold Metallic	Imperial Ant. Gold 2528	Venetian Gold Met. 72	-----	Antique Gold Met. 658	-----	Gold Met.(-) 1510
Rose Pink	-----	-----	-----	-----	CRMH+SCR+SDL (2:1:1)	-----
Sapphire	Sapphire 2607	Sapphire(-) 99	Copen Blue 2051	Paisley Blue(*+) 967	UMB+FGB+PHBL (2:2:1)	Sapphire Blue(-) 1034
Silver Metallic	Regency Silver CJ2530	Shimmering Silver Met. 70	Silver Met. Gleams 2603	Silver Sterling Met. 662	Iridescent Silver 236	Silver Met.(+) 1511
Smoked Pearl	-----	Desert Sand(-) 77	Sandstone(-) 2402	Clay Bisque 601	PAR+SDL (1:t)	-----
Storm Blue	Liberty Blue(-) 2439	-----	Dark Night Blue(-) 2414	-----	NVY+MB (2:1)	Velvet Night(-) 1089
Super Copper Metallic	Royal Copper CJ 2529	-----	-----	Copper Met. 664	Iridescent Copper 233	-----
Teal Green	Teal Deep(-) 2611	-----	Deep River Green(-) 2419	Wintergreen(-) 962	RT+PHGR (3:1)	Deep Sea(-) 1092
Titanium White	Titanium White 2617	Snow (Titanium) White 1	White 2505	Titanium White 574	Titanium White 432	White 1005
Transparent Magenta	-----	Red Violet(*) 140	Sweetheart Blush(+) 2130	Magenta(-) 412	Raspberry(-) 901	-----
Turner's Yellow	Dijon Gold(-) 2318	-----	Empire Gold 2412	Harvest Gold(+) 917	Turner's Yellow 730	Spun Gold 1087
Ultramarine	Ultra. Blue Deep(-) 2608	Ultra Blue Deep(-) 100	-----	Ultramarine(-) 720	Cobalt Blue 170	-----
Ultramarine Blue Deep	Pure Blue(-) 2472	-----	Ultra Blue(-) 2038	Ultramarine Blue 560	Cobalt Blue Hue 381	Electric Blue(-) 1115
Vermilion	Vermillion(-) 2602	Cadmium Orange(-) 14	Orange(*) 2026	Red Orange(*-) 629	SCR+CYMH (3:1)	Orange(*) 1019
Violet Iridescent	N/A	N/A	N/A	N/A	Interference Violet 40	N/A
Warm White	-----	Buttermilk(+) 3	Lt. Ivory 2401	Warm White 649	Soft White(-) 904	Tusk 1080
Yellow Light	Pure Yellow 2471	Yellow Lt. 144	Bright Yellow 2027	Yellow Medium 552	Yellow Medium Azo 412	Hansa Yellow(-) 1020
Yellow Oxide	Yellow Ochre(-) 2601	Antique Gold(-) 9	Antique Gold(-) 2002	Yellow Ochre(-) 572	Yellow Oxide(-) 416	Yellow Oxide(-) 1008

© 1994 Susan Adams Bentley

See notes on next page.

Acrylic Paints

Color Conversion Chart

JO SONJA®

NOTES

(1) A "+" indicates darker (or a "-" lighter) than first column color.
(2) An asterisk "*" indicates floats or washes don't match, though regular basecoats do.
(3) "N/A" indicates there is no comparable product in this brand.
(4) Refer to the Liquitex® Color Key. Numbers shown in parentheses after the color name abbreviations equal "parts." For example, "RAS+SW+BU (2:1:t)" means to mix 2 parts of Raspberry with 1 part Soft White, and just a touch of Burnt Umber.
(5) "Pearl" = "Liquitex® Painter's Pearl Medium": Add small amount of paint to Medium. The more Medium added, the lighter and more pearlescent the color will become.
(6) Product numbers are for the 2-ounce size. DecoArt™ numbers will be preceded by a "DA" (for DecoArt™ Americana™) on the bottles.

Color Conversion Chart LIQUITEX Acrylic Paints

ACRYLICS

Liquitex® Concentrated Artist Colors (See Notes 1-3, 5)	Accent® Acrylics "CJ" = Crown Jewels (See Notes 1-3, 5)	DecoArt™ Americana™ (See Notes 1-3, 5)	Delta® Ceramcoat® (See Notes 1-3, 5)	FolkArt® (Plaid) (See Notes 1-3, 5)	Jo Sonja® (Chroma Acrylics) ("t" = Tad in recipes below) (See Notes 1-4)	Wally R.™ (See Notes 1-3, 5)
Acra Red 112	Razzle Red(+) 2579	Brilliant Red(+) 145	Crimson(+) 2076	Christmas Red(-) 958	Napthol Red Lt. (+)	Fire Truck Red 1050
Acra Violet 114	-----	-----	-----	Magenta(-) 412	Transparent Magenta(+)	-----
Apricot 836	-----	-----	-----	Peach Cobbler(+) 738	WW+VER+YL+BE (7:2:2:t)	-----
Baltic Blue 379	Chesapeake Blue(*-) 2438	Blue Haze(+) 115	-----	-----	COBL+CB+TW (3:1:1)	-----
Baltic Green 835	-----	-----	-----	-----	JADE+WW+FB (3:2:1)	-----
Bright Aqua Green 660	-----	-----	-----	Turquoise(+) 961	AQ+TW+TY (6:2:1)	-----
Brilliant Blue 570	-----	-----	Azure Blue(+) 2483	-----	COBL+PTHBL+TW (1:1:1)	-----
Brilliant Blue Purple (See Cobalt Blue Hue) 381						
Brilliant Orange (See Cad. Orange Hue) 720						
Brilliant Purple 590	-----	Lavender(+) 34	-----	Lavender(+) 410	TW+DP (3:1)	-----
Brilliant Yellow (See Cad. Yel Medium Hue) 830						
Bronze Yellow 530	-----	-----	-----	-----	YO+RU (1:1)	-----
Burgundy 834	Bordeaux 2322	Cranberry Wine(-)112	Mendocino Red(*-)2406	Aliz. Crimson 556	BUR+BU (1:t)	Cranberry(*-) 1083
Burnt Siena 127	Burnt Sienna 2614	Burnt Sienna(*-) 63	Burnt Sienna(-) 2030	-----	RE+BU (1:t)	Burnt Sienna(-) 1022
Burnt Umber 128	-----	Dark Chocolate(-) 65	Burnt Umber 2025	Burnt Umber(-) 570	RU+BE (1:1)	Burnt Umber 1018
Cadmium Orange 150	-----	-----	-----	-----	YL+VER (3:1)	-----
Cad. Orange Hue (Was Bril. Orange) 720	-----	Tangerine(-) 12	Pumpkin(+) 2042	Tangerine(-) 627	YL+VER (3:1)	-----
Cadmium Red Light 152	-----	Cadmium Orange(+) 14	-----	Red Lt.(+) 554	CS+VER (1:1)	Orange(-) 1019
Cad. Red Light Hue (Was Scarlet Red) 510	-----	Cadmium Orange(+) 14	Orange(+) 2026	Red Lt.(+) 554	CS+VER (1:1)	Orange(+) 1019
Cadmium Red Medium 154	Pure Red(+) 2470	Cadmium Red(-) 15	Crimson(+) 2076	Christmas Red 958	Napthol Red Lt.	Toluidine Red(+) 1003
Cad. Red Medium Hue (Was Lacquer Red) 151	Razzle Red(-) 2579	Berry Red(+) 19	Crimson(+) 2076	Christmas Red(-) 958	Napthol Red Lt.	Toluidine Red(+) 1003
Cadmium Yellow Light 160	Yellow Lt.(-) 2600	Yellow Lt. 144	Luscious Lemon 2004	Yellow Lt. 551	Cadmium Yellow Lt.	Juicy Lemon(-) 1098
Cad. Yellow Light Hue 159	Yellow Lt. 2600	Yellow Lt. 144	Luscious Lemon 2004	Yellow Lt. 551	Cadmium Yellow Lt.	Juicy Lemon 1098
Cadmium Yellow Medium 161	Sunkiss Yellow(-) 2432	Cadmium Yellow 10	Yellow(+) 2504	Yellow Medium 552	CYM+TY (3:1)	School Bus Yellow(+) 1004
Cad. Yellow Med Hue (Was Brilliant Yellow 830)	Sunkiss Yellow(-) 2432	Cadmium Yellow 10	Yellow(+) 2504	Yellow Medium 552	CYM+TY (3:1)	School Bus Yellow(+) 1004
Cerulean Blue 164	-----	-----	Copen Blue(+) 2051	Cerulean Blue Hue 562	SAPH+UMB (1:1)	Sapphire(+) 1034

Color Conversion Chart

LIQUITEX®

Acrylic Paints

ACRYLICS

Liquitex® Concentrated Artist Colors (See Notes 1 - 3, 5)	Accent® Acrylics "CJ" = Crown Jewels (See Notes 1 - 3, 5)	DecoArt™ Americana™ (See Notes 1 - 3, 5)	Delta® Ceramcoat® (See Notes 1 - 3, 5)	FolkArt® (Plaid) (See Notes 1 - 3, 5)	Jo Sonja® (Chroma Acrylics) ("t" = Tad in recipes below) (See Notes 1 - 4)	Wally R.™ (See Notes 1 - 3, 5)
Cerulean Blue Hue 470	-----	-----	Copen Blue(+) 2051	Cerulean Blue Hue 562	SAPH+UMB (1:1)	Sapphire(+) 1034
Christmas Green 902	Holiday Green(+) 2577	Kelly Green(+) 55	Jubilee Green(*) 2421	-----	BG+PTHGR (3:1)	Teal Green(*) 1094
Chromium Oxide Green 166	-----	Hauser Med. Green(-) 132	Chrome Green Lt.(-)2011	Old Ivy(+) 927	Green Olive	-----
Cobalt Blue 170	Ultra Blue Deep(-) 2608	Ultra Blue Deep(+) 100	Ultra Blue(+) 2038	Cobalt Blue(+) 561	Ultramarine(+)	-----
Cobalt Blue Hue (was Brilliant Blue Purple) 381	Pure Blue(-) 2472	Ultra Blue Deep(*+)100	Ultra Blue(-) 2038	Cobalt Blue(-) 561	Ultra Blue Deep(+)	-----
Dark Victorian Rose 833	-----	-----	Dusty Mauve 2405	Raspberry Sherbert(-) 966	Plum Pink	-----
Deep Portrait Pink 838	-----	Shading Flesh(-) 137	-----	Spice Pink(+) 750	OPL+RE (4:1)	-----
Dioxazine Purple 186	Diox. Purple 2606	Diox. Purple(-) 101	Purple(-) 2015	Diox. Purple 558	Dioxazine Purple	-----
Emerald Green 450	-----	Holly Green(+) 48	-----	Green 408	BG+PTHGR (3:1)	-----
Fluorescent Blue 984	N/A	Electric Blue DHS6	N/A	N/A	N/A	Fluorescent Blue 1504
Fluorescent Green 985	N/A	-----	N/A	N/A	N/A	Fluorescent Green(+) 1503
Fluorescent Orange 982	N/A	-----	N/A	N/A	N/A	Fluorescent Orange(-) 1507
Fluorescent Pink 987	N/A	Sizzling Pink DHS3	N/A	N/A	N/A	-----
Fluorescent Red 983	N/A	Fiery Red DHS4	N/A	N/A	N/A	Fluorescent Flame 1508
Fluorescent Yellow 981	N/A	Scorching Yellow DHS1	N/A	N/A	N/A	Fluor. Chartreuse 1506
French Gray/Blue 243	Stoneware Blue 2440	French Gray/Blue(-) 98	Cape Cod Blue 2133	Settler's Blue 607	FB+TW (1:1)	-----
Hibiscus 908	-----	-----	-----	-----	CS+NC+OPL (2:1:1)	-----
Interference (were Opalescents)						
Interference Blue 042	N/A	N/A	N/A	N/A	Blue Iridescent	N/A
Interference Gold 083	N/A	N/A	N/A	N/A	-----	N/A
Interference Green 044	N/A	N/A	N/A	N/A	Green Iridescent	N/A
Interference Orange 036	N/A	N/A	N/A	N/A	Orange Iridescent	N/A
Interference Red 038	N/A	N/A	N/A	N/A	Red Iridescent	N/A
Interference Violet 040	N/A	N/A	N/A	N/A	Violet Iridescent	N/A
Iridescents (were Metallics)						
Iridescent Bronze 232	-----	-----	-----	-----	-----	-----
Iridescent Copper 233	Royal Copper CJ2529	Bronze Metallic(-) 73	-----	Copper Metallic 664	Super Copper Metallic	Copper Met.(+) 1512
Iridescent Gold 234	-----	-----	-----	Inca Gold Met. 676	Pale Gold Metallic	49'er Gold(+) 1513
Iridescent Silver 236	Regency Silver(+)CJ2530	Shimmering Silver Met. 70	Silver Gleams 2603	Silver Sterling Met. 662	Silver Metallic	Silver Met.(+) 1511
Iridescent Stainless Steel 239	-----	-----	-----	Gunmetal Gray Met.(+)667	-----	-----

Color Conversion Chart

LIQUITEX — **Acrylic Paints** — **ACRYLICS**

Liquitex® Concentrated Artist Colors (See Notes 1 - 3, 5)	Accent® Acrylics "CJ" = Crown Jewels (See Notes 1 - 3, 5)	DecoArt™ Americana™ (See Notes 1 - 3, 5)	Delta® Ceramcoat® (See Notes 1 - 3, 5)	FolkArt® (Plaid) (See Notes 1 - 3, 5)	Jo Sonja® (Chroma Acrylics) ("t" = Tad in recipes below) (See Notes 1 - 4)	Wally R.™ (See Notes 1 - 3, 5)
Iridescent White (Pearl) 238	Baroque Pearl CJ2532	White Pearl 117	Pearl Finish Gleams 2601	Pearl White Metallic 659	Pearl White Metallic	Pearl White 1520
Ivory Black 244	Soft Black 2447	Ebony (Lamp) Black 67	Black 2506	Ivory Black 576	Carbon Black	Black 1006
Lacquer Red (See Cad. Red Med. Hue) 151						
Light Blue Violet 680	-----	-----	-----	-----	COBH+TW+DP (3:3:1)	-----
Light Magenta 700	-----	Spice Pink(+)	-----	-----	TW+ROSE+TM (3:1:t)	-----
Light Portrait Pink 810	-----	-----	-----	-----	TW+ROSE+YL (8:1:t)	-----
Maroon 501	-----	-----	-----	Burnt Carmine(-) 567	BU+BUR+TM (2:1:t)	-----
Mars Black 276	Ebony Black 2612	Ebony (Lamp) Black 67	Black 2506	Licorice 938	Carbon Black	Black 1006
Medium Magenta 500	-----	-----	-----	-----	TM+WW (3:1)	-----
Metallics (See "Iridescents")						
Mix. Gray (See Neut Gray) 599						
Naphthol Crimson 292	Holiday Red(-) 2421	-----	Napthol Red Lt.(-) 2409	Napthol Crimson 555	Napthol Crimson	Napthol Crimson(-) 1085
Naphthol Red Light 294	Napthol Red Lt. 2603	Napthol Red 104	Crimson(+) 2076	Red Lt.(-) 554	Napthol Red Light	Persian Red 1130
Navy 832	Windsor Blue 2317	Midnite Blue 85	-----	-----	PBH+PTHBL (1:1)	Blazer Blue(+) 1052
Neutral Gray Value 5 (Was Mixing Gray) 599	-----	Neutral Gray Tone(+) 95	-----	-----	NIM+CB (4:1)	-----
Olive 907	-----	Lt. Avocado(+) 106	English Yew(+) 2095	-----	PINE+MOSS+CB (4:1:t)	Green Olive(-) 1100
Opalescents (See "Interference")						
Pale Portrait Pink 837	-----	Flesh(-) 24	-----	Victorian Rose(+) 620	TW+CS+BE (20:1:t)	Pink(-) 1110
Parchment 436	-----	-----	-----	-----	WW+SP+MOSS (6:2:2)	-----
Payne's Gray 310	-----	-----	Dark Night Blue(-) 2414	Payne's Gray 575	PG+CB (4:1)	-----
Perm. Alizarine Crim. Hue 116	Holiday Red(-) 2421	Crimson Tide(+) 21	Tompte Red(+) 2107	-----	NC+BUR (4:1)	Valentine 1065
Perm. Green Light 312	-----	-----	Jubilee Green(+) 2421	-----	BG+CYL (4:1)	Teal Green(+) 1094
Perm. Hooker's Green Hue 224	-----	Forest Green(*) 50	-----	-----	PINE+PTHGR+CB (2:1:t)	-----
Perm. Light Blue 770	-----	Indian Turquoise(-) 87	-----	-----	AQ+UMB+TW (1:1:1)	-----
Perm. Light Violet 790	-----	-----	GP Purple(+) 2091	-----	TW+AM+PBH (1:1:t)	-----
Perm. Sap Green 315	-----	Leaf Green(*) 51	-----	-----	PINE+GRNOX (1:1)	-----
Perm. Viridian Hue 398	-----	Black Forest Green 83	Hunter Green(+) 2471	-----	PTHGR+CB (3:1)	-----

Color Conversion Chart

LIQUITEX® Acrylic Paints

Liquitex® Concentrated Artist Colors (See Notes 1 - 3, 5)	Accent® Acrylics "CJ" = Crown Jewels (See Notes 1 - 3, 5)	DecoArt™ Americana™ (See Notes 1 - 3, 5)	Delta® Ceramcoat® (See Notes 1 - 3, 5)	FolkArt® (Plaid) (See Notes 1 - 3, 5)	Jo Sonja® (Chroma Acrylics) ("t" = Tad in recipes below) (See Notes 1 - 4)	Wally R.™ (See Notes 1 - 3, 5)
Phthalocyanine Blue 316	-----	-----	Pthalo Blue(*) 2502	-----	Pthalo Blue	Pthalo Blue(+) 1002
Phthalocyanine Green 317	Pthalo Green 2610	Viridian Green 108	Pthalo Green(+) 2501	Pthalo Green(+) 563	Pthalo Green(+)	Pthalo Green(+) 1001
Prism Violet 391	True Purple(-) 2475	-----	-----	Red Violet(+) 636	TM+DP+TW (1:1:t)	-----
Prussian Blue 318	Windsor Blue(-) 2317	Prussian Blue(+) 138	Navy Blue(-) 2089	Prussian Blue(+) 559	PBH+PTHBL (1:1)	Manganese Blue(+) 1146
Raspberry 901	Fuchsia(-) 2335	-----	-----	Magenta(-) 412	TM+TW (2:1)	-----
Raw Siena 330	Tumbleweed(-) 2305	Raw Sienna(*-) 93	Raw Sienna 2411	Raw Sienna(-) 569	RS+RE (5:1)	Raw Sienna(-) 1156
Raw Umber 331	Burnt Umber(*) 2613	Raw Umber(-) 130	Walnut(*) 2024	Raw Umber(*-)	BU+RS (5:1)	Raw Umber(*) 1017
Real Teal 903	-----	Blue Green 142	-----	-----	PTHGR+PTHBL+TW (3:3:1)	-----
Red Oxide 335	Pennsylvania Clay(-) 2423	Red Iron Oxide 96	Red Iron Oxide(+) 2020	Rusty Nail 914	NOR+RE (1:1)	Red Iron Oxide 1014
Sandalwood 438	-----	-----	Misty Mauve(-) 2441	-----	SP+BS (1:1)	Dusty Rose 1176
Scarlet 905	-----	-----	-----	-----	NRL+VER (1:1)	-----
Scarlet Red (See Cad. Red Lt. Hue) 510						
Soft White 904	-----	-----	Lt. Ivory 2401	Warm White(+) 649	Warm White (+)	Tusk 1080
Swedish Blue 906	-----	-----	Copen Blue(+) 2051	Cerulean Blue(+) 562	SAPH+PTHBL (1:1)	-----
Taupe 831	-----	-----	-----	-----	BE+SP (2:1)	-----
Titanium White 432	Titanium White 2617	Snow (Titanium) White 1	White 2505	Titanium White 574	Titanium White	White 1005
Turner's Yellow 730	Dijon Gold(-) 2318	-----	Empire Gold 2412	-----	Turner's Yellow	Spun Gold 1087
Turquoise Deep 561	-----	Blue Green 142	-----	-----	PTHGR+PTHBL (1:1)	-----
Turquoise Green 560	-----	Bluegrass Green(+) 47	-----	Turquoise(-) 961	AQ+PTHGR (1:1)	-----
Twilight 910	-----	-----	-----	Blue Ink(+) 642	UBD+FB (2:1)	-----
Ultramarine Blue 380	Pure Blue(-) 2472	Ultra Blue Deep(*) 100	Ultra Blue(-) 2038	Ultramarine Blue(-) 560	Ultramarine Blue Deep	Electric Blue(-) 1115
Unbleached Titanium 434	-----	Toffee(+) 59	AC Flesh(+) 2085	-----	TW+RS+RU (6:2:1)	Warm Beige(+) 1131
Venetian Rose 149	Roseberry(-) 2450	Mauve 26	Bouquet Pink 2132	Potpourri Rose(-) 624	OPL+PLUM+BU (2:1:t)	Zinfandel 1151
Wisteria 909	-----	-----	-----	-----	UMB+NC (2:1)	-----
Yellow Light Hansa 411	Yellow Lt. 2600	Lemon Yellow 11	Luscious Lemon(-) 2004	Yellow Lt. 557	Cadmium Yellow Lt.	Juicy Lemon 1098
Yellow Medium Azo 412	Pure Yellow(+) 2471	Yellow Lt.(-) 144	Bright Yellow(+) 2029	Sunny Yellow(+) 918	Yellow Lt.	Hansa Yellow(+) 1020
Yellow Orange Azo 414	-----	-----	-----	-----	CYM+VER (5:1)	-----
Yellow Oxide 416	Yellow Ochre 2601	True Ochre 143	Antique Gold 2002	Yellow Ochre 572	YO+TW (2:1)	Yellow Oxide(+) 1008

© 1994 Susan Adams Bentley

See notes on next page.

Color Conversion Chart

LIQUITEX®

Acrylic Paints

NOTES

(1) A "+" indicates darker (or a "-" lighter) than first column color.
(2) An asterisk "*" indicates floats or washes don't match, though regular basecoats do.
(3) "N/A" indicates there is no comparable product in this brand.
(4) Refer to the Jo Sonja® Color Key. Abbreviations for the Jo Sonja® recipes are followed by numbers in parentheses, which equal "parts." For example, "SP+ROSE+BU (2:1:t)" means to mix 2 parts of Smoked Pearl with 1 part Rose Pink and just a touch of Burnt Umber.
(5) Product numbers are for the 2-ounce size. DecoArt™ numbers will be preceded by a "DA" (for DecoArt™ Americana™) on the bottles.

ACRYLICS

Color Conversion Chart

WALLY R.®

Acrylic Paints

© 1994 Susan Adams Bentley

Wally R.™ (See Note 6)	Accent® Acrylics "CJ" = Crown Jewels (See Notes 1 -3, 6)	DecoArt™ Americana™ (See Notes 1 - 3, 6)	Delta® Ceramcoat® (See Notes 1 - 3, 6)	FolkArt® (Plaid) (See Notes 1 - 3, 6)	Jo Sonja® (Chroma Acrylics) ("t" = Tad in recipes below) (See Notes 1 - 4)	Liquitex® Concentrated Artist Colors ("t" = Tad in recipes below) (See Notes 1 - 6)
Aegean Blue 1064	-----	Williamsburg Blue(+) 40	Bonnie Blue 2106	Bluebell(-) 909	TW+FB+BU (3:2:t)	FGB+PLB (1:1)
Amethyst 1122	-----	-----	Lilac 2060	-----	TW+AM+STRM (2:1:t)	SW+PV (5:1)
Antique Lace 1007	Off White 2428	Buttermilk(+) 3	-----	Tapioca(+) 903	TW+SP (2:1)	SW+UBT (2:1)
Apache 1141	-----	-----	Cloudberry Tan 2112	-----	-----	BY+SW (1:1)
Apache Dawn 1191	Lt. Roseberry 2464	-----	-----	-----	OPL+PLUM+BU (3:1:t)	TW+DVR (2:1)
Aqua 1222	-----	-----	Tropic Bay Blue(-) 2451	-----	TW+AQ+PTHGR (11:2:1)	-----
Arrowhead 1166	-----	-----	-----	-----	-----	UBT+NG5 (2:1)
Artichoke 1140	-----	-----	Boston Fern 2110	-----	PINE+YO+RU (2:1:1)	PGL+RS (1:1)
Astro Blue 1025	Chesapeake Blue(+) 2438	Blue Haze(+) 115	Avalon Blue(-) 2417	Bavarian Blue(+) 907	COBL+MB+TW (3:1:1)	RT+FGB (2:1)
Aztec 1145	Barn Red 2424	Brandy Wine(+) 79	Burgundy Rose(+) 2123	Apple Spice(-) 951	IRO+RE+NC (4:1:t)	BUR+RO (2:1)
Banana Cream 1061	Mellow Yellow(-) 2410	Lemon Yellow(-) 11	Pineapple Yellow 2101	Lemon Custard 735	TW+CYM (6:1)	CYMH+TW (1:1)
Bay Leaf 1073	Pine Needle Green 2445	Plantation Pine 113	Gamel Green(*) 2120	Southern Pine(+) 730	PINE+SAPH+RU (2:1:t)	YLH+MB (3:1)
Big Sky 1187	Lt. Soft Blue 2461	-----	-----	-----	-----	-----
Bing Cherry 1047	Pueblo Red(-) 2302	Crimson Tide(+) 21	Maroon 2075	Barnyard Red(*) 611	BUR+TM (3:1)	RAS+BUR (2:1)
Black 1006	Ebony Black 2612	Ebony (Lamp) Black 67	Black 2506	Licorice 938	Carbon Black	Mars Black 276
Blade 1042	-----	-----	Leaf Green 2067	-----	GRNOX+YL (1:1)	CYMH+PHGH (4:1)
Blarney 1159	-----	-----	Leprechaun 2422	-----	JADE+OPL (3:1)	BG+PHGH (3:1)
Blazer Blue 1052	-----	Midnite Blue(+) 85	Navy Blue(-) 2089	-----	PBH+PTHBL (1:1)	Navy 832
Blue Birds 1121	-----	-----	Blue Jay 2059	-----	UMB+WW (2:1)	-----
Blue Lagoon 1158	Marina Blue(-) 2507	Desert Turquoise(+) 44	Laguna Blue 2418	-----	Aqua	PLB+RT (1:1)
Brandy 1169	Eggplant(+) 2337	-----	Vintage Wine 2434	Purple Passion(*) 638	UMB+NC (2:1)	WIS+DP+BU (1:1:t)
Breezy Turquoise 1039	Marina Blue(-) 2507	Desert Turquoise(-) 44	Colonial Blue 2058	-----	AQ+TW+UMB (2:1:1)	PLB+RT (1:1)
Brick 1144	Sedona Clay(-) 2301	Red Iron Oxide 96	Burnt Sienna(+) 2030	-----	-----	BS+COH (1:t)
Bright Green 1116	-----	-----	-----	-----	-----	-----
Brown Iron Oxide 1016	-----	Burnt Umber(+) 64	Brown Iron Oxide (+) 2023	-----	BE+RS (2:1)	BU+BS+RS (3:2:1)
Brown Sugar 1036	-----	-----	Golden Brown(+) 2054	English Mustard 959	Raw Sienna(+)	RS+YO (2:1)
Burgundy 1181	Bordeaux(-) 2322	Rookwood Red 97	Sonoma Wine(+) 2446	-----	BUR+BU (1:t)	BUR+BU (1:1)
Burnt Almond 1214	Cool Neutral(+) 2615	Warm Neut. Tone(+) 90	Wild Rice(-) 2453	Milkshake(+)704	OPL+SP (3:1)	SDL+SW+BU (2:1:t)
Burnt Sienna 1022	Burnt Sienna(+) 2614	-----	Burnt Sienna 2030	Burnt Sienna 568	RE+BU (1:t)	Burnt Sienna 127
Burnt Umber 1018	Burnt Umber(+) 2437	Dark Chocolate(+) 65	Burnt Umber 2025	Burnt Umber 570	RU+BE (1:1)	Burnt Umber 128
Cameo Pink 1198	-----	-----	Pink Frosting(+) 2461	Portrait Lt.(-) 421	TW+CS (1:t)	TW+PPP (1:1)
Cappucino 1124	-----	-----	Spice Tan 2063	Teddy Bear Tan(+) 419	RS+YO+WW (5:1:1)	-----

Color Conversion Chart

Acrylic Paints

WALLY R.®

ACRYLICS

© 1994 Susan Adams Bentley

Wally R.™ (See Note 6)	Accent® Acrylics "CJ" = Crown Jewels (See Notes 1-3, 6)	DecoArt™ Americana™ (See Notes 1-3, 6)	Delta® Ceramcoat® (See Notes 1-3, 6)	FolkArt® (Plaid) (See Notes 1-3, 6)	Jo Sonja® (Chroma Acrylics) ("t" = Tad in recipes below) (See Notes 1-4)	Liquitex® Concentrated Artist Colors ("t" = Tad in recipes below) (See Notes 1-6)
Caribou 1049	Golden Harvest(+) 2433	-----	Straw 2078	Buttercup(-) 905	WW+YO (1:1)	YO+CYMH (2:1)
Carnation 1219	Painted Desert 2300	-----	Hydrangea(+) 2449	Sweetheart Pink(+) 955	TW+CS (1:t)	SW+HIB (6:1)
Cashmere Rose 1028	-----	-----	Coral 2044	Promenade(+) 912	ROSE+TY+TW (2:1:1)	SCR+SDL (1:1)
Caspian 1173	-----	-----	Adriatic Blue(+) 2438	Slate Blue(-) 910	FB+TW+CB (2:1:t)	FGB+IB (1:1)
Chamisa 1192	Lt. Peaches & Cream(-) 2465	-----	-----	Apricot Cream(+) 911	WW+GO+TY (5:1:t)	AP+LPP (1:1)
Chamois 1040	-----	Yellow Ochre(+) 8	Maple Sugar Tan(-) 2062	Buttercrunch(-) 737	WW+TY (3:1)	SW+RS+CYMH (7:1:1)
Charcoal Blue 1090	-----	-----	Heritage Blue(+) 2415	Denim Blue 721	-----	TWI+NG5 (2:1)
Cherub 1165	Apricot Stone(-) 2448	-----	Rosetta Pink(-) 2430	Peach Perfection(+) 617	WW+NOR+PINE (4:1:t)	AP+HIB+BU (4:1:t)
Chestnut 1067	Sweet Chocolate(+) 2408	Lt. Cinnamon(-) 114	Brown Velvet 2109	Coffee Bean(-) 940	BE+RU (1:1)	TP+BU (1:1)
Chinney 1030	-----	-----	Adobe Red 2046	-----	RE+NC+OPL (2:1:1)	HIB+RO (2:1)
Chrome Green Lt. 1102	-----	Mistletoe(-) 53	Kelly Green 2052	Evergreen(-) 724	GRNOX+OPL (1:t)	PHGH+BG (2:1)
Cinnabar 1084	Fingerberry Red 2425	Russett 80	Candy Bar Brown 2407	-----	IRO+BU (1:t)	BUR+BU (1:1)
Citrus 1111	-----	-----	-----	-----	-----	TY + PAR (2:1)
Cool Blue 1074	-----	Indian Turquoise(+) 87	-----	-----	-----	-----
Cool Peach 1128	-----	-----	-----	-----	-----	AP+RS (1:1)
Copper Metallic 1512	Royal Copper(-) CJ2529	Bronze Met.(*+) 73	Copper(-) Glms 2607	Copper Met. 664	Super Copper Metallic	Iridescent Copper(-) 233
Corn Flower 1185	-----	-----	Queen Anne Lace 2017	Georgia Peach 615	TW+GO+TY (20:1:t)	-----
Coronado Red 1048	-----	Country Red 18	Cardinal Red 2077	-----	NC+NRL (3:1)	Perm. Alizarine Crim. Hue(-) 116
Cotton Candy 1108	Antique White(+) 2429	Buttermilk(+) 3	Antique White(+) 2001	Taffy(+) 902	WW+TY (1:1)	SW+YO (6:1)
Cotton Seed 1099	Cactus Flower 2306	Pineapple(-) 6	Pale Yellow 2005	Lemonade(-) 904	TW+YL (1:1)	SW+CYMH (4:1)
Country Slate Blue 1205	-----	-----	-----	-----	-----	-----
Cranberry 1083	Burgundy Deep(-) 2338	Cranberry Wine 112	Mendocino Red 2406	Raspberry Wine 935	BUR+BU (1:t)	BUR+RAS+BU (3:1:1)
Creamette 1024	Adobe Wash 2311	Buttermilk(+) 3	Lt. Ivory(-) 2401	Taffy(+) 902	WW+TY (1:1)	SW+UBT (1:1)
Creamy Beige 1023	-----	-----	Old Parchment(-) 2092	-----	WW+YO+BU (4:1:t)	PAR+YO (2:1)
Cypress Green 1188	-----	-----	Cactus Green(-) 2463	Robin's Egg(-) 915	JADE+WW+BU (1:1:t)	SW+COG+BAL (4:1:1)
Daffodil 1125	-----	-----	Pineapple Yellow 2101	Lemon Custard(+) 735	TW+CYM (6:1)	CYMH+TW (1:1)
Damsel Rose 1012	-----	-----	Indiana Rose(+) 2018	Rose Blush(-) 621	-----	PPP+DPP (2:1)
Dark Brown Sugar 1119	Raw Sienna(-) 2436	-----	Dark Brown 2053	Maple Syrup(-) 945	BE+RS (2:1)	BU+BS+RS (3:2:1)
Deep Sea 1092	Deep Forest Gm(-) 2444	Black Forest Green 83	Deep River Green 2419	-----	TEAL+OPL (5:1)	RT+BU+NG5 (2:2:1)
Delft Blue 1207	Lt. Stoneware Blue(-) 2463	-----	Tide Pool Blue 2465	Porcelain Blue(-) 765	TW+FB+BU (3:1:t)	FGB+TW (1:1)
Desert Sand 1081	-----	Cool Neutral Tone(+) 89	Sandstone 2402	-----	SP+TW+MOSS (2:1:t)	UBT+NG5 (6:1)

Color Conversion Chart

WALLY R.®

Acrylic Paints

Wally R.™ (See Note 6)	Accent® Acrylics "CJ" = Crown Jewels (See Notes 1-3, 6)	DecoArt™ Americana™ (See Notes 1-3, 6)	Delta® Ceramcoat® (See Notes 1-3, 6)	FolkArt® (Plaid) (See Notes 1-3, 6)	Jo Sonja® (Chroma Acrylics) ("t" = Tad in recipes below) (See Notes 1-4)	Liquitex® Concentrated Artist Colors ("t" = Tad in recipes below) (See Notes 1-6)
Desert Tea 1194	Lt. Tumbleweed(-) 2467	-----	Western Sunset Yel(-) 2454	-----	WW+YO (4:1)	UBT+AP+YO (7:1:1)
Doeskin 1095	-----	Mink Tan(-) 92	Bambi Brown 2424	-----	Fawn(+)	SW+TP (1:1)
Dove Gray 1038	-----	-----	Quaker Gray 2057	-----	Nimbus Gray(+)	NG5+SW (1:1)
Dover Blue 1079	Stoneware Blue(+) 2440	Williamsburg Blue(-) 40	Cape Cod Blue 2133	Settler's Blue(-) 607	FB+TW (1:1)	FGB+SW (2:1)
Duck Bill 1117	-----	-----	Bittersweet Orange(*) 2041	-----	YL+VER (3:1)	COH+RO (1:t)
Dusty Rose 1176	Victorian Mauve(-) 2452	-----	Misty Mauve 2441	-----	SP+BS (1:1)	UBT+VR (2:1)
Ecru 1213	Lt. Flesh(+) 2330	-----	Putty(+)2460	Georgia Peach 615	TW+GO+TY (15:1:1)	-----
Electric Blue 1115	Pure Blue 2472	Blue Violet(+) 141	Ultra Blue 2038	Ultramarine Blue 560	Ultra. Blue Deep(+)	UMB+SW (6:1)
Emeraude 1199	Telemark Green(+) 2443	-----	Rainforest Green(-) 2462	Bluegrass(+) 916	TEAL+OPL+TW (1:1:t)	BAL+SW (2:1)
Empire 1142	-----	-----	-----	-----	-----	-----
Erin Green 1009	Holiday Green 2577	Leaf Green 51	Green Isle 2008	Shamrock(*+) 926	BG+TEAL (2:1)	PHGH+BG (2:1)
Espresso 1109	-----	Dk Chocolate(-) 65	Dark Chocolate 2021	Chocolate Fudge(-) 950	RU+BE (1:1)	BU+IB (1:1)
Eucalyptus 1070	-----	-----	Blue Spruce (+) 2115	-----	TEAL+OPL+BE (3:1:t)	RT+IB (1:1)
Everglade 1093	Pine Needle Green(+) 2445	Evergreen 82	Dark Jungle Green(*) 2420	Thicket 924	PINE+GRNOX (4:1)	PHGH+RS (1:1)
Faded Rose 1220	-----	-----	Indiana Rose(+) 2018	Rose Blush(+) 621	-----	PPP+DPP (2:1)
Festive Pink 1029	Cottage Rose 2313	Coral Rose(-) 103	Fiesta Pink(+) 2045	Salmon(-) 747	VER+ROSE+OPL (1:1:1)	SCR+SDL+HIB (6:1:1)
Fire Truck Red 1050	Jo Sonja® Red 2449	Berry Red 19	Fire Red 2083	Calico Red 932	Naphthol Red Lt.	Acra Red 112
Flamingo 1134	-----	-----	Pretty Pink(+) 2088	-----	TW+TM+CS (10:4:1)	-----
Flesh 1113	-----	Sand(-) 4	-----	-----	WW+TY+BE (4:t:t)	UBT+SW (1:1)
Fluorescent Blue 1504	N/A	Electric Blue(-) DHS6	N/A	N/A	N/A	Fluorescent Blue(-) 984
Fluorescent Cerise 1502	N/A	-----	N/A	N/A	N/A	-----
Fluorescent Chartreuse 1506	N/A	Scorching Yellow DHS1	N/A	N/A	N/A	Fluorescent Yellow 981
Fluorescent Flame 1508	N/A	Fiery Red(-) DHS4	N/A	N/A	N/A	Fluorescent Red 983
Fluorescent Green 1503	N/A	-----	N/A	N/A	N/A	Fluorescent Green(-) 985
Fluorescent Orange 1507	N/A	-----	N/A	N/A	N/A	Fluorescent Orange(+) 982
Fluorescent Pink 1505	N/A	-----	N/A	N/A	N/A	-----
Fluorescent Turquoise 1501	N/A	-----	N/A	N/A	N/A	-----
Forest Night 1060	Teal Deep(-) 2611	Deep Teal(-) 116	Woodland Night(+) 2100	-----	TEAL+SP (4:1)	UMB+CYMH+IB (1:1:1)
Freedom Blue 1091	-----	-----	Liberty Blue(+) 2416	Paisley Blue(+) 967	-----	UMB+SDL (2:1)
French Blue 1200	-----	-----	-----	-----	OPL+FB (4:1)	-----
Fresh Tangerine 1027	English Marmalade(-) 2315	Cad Orange(*+) 14	Tangerine 2043	Pure Orange 628	VER+CYL (2:1)	COH+CRMH (3:1)
Garland 1101	-----	Lt. Avocado(+) 106	Vibrant Green 2007	Clover(-) 923	BG+YO+BE (1:1:t)	OL+PAR (1:1)

Color Conversion Chart

WALLY R.

Acrylic Paints

Wally R.™ (See Note 6)	Accent® Acrylics "CJ" = Crown Jewels (See Notes 1-3, 6)	DecoArt™ Americana™ (See Notes 1-3, 6)	Delta® Ceramcoat® (See Notes 1-3, 6)	FolkArt® (Plaid) (See Notes 1-3, 6)	Jo Sonja® (Chroma Acrylics) ("t" = Tad in recipes below) (See Notes 1-4)	Liquitex® Concentrated Artist Colors ("t" = Tad in recipes below) (See Notes 1-6)
Gentle Blue 1104	Paradise Blue 2508	-----	Blue Danube 2013	-----	TW+COBH+NIM (8:2:1)	TW+SWBL (3:1)
Gold Metallic 1510	-----	Venetian Gold Met.(+) 72	Kim Gold Met. Glms 2602	-----	Rich Gold Metallic(+)	-----
Gold Metallic, 49'er 1513	-----	-----	14K Gold Glms 2604	Inca Gold 676	Pale Gold Metallic	Iridescent Gold(-) 234
Golden Gourd 1162	-----	-----	-----	Camel 953	-----	TW+YO+NG5 (2:1:1)
Gray Dawn 1075	-----	-----	Blue Haze 2122	-----	-----	BAL+SW (1:1)
Grecian Rose 1172	-----	Mauve(-) 26	Rose Mist(+) 2437	-----	OPL+IRO+PLUM (2:2:1)	DVR+NG5 (1:1)
Green Olive 1100	-----	-----	Avocado 2006	-----	PINE+YO+RU (2:1:1)	CYMH+IB (2:1)
HB Medium Flesh 1076	-----	Medium Flesh(-) 102	Medium Flesh(+) 2126	Skintone(-) 949	WW+GO (1:t)	AP+DPP (2:1)
Hansa Yellow 1020	Pure Yellow 2471	Yellow Lt. 144	Bright Yellow 2027	Yellow Lt. 551	Yellow Lt.(+)	Yellow Medium Azo 412
Hawaiian Green 1103	-----	-----	Turquoise(+) 2012	Aqua Bright(+) 731	AQ+TW+TY (5:3:1)	BAG+SW (2:1)
Hazelnut 1132	-----	Sable Brown(+) 61	Toffee Brown(+) 2086	Acorn Brown(-) 941	-----	TP+SDL (5:1)
Heavenly Blue 1114	-----	-----	Blue Heaven 2037	-----	-----	-----
Holly Green 1043	Holiday Green(-) 2577	Holly Green(-) 48	Christmas Green 2068	-----	BG+TEAL (3:1)	PGL+PHGH (2:1)
Hollyhock 1186	Lt. Seafoam Green(-) 2460	-----	-----	-----	TW+AQ+YL (6:1:1)	-----
Hopi Pink 1184	-----	-----	-----	-----	TW+CS (1:t)	-----
Hortense Violet 1209	-----	-----	Wisteria 2467	-----	-----	-----
Indian Clay 1046	-----	-----	Terra Cotta(-) 2071	-----	Gold Oxide(+)	COH+RO (1:1)
Iris 1135	Wild Heather(+) 2314	-----	GP Purple 2091	-----	TW+DP (5:1)	BP+TW (1:1)
Irish Green 1035	-----	Mistletoe(*) 53	Kelly Green 2052	Evergreen(*) 724	-----	-----
Iron Clad 1056	-----	-----	Hammered Iron(+) 2094	Dapple Gray(-) 937	-----	-----
Ivy 1057	Pine Needle Green(+) 2445	Plantation Pine 113	Dark Forest Green 2096	Thicket(-) 924	OPL+RS (5:1)	IB+PHGH+NG5 (3:1:1)
Jamocha 1033	-----	Terra Cotta(+) 62	Mocha Brown(+) 2050	-----	PINE+SAPH+RU (2:1:t)	RS+SCR+UBT (3:1:1)
Juicy Lemon 1098	Mellow Yellow 2410	Lemon Yellow 11	Luscious Lemon 2004	Lemon Custard(+) 735	RS+GO+WW (4:4:1)	Cad. Yellow Lt.(+) 160
Kohl Blue 1069	-----	-----	Midnight Blue 2114	-----	STRM+PG (2:1)	PG+NG5 (3:1)
Kohl Green 1071	-----	Midnite Green(*) 84	Black Green 2116	Wrought Iron 925	TEAL+CB (3:1)	PG+YLH (2:1)
Lavender 1031	Wild Heather(-) 2314	-----	GP Purple(-) 2091	-----	TW+AM+PBH (1:1:t)	BP+TW (1:1)
Lemon Meringue 1221	-----	Taffy Cream 5	Custard(-) 2448	-----	-----	TW+TY (4:1)
Lichen Green 1137	-----	-----	Salem Green 2099	Plantation Green(-) 604	TEAL+OPL+BU (1:1:1)	BAL+SW (2:1)
Light Rose 1202	-----	Shading Flesh(-) 137	Dresden Flesh 2033	Spice Pink(-) 750	-----	-----
Light Yellow Green 1138	-----	-----	-----	-----	-----	CYMH+OL (2:1)
Lilac Gray 1212	-----	Taupe 109	Taupe(-) 2470	-----	OPL+IRO (12:1)	-----

ACRYLICS

Color Conversion Chart

WALLY R.®

Acrylic Paints

Wally R.™ (See Note 6)	Accent® Acrylics "CJ" = Crown Jewels (See Notes 1-3, 6)	DecoArt™ Americana™ (See Notes 1-3, 6)	Delta® Ceramcoat® (See Notes 1-3, 6)	FolkArt® (Plaid) (See Notes 1-3, 6)	Jo Sonja® (Chroma Acrylics) ("t" = Tad in recipes below) (See Notes 1-4)	Liquitex® Concentrated Artist Colors ("t" = Tad in recipes below) (See Notes 1-6)
Limey 1105	-----	-----	-----	-----	-----	PGL+UBT (1:1)
Lisa's Blush 1051	-----	-----	Lisa Pink(+) 2084	Sweetheart Pink(-) 955	-----	LPP+MM (3:1)
Livid Green 1126	-----	-----	-----	-----	-----	-----
Madder Rose 1211	-----	-----	Antique Rose 2469	Rose Chiffon(-) 753	-----	DPP+ALIZ (4:1)
Maiden's Blush 1123	Lt. Cactus Flower 2462	-----	Pink Angel(+) 2061	-----	WW+NOR (5:1)	PPP+RO (6:1)
Maize 1189	-----	Pineapple 6	Pale Yellow(+) 2005	-----	TW+CYL (1:t)	TW+CYMH (2:1)
Manganese Blue 1146	Windsor Blue(-) 2317	Midnite Blue(-) 85	Manganese Blue 2124	Prussian Blue 559	PBH+PTHBL (1:1)	Prussian Blue(-) 318
Mango 1026	-----	-----	Pumpkin(+) 2042	Glazed Carrots(-) 741	YL+VER (3:1)	RO+SCR+PAR (4:3:1)
Margarine 1062	Devonshire Cream(+) 2312	Moon Yellow 7	-----	Buttercup(+) 905	WW+TY (3:1)	TY+UBT (1:1)
Mellow Marsh 1133	-----	-----	Pale Mint Green 2473	-----	TW+BG (20:1)	-----
Mesa 1143	-----	Burnt Orange(+) 16	Lt. Chocolate 2022	Persimmon 919	-----	COH+RO (1:1)
Milk Chocolate 1015	-----	-----	-----	-----	-----	-----
Misty Blue 1152	-----	-----	Blue Mist 2400	Icy White(-) 701	TW+FB (1:t)	TW+BAL+FGB (2:1:1)
Moss 1010	-----	Avocado(+) 52	Seminole Green 2009	-----	GRNOX+PINE (2:1)	PGL+RS+NG5 (1:1:1)
Mulberry 1149	Wineberry(-) 2426	-----	Dusty Purple(+) 2128	-----	NC+SAPH 91:1	DVR+TW (1:1)
Myrtle Green 1217	-----	-----	Village Green 2447	-----	WW+JADE+OPL (2:1:1)	BG+TW (1:1)
Napthol Crimson 1085	Jo Sonja® Red 2449	True Red 129	Napthol Red Lt. 2409	Napthol Crimson 555	Napthol Crimson	Napthol Crimson(+) 292
Napthol Red Light 1086	-----	Calico Red 15	Napthol Red Lt. 2409	Calico Red 932	NRL+NC (2:1)	NC+HIB (2:1)
Navajo Dust 1182	-----	Medium Flesh(-) 102	-----	-----	-----	-----
Neu Penny Cop. Met. 1514	-----	-----	-----	-----	-----	-----
Nordic Blue 1068	-----	-----	Norsk Blue 2111	-----	-----	FGB+BAL (1:1)
Nutmeg 1037	-----	Lt. Cinnamon(+) 114	Autumn Brown 2055	Nutmeg(*) 944	RS+IRO (2:1)	TP+BU (2:1)
Oak 1097	-----	Antique Gold(+) 9	Cloudberry Tan(-) 2112	-----	Yellow Oxide(+)	TY+RS (2:1)
Oatmeal 1054	Antique White(-) 2429	-----	Old Parchment(+) 2092	-----	WW+YO (2:1)	PAR+YO (2:1)
Olive Branch 1160	-----	-----	-----	-----	Moss Green	YO+OL (1:1)
Olivette 1139	-----	-----	-----	-----	-----	-----
Opal 1167	Victorian Mauve 2452	Dusty Rose(+) 25	Normandy Rose(-) 2432	-----	BS+WW+SP (2:2:1)	SW+VR+SDL (4:1:1)
Orange 1019	Vermillion(*) 2602	Cadmium Orange(*) 14	Orange 2026	Red Orange(+) 629	CS+VER (1:1)	SCR+CYMH (2:1)
Oxford Gray 1195	-----	-----	Dolphin Gray(+) 2457	Amish Blue(+) 715	OPL+FB (4:1)	LBV+NG5 (1:1)
Pacifica 1157	Nevada Turquoise(-) 2307	-----	Avalon Blue 2417	-----	COBL+BU (1:t)	RT+FGB (2:1)
Pamadour Green 1216	-----	-----	Blue Wisp(-) 2455	Summer Sky(+) 906	SP+UMB+GRNOX (12:2:1)	-----
Paprika 1155	-----	-----	-----	Cinnamon(-) 913	Gold Oxide(-)	RS+SCR+UBT (3:1:1)

Color Conversion Chart

WALLY R.®

Acrylic Paints

ACRYLICS

Wally R.™ (See Note 6)	Accent® Acrylics "CJ" = Crown Jewels (See Notes 1-3, 6)	DecoArt™ Americana™ (See Notes 1-3, 6)	Delta® Ceramcoat® (See Notes 1-3, 6)	FolkArt® (Plaid) (See Notes 1-3, 6)	Jo Sonja® (Chroma Acrylics) ("t" = Tad in recipes below) (See Notes 1-4)	Liquitex® Concentrated Artist Colors ("t" = Tad in recipes below) (See Notes 1-6)
Peachee 1168	Peaches 'n Cream 2420	-----	Island Coral 2433	-----	WW+CS+YL (1:t:t)	AP+HIB+OL (4:1:t)
Pearl Aqua 1523	Queen Emerald(+) CJ2525	Crystal Green Met.(+) 76	Aqua Cool Glms 2614	Aquamarine Met.(-) 655	N/A	Pearl+BAG (See Note 5.)
Pearl Blue 1521	-----		Bobby Blue Glms 2609	Blue Pearl Met.(+) 670	N/A	Pearl+NC (See Note 5.)
Pearl Fuchsia 1526	Duchess Rose(-) CJ2522		Fuchsia Glms 2622	-----	N/A	Pearl+FLOR (See Note 5.)
Pearl Orange 1525	-----		Orange Pearl Glms 2617	Peach Pearl Met.(-) 674	N/A	Pearl+FLPI (See Note 5.)
Pearl Pink 1522	-----		Pinkie Prl. Glms(-) 2612	-----	N/A	Pearl+DP (See Note 5.)
Pearl Violet 1527	Faberge Purple CJ2523	Purple Pearl 124	Violet Pearl Glms 2623	Amethyst Met.(-) 654	N/A	Pearl+DP (See Note 5.)
Pearl White 1520	Baroque Pearl CJ2532	White Pearl 117	Pearl Fin Glms 2601	Pearl White Met. 659	Pearl White Metallic	Iridescent White 238
Pearl Yellow 1524	-----		Sunshine Prl Glms 2615	-----	-----	Pearl+YLH (See Note 5.)
Pelican 1223	April Showers 2510	-----	Drizzle Gray(+) 2452	-----	TW+NIM+STRM (1:1:t)	SW+NG5+FGB (4:1:t)
Persian Red 1130	Razzle Red 2579	Napthol Red 104	Crimson(-) 2076	Christmas Red 958	Napthol Red Lt.(+)	Napthol Red Lt. 294
Phantom Blue 1078	Soldier Blue(-) 2441	Uniform Blue(+) 86	Nightfall Blue (+) 2131	Heartland Blue(+) 608	FB+TW+BU (1:t:t)	PG+FGB (3:1)
Pilgrim Gray 1175	-----	Slate Gray(-) 68	Bridgeport Gray 2440	-----	NIM+PB (3:1)	PAR+FGB+NG5 (2:1:1)
Pimento Rose 1183	-----		-----	-----	-----	
Pine Cone 1193	Lt. Village Green 2466	-----	Cactus Green(-) 2463	Robin's Egg(+) 915	JADE+WW+BU (1:1:t)	UBT+BAL (3:1)
Pink 1110	-----		-----	-----	TW+CS+BE (20:1:t)	Pale Portrait Pink(+) 837
Pink Begonia 1153	-----		Lilac Dusk 2403	-----	Amethyst(+)	MM+PLV (2:1)
Pippin Green 1041	-----		Apple Green 2065	-----	WW+CYM+GRNOX (5:1:1)	CYMH+TW+PGL (5:2:1)
Plum Wine 1178	-----		Napa Wine 2443	-----	AM+IRO (2:1)	WIS+DVR (2:1)
Pottery 1148	-----		Dark Flesh(+) 2127	-----	OPL+TY+RE+RU (2:1:1:t)	BS+SDL (2:1)
Prussian Blue 1088	-----	Prussian Blue(*) 138	-----	-----	Payne's Gray(+)	PG+NG5 (3:1)
Phthalo Blue 1002	-----	Ultra Blue Deep 100	Pthalo Blue 2502	Ultramarine Blue(*-) 560	Pthalo Blue	Phthalocyanine Blue(-) 316
Pthalo Crimson 1147	Holiday Red(+) 2421		Berry Red 2056	Holiday Red(+) 612	TM+CS (3:1)	NC+RAS (3:1)
Pthalo Green 1001	Avon On Green(-) 2316	Viridian Green 108	Pthalo Green 2501	Pthalo Green 563	Pthalo Green	Phthalocyanine Green(-) 317
Purple 1106	Dioxazine Purple(+) 2606	Dioxazine Purple 101	Purple(+) 2015	Purple 411	DP+TW (5:1)	PV+DP (6:1)
Purple Sage 1218	-----		-----	-----	-----	NG5+MM+UBT (2:1:1)
Raspberry 1077	-----	Burgundy Wine(*) 22	Sweetheart Blush 2130	Burgundy(-) 957	TM+BUR (5:1)	BUR+MM (2:1)
Raw Sienna 1156	Tumbleweed 2305	Raw Sienna(+) 93	Raw Sienna(+) 2411	English Mustard(-) 959	RS+RE (5:1)	RS+YO (2:1)
Raw Umber 1017	Burnt Umber 2613	Raw Umber(-) 130	Walnut 2024	Raw Umber 571	Raw Umber	BU+IB (3:1)
Rebel Gray 1096	-----		Cadet Gray 2426	-----	NIM+TW (4:1)	TW+UBT+NG5 (1:1:1)
Red Iron Oxide 1014	Pennsylvania Clay(-) 2423	Red Iron Oxide(-) 96	Red Iron Oxide(+) 2020	Rusty Nail 914	NOR+RE (1:1)	Red Oxide 335
Red Pepper 1163	Sedona Clay(-) 2301		Cayenne 2428	Cinnamon(-) 913	-----	RO+SDL (2:1)

© 1994 Susan Adams Bentley

ACRYLICS

Color Conversion Chart

WALLY R.®

Acrylic Paints

Wally R.™ (See Note 6)	Accent® Acrylics "CJ" = Crown Jewels (See Notes 1-3, 6)	DecoArt™ Americana™ (See Notes 1-3, 6)	Delta® Ceramcoat® (See Notes 1-3, 6)	FolkArt® (Plaid) (See Notes 1-3, 6)	Jo Sonja® (Chroma Acrylics) ("t" = Tad in recipes below) (See Notes 1-4)	Liquitex® Concentrated Artist Colors ("t" = Tad in recipes below) (See Notes 1-6)
Reef Blue 1129	-----	-----	Ocean Reef Blue 2074	-----	UMB+TW (2:1)	SWBL+TW+UMB (5:1:t)
Rhino Gray 1053	-----	-----	Hippo Gray 2090	-----	-----	-----
Ripe Tomato 1059	Pueblo Red(+) 2302	Country Red(+) 18	Tomato Spice(+) 2098	Brick Red(-) 631	RE+NC (3:1)	NC+RO (1:1)
Rose Dawn 1150	-----	Gooseberry(-) 27	Gypsy Rose 2129	-----	ROSE+OPL+IRO (4:2:1)	UBT+DVR+RO (5:2:1)
Rouge 1198	-----	-----	Nectar Coral(+) 2458	-----	WW+ROSE+YL (8:1:t)	SCR+HIB+UBT (2:1:1)
Russet 1058	Sedona Clay 2301	Burnt Orange 16	Georgia Clay 2097	Persimmon(-) 919	Norwegian Orange(+)	RO+BS (1:1)
Sage 1177	-----	Jade Green 57	Stonewedge Green(+) 2442	-----	GRNOX+OPL+BE (6:4:1)	OL+BG+PAR (3:1:1)
Sandy Peach 1204	-----	-----	Rosetta Pink(+) 2430	Portrait Medium(+) 422	-----	-----
Santa Fe 1179	-----	-----	Desert Sun Omg(+) 2444	-----	OPL+RE (4:1)	AP+RO (1:1)
Santa Fe Blues 1190	Lt. Stoneware Blue 2463	-----	-----	Porcelain Blue(+) 765	TW+FB+BU (3:1:t)	FGB+SW (1:1)
Sapphire Blue 1034	Ultramarine Blue(+) 2412	Sapphire(-) 99	Copen Blue 2051	Blue Ribbon 719	UMB+SAPH (2:1)	SWBL+TWI (1:1)
School Bus Yellow 1004	-----	Cadmium Yellow(-) 10	Yellow 2504	School Bus Yellow 736	CYM+TY (3:1)	Cad Yellow Med. Hue(-) 830
Shrub 1136	-----	-----	English Yew Green 2095	-----	PINE+MOSS+CB (4:1:t)	Olive(-) 907
Shy Violet 1107	-----	-----	Lavender Lace(+) 2016	-----	-----	-----
Silver Metallic 1511	Regency Silver CJ2530	Shimmering Silver Met.(-) 70	Silver Gleams (-) 2603	Silver Sterling Met.(-) 662	Silver Metallic	Iridescent Silver(-) 236
Skin Tone 1013	-----	-----	Fleshtone 2019	Almond Parfait 705	TW+GO+TY (1:t:t)	PPP+RS (3:1)
Smoky Blue 1063	-----	-----	Fjord Blue 2104	-----	FB+CB+SP (4:2:1)	IB+FGB (2:1)
Soft Black 1201	Soft Black 2447	Ebony (Lamp) Black 67	Black 2506	Licorice 938	Carbon Black	Mars Black 276
Soft Kohl 1171	-----	-----	Charcoal 2436	-----	CB+SP (3:1)	IB+SW (3:1)
Soft Lilac 1210	-----	-----	Ice Storm Violet 2468	-----	WW+BS+ROSE (7:1:t)	UBT+PLV (2:1)
Soil 1161	-----	Sable Brown(-) 61	Territorial Beige 2425	-----	Provincial Beige	RS+BAL+VR (3:1:1)
Solvang 1174	-----	-----	Alpine Green 2439	-----	JADE+TEAL+WW (1:1:t)	NG5+CG (2:1)
Sonora 1066	-----	-----	Palomino Tan(+) 2108	Camel(-) 953	PB+SP+OPL (2:1:1)	COH+NG5+TW (2:2:1)
Spiced Peach 1021	-----	-----	Caucasian Flesh 2029	-----	GO+WW+NC (1:1:t)	-----
Spring Green 1127	-----	-----	Lima Green(+) 2072	-----	-----	-----
Spun Gold 1087	Dijon Gold 2318	-----	Empire Gold(+) 2412	-----	Turner's Yellow(+)	Turner's Yellow 730
Sterling Gray 1072	-----	-----	Lichen Gray 2118	Barn Wood 936	NIM+BE+PINE (4:1:t)	UBT+NG5 (3:1)
Storm Cloud 1164	-----	-----	-----	-----	Nimbus Gray(-)	UBT+NG5 (1:1)
Sungold 1197	Sunsational Yellow 2500	-----	Crocus Yellow 2459	-----	TW+YL+TY (3:2:1)	CYMH+UBT (2:1)
Sweet Cream 1203	Adobe Wash(-) 2311	-----	Ivory(+) 2036	Taffy 902	WW+YO (1:t)	SW+UBT (1:1)
Taupe 1170	-----	-----	Trail Tan(+) 2435	Butter Pecan(+) 939	PB+WW (2:1)	UBT+RU (2:1)

Color Conversion Chart

WALLY R.

Acrylic Paints

Wally R.™ (See Note 6)	Accent® Acrylics "CJ" = Crown Jewels (See Notes 1-3, 6)	DecoArt™ Americana™ (See Notes 1-3, 6)	Delta® Ceramcoat® (See Notes 1-3, 6)	FolkArt® (Plaid) (See Notes 1-3, 6)	Jo Sonja® (Chroma Acrylics) ("t" = Tad in recipes below) (See Notes 1-4)	Liquitex® Concentrated Artist Colors ("t" = Tad in recipes below) (See Notes 1-6)
Teal Green 1094	-----	-----	Jubilee Green 2421	-----	BG+CYL (4:1)	Perm. Green Lt.(-) 312
Terra Rosa 1206	Lt. Roseberry(-) 2464	-----	Sachet Pink(-) 2464	Berries 'n Cream 705	OPL+PLUM+BU (7:1:t)	TW+DVR (2:1)
Terrestrial Green 1011	Forest Green 2341	Avocado(*-) 52	Forest Green(*+) 2010	Old Ivy(-) 927	PINE+SAPH+BE (2:1:t)	OL+PHGH+BU (1:1:t)
Tigereye 1055	-----	-----	Pigskin(+) 2093	-----	-----	-----
Toast 1208	-----	Mocha(+) 60	Dunes Beige 2466	Almond Parfait(+) 705	OPL+GO+TW (5:1:1)	AP+SDL+TW (1:1:1)
Toluidine Red 1003	Pure Red 2470	Berry Red 19	Crimson 2076	Christmas Red 958	Napthol Red Lt.	CRMH+COH (2:1)
Tranquil Green 1180	-----	-----	Green Sea(+) 2445	Poetry Green(*-) 619	JADE+OPL (2:1)	BG+TY (2:1)
Tropicana 1154	-----	-----	Rouge 2404	-----	ROSE+VER+WW (1:1:t)	SCR+HIB+UBT (2:1:1)
Tusk 1080	-----	-----	Lt. Ivory(+) 2401	-----	Warm White	Soft White 904
Valentine 1065	Holiday Red 2421	Country Red(*) 18	Tompte Red 2107	Cardinal Red 414	NC+BUR (4:1)	Perm. Alizarine Crim. Hue 116
Velvet Night 1089	-----	-----	Dark Night Blue 2414	Payne's Gray 575	PG+CB (4:1)	UMB+IB+NG5 (4:4:1)
Velvet Plum 1118	-----	-----	Grape 2048	Plum Pudding(-) 934	DP+BUR+OPL (3:3:1)	RAS+TWI (2:1)
Very Berry 1120	-----	-----	Berry Red(+) 2056	-----	-----	-----
Warm Beige 1131	-----	Toffee(-) 59	AC Flesh(-) 2085	-----	TW+RS+RU (6:2:1)	UBT+SDL (1:1)
Warm Brown 1032	-----	Lt. Cinnamon(+) 114	Spice Brown 2049	Nutmeg(-) 944	BE+RS (1:1)	BS+RS (1:1)
Wedgewood Blue 1044	-----	Baby Blue(+) 42	-----	Lt. Blue(-) 402	TW+FB (3:1)	TW+FGB+UMB (2:1:t)
Wedgewood Green 1045	-----	Jade Green(*-) 57	Wedgewood Green(+) 2070	Bayberry(*-) 922	GRNOX+OPL+BE (7:3:1)	OL+BG+PAR (3:1:1)
Wheat 1215	-----	-----	-----	-----	-----	-----
White 1005	Real White 2476	Snow (Titanium) White 1	White 2505	Wicker White 901	Titanium White	Titanium White 432
Winter Wine 1082	-----	Raspberry(-) 28	Dusty Mauve(-) 2405	Raspberry Sherbert(+) 966	Plum Pink (+)	DVR+TW (2:1)
Yellow Oxide 1008	Golden Harvest(-) 2433	True Ochre 143	Antique Gold 2002	Harvest Gold 917	YO+TW (2:1)	Yellow Oxide(-) 416
Zinfandel 1151	Roseberry(-) 2450	Mauve(+) 26	Bouquet Pink(+) 2132	Potpourri Rose(-) 624	OPL+PLUM+BU (2:1:t)	SDL+DVR (2:1)

© 1994 Susan Adams Bentley

ACRYLICS

NOTES

(1) A "+" indicates darker (or a "-" lighter) than first column color.

(2) An asterisk "*" indicates floats or washes don't match, though regular basecoats do.

(3) "N/A" indicates there is no comparable product in this brand.

(4) Refer to the Color Keys for these brands. Numbers shown in parentheses after the color name abbreviations equal "parts." For example, "RAS+SW+BU (2:1:t)" means to mix 2 parts of Raspberry with 1 part Soft White, and just a touch of Burnt Umber.

(5) "Pearl" = "Liquitex® Painter's Pearl Medium": Add small amount of paint to Medium. The more Medium added, the lighter and more pearlescent the color will become.

(6) Product numbers are for the 2-ounce size. DecoArt™ numbers will be preceded by a "DA" (for DecoArt™ Americana™) on the bottles.

GLOSS

Color Conversion Chart

ACCENT® Acrylic Gloss Enamels

Accent® Hobby Craft High-Gloss Enamel (May be oven "fired")	Apple Barrel® Gloss Acrylic Enamels (Plaid) (Do not oven "fire")	DecoArt™ Ultra Gloss™ Acrylic Enamels (May be oven "fired")	DEKA®-Gloss Water-based Enamels (May be oven "fired")	Delta® Hi-Gloss Acrylic Enamels (Do not oven "fire")	Liquitex® Glossies™ Acrylic Enamels (May be oven "fired")
Antique Gold Metallic 604	N/A	True Gold Metallic DG37	----	N/A	N/A
Bally Hoo Blue 648	Cadet Blue(*+) 20658	True Blue(-) DG30	Ultra Blue(+) 307	Copen Blue(-) 12051	Blue(-) 13
Brass Metallic 605	N/A	----	Gold Metallic(*+) 341	N/A	N/A
Brite Gold Metallic 603	N/A	True Gold Metallic DG37	----	N/A	N/A
Chestnut Brown 625	Coffee Bean 20666	Chocolate(*) DG26	Chocolate Brown(*-) 310	----	Brown(*-) 19
Chrome Plate Metallic 601	N/A	----	----	N/A	N/A
Ebony Black 611	Black 20662	Gloss Black DG02	Carbon Black 611	Black 12506	Black 20
Emerald Green 614	----	Christmas Green(-) DG11	Emerald Green 309	----	Green 11
Fresh Orange 621	Tangerine(+) 20639	Orange DG7	Blazing Orange(*-) 302	Pumpkin(-) 12042	Orange 18
Gleaming White 612	White 20621	Gloss White DG1	Pure White 312	White 12505	White 21
Go Go Green Fluorescent 839	N/A	N/A	N/A	N/A	N/A
Mauve 642	Holiday Rose(-) 26032	Mauve(+) DG23	----	Bouquet(+) 12132	----
Mint Mist 639	Seafoam Green(*-) 20650	----	----	----	----
Peaches 609	----	Peach(-) DG18	----	----	Pink(+) 27
Platinum Silver Metallic 602	N/A	Silver Metallic DG39	Silver Metallic(+) 602	N/A	N/A
Purple Aster 620	Purple Velvet(+) 20627	Purple DG33	Purple 305	----	Purple(+) 15
Really Red 619	Real Red 20636	Christmas Red(-) DG10	Crimson(*) 304	----	Red 17
Rocket Red Fluorescent 836	N/A	N/A	N/A	N/A	N/A
Slate 610	Dolphin Gray(-) 20624	Slate Gray(+) DG34	----	----	----
Solar Yellow Fluorescent 838	N/A	N/A	N/A	N/A	N/A
Sun Glow Orange Fluor. 837	N/A	N/A	N/A	N/A	N/A
Sunshine Yellow 615	Real Yellow 20645	Cadmium Yellow(+) DG06	Bright Yellow(+) 301	Bright Yellow(+) 12027	Yellow 10
W.I. Flat Black 607 (See Note 2.)	Ebony Black 611	Gloss Black DG02	Carbon Black 311	Black 12506	Black 20
W.I. Flat White 608 (See Note 2.)	Gleaming White 612	Gloss White DG01	Pure White 312	White 12505	White 21
Wedgewood Blue 629	----	Williamsburg Blue(*+) DG29	----	----	----

© 1994 Susan Adams Bentley

NOTE 1: Unfortunately, there are very few "good" matches with the acrylic enamels, perhaps because there are far fewer colors in each line than with regular acrylic paints. With the exception of Jo Sonja's Artist Colors, regular acrylics range anywhere from 100 to over 200 different colors in each brand, while acrylic enamels range from 17 to 46. To help you find the closest color, I've included matches that I would not consider including in the conversion charts for regular acrylic paints.
The following symbols are used in this chart:
(-) Lighter than the first-column color.
(+) Darker than the first-column color.
(*) Washes don't match; however, the color may suit your needs if you are basecoating with it. The color value is similar to the first-column color.
(*+) Same as (*), except it is a darker value than the first-column color.
(*-) Same as (*), except it is a lighter value than the first-column color.
N/A There is no equivalent product in this brand (i.e. flourescents, metallics, etc.).

NOTE 2: W.I. Flat Black 607 and W.I. Flat White #608 are not as glossy as the matches shown. For the most gloss, use Ebony Black #611 and Gleaming White #612.

Acrylic Gloss Enamels

olor Conversion Chart

APPLE BARREL

GLOSS

Apple Barrel® Gloss Acrylic Enamels (Plaid) (Do not oven "fire")	Accent® Hobby Craft High-Gloss Enamel (May be oven "fired")	DecoArt™ Ultra Gloss Acrylic Enamels (May be oven "fired")	DEKA®-Gloss Water-based Enamels (May be oven "fired")	Delta® Hi-Gloss Acrylic Enamels (Do not oven "fire")	Liquitex® Glossies™ Acrylic Enamels (May be oven "fired")
Antique White 20623	-----	-----	-----	Ivory(-) 12401	Ivory(-) 12401
Arbor Green 20653	-----	-----	-----	-----	Pine Green(+) 33
Beachcomber Beige 20663	-----	Buttermilk(-) DG03	-----	-----	-----
Belgian Peach 20641	-----	-----	-----	-----	-----
Bermuda Beach 20643	-----	-----	-----	Coral(-) 12044	-----
Black 20662	Ebony Black 611	Black DG02	Carbon Black 311	Black 12506	Black 20
British Green 20654	-----	Dark Teal(-) DG15	-----	-----	-----
Cadet Blue 20658	Bally Hoo Blue(*-) 648	Navy Blue(+) DG31	-----	Copen Blue(-) 12051	-----
Chili Pepper 20638	-----	-----	-----	-----	Red Orange(+) 26
Coffee Bean 20666	Chestnut Brown 625	Chocolate(*-) DG26	-----	-----	Brown(*-) 19
Cornflower Blue 20659	-----	-----	-----	-----	-----
Cranberry Red 20633	-----	-----	-----	-----	Maroon 28
Crown Gold 20647	-----	Mustard(+) DG04	-----	-----	-----
Crystal Coral 20640	-----	-----	-----	Coral(-) 12044	-----
Dandelion Yellow 20646	Sunshine Yellow 615	Cad. Yellow(+) DG06	Bright Yellow 301	Bright Yellow 12027	Yellow(*-) 10
Deep Lilac 20630	-----	-----	-----	Lilac Dusk(-) 12403	-----
Deep Purple 20625	-----	-----	-----	-----	-----
Dolphin Gray 20624	Slate(+) 610	-----	-----	Ivory 12401	-----
Eggshell 20622	Mauve(+) 642	-----	-----	-----	-----
Forest Green 20649	-----	Hunter Green(+) DG12	-----	-----	Pine Green(*-) 33
Geranium 20642	-----	Victorian Rose(-) DG22	-----	-----	-----
Goodnight Blue 20661	-----	Navy Blue(-) DG31	-----	Navy Blue(-) 12089	-----
Grape 20628	-----	-----	-----	-----	-----
Gypsy Red 20635	-----	Cranberry Red DG9	-----	Dusty Mauve 12405	-----
Holiday Rose 20632	-----	-----	-----	-----	-----
Honeysuckle 20644	Sunshine Yellow(+) 615	Lemon Yellow(-) DG05	-----	Custard(-) 12448	Yellow(-) 10
Hot Rod Red 20637	-----	-----	-----	-----	-----
Lanier Blue 20656	-----	Baby Blue(-) DG27	-----	Blue Heaven(-) 12037	-----
Mocha 20665	-----	-----	-----	-----	Brown(*+) 19
Mossy Green 20648	-----	Avocado(*+) DG13	-----	-----	-----
Pacific Blue 20655	-----	Turquoise(-) DG16	-----	-----	Blue Green(*+) 12
Pink Blush 20631	-----	-----	-----	Lisa Pink(-) 12084	-----
Pinwheel Blue 20657	-----	-----	-----	-----	-----
Purple Velvet 20627	Purple Aster(-) 620	Purple(*-) DG33	Purple 305	Purple(-) 12015	Purple(*-) 15
Raspberry 20629	-----	Victorian Rose(+) DG22	Pink(-) 313	-----	Magenta(*-) 29

GLOSS

Color Conversion Chart

APPLE BARREL®

Acrylic Gloss Enamels

Apple Barrel® Gloss Acrylic Enamels (Plaid) (Do not oven "fire")	Accent® Hobby Craft High-Gloss Enamel (May be oven "fired")	DecoArt™ Ultra Gloss™ Acrylic Enamels (May be oven "fired")	DEKA®-Gloss Water-based Enamels (May be oven "fired")	Delta® Hi-Gloss Acrylic Enamels (Do not oven "fire")	Liquitex® Glossies™ Acrylic Enamels (May be oven "fired")
Real Blue 20660	Bally Hoo Blue(*-) 648	True Blue(-) DG30	Ultra Blue(-) 307	Navy Blue(+) 12089	Blue Purple(-) 14
Real Green 20651	-----	-----	-----	Christmas Green 12068	Pine Green(+) 33
Real Red 20636	Really Red 619	Christmas Red(*-) DG10	Crimson 304	Tompte Red(+) 12107	Red(-) 17
Real Yellow 20645	Sunshine Yellow 615	Cad. Yellow(+) DG06	Bright Yellow 301	Bright Yellow 12027	Yellow 10
Rose Wine 20634	-----	Cranberry(-) DG9	-----	Sweetheart Blush(-) 12130	Maroon(+) 28
Seafoam Green 20650	Mint Mist(*+) 639	Light Teal(*+) DG14	-----	-----	-----
Spice Tan 20664	-----	-----	-----	Territorial Beige(-) 12425	-----
Spring Green 20652	-----	-----	-----	-----	-----
Tangerine 20639	Fresh Orange(-) 621	Orange(-) DG07	-----	-----	-----
White 20621	Gleaming White 20621	Gloss White DG01	Pure White 312	White 12505	White 21
Wisteria 20626	-----	-----	-----	-----	-----

© 1994 Susan Adams Bentley

NOTE: Unfortunately, there are very few "good" matches with the acrylic enamels, perhaps because there are far fewer colors in each line than with regular acrylic paints. With the exception of Jo Sonja's Artist Colors, regular acrylics range anywhere from 100 to over 200 different colors in each brand, while acrylic enamels range from 17 to 46. To help you find the closest color, I've included matches that I would not consider including in the conversion charts for regular acrylic paints.
The following symbols are used in this chart:
 (-) Lighter than the first-column color.
 (+) Darker than the first-column color.
 (*) Washes don't match; however, the color may suit your needs if you are basecoating with it. The color value is similar to the first-column color.
 (*+) Same as (*), except it is a darker value than the first-column color.
 (*-) Same as (*), except it is a lighter value than the first-column color.
 N/A There is no equivalent product in this brand (i.e. flourescents, metallics, etc.).

DecoArt™ Ultra Gloss Acrylic Enamels (May be oven "fired")	Accent® Hobby Craft High-Gloss Enamel (May be oven "fired")	Apple Barrel® Gloss Acrylic Enamels (Plaid) (Do not oven "fire")	DEKA®-Gloss Water-based Enamels (May be oven "fired")	Delta® Hi-Gloss Acrylic Enamels (Do not oven "fire")	Liquitex® Glossies™ Acrylic Enamels (May be oven "fired")
Aqua DG17	-----	-----	-----	Turquoise(*+) 12012	Aqua(+) 32
Avocado DG13	-----	Mossy Green(*-) 20648	-----	Forest Green(+) 12010	-----
Baby Blue DG27	-----	Lanier Blue(+) 20656	-----	Blue Heaven 12037	-----
Baby Pink DG19	-----	-----	-----	-----	-----
Blue Glitter DG44	N/A	N/A	N/A	N/A	N/A
Bright Gold Metallic DG38	Brite Gold Metallic(+) 603	N/A	-----	N/A	N/A
Bronze Metallic DG40	-----	N/A	-----	N/A	N/A
Burgundy DG08	Really Red(*-) 619	Real Red(*+) 20636	Crimson(+) 304	Tompte Red 12107	Red Purple(*-) 16
Buttermilk DG03	-----	Beachcomber Beige(+) 20663	-----	-----	-----
Cadmium Yellow DG06	Sunshine Yellow(-) 615	Dandelion Yellow(-) 20646	Bright Yellow 301	Bright Yellow(-) 12027	Yellow (*-) 10
Chocolate DG26	Chestnut Brown(*) 625	Coffee Bean(*+) 20666	Chocolate Brown(*-) 310	-----	-----
Christmas Green DG11	Emerald Green(+) 614	-----	Emerald Green(+) 309	-----	Green 11
Christmas Red DG10	Really Red(+) 619	Real Red(*+) 20636	True Red(+) 303	Fire Red(+) 12083	Red 17
Country Blue DG28	-----	-----	-----	-----	-----
Cranberry Red DG09	-----	Gypsy Red 20635	-----	Sweetheart Blush(*+) 12130	Maroon 28
Dark Teal DG15	-----	British Green(+) 20654	-----	-----	-----
Flesh DG20	-----	-----	-----	-----	-----
Fuchsia Glitter DG45	N/A	N/A	N/A	N/A	N/A
Gloss Black DG02	Ebony Black 611	Black 20662	Carbon Black 311	Black 12506	Black 20
Gloss White DG01	Gleaming White 612	White 20621	Pure White 312	White 12505	White 21
Gold Glitter DG41	N/A	N/A	N/A	N/A	N/A
Green Glitter DG46	N/A	N/A	N/A	N/A	N/A
Hunter Green DG12	-----	Forest Green(-) 20649	-----	Christmas Green(*-) 12068	Pine Green(-) 33
Lavender DG32	-----	-----	-----	-----	Bright Purple(+) 30
Lemon Yellow DG05	Sunshine Yellow(+) 615	Honeysuckle(+) 20644	-----	-----	Yellow(+) 10
Light Teal DG14	-----	Seafoam(*-) 20650	-----	-----	-----
Mauve DG23	Mauve(-) 642	-----	-----	Bouquet(*-) 12132	-----
Mustard DG04	-----	Crown Gold(-) 20647	-----	-----	-----
Navy Blue DG31	-----	Goodnight Blue(+) 20661	-----	Navy Blue(+) 12089	-----
Neutral Grey DG35	-----	-----	-----	-----	-----
Orange DG07	Fresh Orange 621	Tangerine(+) 20639	Blazing Orange(*) 302	Pumpkin(-) 12042	Orange 18
Peach DG18	Peaches(+) 609	-----	-----	-----	Pink(+) 27
Purple DG33	Purple Aster 620	Purple Velvet(*+) 20627	Purple 305	Purple 12015	Purple 15
Red Glitter DG43	N/A	N/A	N/A	N/A	N/A

Color Conversion Chart

DECOART™

Acrylic Gloss Enamels

DecoArt™ Ultra Gloss™ Acrylic Enamels (May be oven "fired")	Accent® Hobby Craft High-Gloss Enamel (May be oven "fired")	Apple Barrel® Gloss Acrylic Enamels (Plaid) (Do not oven "fire")	DEKA®-Gloss Water-based Enamels (May be oven "fired")	Delta® Hi-Gloss Acrylic Enamels (Do not oven "fire")	Liquitex® Glossies™ Acrylic Enamels (May be oven "fired")
Rose Mauve DG21	-----	-----	-----	-----	-----
Sable Brown DG25	-----	-----	N/A	Territorial Beige(-) 12425	Golden Brown(+) 24
Silver Glitter DG42	N/A	N/A	N/A	N/A	N/A
Silver Metallic DG39	Platinum Silver Metallic 602	N/A	Silver Metallic(+) 342	N/A	N/A
Slate Grey DG34	Slate(-) 610	-----	-----	-----	-----
True Blue DG30	Bally Hoo Blue(+) 648	Real Blue(+) 20660	Ultra Blue(+) 307	Copen Blue(+) 12051	Blue(*) 13
True Gold Metallic DG37	Brite Gold Metallic 603	N/A	-----	N/A	N/A
Turquoise DG16	-----	Pacific Blue(+) 20655	Turquoise(+) 314	Laguna(-) 12418	-----
Victorian Rose DG22	-----	Raspberry(-) 20629	-----	Dusty Mauve(+) 12405	-----
Warm Beige DG24	-----	-----	-----	-----	-----
Williamsburg Blue DG29	Wedgewood Blue(*-) 629	-----	-----	-----	-----

© 1994 Susan Adams Bentley

NOTE: Unfortunately, there are very few "good" matches with the acrylic enamels, perhaps because there are far fewer colors in each line than with regular acrylic paints. With the exception of Jo Sonja's Artist Colors, regular acrylics range anywhere from 100 to over 200 different colors in each brand, while acrylic enamels range from 17 to 46. To help you find the closest color, I've included matches that I would not consider including in the conversion charts for regular acrylic paints.
The following symbols are used in this chart:
 (-) Lighter than the first-column color.
 (+) Darker than the first-column color.
 (*) Washes don't match; however, the color may suit your needs if you are basecoating with it. The color value is similar to the first-column color.
 (*+) Same as (*), except it is a darker value than the first-column color.
 (*-) Same as (*), except it is a lighter value than the first-column color.
 N/A There is no equivalent product in this brand (i.e. flourescents, metallics, etc.).

Color Conversion Chart

Acrylic Gloss Enamels

DEKA

DEKA®-Gloss Water-based Enamels (May be oven "fired")	Accent® Hobby Craft High-Gloss Enamel (May be oven "fired")	Apple Barrel® Gloss Acrylic Enamels (Plaid) (Do not oven "fire")	DecoArt™ Ultra Gloss Acrylic Enamels (May be oven "fired")	Delta® Hi-Gloss Acrylic Enamels (Do not oven "fire")	Liquitex® Glossies™ Acrylic Enamels (May be oven "fired")
Blazing Orange 302	Fresh Orange(*+) 621	-----	Orange(*) DG7	Pumpkin(*) 12042	Orange(*) 18
Bright Yellow 301	Sunshine Yellow(-) 615	Real Yellow 20645	Cadmium Yellow DG06	Bright Yellow 12027	Yellow(-) 10
Brilliant Green 308	-----	-----	-----	Jubilee Green(+) 12421	-----
Carbon Black 311	Ebony Black 611	Black 20662	Gloss Black DG02	Black 12506	Black 20
Chocolate Brown 310	Chestnut Brown(*+) 625	-----	Chocolate(*+) DG26	Spice Brown(-) 12049	Brown(*) 19
Crimson 304	Really Red(*) 619	Real Red 20636	Burgundy(-) DG08	Tompte Red 12107	Red(-) 17
Emerald Green 309	Emerald Green	-----	Christmas Green(-) DG11	-----	Green(-) 11
Gold Metallic 341	Brass Metallic(-) 605	N/A	-----	N/A	N/A
Horizon Blue 306	-----	-----	-----	-----	Bright Blue 31
Light Brown 315	-----	-----	-----	-----	-----
Pink 313	-----	Raspberry(+) 20629	-----	-----	Magenta(*+) 29
Pure White 312	Gleaming White 612	White 20621	Gloss White DG01	White 12505	White 21
Purple 305	Purple Aster 620	Purple Velvet 20627	Purple DG33	Purple 12015	Purple 15
Silver Metallic 342	Platinum Silver Met.(-) 602	N/A	Silver Met.(-) DG39	N/A	N/A
True Red 303	Really Red(*+) 619	-----	Christmas Red(-) DG10	Fire Red 12083	Red 17
Turquoise 314	-----	-----	Turquoise(-) DG16	Laguna(*+) 12418	-----
Ultra Blue 307	Bally Hoo Blue(*-) 648	Real Blue(+) 20660	True Blue(-) DG30	Navy Blue (+) 12089	Blue Purple(-) 14

© 1994 Susan Adams Bentley

NOTE: Unfortunately, there are very few "good" matches with the acrylic enamels, perhaps because there are far fewer colors in each line than with regular acrylic paints. With the exception of Jo Sonja's Artist Colors, regular acrylics range anywhere from 100 to over 200 different colors in each brand, while acrylic enamels range from 17 to 46. To help you find the closest color, I've included matches that I would not consider including in the conversion charts for regular acrylic paints. The following symbols are used in this chart:

(-) Lighter than the first-column color.
(+) Darker than the first-column color.
(*) Washes don't match; however, the color may suit your needs if you are basecoating with it. The color value is similar to the first-column color.
(*+) Same as (*), except it is a darker value than the first-column color.
(*-) Same as (*), except it is a lighter value than the first-column color.
N/A There is no equivalent product in this brand (i.e. flourescents, metallics, etc.).

Color Conversion Chart

DELTA®

Acrylic Gloss Enamels

Delta® Hi-Gloss Acrylic Enamels (Do not oven "fire")	Accent® Hobby Craft High-Gloss Enamel (May be oven "fired")	Apple Barrel® Gloss Acrylic Enamels (Plaid) (Do not oven "fire")	DecoArt™ Ultra Gloss™ Acrylic Enamels (May be oven "fired")	DEKA®-Gloss Water-based Enamels (May be oven "fired")	Liquitex® Glossies™ Acrylic Enamels (May be oven "fired")
Black 12506	Ebony Black 611	Black 20662	Gloss Black DG02	Carbon Black 311	Black 20
Blue Heaven 12037	-----	Lanier Blue(+) 20656	Baby Blue DG27	-----	-----
Bouquet 12132	Mauve(-) 642	-----	Mauve(*+) DG23	-----	-----
Bright Yellow 12027	Sunshine Yellow(-) 615	Real Yellow 20645	Cadmium Yellow(+) DG06	Bright Yellow 301	Yellow 10
Burnt Sienna 12030	-----	-----	-----	-----	-----
Burnt Umber 12025	-----	-----	-----	Chocolate Brown(+) 310	-----
Cactus 12463	-----	-----	-----	-----	-----
Cape Cod 12133	-----	-----	-----	-----	-----
Christmas Green 12068	Emerald Green(-) 614	Real Green 20651	Hunter Green(*+) DG12	-----	Pine Green(+) 33
Copen Blue 12051	Bally Hoo Blue 648	Cadet Blue(+) 20658	True Blue(-) DG30	-----	Blue(-) 13
Coral 12044	-----	Crystal Coral(+) 20640	-----	-----	-----
Crocus 12459	-----	-----	-----	-----	-----
Custard 12448	-----	Honeysuckle(+) 20644	-----	-----	-----
Dusty Mauve 12405	-----	Gypsy Red 20635	Victorian Rose(-) DG22	-----	-----
Fire Red 12083	Really Red 619	Real Red(+) 20636	Christmas Red(-) DG10	True Red 303	Red 17
Fleshtone 12019	-----	-----	-----	-----	Almond(+) 23
Forest Green 12010	-----	-----	Avocado(-) DG13	-----	-----
Georgia Clay 12097	-----	-----	-----	-----	-----
Green Sea 12445	-----	-----	-----	-----	-----
Ivory 12401	-----	Eggshell 20622	-----	-----	-----
Jubilee Green 12421	-----	-----	-----	Brilliant Green(-) 308	-----
Laguna 12418	-----	-----	Turquoise(+) DG16	Turquoise(*-) 314	-----
Lilac Dusk 12403	-----	Deep Lilac(+) 20630	-----	-----	-----
Lima 12072	-----	-----	-----	-----	-----
Lisa Pink 12084	-----	Pink Blush(+) 20631	-----	-----	-----
Midnight 12114	-----	-----	-----	-----	-----
Navy Blue 12089	-----	Goodnight Blue(+) 20661	Navy Blue(-) DG31	Ultra Blue(-) 307	Blue(*-) 13
Palomino 12108	-----	-----	-----	-----	-----
Pumpkin 12042	Fresh Orange(*+) 621	-----	Orange(+) DG07	Blazing Orange(*) 302	Orange(+) 18
Purple 12015	Purple Aster(-) 620	Purple Velvet(+) 20627	Purple DG33	Purple 305	Purple 15
Quaker Grey 12057	-----	-----	-----	-----	-----
Spice Brown 12049	-----	-----	-----	Chocolate Brown(+) 310	-----
Straw 12078	-----	-----	-----	-----	-----
Sweetheart Blush 12130	-----	Rose Wine(+) 20634	Cranberry(*-) DG09	-----	Maroon(+) 28
Territorial Beige 12425	-----	Spice Tan(+) 20664	Sable Brown(+) DG25	-----	-----

Color Conversion Chart

DELTA **Acrylic Gloss Enamels**

Delta® HI-Gloss Acrylic Enamels (Do not oven "fire")	Accent® Hobby Craft High-Gloss Enamel (May be oven "fired")	Apple Barrel® Gloss Acrylic Enamels (Plaid) (Do not oven "fire")	DecoArt™ Ultra Gloss™ Acrylic Enamels (May be oven "fired")	DEKA®-Gloss Water-based Enamels (May be oven "fired")	Liquitex® Glossies™ Acrylic Enamels (May be oven "fired")
Tompte Red 12107	Really Red(-) 619	Real Red(-) 20636	Burgundy DG08	Crimson 304	Red Purple(*-) 16
Turquoise 12012	-----	-----	Aqua(*-) DG17	-----	Aqua(+) 32
White 12505	Gleaming White 612	White 20621	Gloss White DG01	Pure White 312	White 21
Wisteria 12467	-----	-----	-----	-----	-----

© 1994 Susan Adams Bentley

NOTE: Unfortunately, there are very few "good" matches with the acrylic enamels, perhaps because there are far fewer colors in each line than with regular acrylic paints. With the exception of Jo Sonja's Artist Colors, regular acrylics range anywhere from 100 to over 200 different colors in each brand, while acrylic enamels range from 17 to 46. To help you find the closest color, I've included matches that I would not consider including in the conversion charts for regular acrylic paints. The following symbols are used in this chart:

(-) Lighter than the first-column color.
(+) Darker than the first-column color.
(*) Washes don't match; however, the color may suit your needs if you are basecoating with it. The color value is similar to the first-column color.
(*+) Same as (*), except it is a darker value than the first-column color.
(*-) Same as (*), except it is a lighter value than the first-column color.
N/A There is no equivalent product in this brand (i.e. flourescents, metallics, etc.).

GLOSS

Color Conversion Chart

LIQUITEX®

Acrylic Gloss Enamels

Liquitex® Glossies™ Acrylic Enamels (May be oven "fired")	Accent® Hobby Craft High-Gloss Enamel (May be oven "fired")	Apple Barrel® Gloss Acrylic Enamels (Plaid) (Do not oven "fire")	DecoArt™ Ultra Gloss Acrylic Enamels (May be oven "fired")	DEKA®-Gloss Water-based Enamels (May be oven "fired")	Delta® Hi-Gloss Acrylic Enamels (Do not oven "fire")
Almond 23	-----	-----	-----	-----	Fleshtone(-) 12019
Aqua 32	-----	-----	Aqua(-) DG17	-----	Turquoise(-) 12012
Black 20	Ebony Black 611	Black 20662	Gloss Black DG02	Carbon Black 311	Black 12506
Blue 13	Bally Hoo Blue(+) 648	-----	True Blue(*) DG30	Ultra Blue(*+) 307	Copen Blue(+) 12051
Blue Green 12	-----	Pacific Blue(*-) 20655	-----	-----	-----
Blue Purple 14	-----	Real Blue(+) 20660	-----	Ultra Blue(+) 307	-----
Bright Blue 31	-----	-----	-----	Horizon Blue 306	-----
Bright Purple 30	-----	-----	Lavender(-) DG32	-----	-----
Brown 19	Chestnut Brown(*+) 625	Mocha(*) 20665	Sable Brown(-) DG25	Chocolate Brown(*) 310	-----
Golden Brown 24	-----	-----	-----	-----	-----
Green 11	Emerald Green 614	-----	Christmas Green DG11	Emerald Green(+) 309	-----
Magenta 29	-----	Raspberry(*+) 20629	-----	Pink(-) 313	-----
Maroon 28	-----	Cranberry Red 20633	Cranberry DG9	-----	Sweetheart Blush(-) 12130
Orange 18	Fresh Orange 621	-----	Orange DG7	Blazing Orange(*) 302	Pumpkin(-) 12042
Pine Green 33	-----	Forest Green(*+) 20649	Hunter Green(+) DG12	-----	Christmas Green(-) 12068
Pink 27	Peaches(-) 609	-----	Peach(-) DG18	-----	-----
Purple 15	Purple Aster(-) 620	Purple Velvet(*+) 20627	Purple DG33	Purple 305	Purple 12015
Red 17	Really Red 619	Real Red(+) 20636	Christmas Red DG10	True Red 303	Fire Red 12083
Red Orange 26	-----	Chili Pepper(-) 20638	-----	-----	-----
Red Purple 16	-----	-----	Burgundy(*+) DG08	-----	Tompte Red(*+) 12107
White 21	Gleaming White 612	White 20621	Gloss White DG1	Pure White 312	White 12505
Yellow 10	Sunshine Yellow 615	Real Yellow 20645	Cadmium Yellow(*+) DG06	Bright Yellow(+) 301	Bright Yellow 12027
Yellow Green 34	-----	-----	-----	-----	-----
Yellow Orange 25	-----	-----	-----	Blazing Orange(+) 302	-----

© 1994 Susan Adams Bentley

NOTE: Unfortunately, there are very few "good" matches with the acrylic enamels, perhaps because there are far fewer colors in each line than with regular acrylic paints. With the exception of Jo Sonja's Artist Colors, regular acrylics range anywhere from 100 to over 200 different colors in each brand, while acrylic enamels range from 17 to 46. To help you find the closest color, I've included matches that I would not consider including in the conversion charts for regular acrylic paints.
The following symbols are used in this chart:
(-) Lighter than the first-column color.
(+) Darker than the first-column color.
(*) Washes don't match; however, the color may suit your needs if you are basecoating with it. The color value is similar to the first-column color.
(*+) Same as (*), except it is a darker value than the first-column color.
(*-) Same as (*), except it is a lighter value than the first-column color.
N/A There is no equivalent product in this brand (i.e. flourescents, metallics, etc.).

Chapter 3

SURFACES

The purpose of this chapter is to inform you of what must be done to prepare and finish a variety of surfaces.

In researching this chapter, I found that surface preparation techniques varied, depending upon which book I read or to whom I was talking. While the methods I am recommending are not always the only possibilities, they are the ones I have found that meet my needs.

Surface preparation and finishing is definitely not an exact science, but experimenting can be fun and educational. As you learn of other techniques, try them out for yourself and make your own decision.

Sealers and Varnishes

Before we venture into the various types of surfaces, I think it will help you to understand why most surfaces need to be sealed first, and then varnished after being painted.

Figure 3-1, below, illustrates the role of sealers and varnishes. Sealers are very important in any kind of painting. In decorative painting, the sealer is applied to the surface before doing the painting. It performs two major functions:

1. It provides a barrier between the object to be painted and the decorative paint which will be applied.

The barrier stops moisture, pitch, and other volatile products within the object from diffusing into the paint, which might cause the paint to peel or chemically react.

2. It provides a suitable surface to which the decorative paint can adhere.

For the sealer to adequately perform its function, it must:

1. Be applied to a clean, dry surface.
2. Be appropriate for the type of object to be sealed.

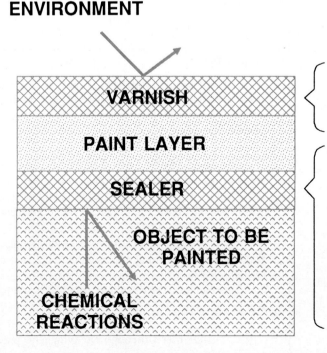

ENVIRONMENT

VARNISH — Protects paint against the environment (e.g., cleaning products, moisture, scuffing, etc.)

PAINT LAYER

SEALER

OBJECT TO BE PAINTED

CHEMICAL REACTIONS

Provides surface to which paint can adhere and prevents chemical reactions between the paint and the object. For example:

1. Corrosion products in metal objects.
2. Oils and pitch in wood.
3. Volatile petroleum products and dyes in plastics.

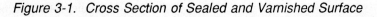

Figure 3-1. Cross Section of Sealed and Varnished Surface

3. Provide for adequate adhesion to the object surface. For example, if the sealer easily peels off the object after it dries, then the decorative paint will peel off too.

4. Provide an appropriate surface for the decorative paint to adhere to.

5. Be compatible with the paint to be applied over it. For example, the paint to be applied over the sealer should not be a solvent for the sealer.

Varnish, applied on *top* of the decorative painting, provides a protective barrier between the delicate painted pattern and the harsh outside world. Things, such as oils, cosmetics, moisture, alcohol, cleaning products, scuffing, and even inquisitive fingers, all conspire to destroy your creation. Having invested valuable time to create your project, you should take a little extra time to varnish it. It will be well worth the trouble.

To save time and money, it's a good idea to verify the performance of unfamiliar surfaces or paints with an experiment before attempting a large project.

Surfaces

In the instructions that follow, be sure to allow adequate time for each coat of sealer, paint, or varnish to dry before going to the next step. The list of supplies given for each surface includes only the special things needed for that particular surface. Things, such as tracing paper, paints, and brushes, are not listed unless a special type is needed for that surface.

Binders, Three Ring

This refers to the coarse fabric binders used by students. Though typically blue, they are now available in a variety of other colors as well. The Mead Corporation of Dayton, Ohio is one manufacturer. I use regular acrylic paint; textile medium isn't required.

Supplies Transfer paper, water-based varnish, fabric brushes (optional), wide flat soft-bristled brush (for varnishing).

1. No sealing is necessary. However, if you don't plan to paint the back, I recommend applying a coat or two of varnish to the back only to protect it from accidental spills. Transfer the pattern using transfer paper.

2. Paint the design with brushes of your choice. Fabric brushes aren't necessary. However, you may want to avoid using your newer soft-bristled brushes because this surface is coarse. Several coats may be required to penetrate the fibers of the notebook.

3. When painting is completely dry, apply at least 5 coats of brush-on water-based varnish with a wide, flat brush. Avoid using sponge brushes because the coarse fabric causes small pieces of sponge to break off. Notebooks look much nicer when multiple coats of varnish are applied.

Bisque See "Porcelain" category.

Brick, Common Red

Supplies Stiff scrub brush, wood sealer, sponge brush, chalk, water-based varnish, wide flat brush.

1. Brick must be clean and dry. Often, bricks have some loose material which should be removed with a stiff scrub brush.

2. Because brick is porous, apply two to three coats of wood sealer with a sponge brush.

3. Transfer the pattern with chalk and paint the design.

4. Use a wide, flat brush and apply several coats of brush-on water-based varnish.

Candles

This section is more extensive than some of the others because candles can be a challenge due to their slick surface. Hopefully, this extended coverage will help you to meet that challenge.

When you purchase candles, try to find ones with as little gloss as possible. It's difficult to paint on glossy surfaces because the paint doesn't adhere well, and tends to slide around. Getting good paint coverage is difficult.

I've read books that suggest you don't need to do anything to the candles before painting them. The results of my candle experiments, however, indicate that surface preparation and finishing are essential to obtain acceptable results.

There are three reasons why candles should be sealed before painting:

1. **Color Bleed-through.** Sealing helps prevent the candle color from bleeding through your painting. The darker the candle color, the more noticeable the bleed-

through will be if you don't seal it first. Over time, however, some bleed-through is inevitable, even with sealing.

2. **Protection.** As soon as you brush a water-based varnish on an unsealed candle, the varnish will lift the paint.

3. **Pattern Transfer.** It is very difficult to transfer a pattern onto an unsealed candle because it is so slick.

Candle Painting Instructions

Supplies Right-Step™ Varnish (both matte and gloss), sponge brush, soft rags, Conté drawing pencil.

1. Gently rub the sides of the candle with a clean, soft rag to remove excess gloss and any scratches. An old T-shirt works well for this. Wipe off all candle residue.

Use another clean rag to handle the candle. This will keep the oils from your hands from getting on the candle, causing adhesion problems.

2. Use a sponge brush and evenly apply one coat of Right-Step™ Matte Varnish to the entire candle, except the wick itself. The Matte Varnish makes a better surface on which to paint the pattern than the Gloss or Semi-Gloss. To avoid excessive streaking, use even strokes moving in the same direction (up and down, not around the candle).

3. Apply one more coat of Matte Varnish to help minimize candle color bleed-through.

4. Trace your pattern on tracing paper, then retrace the back of the pattern using a Conté drawing pencil. Use a pastel pencil color for dark candles, or a red-brown for lighter candles.

5. Position the tracing, penciled side down, on the candle. *Lightly* trace the main pattern lines. Too heavy a touch will indent the candle.

6. Do your decorative painting.

7. Varnish with several coats of Right-Step™ Gloss Varnish. As with the initial application of varnish, make all strokes go the same direction. Cover the sides and top of the candle.

Hints for Candle Painting

Painting Because of the slick surface, stroke work designs are very appropriate for candles. These tips should help you if you choose to paint a design that requires basecoating first, then shading and highlighting separately. Apply light, even coats. It's better to have several thin coats than one thick one. Avoid reworking the areas you are painting because paint tends to look globby. Be patient; wait for each coat to dry before applying the next. Depending on the color of paint, it may take up to 5 coats of paint to get good coverage.

Correcting mistakes If you make a mistake, clean it off immediately with water. A dampened Q-Tip® works well

for this. If some of the paint still remains on the candle, rub the area gently with a damp cloth, then wipe with a clean, dry, soft rag.

Glitter Glitter can enhance candle designs, especially Christmas ones. It is applied by sprinkling a product such as Prisma Glitter™ on wet Right-Step™ water-based varnish. Choose the grade (size) of glitter that suits your design.

Dip a brush in Right-Step™ Gloss Water-Based Varnish and apply it only to the areas that you want glittered. Apply the varnish just as if you were using paint. Do small areas at a time because glitter will only adhere when applied directly to *wet* varnish. Do not shake off excess glitter before the varnish has dried.

Once the varnish is dry, remove excess glitter, brushing very lightly with a soft brush. Once this is done, apply one or more coats of Right-Step™ Gloss Water-Based Varnish to the entire candle.

Storing finished candles Candles are delicate. To protect them, wrap in waxed paper when not in use. Make sure the candle has dried at least 24 hours before wrapping.

Canvas Accessories

The following refers to desk sets, bookends, waste baskets, etc. covered with canvas.

1. No surface preparation is needed.

2. Transfer the pattern using the graphite method. Make sure transfer lines are light. If they are too dark, they will show through the paint.

3. Paint the design using your favorite acrylics. It is not necessary to use fabric brushes.

4. No varnishing is required.

Canvas, Pre-stretched

The following applies to the pre-stretched canvas suitable for framing.

Supplies Gesso (optional), transfer paper, water-based varnish, wide flat brush.

1. Basecoat the entire piece with straight gesso, a mixture of gesso with acrylic paint, or straight acrylic paint. For complete coverage, this will take two to three coats, depending on what you are using. If you use a color, choose one that becomes part of the background of your painting.

2. Transfer the pattern using the appropriate color transfer paper.

3. Do your decorative painting.

4. Use a wide, flat brush and varnish with one or two coats of water-based varnish.

Canvas Shoes[1]

Supplies Canvas tennis shoes, textile medium, old rags (tissue paper or paper towels), regular acrylics or fabric dyes.

1. Sponge wash the shoes with soap and water. This will remove the sizing. Rinse well, then dry completely before painting.
2. Stuff the shoes with old rags, paper towels, or tissue paper to make a firmer painting surface.
3. Transfer the design. Keep in mind that some designs require that the pattern face one way on the left shoe, another way on the right shoe.
4. Paint as desired. If you're using standard acrylics, mix approximately 2 parts of paint to 1 part textile medium. (This may vary with the brand of medium used.)[2]

If you're using fabric dyes such as Delta's®, premix equal parts of dye and textile medium.

5. When the painting is completed, allow to dry for 24 hours. Heat setting is required. Here are two possible ways to do this. The first method is to place a towel over the painted surface and iron at a setting appropriate for canvas. Avoid ironing the rubber soles. The second method is to place shoes in a dryer at a medium setting for approximately 20-30 minutes.

Ceramic/Ceramic Tile See "Tile, Ceramic."

Clay, Air Drying[3]

Available in most craft stores, air-drying clay is rolled out just like cookie dough and cut out with cookie cutters.

Supplies Air-drying clay, cookie cutters, rolling pin, extra fine sandpaper, brush-on water-based varnish.

1. Roll out the clay with a rolling pin. If you're making Christmas ornaments, put a hole at the top of the cutout (for tying the ribbon) using a pencil tip.

Note: If the clay starts to dry out as you are working with it, knead in a little water. Keep unused clay in an airtight bag or container.

2. Allow to dry for three to five days at room temperature.
3. Once clay has dried, sand with extra fine sandpaper if needed.
4. No sealing is necessary, just paint with acrylic paints.
5. When painting has dried, apply several coats of brush-on water-based varnish.

Clay Pots

Inexpensive flower pots and other clay items can be transformed into lovely decorative pieces.

Supplies Either gesso or Designs From the Heart™ Sealer, graphite paper, brush-on water-based varnish.

1. Clay item should be clean and dry.
2. Seal the pot *inside and out*. I have had good success using either one coat of Designs From The Heart™ sealer or two or more light coats of acrylic gesso. If you want the original pot color to show through, use the clear sealer, not gesso.

Sealing with gesso makes it easier to get good paint coverage. It must be applied evenly. Wait 30 minutes between coats. The sealed pot should be completely covered so that it looks as if it had been basecoated.

You must be sure to seal *everything*, including the little hole at the bottom of the pot. If any areas are left unsealed, moisture from the potting soil will seep through, causing your painted surface to discolor and crack in time.

3. If you want the original pot color to show through, transfer your design using the graphite method and do the decorative painting.

If you want to basecoat the pot a different color first, paint the entire pot except for the area where the potting soil will be. (On the inside, only the brim at the top needs to be painted.)

4. When decorative painting is completed, allow to dry, then varnish with several coats of brush-on water-based varnish. Do not varnish the area where the potting soil will be.

Crockery[4]

There are various grades of crockery ranging from smooth to rough. If you plan to use crockery for food storage, it must be glazed on the inside and marked to indicate that it is safe for this type of use.

Supplies #400 wet/dry sandpaper for rough crockery, graphite paper, Jo Sonja's® All Purpose Sealer.

1. Smooth crockery is ready to paint. Rough crockery must first be sanded. Remove all sanding residue. The crockery should be clean and dry.
2. Transfer pattern using graphite method and do decorative painting.
3. Seal with one thin coat of Jo Sonja's® All Purpose Sealer.

Enamelware

Enamelware decorated in the following manner is for decorative rather than functional purposes.

Supplies Matte spray sealer, graphite paper, brush-on water-based varnish.

1. Make sure surface is clean and dry.
2. Spray surface to be painted with a light coat of matte spray.
3. Trace pattern using graphite method.
4. Do decorative painting and allow to dry.
5. Varnish with brush-on water-based varnish.

Fabric, Washable

The focus of this section is to describe some of the basic instructions that apply to fabric paints, dyes, or regular acrylics mixed with textile medium. Although you can paint on almost any fabric, this section deals mainly with painting on washable fabric, as opposed to those fabrics which must be dry cleaned. If you wish to paint on a fabric that must be dry cleaned, be sure to use a paint that is not affected by the dry cleaning process. Read the label to be sure. See the "Silk" section for basic instructions on three silk painting techniques: resist, stop-flow, and watercolor.

For wearable art, ideally the fabric should be a blend of 50% cotton and 50% polyester. Fabrics that are 100% cotton tend to shrink; 100% acrylics tend to resist the paint and get fuzzy. However, with the many fabric paints/dyes available today, you can use almost any fabric and enjoy good results.

Some Methods to Try

Paint can be applied to fabric in a variety of ways. Here is a description of some of the methods:

Brush Method Many of the same techniques are used for painting on fabric as for painting on other surfaces. Examples are basecoating, shading, highlighting, etc. The type of brush you use depends on the brand of paint you're using. Refer to Chapter 2, "Fabric Paints," for a description of the various fabric paints available and the type of brush recommended.

If you are using regular acrylics with a textile medium, you may prefer to paint with fabric brushes, especially if you're painting on heavy fabrics (such as sweat shirts). Because regular acrylic paints were not designed specifically for fabric, they don't penetrate the fabric as well as fabric paints or dyes. Therefore, a slight scrubbing action is required that isn't needed on most other surfaces. Fabric brushes have stiffer bristles to support this scrubbing technique. Experiment and see what you prefer to use.

Drawing On Method Fabric marker pens are available that make it possible for you to write or draw on fabric. See "Fabric Pens" category in Chapter 2 for possible brands to try.

Drizzling Paint Method This is often done using dimensional paints such as Delta® "Dimensionals" or other equivalent products. Paint is applied straight from the bottle. It's an excellent way to do fine liner work and is, therefore, effective in outlining fabric appliqués that have been bonded by using a product such as Pellon's® "Wonder-Under"™ transfer web.

When applying the paint, it's important to keep a constant, gentle pressure on the plastic bottle. To create a strong bond, keep the writer tip in contact with the fabric as you apply the paint. Shake the bottle every so often to break up any air bubbles. If an air bubble does get onto your fabric, quickly pop it and smooth out the paint using a stylus or toothpick.

Spraying Method Thin the paint as recommended by the manufacturer. Place it in a small size spray bottle such as those sold in beauty supply houses. Areas you don't want painted should be covered (masked) with plastic when the paint is sprayed on. Experiment on a rag first to help you decide how far from the fabric the spray bottle should be held and how heavily the paint should be applied. No pattern is needed.

Stamping Method Fashion stamping is done by brushing a product such as Soft Sparkling Tints™ (by Tulip®) onto a sponge (or stamp) and then applying it to fabric. The sponges come in a variety of shapes so no pattern is needed.

Fabric Painting Guidlines

Here are some guidelines to follow when painting on *washable fabric*, no matter what type of paint you're using.

1. Wash the fabric *without* using a fabric softener because paint doesn't penetrate the fabric as well when a softener is used. The purpose of pre-washing is to pre-shrink the fabric and to remove the sizing.
 Note: Be sure to check that the detergent you are using doesn't have a built-in softener.
2. Dry according to instructions for that particular fabric. Iron, if needed, at a setting appropriate for the fabric.
3. Place plastic or plastic-treated cardboard between the layers of fabric to be painted to prevent the paint from soaking through to the other layers of the fabric. If you are painting a sweat shirt, plastic-treated cardboard shaped

like a shirt is available at craft stores.

Note: This is an optional step. Cover the cardboard with wax paper or aluminum foil and tape it in place. Before putting the fabric on the cardboard, *lightly* spray the covered cardboard with a spray adhesive.[5] This keeps the fabric from moving around when you're painting it. When you purchase the spray adhesive, check the label to make sure the product is for *temporary*—not permanent—bonding. The product I'm familiar with is Delta® Stencil Adhesive.

4. Secure the fabric with clips, pins, or tape. I like to attach a piece of plastic kitchen trash bag to the areas of the fabric that won't be painted. This protects against accidental paint spills...and believe me, these can happen.

5. Apply the pattern using one of the fabric transferring methods described in Chapter 4.

6. It's a good idea to start painting at the top of the design and work down to avoid smearing newly applied paint.

7. Choose the type of paint and fabric that compliment each other. For example, light-colored fabrics lend themselves well to pastel designs because you can get good coverage without needing to use multiple coats of paint. Dark fabrics, on the other hand, require opaque paints or dyes such as Delta's® Starlite™ or Wally R's™ Galaxy™ dyes.

8. Painting mistakes are difficult to remove. It *may* be possible to remove paint if it hasn't dried. Keep a container of clean water, a fabric cleaner such as Spoto™, and a clean fabric scrubber brush handy. If you do get a spill, apply a small amount of Spoto™ and scrub with the scrubber brush immediately. Rinse with clean, cool water. Repeat this procedure several times until the color is gone.

Note: As a precaution, you may want to put a little cleaner on an inconspicuous area of the fabric before putting it on the actual spot...just in case it reacts in a less than desirable way.

Another method is to put a little rubbing alcohol (vodka works even better) on the spot immediately and try to brush it off with a fabric scrubber brush.

If you can't remove all of it, you should consider painting something over it.

9. If you painted with brush-on fabric paints or dyes and used a cardboard under your fabric, remove it as soon as the painting is completed and hang the painted fabric to dry. However, if you used dimensional paints and/or applied jewels, etc., allow the painted fabric to dry flat. Don't allow the painted fabric to dry on the cardboard because it will stick to it.

10. Heat set if required. Refer to Chapter 2 under "Fabric Paints" for information on whether the paint you are using requires this process. Never heat set the fabric while it's on the cardboard.

11. You can wear your newly painted fabric as soon as it's dry. However, to be on the safe side, I prefer to wait at least 5 days before laundering it...even if the

manufacturer recommends a shorter time. Refer to "Fabric Paints" in Chapter 2. If special washing instructions are recommended for a particular brand, they are shown under the "Special Instructions" category.

In general, if you've painted a shirt or some other garment, turn it inside out for washing. Use a mild detergent that doesn't contain bleach, whiteners, lemon scents, or other additives. Wash at a gentle cycle in cold water. Avoid using fabric softener and softener sheets.

12. Many manufacturers indicate painted fabric may be dried in a clothes dryer at a setting appropriate for the fabric. However, I've learned from experience that the painted fabric will look newer longer if allowed to drip dry instead of using a clothes dryer, especially if dimensional paints were used on the design. I hang my painted garments up to dry on padded hangers, with the right side out. For designs with a lot of jewels and dimensional paint, lay it flat on a sweater drying device.

Using Acrylics for Fabric Painting

Regular acrylic paints may be used to paint fabric. However, because they were not designed exclusively for fabric, the majority of them tend to dry stiffer than do fabric paints or dyes. Even so, there are times when painting with regular acrylics works just fine. For example, when you're painting on canvas totes and similar accessories, it isn't as important to maintain the "soft hand of fabric" because the items are stiff to begin with.

When painting with regular acrylics, most manufacturers recommend mixing textile medium into the paints. Textile medium changes the consistency of the paints, enabling them to better penetrate the fabric, and bond around the fibers. The textile medium also reduces the tendency for the paint to bleed outside the pattern areas.

Textile medium is used in two ways. You can either (1) brush it onto a small area of your pattern and then brush on the regular acrylic paint, or (2) mix the paint and medium together on a palette, then apply to the fabric. I recommend that beginners use the second method because it ensures that every painted area will have a mixture of textile medium and paint.

The ratio of textile medium doesn't need to be exact, and the ratio is often changed to create specific effects. If you're in doubt as to the ratio to use, I recommend you start by using approximately equal parts of medium to paint.

Using Jo Sonja's® Artist Colors[6] for Fabric Painting

1. Mix equal parts of Jo Sonja's® Artist Colors and Textile Medium.

2. Once the paint has been mixed with Textile Medium, water may be added to thin it for more transparent techniques or for liner work.

3. Put a thin layer of plain textile medium over any painted areas where you want to blend the paint, and then

apply the paint on top of this.

4. Heat set the finished, dried painting. Put a piece of tissue paper over the painting and use a dry iron (no steam) set to the appropriate temperature for the fabric. The iron temperature needs to be 250 degrees to heat set. If hotter than 280 degrees, reds and pinks may undergo a color change.

Because it's difficult to tell what setting equals 250 degrees, Jo Sonja suggests painting a piece of scrap fabric with reds and pinks. Allow it to dry, then heat set it. Notice the setting at which the colors change, then stay below that for heat setting your actual project. Heat set the back side of your design in the same way.

Fingernails[7]

At a recent convention, I discovered a new surface to paint on. For those of you who apply decals to your nails for special occasions, why not paint your own fingernails? There is one problem, unless you're ambidextrous, you'll only be able to paint the nails on one hand.

1. Polish your nails with at least two coats of nail polish in the color of your choice. Allow the polish to dry well between coats. Wait at least 30 minutes before painting the design. This way, if a painting mistake occurs, you can wipe it off with a damp towel without damaging the original coats of fingernail polish.

2. Don't worry about applying a pattern. Just paint a simple stroke rose, daisy, or object of your choice. Because polished fingernails are such a slick surface, stroke designs offer the best results.

3. Paint the design with your favorite acrylic paints. I use a 1/8" angle brush for stroke roses, and a 10/0 filbert for the leaves.

4. If you make a mistake, wipe the paint off *immediately* using a damp cloth or tissue. (This shouldn't damage the original nail polish if you gave it plenty of time to dry.) Gently pat the nail dry and try again.

Note: When the painting is dried, you might like to add a bit of sparkle, especially for Christmas designs. If so, brush glitter paint on the areas you choose. (DecoArt™ Heavy Metals™ Glimmer Clear (DHM3) works well.) Make sure whatever glitter paint you use has a clear base so you can easily see your painted design under the glitter.

5. When the paint is *completely* dry, apply one to two coats of clear acrylic nail polish top coat. This is very important, because it protects your painting.

6. I've had painted roses last up to two weeks on my nails. Keep the original nail polish color handy for touch ups, and add an additional coat of clear acrylic every 3-4 days.

7. The paint is easily removed with nail polish remover.

Glass

Painting on glass is a challenge because it's such a smooth surface. The paint doesn't adhere as well as it does on rougher surfaces. It is now possible to paint on glass, bake it in your home oven, and maintain the beauty of the painting after repeated washings in a dishwasher.

Here are instructions for painting with Liquitex® Glossies™. I hope you enjoy this method as much as I have.

Supplies Liquitex® Glossies™, white vinegar, chalk, or non-waxy graphite paper.

Note: Liquitex® Glossies™ are not to be confused with Liquitex® Concentrated Artists' Colors. The Glossies™ are acrylic *enamels* which provide a high-gloss, dishwasher-proof color on any surface that can be baked in your home oven. Cleanup is with soap and water.

In addition to glass, try this on ceramic tile, crockery, tin, or other primed metals. Though Liquitex® Glossies™ are completely non-toxic and have no solvents, they are not recommended for use in food contact applications. Therefore, place your pattern so the painting will not come in contact with your mouth or food. For example, try painting the underside of glass plates for decorative tableware.

1. Wash the glass with soap and water to remove all oils. Rinse with a 50/50 mixture of white vinegar and water. Dry well. Try to avoid touching the areas you will be painting because putting your hands on the clean object may put oils back onto the surface.

2. Transfer the pattern. This is a little tricky on a slick surface. Use chalk, non-waxy graphite paper, or freehand the pattern on with a non-waxy pencil. Don't use a marking pen because the ink will mix with the paint and change the color. Waxy graphite will repel the paint.

3. Shake the paint well before each use. The Glossies™ are intermixable so you can obtain a variety of colors.

4. For best results, paint with a medium thick coat of paint instead of using heavy applications. Avoid over-working the paint. When it starts to grab, leave that area and paint another area of the design. Heavy coats may bubble or crack when baked. Thin coats may not with-stand dishwashing.

To save time, paint with a wet-on-wet technique. Basecoat the area, then shade and highlight while the basecoat is still wet. Experiment to see what works best for you.

5. It may be necessary to apply more than one coat of paint to obtain the desired coverage or to apply floats for shading and highlights. Liquitex® Glossies™ take longer to dry than the regular acrylics. Wait 2 hours for the first coat to dry before applying the next.

If you are floating on color, you may thin the paint

with up to 25% water. However, the more water you add to the paint, the more you break down the special adhesives that make it adhere to non-porous surfaces.

6. If you make a mistake, just rub off the paint with a paper towel or Q-Tip®. Erasing is easy when painting on glass.

7. Allow the finished painting to dry completely (about 2 hours) before baking. This will vary with climatic conditions. These paints look wet even when they are dry because of the glossy finish.

8. Put your painted glass on a cookie sheet in a cold oven. Set the oven at 325 degrees and bake for 45 minutes. Open a window or leave the room while it is baking because there will be some fumes. Baking at a higher temperature may cause excessive fumes as well as over-baking, causing the paint to flake off. The object may not be dishwasher safe if baked at a lower temperature or for less time.

At the end of the baking time, turn off the oven, open the oven door, and allow your painting to cool *completely* before removing it.

Note: Do not rub your finished design with any abrasive materials. After four times through the dishwasher, the glass I painted looks as good as new. I now wash it by hand, as I do any of my favorite glassware.

Glass, Etching

There is a way to make painting on glass and mirrors easier, and that is to "give tooth" to the areas you plan to paint by applying either an etching cream or liquid.

From my experiments, the following methods proved to be very effective.

Etching Creme Method

Supplies B&B Etching Creme™, swivel knife, squeegee, straight knife (such as X-Acto®), cotton swab, white contact paper, object to be etched. If any of these products are not available locally, write to B&B Etching Products, Inc., 18700 N. 107th Avenue, Suite 3, Sun City, AZ 85373

1. You may etch any mirror or glass surface except Pyrex®. Pyrex® can't be etched because it has a hard fired glaze that the Etching Creme™ can't penetrate.

2. Cover the entire object with white contact paper. Use a squeegee to smooth the paper and remove any air bubbles. On rounded surfaces, fold up edges so contact paper remains flat against the surface.

Note: Any color of contact paper will work. However, your transfer lines will show up better on the plain, white background.

3. The only areas that need to be etched are those where you plan to paint. However, let your creativity be your guide. Etching the base of a wine glass, for exam-

ple, even if you don't plan to paint it, looks very pretty. In this sort of application, using an etching liquid would work best. (See "Liquid Etching Method" that follows.)

4. Transfer the design to be etched onto the contact paper using either graphite or carbon paper under your pattern. For example, if you want to paint a design *within* an oval, all you transfer are the outside lines of the oval. See Figure 3-2. If you want an irregular pattern, such as a Christmas tree, you still trace the outside lines only. Refer to Figure 3-3.

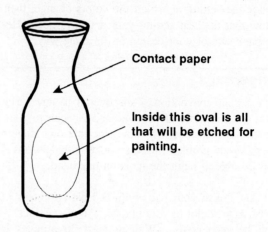

Figure 3-2. Area To Be Etched (Oval)

Figure 3-3. Area To Be Etched (Christmas Tree)

5. After applying the contact paper to the glass, cut along the transfer line using a swivel or straight knife. Carefully pick off the contact paper within the transfer lines. Start at the middle of the design. This will keep the edges from stretching. The remaining contact paper will mask the surrounding areas.

Note: Contact paper stretches. That is why it needs to be cut out while it is on the glass—not before. Also, the glass provides a hard surface, making it easier to cut the paper.

6. Use your finger to remove any glue residue left

by the contact paper. Feel along the cutout for loose edges. Press them firmly in place using the squeegee. The remaining contact paper must be smooth and tight against the glass. If it isn't, the cream can get under the paper, etching an area you don't want etched.

7. Apply a heavy coat of Etching Creme™ to the desired areas, using a cotton swab on small areas and a squeegee on large ones. Make sure the design area is well covered with the cream. (You can only etch it once. A second application is ineffective.)

Note: Never apply the Creme with a brush because it may cause streaking.

An easy way to apply the cream, especially to larger areas, is to put a large glob of it on the contact paper, close to the area to be etched. Roll the cream onto the surface using the squeegee. The squeegee should touch only the cream not the surface. This enables you to get the heaviest application. Be very generous in the amount of Creme you apply. Keep in mind that it is reusable.

8. If you are etching a wine glass, for example, carefully lay it flat with the surface to be etched facing up. This will keep the cream from running off the design area.

Leave the cream on for 15 minutes. It may be left on for up to 45 minutes, although it isn't necessary. Leaving it on too long may cause the contact paper to lift due to the dampness.

9. After 15 minutes, the etching is complete. Remove the cream with a squeegee and scrape it back into the jar. It can be used many times. Wipe off the rest of the cream with a damp sponge or paper towel.

If the etching is not even, this was most likely caused by one of the following:

 a. Not enough cream was used
 b. Some glue residue from the contact paper remained on the area to be etched
 c. The glass was dirty
 d. There was an imperfection in the glass
 e. The etching cream was too cold. If the temperature is below 70°F, one of the chemicals crystallizes.

10. Rinse the glass under running water. Peel off the contact paper, rinse the glass again, and dry thoroughly. The etched glass is now ready to paint.

11. Use standard graphite paper to transfer the pattern onto the etched glass. See Chapter 4 for more information on how to transfer your pattern.

12. You may paint with regular acrylics or acrylic enamels such as Liquitex® Glossies™. If you choose to paint with the Glossies™, follow the glass painting instructions in the previous section and "oven fire" the object for added durability.

13. When painting, use light coats, allowing each to dry before applying the next. Avoid "playing with the paint," or moving it around too much because this causes

it to glob up. Just be patient. Even if it takes several coats, I think the end result will please you.

14. If you etched an oval, for example, and think the lines don't look even enough, get creative. Painting comma strokes, dots, or scallops creates a great camouflage. Just paint them on the outer edge of the oval, (but make sure you are still painting only on the *etched* area of the glass.)

15. Allow the paint to dry completely. If you painted with *regular acrylics* and the object will be washed often, protect the painted area by applying two to three coats of water-based varnish *to the etched area only.* Allow each coat to dry before adding the next. (This isn't necessary if you painted with Liquitex® Glossies™.)

Hint: I use the largest paint brush I can to fit the area and apply the varnish with a soft touch. If you are varnishing a large area, a sponge brush works even better. Try to go in one direction only to minimize streak marks. If you accidentally get varnish on the clear glass, don't worry. Use a dampened paper towel and carefully remove it before it has a chance to dry.

16. You have now created a hand-painted decorative object that needs tender loving care. Treat it like fine china. If you painted with regular acrylics, do not wash it in a dishwasher because harsh detergents can remove the paint. When it gets dirty, carefully wipe it off with a damp cloth. Don't allow the object to soak or remain wet as the paint may soften and peel off.

If the glass was painted with Liquitex® Glossies™ and was "oven fired," it can be washed in a dishwasher, though I choose to wash my painted glass by hand.

Liquid Etching Method

B&B Etching makes a product called "Dip 'n Etch"™. This is used for two-sided etching, (for items, such as bottles, stems of wine glasses, Christmas ornaments, glass beads, etc.) If it isn't available locally, write to B&B Etching Products, Inc., 18700 N. 107th Ave., Suite 3, Sun City, AZ 85373.

Supplies B&B Dip 'n Etch™, plastic container (larger than object you want to etch), object to be etched.

1. Set the object to be etched in the empty plastic container. Fill the container with water to the height of the desired etch.

2. Take the object out of the container and mark the water level. This mark will show how much Dip 'n Etch™ to use. Pour out the water and dry the container.

Note: The water level can be marked with masking tape, paint, or any kind of marking device that will stick to the surface.

3. Pour Dip 'n Etch™ to the level of the water mark.

4. Place the object into the container and hold it down with something heavy. (This keeps the object from

floating.) A hollow object, such as a wine decanter, may be filled with water to keep it from floating.

5. Leave the object in the etching liquid for 30 minutes.

6. At the end of 30 minutes, lift the object out of the container and rinse under running water.

7. Clean the object with soap and water. Dry thoroughly. The glass is now etched and ready to paint.

8. Pour used Dip 'n Etch™ back into the original jar for re-use.

9. From this point on, refer to steps 11-13, 15, and 16 under "Etching Creme."

Note: If you are etching some areas but not painting them, no varnish is needed.

Gourds[8]

Gourds can be transformed into interesting painting surfaces, especially for the holidays.

1. Gourds must be dried before painting them. Place them in a warm, dry area for 3-4 months.

2. Once they have gone through the drying period, wash them with warm, soapy water, rinse, and dry them.

3. Lightly sand the bumps, then wipe off any residue.

4. Seal with your choice of wood sealer. If you don't want the color of the gourd to show through, you could seal and basecoat at the same time. (Refer to Chapter 6, "Basecoating Wood Without Sealing—Jo Sonja's Method".)

5. Paint as desired.

6. When paint has dried, varnish. Gourds handled in this manner should last a long time.

Leather[9]

Leather shoes, handbags, and briefcases make interesting surfaces on which to paint. Some preparation is required so the paint will adhere to the leather.

Supplies Acetone or lacquer thinner, Liquitex® Concentrated Artists' Colors.

1. Transfer the outline of your pattern onto the leather.

2. Apply acetone or lacquer thinner inside the outline created in step 1, using a cotton ball or Q-Tip®. This will pull the oil out of the leather. Do this in a well-ventilated area and wear gloves to protect your hands.

3. Wipe the area thoroughly to remove any residual oil and allow the leather to dry for about an hour before you start painting.

4. Paint your design. The Liquitex® paints will penetrate the leather so the painted design won't chip or crack.

5. When dry, varnish painted area with several coats of brush-on water-based varnish.

Masonite

This is available at many hardware stores, can be cut to size, and is appropriate for framing. I suggest you purchase untempered masonite because, unlike tempered masonite, it has not been treated with an oil-based product.

Supplies Sandpaper, transfer paper, brush-on water-based varnish.

1. Sand any rough edges. Wipe off the sanding residue. Surface must be clean and dry.

2. Assuming you will be framing it, basecoat one complete side of your project in your choice of acrylic paints.

3. Transfer pattern.

4. Do the decorative painting.

5. Varnish with several coats of brush-on water-based varnish.

Metal, New

This covers all metal except for tin. Start with step 3 under "Metal, Old" category.

Metal, Old

An old mail box, outdoor chair, or metal saw blades are a few examples of metal items that can be transformed with decorative painting.

Supplies Sandpaper, Duro™ Naval Jelly® (only if badly rusted), white vinegar, protective sealer (see step 4), graphite paper, brush-on water-based varnish.

1. Remove all rust. If it isn't badly rusted, sanding should do the trick. Apply Naval Jelly® to badly rusted metal, following directions on the container. Wear gloves to protect your hands. If all else fails, a heavy gauge metal can be sandblasted.

2. If you sanded the piece, remove all residue. If you used Naval Jelly®, wash it off with soap and water.

3. Wash the metal with a mixture of half water and half white vinegar. Dry *completely*.

4. Apply a protective sealer to prevent rust. Suggestions—Krylon® or Rustoleum® metal primers. Follow the directions on the container.

5. Basecoat with your choice of paint. Don't rework areas as paint will glob up. Apply thin coats, allowing each to dry before applying the next.

6. Transfer the pattern with graphite paper and do the decorative painting. Allow the finished painting to dry.

7. Use the varnish of your choice. Some artists have had the problem of spray varnishes cracking after being applied to a metal surface. This usually results from chemical incompatibility between the spray, previous coats of paint, or sealer. As mentioned earlier in the chapter, be sure that the products you use are compatible. Experimenting on a test surface first is a good idea.

Notebooks See "Binders, Three-Ring."

Paper

Watercolor paper, illustration board, mat boards, blank note cards, and parchment paper are all suitable for painting.

Supplies Transfer paper, brush-on water-based varnish (optional).

1. Lightly transfer your pattern with transfer paper. It is important that the transfer lines be light so they won't show through your painting.
2. If you're working on note cards or other items that have a fold, avoid repeated folding and unfolding because this can crack the paper.
3. Paint with light coats of paint. If it's too light, you can add more. If it's too heavy, you're stuck with it.
4. When the decorative painting is complete, you may apply a coat of brush-on water-based varnish. This is not necessary, but it gives the painted area a nice shine. Generally, varnish only the painted areas.

Papier Maché[10]

Supplies Graphite or chalk, Krylon® spray varnish.

1. No sealing or sanding is required.
2. Basecoat object. The number of coats needed will vary depending on which brand of paint you use. Wait for each coat to dry before applying the next one.
3. If the papier maché surface has lots of nooks and crannies, transferring the pattern with graphite is almost impossible. In these cases, chalking the main pattern lines directly to the surface works the best.
4. Do the decorative painting using any acrylic paint.
5. Varnish with varnish of your choice.
Note: The brush-on variety gives sturdier protection in fewer coats than the sprays. However, sprays, such as Krylon®, are also effective and make it easy to cover all the crevices in the object.

Pigskin Suede See "Suede, Pigskin."

Plastic

Supplies Jo Sonja's® All-Purpose Sealer, transfer paper, clear acrylic spray or brush-on water-based varnish.

1. Surface should be clean, free of soap residue, and dry.
2. Seal with Jo Sonja's® All-Purpose Sealer or a similar product.
3. If you choose, basecoat the entire surface. If you want the original plastic to show through, proceed to step 4.
4. Transfer the pattern using transfer paper in the appropriate color for your surface.
5. Do the decorative painting. Plastic, like glass, takes several coats to cover. Use light coats and don't overwork the paint or it will get globby.
6. When dry, spray with clear acrylic or brush-on water-based varnish.

Note: Though this book deals only with using acrylic paints for decorative painting, I think I should mention that oil paints shouldn't be used as basecoats on plastic. When combined with plastic, a chemical reaction *may* occur that destroys the plastic surface.[11]

Porcelain[12]

This method is not to be confused with traditional china painting where the painted object is kiln fired and, therefore, more durable. Objects are for decorative purposes only and should not be subjected to frequent washings.

Supplies Graphite paper, Krylon® Matte Spray Finish, #400 wet/dry sandpaper, dishwashing liquid (for rough bisque), and brush-on water-based varnish.

Fine Bisque This expensive, high quality porcelain has a smooth, silky finish. No sanding or sealing is required. Transfer pattern using graphite paper.

Rough Bisque This is heavier than fine bisque and is more easily available to the consumer.
To prepare the rough bisque for painting, first moisten it with water. Dampen a piece of #400 wet/dry sandpaper, add a drop of dishwashing liquid, and sand in a circular motion until smooth. Rinse. Pat dry with a soft cloth and allow to dry completely. No sealing is necessary. Transfer the pattern using the graphite method.

Glazed Porcelain Because of its slick surface, glazed porcelain needs to be misted with several light coats of Krylon® Matte Finish to give "tooth" to the surface for

SURFACES

proper paint adhesion. If you prefer a brush-on type product, use one or two coats of McCloskey® Heirloom Clear Varnish (Eggshell 0032). Allow 24 hours between coats before transferring pattern.

After the painting has dried, each type of porcelain should be sprayed with two light coats of matte spray sealer to set the paint and keep it from lifting when you apply brush-on water-based varnish. Once the spray sealer has dried, apply a minimum of 2 coats of brush-on water-based varnish. Some artists apply as many as 10 coats of varnish on porcelain that will get a lot of use.

Pottery

Supplies All-purpose sealer, graphite paper, brush-on water-based varnish.

1. Surface should be clean, free of soap residue, and dry.
2. Apply a coat of all-purpose sealer.
3. Transfer the pattern using the graphite method.
4. Do the decorative painting.
5. Apply several coats of water-based varnish.

Records[13]

Records have become relatively obsolete in the music industry since they've been replaced by tapes, and more recently CD's. They are, however, another possible painting surface for the decorative painter.

Supplies Old record, Conté white pastel pencil (or similar product), cotton ball, alcohol, Krylon® Crystal Clear Acrylic Spray.

1. Clean the record. Wipe it carefully with a dish rag that's been dipped in soapy water. Make sure to squeeze the rag so it's not too wet. As you wipe the record, be careful not to get the label wet. Dry with a clean, lint free towel. Avoid using paper towels as they will leave lint on the surface.
2. Wipe the record, (not the label), with a cotton ball that has been dipped in alcohol.
3. Sketch the pattern on with the white pastel pencil.
4. Paint with your favorite acrylic paints. (Oil paints may be used in place of acrylics.)
5. When completely dry, spray it lightly with Krylon® Crystal Clear Acrylic spray. Several light coats are more effective than one heavy coat. Because dust would be very noticeable on the record surface, allow the record to dry in an area that is as dust-free as possible. One idea is to cover the record with a cardboard box while it is drying.

Rocks[14]

The creativity of decorative painters never ceases to amaze me. I first learned of "Rock Art" in a magazine article (referenced in the footnote). The painted rocks are used for both indoor and outdoor decorations.

1. Look for rocks with flat bottoms so they can stand properly. Try to visualize what the shape of the rocks reminds you of—an animal, a Santa, etc.
2. Clean the rock by first brushing it with a wire brush to remove dirt and loose particles.
3. Wash the rock in soapy water, rinse well, and dry it completely before painting.
4. For some designs, the rock color can be incorporated into the painting. For others, basecoat the entire rock.
5. Allow the finished painting to dry for 24 hours, then seal with water-based varnish.

Shade Cloth

This is a relatively inexpensive surface that is especially appropriate for framing in hoops trimmed with lace.

Supplies Hoop (optional), gesso (optional), graphite paper, brush-on water-based varnish.

1. Secure shade cloth in a flat position so that the ends won't roll up. If you plan to use a hoop as the frame, center the shade cloth over the smaller half of the hoop. Put the larger half on top and push down, making sure the shade cloth is smooth all the way around. Tighten the screw on the hoop as you stretch the cloth.[15]
2. This step is optional. Basecoat the shade cloth first with acrylic paint or with gesso mixed with acrylic paint. A sponge brush works well for this.
3. Transfer the pattern using transfer paper of your choice.
4. Do the decorative painting.
5. Apply several coats of brush-on water-based varnish.
6. If you used a hoop, the lace may be applied to the wood using tacky glue.

Shoes[16]

These instructions are for restoring old shoes or adding your special touches to new shoes using Color Steps® Shoe Paint by Plaid®. This is appropriate for use on leather and vinyl shoes and accessories. It may also be used on tennis shoes. It is *not* intended for use on patent or suede.

Supplies Color Steps® Shoe Paint and "Shoe Repair", Fine grade sandpaper (#400-600), soft rag.

1. **Old Shoes.** Check the shoes carefully for any gouges or tears that need mending. To fill deep gouges, put a little Color Steps® Shoe Repair in each gouge, and smooth away the excess with your finger. If there is a tear and the material is still attached, glue it down using the same product, and again, wipe off any excess with your fingers. Shoe Repair looks white when first applied and dries clear in 30-60 minutes.

If you repaired deep gouges, you may need to repeat this step when the first application has dried. Allow to dry before going to the next step.

2. **Old or New Shoes.** To remove oils and polish that would interfere with paint adhesion, lightly sand *only* the areas of the shoes that you'll be painting. (You need to do this even on tennis shoes.) Leave the other areas alone as sanding will dull the finish. Wipe sanding residue off with a soft cloth.

3. Apply the paint using a flat brush. For hard-to-reach areas, such as under a buckle, use a small round brush. Use the chisel edge of your flat brush for applying the paint on the areas by the sole. Start at the sole and work up, then smooth the paint by brushing in a horizontal direction. Don't work the paint once it starts to feel tacky.

For a professional look, avoid getting paint on the sole. If you do, wipe it off with a clean brush dampened with water. After the shoe is painted, allow it to dry to the touch (about 30 minutes), then apply another coat of paint.

4. Allow the shoes to dry completely before wearing.

Note: Look for the Plaid® View 'n Do™ Video #27, "Color Steps®...Restore & Restyle Your Shoes," for project ideas. A book, "Step by Step," is also available (Plaid® Publication #8624).

Shrink-It™ Plastic

Aleene's Shrink-It® (formerly called "Shrink-Art"), is a plastic material that shrinks approximately 60 percent when heated. After shrinking, it's about as thick as a nickel. It is manufactured by Artis, Inc. and is available in two types: Clear, and "Opake" (which is slightly cloudy, but clear enough to trace through and shrinks to a pearlescent, opaque finish).

Supplies Shrink-It® Plastic, #400 sandpaper, permanent marker pen, extender, scissors, brush-on water-based varnish.

1. For color fastness on designs that will be washed or used often, lightly sand the plastic with #400 sandpaper.
 a. Sand *after* inking if you plan to use a permanent marker in order to maintain a fine line.[17]
 b. Sand *before* inking if you are using a pencil for tracing.

2. Trace your design by laying the plastic over the pattern. Make as fine a line as possible. You can use a pencil, a thin brush, or an extra-fine permanent marker (my preference). For a "pen & ink" appearance, trace all pattern lines. Otherwise, transfer only the ones you need.

3. I suggest that you use regular acrylic paints. However, the product instructions indicate that you can use permanent marking pens, colored pencils, ink, etc..

4. Thin the paint slightly with water. It should be somewhat transparent because shrinking intensifies the colors. Where paint is thicker, the plastic will not shrink flat, resulting in a textured effect.

Note: Although texture isn't usually desired, it can be effective, for example, in creating Santa's beard.

5. The finished painting will look streaky and you probably won't like it. However, shrinking will take care of this.

6. After the paint has dried, coat everything with one coat of extender. This helps paint adhere to the plastic.[18]

7. Cut out your design with household scissors or a craft knife. If you are making an object that needs holes in it, do that *before* shrinking. Holes can be easily punched with a single hole punch, such as those available at your local market or stationery store. A 1/8th inch paper punch is a good size for punching the holes for buttons and other designs that will be sewn onto clothes.

8. Preheat oven to 200-250 degrees. A low temperature is necessary to keep the plastic from shrinking too fast, causing distortion. Either a regular or toaster oven will work. If your design curls rapidly, the oven is too hot, regardless of what the temperature setting indicates.

9. Place the design on a cool, Teflon-coated cookie sheet and bake. The plastic doesn't start to shrink immediately. The shrinking process, however, is fast—from 1 to 2 minutes for small pieces, and a little longer for larger ones.

In 30 to 40 seconds, the plastic will begin to curl and move. When the plastic has finished curling and uncurling, it will become thicker. When it's completely flat, you may remove it from the oven.

10. Use a spatula to remove the plastic from the cookie sheet. Place a large book on top of it to keep it flat while it cools.

Note: If you remove the Shrink-It™ from the oven too soon, all is not lost. Just put it back in the oven until the shrinking is complete.

Occasionally a piece will curl and touch another portion of the plastic and stick. This can be taken apart while still warm. Plastic coming from the oven is pliable and can be shaped. Use a pair of pot-holder gloves to handle the hot plastic.

11. Apply a coat of brush-on water-based varnish to the surface when it has cooled completely.

Note: This is a lot of fun for adults, and for children with proper supervision.

SURFACES

Silk

There are three basic silk painting techniques: Resist, Watercolor, and Stop Flow.

The following instructions are for using DEKA®-Silk Paints (described in Chapter 2). They are water-based, non-toxic, and permanently machine washable and dry cleanable (after being heat set). Colors may be inter-mixed, and delicate pastel shades are created by adding water to the paints.

With silk painting techniques, paints are absorbed by the fabric and spread evenly into the fibers. Use of brush strokes isn't necessary. Fabrics painted with DEKA®-Silk remain soft to the touch.

DEKA®-Silk is appropriate for use on any smooth textured, fine weave, light-weight synthetic or cotton fabric. However, working on pure silk offers the best results. Both the Resist and Watercolor techniques may be combined in your designs.

No matter which technique you use, it's a good idea to experiment on a sample of fabric before painting on the "real thing." This will allow you to get the feel of the paints and fabric and to decide which method you like best.

Instructions That Apply to All Three Methods

Here are basic instructions that apply to the three silk painting methods that follow.

1. Pre-wash the fabric to remove the sizing. Do not use a fabric softener. Iron at a setting appropriate for your fabric.

2. Organize your work area as neatly as possible. This will help you avoid accidents that could ruin your painting.

3. Stretch the fabric onto a hoop or stretcher frame because it's important that the fabric remains taut while you're painting it. If using wooden hoops, make sure there aren't any snags that could damage your fabric. For very thin fabrics, it may be necessary to put several layers of masking tape on the smaller portion of the hoop to keep the material taut.

If using stretcher frames, fasten with stainless steel tacks or push pins.

4. Transfer the pattern. Refer to Chapter 4, "Silk Painting Method" in the "Fabric Transferring Section" for details.

5. Shake the paints before using.

6. After painting is complete and dry, heat setting is required. This ensures the permanence of your painted design whether it is machine washed or dry cleaned. Heat set by ironing the wrong side of the painting for 2-3 minutes at a setting appropriate for the fabric.

An alternate heat setting method is to wrap the fabric in aluminum foil and put it in a *preheated* 300° oven for 10 minutes. (Make sure the oven is completely preheated for proper heat setting.)

7. Launder your painted garment with the method that is appropriate for the type of fabric used.

Three Silk Painting Techniques

Resist[19] This technique is done by first outlining pattern lines with DEKA®-Silk Resist. The lines you create will be very distinct and will "resist" paint colors from flowing outside of the lines.

Choose the color of Resist to suit your design and fabric. You may also tint the clear Resist using any shade of DEKA®-Permanent Fabric Paint. Mix 1 part clear Resist with 4 parts paint.

1. Follow basic silk painting steps 1 through 4.

2. Pierce the tip of the Resist applicator with a pin. Press the applicator tip firmly against the fabric, keeping the bottle in a vertical position. Squeeze the bottle gently as you outline your pattern lines.

After you have applied the resist to the pattern lines, hold the fabric up to the light and check both the front and back side to make sure there are no skips in the Resist lines and to ensure that it has completely soaked through to the back. For heavier fabric, you may need to apply Resist to both sides if the first application didn't penetrate through to the back.

Note: Any skips in the Resist will cause paint to bleed outside the pattern area instead of containing it within one specific area as intended.

3. Allow Resist lines to dry for 15 to 20 minutes before painting.

4. Apply DEKA®-Silk paint. As mentioned earlier, brush strokes aren't necessary. Apply the paint sparingly in the middle of the Resist lines using either a *soft* brush or cotton swab.

Firmly guide the paint toward the pattern lines. (Avoid using your stiff fabric brushes for this.) Be careful not to get paint too close to the Resist lines—just wait for it to spread toward the lines, guiding it along as needed.

5. Allow the finished painting to dry overnight.

6. After heat setting, (described in Step 6 of basic silk painting instructions), the fabric must be soaked in lukewarm water to remove the Resist. If you used the clear Resist, the original fabric color will show through. The color from metallic or tinted Resists remains to enhance your design.

Stop-Flow As the name implies, when Stop-Flow Primer is applied to the fabric, the paints will hold their line without spreading across the fabric (wicking). This method allows you to have more control of the paint flow, without using a Resist. Unlike the watercolor method where the paint spreads gracefully over the fabric, the stop-flow method enables you to create a more precise

painting.

1. Follow basic silk painting steps 1 and 2.
2. Stir DEKA®-Stop Flow Primer. Use a large, soft brush, and apply it evenly to the entire piece of fabric.
3. Allow the Primer to dry thoroughly. This will take from 20-40 minutes, depending on the thickness of the fabric, weather conditions, etc..
4. Follow basic silk painting steps 3 through 7.

Watercolor[20] This method allows the paints to flow freely over the fabric, blending into each other. The result is a softer, more pastel design with subtle pattern lines instead of the distinct ones created with the Resist technique.

This technique is best accomplished if you let your imagination guide you along. It lends itself well to creating impressionistic, almost ethereal designs.

1. Follow basic silk painting steps 1 through 3.
2. Here are some of the different ways you can apply the paint:

✦ Put two different colors next to each other on the fabric so they blend into each other. When the fabric is pre-dampened with water, the effect is enhanced. The more water you use, the more the colors will blend, resulting in a more impressionistic effect.

✦ If you're not into impressionism and don't want the colors to blend as much, apply one color and allow it to dry before applying the next one. This will give your design a more distinct appearance.

✦ Apply paint to the fabric, then use a damp cotton swab and immediately stroke through any areas of the paint that you want lightened in color.

✦ Apply one color of paint and then drip a second color onto it for contrast. The first color must still be wet.

✦ Dampen a soft brush with water then apply paint.

✦ Apply highlights by removing paint in certain areas with a dry paper towel or cotton swab.

✦ Sprinkle *wet* paint with DEKA®-Silk Salt to create a starburst effect. You need to work fast for this method because the Salt needs to be applied to the wet paint within one minute.
The Salt crystals absorb some paint resulting in intense spots of color directly beneath the crystals, and lighter areas surrounding them. You can even use table salt or coarse salt. The coarser the grain, the larger the starburst effect.

3. Allow the finished painting to dry overnight, then heat set as described in Step 6 of basic silk painting instructions.

Note: See Chapter 8 under the "Suggested Reading" and "Videos" categories for more information about how to learn more about silk painting.

Slate Shingles[21]

In some areas of the United States, slate shingles are a very popular painting surface for country style decorations. Slate shingles from old barns, for example, come in an assortment of colors. Some artists prefer to cut them into different sizes, while others use them just as they came from the barn.

Supplies Wood sealer (optional), Saral®, water-based varnish (or varnish of your choice).

1. Because the shingles are old, you must check for any cracks or chips. Find a piece that is in good condition.
2. Scrub the slate with soap and water. Rinse, then allow it to dry completely.
3. Apply a thin coat of water-based varnish or wood sealer to keep the porous slate surface from absorbing too much paint.
Variation: If you prefer, you may spray the entire piece of slate using a matte spray paint.
4. Transfer the pattern using Saral® transfer paper.
5. If you did not spray the entire piece of slate, basecoat the pattern area only with white or ivory acrylic paint, then transfer the necessary pattern lines.
6. Do the decorative painting.
7. Protect your finished project by using the varnish of your choice. For this type surface, a matte finish is very effective. If you painted just one area of the slate, and left the remaining area natural, varnish just the area you painted. However, if you sprayed the entire piece of slate, varnish the entire piece.

Soap, Bar[22]

Regular bar soap can be transformed into a lovely, usable decoration. The top of the soap is painted, then the painting is "sealed in" by coating with paraffin wax. The bottom of the soap remains uncoated so it can be used, if desired. Soap decorated in this manner may last several months depending on use.

Supplies Bar soap, matte spray (such as Krylon®), paraffin wax (same as used for canning), sponge brush, non-serrated paring knife.
Note: The color of the soap will become your background. Keep it, and the shape of the soap in mind when selecting the soap to be decorated. (Procedure according to William Crawley.)

1. If the name of the soap is on one side only, use

the plain side for painting. If the name appears on both sides, use a non-serrated paring knife to carefully peel the name off one side. After the surface is carved smooth, rub it with a soft cloth or facial tissue to make it even smoother.

2. Spray the smooth, top surface and the sides with matte spray. Do *not* spray the bottom of the soap. Allow it to dry. Remember to spray in a well-ventilated area and avoid breathing in the fumes.

3. Carefully transfer the pattern. Use gentle pressure to avoid indenting the soap. See Chapter 4 for various methods of transferring patterns.

4. Paint with your favorite acrylic paints. (Oil paints may also be used.) If you need to correct any painting mistakes, gently wipe them away with a moistened Q-Tip®. Spray again with matte spray. When dry, resume painting.

5. After your painting is completed, allow it to dry, then spray the top and sides again with matte spray. Again, do *not* spray the bottom of the soap.

You're now ready to coat the painted area with paraffin wax. If you plan to paint a number of bars, it's a good idea to get them all to this same stage and coat them at the same time.

6. Break or cut a paraffin block into pieces. Put the pieces in the top of a double boiler. Place over water and heat until the paraffin has melted. It becomes a clear liquid when melted.

Note: Be careful. Paraffin is very flammable and should be kept away from open flames. Therefore, always melt paraffin over water in a double boiler or in a can placed in a pot of water. Use a sponge brush and brush the paraffin on the top and sides of the soap. Do not coat the bottom. If you choose to hold the soap while you coat it, wear an oven mitt. Melted wax is hot.

7. After the wax has cooled and hardened, you may hand buff and shine the soap by rubbing it with a soft cloth or facial tissue.

Suede, Pigskin

Checkbook holders, eyeglass cases, key chains, and many other useful objects are made of pigskin suede. This surface is easy to paint. I use regular acrylic paints, such as DecoArt Americana™ or FolkArt®, although fabric paints also work well.

Supplies Conté drawing pencil, Gardé® Rain and Stain Repellent.

1. No surface preparation is needed other than transferring the pattern. I suggest you put a piece of plastic over all areas that won't be painted. Make sure your hands are clean and dry before you handle the suede product.

2. Trace the pattern on tracing paper, then *lightly* retrace the back of the pattern with a Conté drawing pencil. Use a color that will barely show on the suede. Lay the tracing, penciled side down, on the surface. Lightly trace with a stylus.

3. Do the decorative painting and allow it to dry completely.

4. Protect the painted suede surface by spraying with a product designed for use on suede and leather, such as Gardé® Rain and Stain Repellent or an equivalent product. If possible, hang up the item to be sprayed. If you lay it flat on a piece of plastic and then spray it too heavily, there's a chance of getting a puddle of water repellent that will cause a permanent ring on the suede. Hanging the item up will help to prevent this. Spray with a sweeping motion, holding the can about 6 inches from the surface. Apply evenly and wet the area, overlapping the spray areas so you don't miss any.

Note: Gardé®, as well as pigskin suede accessories, may be ordered through PIGmentation, 2056 300th Street, Odebolt, IA 51458-7574; telephone (712) 668-2625. An equivalent protective spray should be available in your local shoe repair store. Make sure the product you purchase is designed for use on suede and leather.

5. Allow the suede surface to dry at least 3 hours (more in high humidity areas). Then test for water repellency by putting a tiny drop of water on an inconspicuous spot on the surface. If water soaks in, another application is needed. If water beads up, the surface has been adequately covered.

6. When it's necessary to clean the painted suede, take it to a professional leather cleaner.

Terra Cotta

This is earthenware that is naturally a brownish-orange color. These instructions are for painting on *unglazed* terra cotta.

1. Wipe terra cotta with a soft, dry cloth. Spray with a matte spray sealer.

2. Transfer pattern using graphite paper.

3. Keep hands as clean as possible because the oil from your hands is difficult to remove from terra cotta.

4. Paint as desired. If you make a painting mistake, remove it with a dampened cloth before the paint has a chance to dry.

5. After the painting is completed and dry, remove graphite markings with a kneadable eraser.

6. Spray with a matte spray if desired. Keep in mind that if your painted object will be kept outside, your painting will fade in time.

Tile (Ceramic)

Painting on ceramic tile can be done using Liquitex® Glossies™, the same as on glass. Refer to the "Glass" category in this chapter.

There is one extra step to use when painting ceramic tile that will get a lot of use (such as on walls or floors). To make it more durable, apply 2 coats of Liquitex® High-Gloss Varnish *after baking*. Allow 30 minutes between each coat.

Tin, New

When buying new tinware today, you have a choice: Primed, but not basecoated (black or gray); Primed and basecoated (ready for decorative painting); or Unprimed (shiny metal surface).

The following instructions are for using unprimed, unbasecoated new tin, (including galvanized tin). For tin that is factory primed but not basecoated, start with step 7. For factory primed and basecoated tin, start with step 8.

Supplies Fine steel wool or 3-M Pad®, white vinegar, primer (see step 6), #400-600 wet/dry sandpaper, transfer paper (or chalk), varnish of your choice.

1. If tin is very shiny, sand lightly with fine-grade, soapy steel wool and hot water or a 3-M Pad®. This will make the surface easier to paint on. If tin isn't shiny, proceed to step 2.
2. Wash in dishwashing liquid that is *not* lemon scented. It seems the lemon causes a chemical reaction with electro-tinplate and causes rusting.[23]
3. Wash a second time in a solution of 50/50 white vinegar and water.
4. Wash again in dishwashing liquid as in step 2. Rinse well.
5. Allow to dry thoroughly. To speed the drying time, preheat oven to 200 degrees, put the tin in and turn the oven off. Be sure not to use a high temperature, since too much heat will loosen the solder.
6. Prime with either a spray or brush-on primer. The nature of the tin surface makes it advisable to apply several thin coats of paint rather than one heavy one. Make sure that all surfaces are covered. Allow each application to dry thoroughly before applying the next one, being careful to avoid creating drip or run lines.

Suggested products for this step are Krylon®, Rusticide, Penetrol, or Rustoleum®. Use of a primer helps paint adhere to tin surfaces, prevents rusting, and protects paint against chipping. Allow to dry from 12 to 36 hours or longer, depending on weather and humidity.

7. You may choose to basecoat the entire piece before doing the decorative painting. This will take 3 or more thin coats of paint. Allow 15-20 minutes between coats. When paint coverage suits you, allow it to dry overnight. Sand lightly with #400-600 wet/dry sandpaper (use it dry), then tack.

Note: Some artists prefer to basecoat the tinware with a flat enamel paint before doing any decorative painting because they think it helps the paint adhere better.

8. Transfer the pattern using an appropriate color of transfer paper or chalk.
9. Do decorative painting with the acrylic paint of your choice. Keep in mind that painting on tin requires special attention because the surface is slicker than wood. Therefore, you must be sure to always apply *thin* coats of paint. Don't rework the same area because the paint tends to glob up. Wait for each coat to dry before applying the next.
10. When the painting has completely dried, varnish it with several coats of brush-on water-based varnish or a coat of Krylon® Crystal Clear Acrylic Spray.

Caution If you plan to use the tin to serve food, make sure the solder is food safe. Avoid storing any wet substance in tinware for long periods of time, and never serve anything in tin that contains citric acid or is pickled.[24] To be completely safe, avoid serving food of any sort on any painted surface.

Tin, Old

1. You must first remove rust. If it isn't heavily rusted, scrub with a wire brush and then sand the remaining areas with a fine grade sandpaper. Since sandpaper will leave scratches, do final sanding with fine-grade steel wool.

For heavily rusted areas, use a product such as Duro™ Naval Jelly®, following instructions on container. Scrub it off with a stiff metal brush.

Another possibility for badly rusted tin is to use muriatic acid. If you use this acid, please be careful. Protect your clothing and wear rubber gloves. Follow instructions on the product container. Do this outdoors because you need good ventilation.

Once the tin has been treated with muriatic acid, wash it off with water. If outdoors, hose it off. Avoid getting the residue on any plants and keep away from children and pet areas.

2. From this point on, refer to instructions given under "Tin, New" category.

Tire Covers (Metal)[25]

A friend of mine painted the metal spare tire cover for her trailer about six years ago. It still looks beautiful, and the paint has remained as bright as when it was new. Although painting on metal is covered in another section of this chapter, I felt this should be described separately because there are extra steps that need to be taken to keep

a painted tire cover looking new.

Supplies Metal pre-primed Continental Tire Cover Kit for trailer, 3-M Pad® (green nylon kitchen scrubber), Comet®, Jo Sonja's® water-based sealer, automotive vinyl clear-coat spray (such as "Plasti-kote," available in auto supply stores).

1. Scrub the area to be painted with Comet® and the 3-M Pad®. This will "rough up" the surface to help the paint adhere well. Rinse well.
2. Dry thoroughly, (overnight or 4 hours in the sun).
3. Seal with one coat of Jo Sonja's® All-Purpose Sealer and allow to dry completely, (about 2 hours).
4. Paint with regular acrylic paints. You may apply the paint using regular basecoats, washes of color, or use a layered technique where paint is built up gradually.
5. After the painting is complete, allow it to dry thoroughly.
6. Apply 4 coats of the automotive vinyl clear coat spray to the entire cover. Allow 24 hours drying time between each coat.
7. For added protection, wax the tire cover once or twice a year with a car wax, such as Turtle Wax®, McGuire's #6®, or Armor-All® Car Wax. Make sure car wax is *non-abrasive* or is made for clear-coat paints. When not in use, placing a canvas cover over the painted area will make it last even longer.

Umbrellas[26]

I've been told a number of times that we should avoid painting on water-repellent fabric because the paint doesn't adhere well. However, Kim Mauro has had excellent results painting umbrellas using the following method:

1. Open the umbrella and apply the pattern. Put a book behind the area you're going to paint on to provide support. For dark colored umbrellas, use white transfer paper. If you're painting on light colored umbrellas, you will probably be able to see the pattern through the material. If this is the case, place the pattern behind the fabric to be painted and mark the main pattern lines onto the umbrella using an appropriate color of chalk.
2. Paint with your favorite acrylics. Put a few drops of textile medium in with each puddle of paint. This helps prevent the paint from wearing off in time.
 It's important to use a thin application of paint because this will prevent your painting from cracking or peeling. Wait for paint to dry before applying shading and highlights.
3. When painting is dry, remove any transfer markings with a damp paper towel.
4. Do not varnish the design because doing so will make the paint peel.

Wallpapered Boxes

Painting on wallpapered boxes has become popular, as they are easy surfaces to paint on. No sealing is necessary. Lightly transfer the pattern, then paint with regular acrylic paints. It's a good idea to protect the areas that aren't to be painted by covering them with a piece of plastic. After your painting is complete and dry, varnish with brush-on water-based varnish.

Wood, New

Anything from unpainted furniture to small wooden refrigerator magnets are handled in a similar manner. This category explains the basic surface preparation and finishing for new wood. For information on how to do specialized procedures such as antiquing, staining, etc., refer to the appropriate category in Chapter 6, Techniques.

All wood is porous, so whether you are planning to paint on particle board or pine, it should be sealed. Assume this to be the case unless you are using a project book that says not to seal for the purpose of creating some special effect.

Here are the steps to follow for preparing new wood:

Supplies Sandpaper (medium and fine grade), wood sealer, wood filler if needed, tack cloth, transfer paper or chalk, brush-on water-based varnish.

1. Sand wood with medium grit sandpaper, moving with the grain, until smooth. Remove sanding residue with tack cloth.
2. If necessary, fill nail holes with wood filler, following instructions on the container. When it has dried, sand again to level off the surface.
 Note: Wood fillers won't always blend in with the color of the original wood. This isn't a problem if you plan to basecoat the surface. However, if you plan to stain it, the filled areas may show. If there aren't too many troublesome areas and you want a natural wood color, try designing your decorative painting to cover the filled areas.
 Also, if the particular wood filler used is harder than the wood being filled, sanding it smooth can be a problem. Look for a wood filler that matches both the color and type of wood you are working with for the best results.
3. Apply your favorite sealer to the wood. See Chapter 1 for specific brands.
 Note: On some woods, pitch can ooze out of the grain, especially through knots. This can eventually bleed through to your painting, leaving a brown discoloration. For this type of wood, I recommend sealing with Jo Sonja's® Tannin Blocking Sealer, which has been specially formulated to prevent this from happening.
4. If the wood grain was raised when the sealer was applied, sand lightly with a fine grade of sandpaper. Wipe

with a tack cloth.

5. Here are some of the options you have at this point:

 a. Transfer the pattern and do the decorative painting. This is appropriate for a natural wood background.
 b. Basecoat the entire surface. No wood should show; the background will be in your choice of color.
 c. Apply a stain or a "wash" to the surface. These procedures allow the wood grain to show through.
 d. Apply a "faux finish." This will become the background.

6. Transfer the pattern using one of the methods described in Chapter 4 and do your decorative painting.

7. Apply several coats of brush-on water-based varnish.

Wood, Old

Old wood furniture requires more work than new wood, but you can create a real treasure from an old piece of furniture.

How to Tell If Wood Needs Stripping[27]

Before doing anything else, decide whether or not the surface needs to be stripped. Here is what to look for to help you make this decision:

1. How does the old finish look? If there is flaking, cracking, or chipping, it will need to be stripped.
2. Check the corners, edges, and high-use areas for wear. If they look worn, strip the wood.

If you have decided the wood *does* need stripping, here are some basic instructions. If you would like more detailed information on refinishing wood, I recommend reading "How To Do Your Own Wood Finishing," by Jackson Hand.

1. Purchase a commercial wood stripper and follow package instructions. Before applying the stripper, remove hinges, knobs, or any other hardware. Wear protective clothing, gloves, and a mask. If this product removes paint, just think what it will do to your skin.
2. Clean off the stripper using the method recommended on the package.
3. Sand in the direction of the grain until smooth. Start with a medium grade sandpaper, and change to a finer grade as the surface is smoothed.
4. Follow instructions under "Wood, New," starting with step 2.

Wood Requiring No Stripping

Old wood is most likely dirty. Even if the wood was well cared for, there is bound to be a build-up of wax and grease that would prevent a new finish from adhering well.

1. Clean thoroughly with detergent and water.
2. Rinse well, then allow to dry.
3. Sand with a fine grade of sandpaper until smooth. The sanding is important because painting on a glossy finish may result in adhesion problems.
4. Remove the sanding residue with a tack cloth.
5. Follow the instructions under "Wood, New," starting with step 3.

Wood Resin Figurines[28]

Techniques used in painting these are very similar to those used when painting on wood. The difference is that no sanding is required.

Supplies Matte spray sealer, brush-on water-based varnish.

1. If figurines are dusty, wash with hot soapy water, rinse well, and dry thoroughly before painting.
2. Basecoat the object. It may be necessary to apply two coats, depending upon the brand of paint you use.
3. Do the decorative painting.
4. When dry, spray with matte sealer. After that has dried, apply a coat of brush-on water-based varnish.

Wrist Watches, Paintable[29]

Painting watch faces has become very popular. A friend painted a beautiful watch and gave it to me for a gift. I've received many compliments on it and have really enjoyed wearing it.

Supplies Wrist watch (type made for decorative painting purposes), tool such as a kitchen knife, Jo Sonja® All-Purpose Sealer (if you're painting on the watch band), soft rag or towel, epoxy (optional).

1. Pull the crown out carefully. Don't remove it entirely; just pull it out enough so that when you turn it, the hands will move and the watch will stop running. Turn the crown to move the hands to any position desired during the painting process. Leave the crown in this position until you're finished painting.
2. To protect the watch, work on a table or other firm surface that is covered with a cloth or towel.
3. Carefully remove the watch crystal by putting a tool between the crystal and the case. Push in and slightly pull up on the crystal with the tool. Be careful; if the tool

SURFACES

slips, you could hurt yourself. The crystal should pop off easily. Carefully remove it and wrap it in a tissue, or soft cloth.

Note: Read the instructions that come with your watch. The above technique works for removing the crystals from most watches made specifically for decorative painting, but it's wise to double check. This technique probably won't work for removing crystals from other watches.

4. Here are some precautions:
+ Don't remove the hands.
+ Don't get paint on the hands.
+ Don't get paint too close to the center hole. If paint gets in the hole, it could damage the watch mechanism.

5. Trace the pattern onto tracing paper and cut it to fit the size of your watch face. Cut your transfer paper the same way. For watches where hands come out of the center of the face, cut the pattern down a little past the center so it will fit under the hands. For oversized watches with the hands off to the side, adjust where you cut the tracing and transfer paper accordingly.

6. If you have never painted a watch before, practice painting the design on paper or a manila folder first. You might not be used to painting such a tiny pattern. This will also help you decide what size brushes to use.

7. Paint with thin coats of paint using your favorite acrylics. If you're making dots, don't make them too thick or the paint may hamper the movement of the watch hands. (If you're painting on the oversized watches that

have dome-like crystals, this shouldn't be as much of a problem.)

8. You may choose to paint on the leather watch band as well. For best adhesion, mix your regular acrylics with Jo Sonja® All-Purpose Sealer (3 parts paint to 1 part sealer), and paint as desired. If painting with Jo Sonja's® Artist Colors, mix equal parts paint and sealer when painting the watch band.

9. Allow finished painting to dry completely. For best results, protect it from dust. You might consider letting it dry in a covered box.

10. Put the crystal back on the watch. Make sure it's fingerprint free. To snap the crystal and watch together, place the crystal on the watch body and apply pressure at several places at once by running your fingers around the watch.

Note: If the crystal doesn't pop in to suit you, you could apply adhesive or epoxy on the rim of the crystal before doing this. If you do, apply it very sparingly using a toothpick. Be careful that you don't get it on the face of the crystal.

11. Reset the time by turning the crown, then push the crown in to start the watch running.

12. Keep in mind that most of the watches available are *not* waterproof.

Here is one mail order source for watches and pattern packets for them. To receive a brochure, send a check for $2.00 (refundable with your first purchase) to: Watches With Love, Shirley McCollum Designs, 2739 W. Broadway, Anaheim, CA 92804. Telephone: (714) 761-8432.

Summary

I hope that reading about the wide variety of surfaces on which to paint will spark your imagination and perhaps inspire you to discover new ones. Remember, one of the popular sayings among decorative painters is "if it doesn't move...paint it!"

Keep in mind that surface preparation and finishing often varies, depending upon the artist. As you experiment, you may find other methods that you prefer. Hopefully, this chapter will give you a starting point.

Let your creativity be your guide. If you are a beginner, you will probably paint most of your projects on wood. However, once you have some experience, experiment and discover new surfaces. In all likelihood, you will sometime wish to paint a surface that isn't covered in this chapter. In this case, choose a similar surface that is covered and use that as a guide for experimenting.

If you have any comments, find an easier way to handle a particular surface, or learn about another surface that is not covered in this chapter, I would love to hear from you. There are always new things to learn about decorative painting. This ever-growing wealth of information is one of the things that keeps the art fresh and makes it so interesting.

Chapter 4

PATTERN TRANSFER

In this chapter, you will learn the basics of how to transfer patterns onto a surface. The chapter is divided into three sections: a general section, which applies to all pattern transferring; a section on transferring patterns onto solid surfaces; and a section dealing with fabric surfaces.

General

Patterns

Patterns for decorative painting come from a variety of sources. The most common are books and pattern packets. There are specialty magazines for our craft that also include patterns with instructions on how to complete the project. Be aware that these are all copyrighted patterns. When you purchase them, they are for your use only.

There will be times when a pattern isn't the right size for your needs. In this instance, it is permissible to have the pattern mechanically enlarged or reduced. All photocopies of material from a copyrighted book must carry the marks identifying the copyright. These photocopies are for *your use only*. Sharing them with friends or using them in classes, etc., would be infringing on copyright laws.[1]

Tracing

Put a sheet of tracing paper on top of the pattern. I generally use a good quality HB pencil for tracing, however, a fine-point felt-tip marker or a pen also work well. Trace the entire pattern, being as accurate as possible. The tracing will be your painting guide throughout the entire project.

Unfortunately, there will be times when a pattern doesn't exactly fit your surface. This happens most often with wood surfaces, even if they were cut for a specific pattern. One way to handle this is to trace around the wood piece onto tracing paper. Lay the tracing on top of your pattern. Trace your pattern, shifting the tracing as necessary to make adjustments for a better fit.[2] This can be frustrating, especially for beginners; but it's something you need to learn to deal with because it's a fairly common problem.

Tracings can be kept for future use. I suggest you write the source of the pattern on the tracing, because the longer you paint, the more of these you will collect. This added information can come in handy. Keep tracings in an envelope, plastic holder, or folder to protect them.

Transferring

The rule is *least is best*. When you transfer a pattern onto the painting surface, put only the main lines you can't do without.

Transferring is usually done in steps, with the initial step for placement of the basecoat colors. Once the basecoating is completed and the paint is dry, detail lines are transferred on top. For example, let's say Pattern A, shown in Figure 4-1, is the pattern you want to transfer. Trace Pattern A *exactly*.

PATTERN A **PATTERN B**

Figure 4-1. Transferring a Pattern.

Pattern B shows the lines to transfer for basecoating. Personal choice comes into play here. For example, some painters might not want to basecoat the bow on the hat separately. They would paint the entire hat one color, then paint the bow on top of the basecoat. For this example, let's assume the bow will be basecoated separately.

Compare Pattern A and B. Notice that a lot of detail lines are missing from Pattern B. They aren't needed at this point because they will be transferred later, on top of the basecoat.

Once the basecoating is complete and dry, transfer the detail lines you need from Pattern A. Again, put on *only* the ones you need. For example, the little flowers can be painted quite easily without a pattern. All you really need to transfer is the dot for the flower centers or a little dash where the leaves are to be placed. The scallops on the collar are easily painted without a pattern using C-stroke floats. Referring to the pattern as you paint is extremely helpful. Remember, however, the pattern is only a guide. If you want to add more embellishments to a design (or remove some), it's up to you. Using your own creativity is very rewarding.

Pattern Transfer—Solid Surfaces

"Solid Surfaces" include such things as wood, plastic, metal, ceramic, etc. It's important that the pattern be positioned properly on the surface. Here's a suggestion on how to center a pattern on a flat surface. Let's assume you want to paint the lid of a rectangular shaped box:

First cut the tracing paper to the exact shape of the lid. Next, fold the cut tracing paper in half lengthwise, and then fold it in half again vertically. The center of the box lid is where all four of the fold lines intersect. Unfold the tracing paper and place your pattern underneath it. Refer to the diagram below. Shift the pattern until it appears to be centered. Measure to see that there's approximately the same distance from the outer edges of the design to the edges of the cut tracing paper on all four sides.

Figure 4-2. Centering a Pattern

Chalk Method

This is a favorite method for many painters, however it does have its drawbacks. Chalk markings can be easily removed by the brush of a hand. You need to be careful not to rub against them or you'll lose some of your transfer lines.

Regular, inexpensive chalk, (the same kind you would buy for use on a child's chalkboard) is all you need. Avoid buying artists' chalk, because it has an oil base that can affect the way paint adheres to the surface.

1. Carefully trace the entire pattern onto tracing paper. Use a pencil or fine-point marker.
2. Turn the tracing over and rub chalk over all of the lines, using a color that will show on your background. Make sure that all the pencil lines are covered with chalk. It doesn't matter if the chalk extends beyond the tracing line.
3. Shake the tracing paper to remove excess residue.
4. Place the tracing paper on your surface, chalked side down. Check to be sure it is positioned just the way you want it. Secure with masking tape. (Be sure that the surface is completely dry because the tape can damage a basecoat if it isn't.)
5. Trace the main pattern lines with a sharp-pointed stylus or pencil. Press gently so you don't damage the surface.
6. After tracing a couple of lines, carefully lift the tracing paper back a bit and look to be sure the pattern is transferring properly. You may need to adjust the pressure you use.
7. After you have basecoated areas and allowed them to dry, you may want to transfer more detail lines. Do this the same way as you did originally. You may need to change chalk colors, depending upon the basecoat colors you used.

Conté Drawing Pencil Method

I have used the same steps as shown under "Chalk Method," but used a Conté Drawing Pencil instead of chalk. Again, choose a color that will show up on your surface. A Conté Drawing Pencil is very effective for transferring patterns onto candles. The pencil adheres well to the surface without causing any adverse affects.

Graphite See "Transfer Paper" category.

Transfer Paper

Transfer paper is available in a variety of colors and brand names.

Chacopaper® This is applied the same way as graphite paper (see below). The difference between this and standard graphite paper is that the transfer marks can be removed with water. You no longer need to be concerned about leaving any telltale transfer markings on your finished painting.

However, a word of warning–from personal experience, I've found that Chacopaper® is appropriate to use for most painting techniques *unless* instructions call for dampening the design area before painting or if you'll be doing a lot of blending on intricate designs.

For example, I took a class where the pattern was to be applied, then Retarder was to be brushed onto each part of the pattern before painting it. Transfer lines would have been removed had I used Chacopaper®. Another example is a blended rose I recently painted. I tried using Chacopaper®, but some areas of the design were too small to "work around" the transfer lines, therefore some of them were lost. In situations such as these, it would be better to use standard graphite paper.

Graphite Paper This has almost become a generic term for transfer paper. However, to be accurate, only the gray/black color is actually graphite paper.

Standard graphite paper can be purchased in single sheets or in packages at your local craft store. Often you won't see a brand name on the sheet.

New graphite paper should be used very carefully because your tracings can easily become too dark and tend to smear. Before using a new graphite sheet, wipe it down with a soft rag or tissue to get all the excess graphite off.

Using regular graphite paper is not recommended for transferring patterns for pen and ink work because the graphite repels the ink. This makes the pen skip and keeps you from getting a smooth line. However, Saral® transfer paper in the graphite color does not cause this problem, according to their literature, because it doesn't contain grease or wax.

Homemade Graphite It is possible to make your own graphite paper. To do this, transfer the pattern onto tracing paper in the usual manner, then rub a soft pencil across the back of the tracing. Buff it a little, then position the tracing paper with the penciled side to your surface. Trace with a stylus.

Saral® This is a brand name for a transfer paper that is available in five colors—graphite (a gray-black), blue, red, yellow, and white. It is reusable, greaseless, and erases like a pencil. White and gray-black are the most popular colors for decorative painting. The manufacturer recommends using yellow Saral® for transferring onto metal.

I avoid using red Saral® because it's too difficult to cover up. It is effective, however, in transferring patterns onto china that will be fired or glazed.

How to Use Transfer Papers

These steps apply for any type of transfer paper.

1. Cut the tracing paper to an appropriate size. Refer to Figure 4-2 and the accompanying text for hints on how to center your design on tracing paper.
2. Carefully trace all pattern lines onto tracing paper. Use a pencil, felt tip marker, or pen.
3. Position the tracing on the area to be decorated. Use Scotch™ Magic™ Tape or masking tape to secure the tracing paper. Be absolutely sure that the surface is totally dry. If you basecoated the area and it hasn't completely dried, the tape may cause the paint to lift. The less time the tape is on your surface, the better. Once you have begun the transferring process, try to complete it without interruptions.
4. Slide the transfer paper under the tracing with the shiny side down. Use a dark color (such as graphite or blue Chacopaper®) for light backgrounds or a light color for dark backgrounds.
5. Optional Step. For tracings that you'll be using repeatedly, here's a handy tip. Place a clear piece of thin acetate (available at artists' supply stores) on top of your pattern before transferring it to your surface. Then trace with your stylus, using a medium pressure. Check to see that the transfer lines suit you before doing the entire process, and adjust pressure as needed. The acetate will save a lot of wear and tear on your pattern.[3]
6. Use a stylus or ball point pen that has run out of ink and trace the main pattern lines only. To avoid indenting your surface, use a light touch and press just firmly enough to transfer the pattern.
 Note: If you're using acetate sheeting over your pattern, a firmer pressure is required.
7. After transferring a few lines, carefully peek to see that the transfer is successful. Adjust your tracing pressure and retrace areas that appear too light, or lighten pressure if it looks too dark. Once the entire pattern has been transferred, remove the tape, tracing paper, etc.
8. Before you do your decorative painting, lighten any tracings that appear too heavy using a kneaded rubber eraser. If you used Chacopaper®, this step isn't necessary because your transfer lines can be easily removed with water later.
9. When the painting is complete and dried, erase any tracing lines that still show. For regular transfer paper, remove them with a kneaded rubber or other soft eraser. Make sure you do this in good lighting. If you

TRANSFER

miss any graphite lines and varnish over them, they are there to stay. For Chacopaper®, remove with a Q-Tip® or

clean flat brush that has been dampened in water.

Pattern Transfer—Fabric Surfaces

Some of the more common methods used for transferring patterns onto fabric are described in the following section. These pointers apply to all the methods described except for transferring onto silk for the Resist and Watercolor techniques.

1. Trace pattern onto tracing paper.
2. Place your fabric on a firm surface.
3. If you are going to paint a T-shirt, place a cardboard inside the shirt to secure it; check to see that you transfer the pattern onto the front of the shirt (unless you want the pattern on the back). Secure the sleeves behind the shirt.
4. Position the tracing carefully and secure with pins or tape.
5. Towards the beginning of the transferring process, gently pull back the tracing to be sure the pattern is being successfully transferred.
6. Don't transfer the pattern too heavily. All you need is a guide.

Bridal Veiling Method

This is one of my favorite methods of transferring onto blouses or T-shirts because it makes it easy to position the pattern to the shirt while you're wearing it. This enables you to move the pattern around until it is positioned to suit you.

Put a piece of wax paper on top of the pattern, then put a piece of bridal veiling material on top of this. Trace the pattern with a black felt tip marker onto the bridal veiling.

At this point, it's a good idea to try on the shirt and pin the marked veiling to the shirt to position the pattern as desired. When properly positioned, remove the shirt, being careful not to remove the pins. Place it onto a fabric painting board. Use a washable Wonder Marker (a W.H. Collins Inc. product), or similar marker, and retrace all the pattern lines on the shirt. Any marking lines that aren't painted over are easily removed with plain water.

Chalk Method

This is appropriate for all colors of fabric. Retrace the back of your tracing with an appropriate color of chalk. Place the pattern onto the fabric, chalk side down, and firmly press the pattern lines with your hand. Chalk

brushes off easily so avoid brushing against the chalked fabric. If some of the lines aren't dark enough, retrace directly on the fabric using a quilter's pen.

Chacopaper® Method

See Graphite Method below. Although the products are different, the method is the same.

Conté Drawing Pencil Method

This is appropriate for transferring patterns onto dark colored fabric. Retrace the back of your tracing with a white Conté Drawing Pencil, sharpened to a fine point. Place the tracing on the fabric and firmly press with your fingers over all the pattern lines. As with chalk, this brushes off easily.

Graphite Method

Work on a hard surface, such as a table. For lightweight fabrics, place graphite paper, shiny side down, on the fabric. Put the tracing on top of the graphite paper and secure it with masking tape. Put a thin piece of clear acetate on top of the tracing. Use a stylus and retrace the pattern lines onto your fabric.

For heavy or quilted fabrics, use a "direct transfer" method. This is done by putting graphite paper, shiny side down, on the fabric and the tracing on top of that. Secure the tracing with masking tape. Instead of lightly retracing the pattern lines, you can use a pencil with a sharp point and make dots or dashes on the main lines of your pattern, actually cutting through your tracing and graphite paper. You will be making these marks directly onto your fabric.

When the main lines are transferred, remove tracing and graphite paper. Use the pencil to lightly connect the marks. Unfortunately the direct transfer method ruins your tracing and graphite paper.

Saral® Transfer Paper

Place the appropriate color of Saral® on the fabric. Put the tracing on top of that and secure it with masking tape. Use a tracing wheel and follow the lines you wish to transfer. Saral® product literature indicates that the tracing wheel dots will not melt into the material when ironed and the dots may be easily sponged off or washed out if the

material is washable. Saral® also indicates it is strong enough so it will not crack apart along the tracing wheel lines, so it will last longer.

Silk Painting Methods[4]

These methods are appropriate for transferring a pattern onto fabric that will be painted using the Resist, Water-color, and Stop-Flow methods of silk painting. The material should be pre-washed, dried, and ironed. If doing the "Stop-Flow Method," the fabric should have been treated with the Stop-Flow Primer as well. If at all possible, try the transfer method on a scrap of the fabric first to make sure you understand the process.

Transferring a pattern onto a thin or light-weight material, such as silk, can be done by using a standard pencil or disappearing fabric marking pen (marks dissolve when dampened). No matter what you use, be sure to use a very light touch. Both the Resist and the silk dyes can permanently set the transfer lines into your fabric.

For direct transferring onto fabric:

1. Trace the pattern onto tracing paper.
2. Stretch the fabric onto an embroidery hoop or stretcher frame. The fabric must be stretched taut.

Note: If you are using a wooden embroidery hoop, make sure there are no snags because these will damage your fabric. Because it is important for the material to remain taut, it might be necessary to put masking tape on the small part of the hoop to keep thin material from slipping loose. If using stretcher bars, attach the fabric with stainless steel push pins.

3. Select a transfer technique appropriate for the weight of the fabric.

Thin Fabric If the fabric is thin enough that you can see the tracing through the fibers, simply tape the pattern to the back side of the fabric and trace it with the pencil or disappearing fabric marking pen.

Note: If you're using a stretcher frame, you can get by without directly transferring onto the fabric. Simply tape the pattern under the frame. You should be able to see the pattern well enough to guide you. However, if you choose this method, be sure the pattern doesn't touch the fabric because it can smear the Resist and dyes.

Not-so-thin fabric If the tracing isn't easily seen through the fabric, there's a chance you can see it if you hold it up against a window or a light table and trace it that way.

Heavier Fabric If you can't see the pattern through the fabric, here are two suggestions. (1) Use a non-oily transfer paper, such as Saral®, or (2) Rub the back of your pattern with a pencil. This will create a thin layer of graphite. Place the pattern on the fabric (graphite side down), and trace with a stylus or other smooth-pointed implement. Using a sharp one will tear the tracing.

Transfer Pencil (Iron-On)

Transfer pencils are appropriate for transferring patterns to light-colored fabric. Retrace the back of your tracing with the pencil (available in fabric stores). Secure the pattern to the fabric with pins or tape.

Set iron to a setting that is appropriate for the type of fabric you are using. Place the iron on one spot and press until that portion of the pattern has been transferred. This shouldn't take longer than 30 seconds. Before you do the other areas, carefully pull the pattern back to see that the transferring was successful. Do small areas at a time. Avoid sliding the iron over the surface because this can cause the tracing to shift.

Summary

You have now learned some of the popular methods used to transfer patterns. Every painter has their own favorite, so I suggest you try all of them and decide which you like best.

Notes

Chapter 5

BRUSH STROKES

This chapter is divided into three sections. The first is a general introduction to brush strokes, why they are so important and what is involved in doing them most effectively.

The second section is especially for beginners and contains step-by-step instructions for six basic brush strokes (Broad, Chisel, "C" or Crescent, Comma, "S", and Teardrop) and a sample brush stroke worksheet demonstrating ways to practice them.

The third section is for painters of all levels and consists of an alphabetized presentation of many different strokes, including "specialty" strokes created by specific artists. It includes a sample of each stroke, instructions on how to paint it, and what brush to use.

If you are a beginner, don't be overwhelmed by the variety of brush strokes shown in this last section. They are included for future reference only.

Basics for Beginners

Importance of Learning Brush Strokes

To put it simply, good brush stroke technique will enable you to paint better and with less effort. It's the key that unlocks the door to creating professional looking projects.

The Beginner's Trap Unfortunately, beginners often avoid taking the time to practice brush strokes because they are too busy painting projects. I call this "the beginner's trap." Brush strokes are to decorative artists what scales are to a piano student. Both develop your skills so that you will be able to reach your full potential, and create things of beauty.

Although it's definitely more fun to paint a project than to practice brush strokes, take my advice and practice them anyway. It's well worth the effort.

The Brush

Care Chapter 1 gives complete instructions on how to care for your brushes, so I won't elaborate too much here. Reread the "Brush" Section of Chapter 1 before you roll up your sleeves and start painting.

Keep in mind that the quality of your brushes and the care you give them are of vital importance. No matter how good your brush stroke technique, if your brush is in bad shape, your brush strokes will be too.

Design of a Brush Figure 5-1 is an illustration of a flat brush. All bristle brushes, whether flat, round, liner, angle, etc., have three parts: a handle (sometimes called a "stick"), a ferrule, and bristles (sometimes called "hairs").

The *ferrule* is the metal piece that holds the bristles in place. It can be a problem area if you don't clean your brushes well, especially with flat brushes. Paint, allowed to dry in the ferrule, is almost impossible to remove. The dried paint spreads the bristles, causing flat brushes to lose the chisel edge they had when they were new.

STROKES

Bristles **Ferrule** **Handle**

Figure 5-1. Parts of a Brush

STROKES

Hint: Never load a flat brush all the way up to the ferrule. If you accidentally do, *immediately* rinse the brush in cool water, then wash it well with either a brush cleaner or Ivory® soap.

Let's take a closer look at the *bristles* of a flat brush. The *broad edge* refers to the entire flat side of the bristles, while the *chisel edge* refers to the line formed by the ends of the bristles.

Each stroke painted with a flat brush uses one or both of these edges as a basis. For example, the broad stroke uses the broad edge, the chisel stroke uses the chisel edge, the "S" stroke uses both.

Look at Your New Brushes Take a good look at a new brush. Feel the area along the ferrule and notice how smooth the transition is from the ferrule to the bristles. Try to keep your brushes in this same condition.

Removing Sizing From New Brushes Before painting with a new brush, remove the sizing by rinsing the brush in cool water and gently blotting on a paper towel. Then carefully reshape the bristles with your fingers to their original shape.

Flats—need a chisel edge, no straying bristles.
Liners and Rounds—form to a point with no straying bristles.

Reshaping Bristles Once you have used your brushes, reshape them after they are thoroughly clean. Rub the damp bristles across a bar of Ivory® soap and gently reshape them with your fingers. (You are using the soap as a sizing).

Some painters reshape a brush by putting it in their mouth. Be safe and avoid doing this. Developing good painting habits now is a lot easier than breaking bad ones later.

Soap in Bristles Soap must be rinsed out of brushes before painting because it may adversely affect the adhesive quality of paint. Therefore, have two containers of water near your painting area—one for rinsing out the soap, and the other for general use while you paint.

Fully Loading a Brush The strokes you will be learning in this section are painted with a fully loaded brush. All three brush types are loaded the same way unless indicated otherwise.

1. Rinse the brush in clean, cool water, then blot well on a paper towel.
2. Put some paint on a small area of your palette so that it forms a small puddle.
3. Dip the bristles into the paint, going about half way to the ferrule. On flat brushes, stroke the wide part of the bristles through the paint.
4. Gently stroke the brush back and forth in the same spot on your palette so that more paint is added as the stroking spreads the paint toward the ferrule.
5. Make sure there are no globs of paint on the sides.

Supplies Needed for Brush Stroke Practice

For starters, I suggest that you use only two types of brushes for your stroke practice: a flat and a liner. Once you feel comfortable with these, venture into new territory and practice the Liner Brush Worksheet using a #3 round brush. All liner brush strokes may also be painted with a round brush.

The brushes that I am recommending are the ones I have used and enjoyed. There are, however, many good synthetic brushes on the market. If you want to purchase another brand, try to get the same type and equivalent size.

Supplies Needed
 #1 Script Liner Brush (Loew-Cornell® series 7050)
 #3 Round (Loew-Cornell® series 7000)
 #8 Flat Shader Brush (Loew-Cornell® series 7300)
 Two containers for water
 1 sheet Loew-Cornell® "Brush-Up" Paper or Raphaél® Magic Paper
 1 bottle acrylic paint (i.e. Delta®, FolkArt®, etc.) in your choice of color
 Clipboard (or other firm surface)
 Tracing paper
 Scrap paper or manila folders

Learning Brush Strokes

I suggest that you practice three different ways in the order given: (1) With paint on tracing paper, copying strokes from the Brush Stroke Worksheet, (2) with water on Loew-Cornell® Brush-Up Paper or Raphaél® Magic Paper, and (3) with paint, freehanded.

1. Using Paint on Tracing Paper The worksheet is provided to help you practice each stroke. Feel free to photocopy the worksheet so you don't risk getting paint on your book. Put a piece of tracing paper over the worksheet and paint the strokes so they resemble the samples. Use a paint color that's easy to see on your practice surface.

Be sure to use the same size and type brush indicated because that is what the samples were painted with. Follow the direction of the arrows that appear on the first example of each different stroke. This method of practice helps you get used to the flow of the strokes.

2. Using Brush-up or Magic Paper This product was designed for practicing with *water only*, never paint. The paper changes color when it is wet, so the strokes are visible while they are wet. All you need is one sheet and it can be reused many times because as soon as the water dries, the strokes fade away. Because there is no mess to clean up, you tend to practice more often.

Make sure the brush is clean and free of soap. Just dip the brush into water, going almost up to the ferrule, tap off excess water, and start practicing, redipping in water only when necessary. Refer to the worksheet and copy the strokes.

3. Using Paint on Paper, No Tracing This last method of practice is perhaps the most important because you will be freehanding, not tracing, the strokes. Paint on manila folders, tracing paper, or even typing paper. Fully load your brush with paint, following instructions given earlier in this chapter. Keep in mind that how you load your brush will affect the way your strokes look.

Practice Hints If you're right handed, start at the top left-hand side of the page and work toward the right. Lefties, start at the right and work to the left side. Learn to paint the six basic strokes in all directions (right to left, left to right, top to bottom, bottom to top, and diagonally).

Body Position While Painting

As with many aspects of decorative painting, individuals develop techniques that seem most comfortable for them—the position you use while painting is no exception. When discussing this with artists, I found that each had strong feelings about the "proper position." Because of this, I felt you should be aware of two of the more popular positions being used. They are totally different and in some ways, actually contradict each other. I suggest you give each of them a fair try and make your own decision.

Position One This is really quite simple and easy to get used to. It's very suitable to use when painting small projects that require fine detail (as opposed to large pieces of furniture requiring long, flowing brush strokes). The main points are:

1. The object you are painting should be on the table, not on your lap. Sit all the way to the back of the chair. Pull the chair as close to the table as possible. Your feet should remain flat on the floor (around 12 inches apart). This position enables you to paint longer with less fatigue.
2. Rest your painting hand on your other hand to steady it while you are painting. This gives you greater control and makes painting fine detail work easier.
3. Paint from your wrist, not your shoulder.
4. Stay as relaxed as possible. Even though you are painting from your wrist, your shoulders should be loose.

Position Two[1] Your body position will affect the quality of your brush stroke technique. This method is especially good for painting free-flowing brush strokes.

1. Keep your shoulders relaxed. Tension will be reflected in your strokes. If you find your shoulders up around your ears, you're doing something wrong. Painting should be a very relaxing experience...let your body reflect that.
2. Allow your arms to hang freely.
3. Your painting surface needs to be low enough so your shoulders remain low and loose. Putting your practice paper on a clipboard on your lap is one way to accomplish this.
4. Hold your brush in an upright position, not as you would a pencil.
5. Your little finger is your guide and is the only thing (other than your brush), that should be on the paper. It will move around as you flow through the brush strokes. Experiment and find your most comfortable position.
6. Your wrist and elbow should not be resting on anything. (This step is the part that really takes some getting used to.)
7. Your brush, little finger, arm, and shoulder should work together as a team. As you make your brush strokes, paint from your shoulder.

Basic Brush Strokes

Now that you have some background information, it's time to learn the six basic brush strokes. The sample strokes were painted with the following brushes:

#8 Flat Shader (Loew-Cornell® series 7300)
#1 Script Liner (Loew-Cornell® series 7050)

The broad and the chisel strokes are the first ones to learn because they are the basic strokes that are used to form most other strokes.

STROKES

STROKES

Broad Stroke (Flat Brush)

1. Fully load a flat brush. Angle the handle slightly toward you. Start at the top of the stroke with all the bristles touching the surface. Pull toward you, maintaining even pressure throughout the stroke. Slow down toward the end and lift the brush straight up.

2. The top and bottom edge of the stroke should be as even as possible, and there should be no bulges on the sides of the stroke. Ideally, the stroke resembles a perfect rectangle.

3. Uneven sides may be caused by:
 - ✦ A poorly loaded brush—paint globs on sides.
 - ✦ You're holding the brush incorrectly.
 - ✦ You didn't maintain even pressure throughout the stroke.

4. When you apply gentle pressure, the stroke will be just as wide as the bristles. Press harder for wider strokes.

Chisel Stroke (Flat Brush)

This is sometimes called a "Knife" or "Line" stroke. It should be a fine line, similar to what you could make with a felt tip marker.

1. Fully load a flat brush. Start at the top of the stroke and work down. Keep the brush in an upright position, keeping even pressure throughout the stroke.

2. The brush should remain in an upright position and not rotate as you paint the stroke. Slow down toward the end of the stroke, then lift straight up.

3. The width of the stroke should not vary, but should remain a fine line with no bulges.

"C" Stroke

This is often referred to as a "Crescent" stroke, and sometimes a "U" stroke. It can be painted with the flat, liner, and round brushes. How much of a curve you use depends on what you are painting. At times you may want straight sides like those in the letter "U." Other times you will want a more rounded stroke (for flower petals, etc.).

Flat Brush **Liner or Round Brush**

1. Fully load the brush. Stroke flat brushes so they have a fine chisel edge; for liners and rounds, twirl the bristles to a fine point.

2. Hold the brush in an upright position.

3. Set the bristles down using light pressure and pull the stroke to the left. Increase pressure as you move down and form the wide, curved part of the "C."

4. Slow down and gradually decrease pressure, allowing the bristles to return to a fine point, then slide to the right to form the end of the "C."

Comma Stroke

This stroke is occasionally called a "Polliwog," "Daisy," "Squiggle," "Tadpole," or "Eyebrow." However, "Comma" is the most commonly used name.

The comma stroke is painted with all three brushes—flat, liner, or round. The flat brush comma doesn't have as round a head as ones painted with liners or rounds. No matter which brush you use, they are basically painted the same way.

As you paint this stroke, think:
 PRESS...the brush to spread the bristles.
 PULL...the brush toward you, and as you do,
 LIFT...until you get the thin tail.

Flat Brush **Liner or Round Brush**

1. Fully load your brush. For liners and rounds, dip the tip in a little more paint after fully loading it to make the top of the comma rounded.

2. Press the bristles on the surface, hesitating long enough for them to spread out. Maintain a constant pressure as you make the slight curve.

3. Gradually reduce pressure as you pull the stroke toward you. Slow down to allow bristles to return to the chisel edge (for flats) or a fine point (for liners and rounds). This makes the thin tail of the comma.

"S" Stroke

This stroke is made with either the flat, liner, or round brush. It should be a subtle "S." As you paint it, think: PULL...PRESS...PULL...RELEASE.

Flat Brush **Liner or Round Brush**

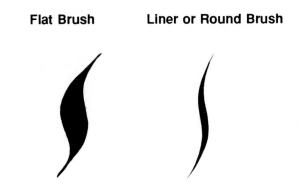

1. Fully load the brush. If using a liner or round, twirl the bristles to make a fine point. Hold the brush in an upright position. The brush handle should face the same direction throughout the stroke. The curve of the "S" should be subtle.

2. Start at the top of the stroke on the chisel edge (for flats) or a fine point (for liners and rounds) and pull down with light pressure to create the fine line at the top of the "S."

3. Press down for the wide part of the "S." The brush handle should still be facing the same way as when you started.

4. Reduce pressure and slow down to allow the bristles to return to a fine point for the bottom of the "S."

Teardrop Stroke

The full name for this stroke is "Norwegian Teardrop." It is sometimes referred to as a "Reverse Tear," especially when painted with a little sideways slide to it. To the untrained eye, it looks like a comma stroke because it has a fat head and a skinny tail. However, when you look closely, the head of the stroke is different than that of a comma. So when instructions say to paint a teardrop stroke, remember: start skinny, end fat.

This stroke is painted with either a round or liner brush.

1. Fully load a round or liner brush. Make sure there is plenty of paint in the middle of the bristles.

2. Twirl the bristles on your palette so they form a point.

3. Hold the brush perpendicular to the surface.

4. Start on the skinny end of the stroke with light pressure. Pull the stroke toward you, gradually adding pressure to form the round head.

5. Stop and lift the brush straight up. Remember, the brush should still be perpendicular to the painting surface.

Practice

I hope by now you have practiced all the basic brush strokes. It's possible that you're having problems with some of the strokes. If they don't look like those in the painted samples, ask yourself these questions. Any one of these could be the cause of your difficulties.

1. Did I load the brush properly?
2. Am I holding the brush properly?
3. Do my shoulder and arm move freely?
4. Did I follow the arrow(s) indicated on the samples?
5. Are my brushes in good shape?

When you paint, choose a brush size that is appropriate for the size stroke you want to paint, keeping in mind that both the size of the brush and the amount of pressure applied to the bristles will affect how large or small a stroke will be.

Be patient and don't allow yourself to become discouraged. Learning anything new takes time, practice, and, unfortunately, some frustration. All painters were beginners once and probably experienced similar problems. You can do it if you just "keep on truckin'."

STROKES

BRUSH STROKE WORKSHEET

LINER BRUSH These were painted with a #1 Script Liner Brush (Loew-Cornell®, series 7050). Once you have mastered using the liner, try using a round brush (such as a Loew-Cornell® #3 round, series 7000).

FLAT BRUSH These were painted with a #8 Flat Shader Brush (Loew-Cornell®, series 7300).

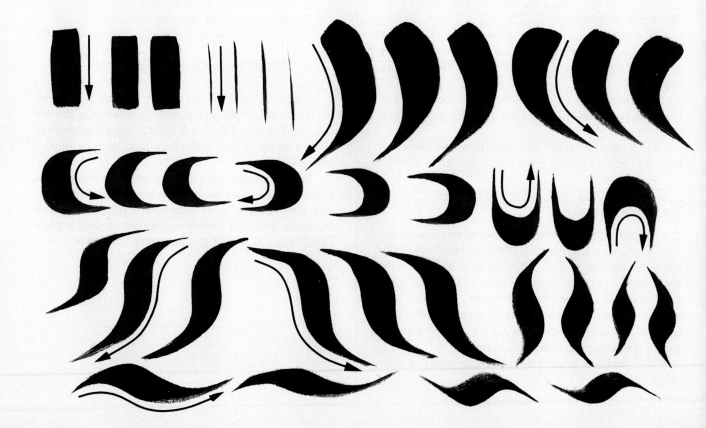

STROKES

List of Brush Strokes

This section is alphabetized by brush stroke name. In addition to the basic brush strokes, it includes some "specialty" strokes.

Sometimes one brush stroke has several different names. If there is more than one name for a brush stroke, it is cross-referenced for your convenience and the description of the stroke is given under what I believe to be the most commonly used name. The type of brush to use is shown next to the stroke name, along with a picture(s) of the stroke.

Alphabet Stroke[2] (Liner/Round Brush)

This is painted by adding a squiggle or curlicue to a "C" stroke, "S" stroke, etc.

Basic Flat (Flat Brush) See "Broad Stroke."

Blip See "Pudmuckle."

Blossom Stroke[3] (Flat Brush) See "Leaf Stroke."

Border Stroke[4] (Flat Brush)

A continuous "S" stroke is very effective for creating borders. Hold brush upright with the handle facing the same direction throughout the stroke. Start at the top with a chisel stroke, pull down following the gentle curves of the "S" stroke (throughout the length of the entire border), then press the bristles down for a broad stroke in the middle of the "S." Continue to pull down slowly as you return to the chisel edge.

Repeat the sequence as needed, reloading when necessary. Maintaining a constant speed is important for creating a smooth flowing stroke.

Broad Stroke (Flat Brush) Also referred to as "Basic Flat."

Start at the top of the stroke with the brush angled slightly toward you and all the bristles touching the surface. Pull toward you. Maintain an even pressure throughout the stroke. Slow down toward the end of the stroke, then lift straight up.

"C" Stroke (Liner/Round/Flat Brush)

Also referred to as a "Crescent" stroke or "U" stroke. The instructions given apply to all three brush types.

Flat Brush **Liner or Round Brush**

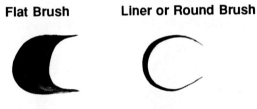

Adjust the amount of curve depending on what you are painting. Hold the brush in an upright position. Start on the chisel edge for flats. Twirl the bristles of liners and rounds to a fine point. Set the brush down using light pressure and pull the stroke to the left. Increase pressure as you move down and form the curved, wide part of the "C." Gradually decrease pressure, slowing down to allow time for the bristles to return to a chisel or pointed edge, then slide to the right to form the end of the "C."

Chisel (Flat Brush) Sometimes referred to as "Knife" or "Line" stroke.

Hold the brush in an upright position throughout the stroke. Set it down on the chisel edge with gentle pressure and pull toward you, keeping an even pressure throughout the stroke. Slow down toward the end, then lift.

Chocolate Chip[5] (Liner/Round Brush)

Make the fat, bottom part of the chip by pressing the fully loaded brush onto the surface to create a little puddle of paint. Then lift the brush and gently flick it through the puddle to create the tiny top part of the chip.

STROKES

Circle (Flat Brush)

Hold the brush in an upright position. Press on the surface and turn a quarter turn at a time. Maintain even pressure as you go around the circle.

Comma (Flat/Round/Liner Brush)

This is sometimes called a "Polliwog," "Squiggle," "Tadpole," "Daisy" (when painted without a curve), or an "Eyebrow" (when painted sideways). "Comma Stroke" is the most widely used name. The instructions given apply to all three brush types.

Flat Brush **Liner or Round Brush**

Start with the fat part of the comma. Use a fully loaded brush and press down on the surface to allow the bristles to spread. Maintain the pressure as you make a gentle curve. Gradually release pressure as you pull the stroke toward you. Slow down to allow the bristles to return to the chisel edge for flats or the pointed edge for liners/rounds. Gently slide and lift brush for the thin part of comma. Think:

PRESS...PULL...LIFT.

Comma, Wiggly Tail[6] (Liner/Round Brush)

Start by making a comma stroke in the usual way. However, as you start to lift for the fine tail, make thin curvy lines.

This stroke should look like you are totally in control for the first part of the stroke, but develop a shaky hand when you paint the skinny tail.

Corner Smash[7] (Flat Brush)

Hold the brush straight up and down as if you were going to paint a chisel stroke. Press down hard on the bristles closest to you. Gradually pull the stroke toward you as you release pressure to end on a chisel edge.

Crescent See "C" Stroke.

Crescent, Curved[8] (Flat Brush)

This, and the other variations of the crescent stroke that follow are specialty strokes created by Jackie Shaw. Because she is well-known for her brush stroke and freehanding books, I felt it would be helpful for you to become familiar with these strokes.

Start on the chisel edge and apply pressure as you move toward the center of the stroke. Apply a little more pressure at the top of the stroke. Slightly reduce pressure at the end of the stroke to match the beginning.

Crescent, Dipped[9] (Flat, Liner/Round Brush)

Instructions apply to all three brush types. However, the liners and rounds need to be shaped to a point, while flats need a fine chisel edge.

Flat Brush **Liner or Round Brush**

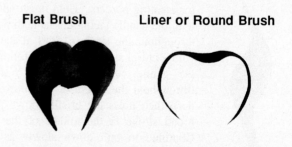

Start and end the stroke on the chisel edge (for flats) or the pointed edge (for rounds/liners). Each curve is made by increasing the pressure, (a broad stroke for flats). However, you need to slow down near the center and release the pressure a bit, then make the dip by increasing the pressure. Remember to slow down at the end of the stroke so the bristles have a chance to return to a chisel or fine point.

Crescent, Elongated[10] (Flat Brush)

This stroke starts and ends on the chisel edge. When you get to the top of the stroke, turn your brush a quarter turn and apply pressure. Then begin sliding down and turn your brush to its original position.

Crescent, Flat[11] (Flat Brush)

Start on the chisel edge and keep even pressure as you rotate the brush slightly to make the curve. End on the chisel and lift straight up to get a nice clean edge.

Crescent, Ruffled[12] (Flat Brush)

This is painted very much like a "C" stroke in that it starts on the chisel, has increased pressure toward the top of the stroke, then returns to a chisel at the bottom. The difference is that as you work up toward the top and back down again, you vary the pressure to create the ruffled look.

Crescent, Sliding[13] (Flat Brush)

Paint this just as you d a "C" stroke. Begin on the chisel edge and gradually apply pressure until you are across the top curve. On your way back down, decrease the pressure, slow down, and end on the chisel edge.

Crescent, Straight Edged[14] (Flat Brush)

The best way to keep this even is to draw a line at the bottom edge of the stroke to guide you. Slightly angle the brush in the direction of the stroke. Vary the pressure to change the width of the stroke. Keep one edge of the brush on the guide line.

Daisy See "Comma" stroke.

Diamond[15] (Liner/Round Brush) This is sometimes referred to as a "T.T.T." stroke, or a "Parentheses" stroke when it curves.[16]

The fully loaded brush should be shaped to a fine point. Think "THIN, THICK, THIN." Start on the tip of the brush and slowly pull brush toward you. Increase the pressure for the center. Decrease the pressure and slow down as you slide to the end of the stroke, ending with a fine line.

Eyebrow Stroke See "Comma" stroke.

Fill-in Swish[17] (Liner/Round Brush)

Start with the bristles on the line and apply pressure. Rotate and lift the brush so the tip slides up, then make a comma stroke.

Flick Leaves See "Leaves, One-Stroke."

STROKES

Half Circle[18] (Flat Brush) This is sometimes called an "Igloo" stroke.

Hold the brush in an upright position. Start on the chisel edge, apply pressure. Maintain pressure as you pivot the brush and move through the half circle. Reduce the pressure and lift. The brush should end on the chisel edge.

Heart (Half-A)[19] (Flat Brush)

Start the stroke at the line. Apply pressure and move up, then rotate either to the left or right, depending on which half of the heart you are doing. Release the pressure and slow down to give the bristles time to return to a chisel edge for the end of the stroke.

Igloo Stroke See "Half Circle."

Knife See "Chisel" stroke.

Leaf Stroke[20] (Flat Brush) Sometimes referred to as a "Blossom Stroke."

The stroke begins like a broad stroke. Pull the brush down slowly while rotating through a quarter turn. The stroke ends on the chisel edge to make the short, narrow line

Leaves, One Stroke[21] (Round Brush) Sometimes called "Flick Leaves."

Put extra paint on the tip of a fully loaded brush. Apply pressure for the fat part of stroke (as you do for a comma). However, as you lift the brush and the bristles return to a chisel edge, pull the tip through the fat part of the stroke. End with the short, fine line either curving to the left or the right.

Line See "Chisel" stroke.

Norwegian Teardrop See "Teardrop" stroke.

Oval[22] (Flat Brush)

Start at the bottom on the chisel edge. As you push the brush toward the top, increase pressure. When you pull down the other side, release the pressure, and slow down to give the bristles a chance to return to a chisel edge. The brush handle only angles slightly as you make this stroke. At the beginning and end of the stroke, it should be in the same position. This stroke can be painted with a round brush, but it isn't as easy.

Parentheses See "Diamond Stroke." It's the same stroke, only painted with a curve.

Pivot/pull[23] (Flat Brush)

Start the same as you would for a broad stroke. Pivot the brush a quarter turn, gradually releasing the pressure. Slow down slightly so the bristles can return to a chisel edge, then slide down for a narrow line at the end of the stroke.

STROKES

Pivot/pull, Bumpy[24] (Flat Brush)

Paint this just like the "Pivot/Pull" above except vary the pressure to make the bumps.

Polliwog See "Comma Stroke."

Pudmuckle[25] (Round/Liner Brush)

This stroke is sometimes referred to as a "Sit-down," "Blip," or "Push Dot." Fully load the brush, then press the bristles halfway down on the surface and lift straight up.

Push Dot See "Pudmuckle."

Reverse Tear See "Teardrop" stroke.

"S" Stroke (Liner/Round/Flat Brush)

Flat Brush **Liner or Round Brush**

Start on the chisel edge for flat brushes, or pointed edge for liners and rounds. Hold the brush in an upright position. The handle must not change position throughout the entire stroke. Make gentle curves. Start at the top of the stroke on the chisel edge and pull down with a chisel stroke. Gradually increase pressure as you create the thick part of the "S." Gradually release pressure, and slow down at the end of the stroke, ending on a fine chisel edge.

Scroll[26] (Liner/Round Brush)

This is similar to the "S" stroke in that it starts thin, gets thick, and ends thin. However, it can twist and turn in any direction, curving as much as you like. The keys to creating free-flowing lines are (1) the paint should be the consistency of light cream, (2) use your entire arm, not just your wrist, (3) emphasize the thick and thin parts of the stroke, and (4) slow down on the curves.

Scroll[27] (Flat Brush)

Though this may look like a comma stroke, it is painted in reverse. Start at the thin part on the chisel edge, then gradually increase pressure and curve around as you go into a broad stroke. Slow down as you reach the end of the stroke to allow the bristles to return to a chisel edge. Lift straight up to get a clean line.

Sit-Down See "Pudmuckle."

Squiggle See "Comma" stroke.

T.T.T. See "Diamond" stroke.

STROKES

Tadpole See "Comma" stroke.

Teardrop **(Liner/Round Brush)** The full name is Norwegian Teardrop. It's sometimes referred to as a "Reverse Tear."

Make sure there is plenty of paint in the middle bristles of your brush. Twirl the bristles so they form a point. Hold the brush in an upright position and start on the thin end of the stroke using light pressure. Pull the stroke toward you, gradually adding pressure to form the round head. Stop and lift the brush straight up.

Teardrop, Pigtail[28] **(Liner/Round Brush)**

Follow the directions for the previously described Teardrop. However, instead of lifting off at the end of the stroke, just lift your brush up so the bristles return to a fine point. Make fine, curvy lines through the fat part of the stroke. Keep the thin, curvy lines at the end of the stroke shorter than the thin line at the beginning.

Teardrop Push[29] **(Liner/Round Brush)**

Paint this the same way as the basic teardrop except before lifting off at the end of the stroke, gently push the brush as you would if you were painting a chocolate chip.

"U" Stroke See "C" Stroke.

STROKES

Chapter 6

TECHNIQUES

The basic techniques described in this chapter are those that you will most likely encounter as you delve into the field of decorative painting. With the ever-growing popularity of the art, new techniques are developed due to the creativity of artists and manufacturers alike. As you read this chapter, please keep in mind that these are certainly not the only techniques being used or the only way to do them.

For your convenience, the techniques are listed in alphabetical order. If there is more than one name that I know of for the same procedure, it has been cross-referenced, with the directions given under the most commonly used name.

When a list of supplies is given, it includes only the special things needed for that particular technique. Supplies, such as palette paper, paints, and brushes, are not included unless a special type is required for that technique.

Antiquing

This technique is used to make a surface look as if it had been darkened with age. It's most often done after all the decorative painting is complete and dry.

Antiquing Method Number 1

Supplies Oil paint, Scottie's Antiquing Patina, several clean 100% cotton rags (8" or so squares will do), disposable plastic gloves, water-based varnish (brush-on), Mop brush (soft, full-bristled "dusty" brush).

Note: You may antique with any color of oil paint or mix them to suit your taste. I prefer using Liquitex® Burnt Umber. However, Raw Umber, Black, Prussian Blue, Burnt Sienna, and Raw Sienna are also popular colors for antiquing.[1] Be sure to purchase *oil* tube paint, not acrylic.

Antique in a well-ventilated area. Wear plastic disposable gloves, and when antiquing is completed, throw all the trash in an outdoor trash can.

1. Take a close look at your painted surface. Remove all remaining transfer lines and do any needed touch up. For example, you might want to strengthen a highlight, clean up some liner work, etc. This step is important, because once you have antiqued the piece, making corrections is difficult if not impossible.

2. The surface to be antiqued must be completely dry.

3. For small, flat items, the entire surface can be done at one time. However, for large items, do smaller areas at a time, such as one side of a cabinet, the front of one drawer, etc. Make sure you only get the antiquing mixture on the side you are doing. If you get any on a side you'll be doing later, wipe it off quickly and thoroughly.

Oil paints take much longer to dry than acrylics, so you must be careful to avoid getting finger marks on newly antiqued areas. If you're working on large items, wait several hours before antiquing other areas unless you are sure you can avoid smudging them.

4. Dampen one small clean cloth with Scottie's Antiquing Patina just as it comes out of the bottle. Rub the entire area to be antiqued with this cloth, making sure all areas are covered, but *not* dripping. There should be an even sheen with no puddles.

5. Now you need to get the oil paint on top of the Scottie's Antiquing Patina you applied in step 4. To do this, put a tiny dab of oil paint on the same spot of the rag you used in step 4. Apply this to the surface using smooth, even strokes that start at one side and end at the opposite side, with no stops in between.

6. If you want the edges to be darker than the center, put a little more oil paint on the same rag and work it into the edges with a circular motion, then smooth it out by rubbing the area with long, flowing motions.

7. Use a mop brush and brush the newly antiqued surface with long, sweeping strokes. Use a light touch and work from side to side without stopping in the middle. This removes any streaking caused when you applied the antiquing mixture and softens the effect.[2]

8. For those areas that were painted in white or flesh tones, (for example faces or Santa's beard), use a clean rag and wipe the antiquing mixture off using a gentle, circular motion. Then use a mop brush and gently brush these areas only.

Note: A large percentage of the antiquing mixture can be removed if you don't like the way it looks. To do this, dampen a clean, cotton cloth with Scottie's Antiquing Patina and gently wipe the antiquing off. That's why this method is so good for beginners–you can easily undo what you don't like. So relax and enjoy yourself.

9. When the antiquing is finished, allow it to dry at least one week before varnishing. In damp weather, it's best to wait 9 or 10 days. Keep it in a place where it won't get smudged during the drying time.

10. Once the antiquing has dried, varnish as desired.

I prefer to use a brush-on water-based varnish, such as J.W. Etc. Right Step™. The water-based varnishes resist yellowing with age, which is a common problem with the oil-based varnishes. For best results, apply at least 5 coats, allowing an hour drying time between coats.

Antiquing Method Number 2–Jo Sonja's®[3]

This is an easy method for you to try, using all Jo Sonja® products.

Supplies Jo Sonja's® Polyurethane Water-Based Varnish, Artists' Color of your choice, Retarder, wide flat brush (1"), dusty (mop) brush, soft rag.

1. Apply one coat of varnish and allow it to dry about 8 hours. If you don't wait long enough, too much glaze will be absorbed into the surface.

2. Use a color of your choice for the glaze. Keep in mind you can combine more than one color. Squeeze a little color onto your palette. Slowly add Retarder to the paint, mixing it in with a palette knife until you have a thin creamy consistency. Exact proportions cannot be given because pigments vary in their tinting strength.

3. Lightly apply the glaze with a wide brush, using a "slip-slap" motion to pull and stretch the glaze over the surface. The entire surface should have an even, wet sheen. It should not look oily.

4. If you have a little too much glaze in one area, dress your brush (explained later in this chapter) in a little fresh Retarder and move it over the piece to help level out the glaze. Then, use a dusty brush to remove any remaining streak marks.

5. Now you need to make a decision. You may begin to wipe it down with a soft rag immediately. However, for beginners, Jo Sonja recommends that you let the glaze dry until there are no visible wet spots. Then use a damp rag and wipe only the areas where you want the highlights to be.

Do not force dry the glaze in any way, such as placing it in direct sunlight or using a hair dryer on it. This will cause the glaze to cure too fast and make it difficult to remove. Just put the piece in an area that has adequate air flow and let it dry naturally. Drying time will vary with weather conditions, etc.

Hint: Since you are antiquing the project to make it look old, remember to wipe the glaze off the edges or any areas where the hands would normally touch the piece. This will make these areas look as if they had more wear.

6. Once the glaze has been rubbed off to suit you, allow the piece to dry completely.

7. For an alcohol-proof surface, apply 4 coats of varnish. Allow each coat to dry to the touch before applying the next one. It takes about two weeks for the varnish to reach its maximum hardness.

Basecoating

Basecoating is usually the first painting you will do on an object after sealing. There are two types of base-coating–Preliminary and "Color Book Painting."

Preliminary This is the basecoating that becomes the background color of your object. For example, if you are painting a wooden tray and you want the background to be ivory, you simply paint the entire tray ivory. Or, you might choose to paint the sides one color and the bottom another. When this preliminary basecoat has dried, you would then proceed to transfer your pattern and do the decorative painting.

Color Book Painting This technique is used to solidly fill in a specific area with paint. Use shape-following strokes to fill in pattern areas. If you have applied a preliminary basecoat, this will go on top of it. Refer to Pattern B of Figure 4-1 in Chapter 4. This shows the areas that will be "Color Book Painted" on this particular pattern. The name "Color Book Painting" is derived from the fact that you are applying different colors to the specific areas of the pattern, with no detail work.

After the Color Book basecoating is complete, your object will look lifeless until other techniques, (such as floating) have been used. It's a lot of fun watching your painting as it makes the transition from this dull stage to a more life-like one.

Basecoating Hints The ideal basecoat is smooth and ridge-free. The following hints will help you achieve this.

1. Use as large a flat brush as possible for the area you are working on because it holds more paint and you will create fewer brush stroke marks.

Note: If you want an eggshell finish (which is more textured), apply the paint with a small sponge roller. This is available at craft and hardware stores.

2. Put out fresh paint on a clean area of your palette. Do not thin the bottle acrylics (such as DecoArt™) with water unless pattern instructions advise you to do so.

3. First dip your brush in water, blot on a paper towel, then dip in paint. Fully load the brush, but don't load it all the way to the ferrule.

4. To avoid creating paint ridges, use two or three thin coats rather than one thick one. Paint from the middle of the area you're basecoating out towards the edges. If you slip and get a ridge, take your finger and gently pull it over the ridge, going towards the paint, then smooth over the area with your brush.

5. Another trick for avoiding ridges is to work your fully loaded brush out on the palette first, making sure there are no globs of paint on the sides of the brush.

Be as neat as possible. If you don't plan to paint the back of the object, you need to be especially careful not

TECHNIQUE

to get any paint on it. Have a damp cloth or baby wipes handy to clean up any drips or smears before they have a chance to dry.

6. Allow each coat to dry before applying the next. Use your own judgment as to how many coats to use. This will vary with project surfaces.

7. If the coats don't look smooth enough to you, sand lightly between coats after the paint has dried. I like to use #400 wet-dry sandpaper, (using it dry), or a piece of plain, brown paper bag.

You may think that your basecoat looks too scuffed after you have sanded it. To ease your mind, just dampen the area you are concerned about with a little water. The way it looks when it's wet is how it will look once it has been varnished. If the scuff marks don't show with the water, they won't show on the piece when it is varnished.

8. If you sanded the surface, wipe it with a tack cloth before applying the next coat of paint.

9. Clean your brush often. No matter how hard you try to avoid this, you will sometimes still get paint in the ferrule area when you are basecoating. If this happens, clean the brush immediately.

10. When basecoating an entire object, make long, sweeping strokes with all the strokes going in the same direction. For Color Book Painting, adjust the size of your stroke to the area you are painting, following the natural contour of the object.

Basecoating Wood Without Sealing–Jo Sonja's Method[4]

Jo Sonja's® Artists' Colors, described in Chapter 1, are tube acrylics that are thick and more richly pigmented than the bottled acrylics. With this method of basecoating, sealing the wood first is not necessary because the paint is mixed with All-Purpose Sealer, providing one-coat coverage.

Supplies Jo Sonja's® Artists' Colors, Jo Sonja's® All-Purpose Sealer, wide flat brush.

1. Mix your choice of Artists' Colors with the sealer on your palette. Although there isn't an exact recipe, start by using equal parts. Mix well with a palette knife.

2. Dip your brush in the mixture, and apply it to the surface with a "slip-slap" motion. Then, smooth the paint, going with the grain. Do small areas at a time.

3. Allow the paint to dry to the touch. Then, lightly sand it with fine sandpaper to rough up the surface.

Don't worry if the piece seems to resist your sanding. Instead of getting the usual sanding dust, you will get erasure-like particles. This is not a problem, and it's better for your health because you won't be inhaling sanding dust.

4. Remove the sanding residue. Your surface should look slightly scuffed. You don't have to give it

another coat of paint. When you apply the final coat of varnish, the surface will be evened out.

Calico Dots

These dots are uniformly spaced in groups of threes or fours, etc. Refer to "Dots" for complete instructions on the various ways to do them.

Color Book Painting

See "Basecoating," the more commonly used name for the same technique.

Contrast

To state it simply, contrast is the sense of the lights and darks in your painting. Good contrast brings a painted object to life. Refer to "Layering" and "Floats/Floating" categories in this chapter as well, because they are techniques used to create contrast.

Contrast Hints For The Beginner Let's assume you are painting leaves. To create the feeling of depth, you shade the leaves with a darker color, and highlight them with a lighter one.

Here is an easy way to decide what should be dark, medium, or light in value. Make the leaves in back darker, those in the middle a medium value, and those towards the front lighter. To repeat:

+ Dark to the Back
+ Medium in the Middle
+ Light in the Front

To show the separation between leaves that are touching, shading and highlights provide the contrast needed to give dimension. In Figure 6-1, "X's" indicate highlight floats and dots the shading floats. The two back leaves are shaded where they go under the front leaf. The front leaf is highlighted where it meets the two back leaves. To provide contrast in a single leaf or object, shade one area and highlight another.

Notice the fold on the leaf on the right side. Shading is placed under the fold and also on the back of the fold; highlighting is placed on the edge of the fold. The shading and highlighting makes the leaf appear to fold under.

Think in terms of where the light is hitting the various objects in your painting. It's these areas that should be highlighted. The areas away from the light should be shaded.

Please, keep in mind that I'm over-simplifying these instructions to give beginners a starting place in creating contrast. The more advanced you become in your painting techniques, the more you will learn to use contrast to its

TECHNIQUE

fullest potential. For now, following these simple steps will greatly enhance your first projects.

Figure 6-1. Contrast Through Shading and highlighting

Crackling with DecoArt™ Weathered Wood™

Use this technique whenever you want to make a surface look old and cracked with age. It may be done on any solid surface that will hold a coat of acrylic paint. It is not appropriate for use on fabric.

1. Prepare the surface. If working on wood, sand it until it's smooth, and wipe it with a tack cloth.
2. Seal the surface with the product of your choice. When it is dry, sand it, then wipe it with a tack cloth again.
3. Apply one coat of either DecoArt™ Americana™ acrylics, Dazzling Metallics™, or Heavy Metals™. Allow about 30 minutes to dry.
4. Apply a smooth, even coat of Weathered Wood™ using either a fan brush (for beginners especially), or a soft-bristled brush.

Note: Beginners tend to use the product a little too sparingly. If they apply it with a fan brush, the Weathered Wood™ tends to even itself out and the result is a better crackled effect.

5. Allow the Weathered Wood™ to set at least 20 minutes, then apply the top coat of color with a large, soft, flat brush. Be careful to apply the paint as smoothly as possible. Don't "work" the paint too much in any one area or the paint will not crackle uniformly. The crackling begins within minutes of applying the top coat.

When using a brush, brush in one direction only. A damp sponge may be used when smaller crackles are desired.

Note: Use only DecoArt™ Americana™ paints *on top of the* Weathered Wood™. Though Dazzling Metallics™ may be used as the initial basecoat, they won't crackle when used as the top coat.

6. When completely dry, you may antique the piece

if desired.

7. Varnish with either spray or brush-on varnish.

Crosshatching

These are crisscrossed lines used to enhance a design. Here is how to do this technique:

1. For best results, freehand your crosshatching, referring to your pattern as you paint. There are two reasons for this. (1) The paint will be thinned with water so there is a possibility that the transfer lines would show through your work. (2) Crosshatching should look free and easy; transfer lines could inhibit your ability to achieve this.
2. Thin *fresh* paint with water or extender until it flows like ink. Paint that has been sitting on your palette for a while won't flow as well.
3. Fully load a liner brush with fresh, thinned paint. With liner brushes, you can load all the way up to the ferrule. I like to use a #1 script liner. The fully loaded brush should have a reservoir of paint in the middle. Twirl the bristles on a palette until they form a point.
4. Wipe off any excess water from the ferrule.
5. Try painting a line on your palette to test how the paint flows. If it flows evenly, you are ready to paint on the actual surface.
6. Every painter has a preferred method of doing this. I support my painting hand with my other hand and pull the brush toward me, turning the work when needed. As you learn this technique, decide how you like to do it. The end result is all that matters.
7. Paint crisscrossed lines on your project surface as shown in the examples in Figure 6-2.

Hint For Beginners. The farther apart your lines are, the less you will notice ones that aren't as straight as you would like.

Figure 6-2. Crosshatching Examples

Crow Quill Pen, Use Of[5]

The picture below shows you the three parts of the pen: the nib (which is replaceable), the grip, and the handle. The pen is used with thinned paint to outline designs. I've mainly used this pen on watercolor paper to do linework on acrylic paintings that emulate the look of watercolors. The crow quill pen may be used on other surfaces as well.

Nib Grip Handle

Figure 6-3. Crow Quill Pen

Figure 6-4. Curlicue Examples

Before you begin using the pen, take a good look at the nib. Notice how it splits up the middle. As a general practice, avoid using the pen so that the nib moves either sideways or is pushed forward. The reason is this causes the nib to split and paint will leak on to your work. However, with practice, you can learn to control the pen enough to sign your name, etc. The trick is to slightly lift the nib while writing so it doesn't split and spill the paint.

Hold the pen in a firm but relaxed way. Pull the pen handle toward you with the nib following, turning the project as necessary.

1. When the pen is new, the metal nib may be coated with a waxy substance intended to inhibit rust. This must be removed before using. To remove, gently wash the tip in hot, soapy water.

2. Put a small dab of acrylic paint on your palette and add at least an equal amount of water to it. Mix well.

3. Dip a #3 or #4 round brush into the watered-down paint. You will use this to "load" the pen. Hold the pen so the nib opening faces up, then load one or two brush loads of thinned paint into the nib.

4. Be sure and make some practice strokes on a scrap of paper before working on the project piece because sometimes the pen nib will get too full, causing a blob when the tip of the pen is touched to paper. It's a good idea to have a clean paper towel handy. If you get a blob on your surface, you'll be able to quickly blot it off without any problem.

Use gentle pressure Normal downward pressure will create a thin line; more pressure will make a thicker, wider line.

5. Clean the nib well between color changes. Also, clean it every few minutes even if you're using the same color. This keeps paint from drying in the point of the nib, thereby obstructing the flow of paint.

6. Carefully clean and dry the pen before putting it away. Also, to protect the nib when not in use, insert it point first into the grip.

Curlicues

These are little embellishments that enhance your painting. Thin the paint with water so that it flows like ink. Fully load a liner brush, (the same way as you would for crosshatching). Twirl the bristles to form a fine point. Relax and paint free, flowing strokes, slowing down as you make the curves. Here is an example of curlicues:

Diamond Dusting

With this technique, an iridescent, glittery substance is sprinkled on a surface to add sparkle. It is especially effective on Christmas projects. Prisma Glitter™ works well, and is available in different grades (sizes of the glitter pieces) and colors. My method for diamond dusting is shown below.

Note: Prisma Glitter™ is also used in some methods of fabric painting. The following steps, however, are for painting on solid surfaces, such as wood or candles.

Supplies Prisma Glitter™, Brush-on water-based varnish.

1. Prisma Glitter™ is applied to your *finished* project, so make sure any remaining transfer lines are erased. If you want to do any touching up, now is the time to do it.

2. Decide how many coats of varnish you want to apply. The glitter is applied with the *last* coat of varnish. I suggest applying at least 2 coats of brush-on water-based varnish before you add the glitter. Allow each coat to dry thoroughly before applying the next one.

3. Put your varnished surface on a piece of newspaper. Glitter tends to scatter.

4. Brush varnish only on the areas to be glittered, and immediately sprinkle glitter on top of the *wet* varnish.

5. Wait to shake off the excess glitter until the varnish has completely dried.

Distressing[6]

To put it simply, "distressing" is a technique used to "beat up" perfectly good wood to make it look old and worn. (Can you tell by my description that I'm not wild about this technique?)

1. Put the wood on a surface that won't be harmed if you make a wild swing and miss the wood. (Outside on a newspaper on grass or cement will work fine.)

2. Don't get too carried away and over-distress the wood. A bit of moderation will give you a more professional looking piece. Some ways to accomplish this include hitting it with a hammer, poking it with an ice pick, and pounding nails into it. Use caution when doing any of the above methods.

3. To give the distressed wood a softer look, round the corners and edges by sanding them.

For beginners, it's a good idea to distress the wood *before* you paint it. This way, if you don't like the way it looks, you can throw it away. All you will have lost is the cost of the wood–not the hours you spent painting it.

However, if you so choose, wood can be distressed after the decorative painting has been done. Don't varnish it first. Use sandpaper and sand off a little of your painting here and there. Sand off just enough paint to give your surface a well-used appearance.

Dolly Parton Hearts

Dots are the basis of these hearts. They are easily freehanded because two dots form the main part of the heart. To make a Dolly Parton heart:

1. Make two dots close together, using either the wooden end of a brush or a stylus, depending on the size of heart you want.
2. As soon as you have made the dots, take a liner brush and pull down a line from each dot, forming a V where the lines meet. (I use a 10/0 liner for this). This forms the heart shape. You don't add paint to the liner brush. The paint is just pulled out of the dots.

Two dots **Finished heart**

Figure 6-5. Dolly Parton Heart Example

Note: If the second line doesn't fill in the heart completely, pull a little more paint from the bottom of one of the dots until the heart is filled in.

Dots

Dots are made in several ways. One method is to dip the wooden end of a brush in the paint and apply it to the surface to be painted, or use one of the ends of a double-tipped stylus. You can also make dots with the end of a pencil, a toothpick, or a knitting needle.

It's important to use a fresh pile of paint, and to clean the dot-making tool every so often. If you get a build-up of paint on the tool, the dots won't be perfectly round.

If you have a lot of dots to make, it's a good idea to do them last when possible. Because they are heavily textured, they take longer to dry and are, therefore, more easily smeared.

The size of the dots is varied by the size of the tool you use. For textured dots (thick paint build up), carefully touch the paint to the surface, not the dot-making tool. For flatter, less textured dots, both the paint and the tool must touch the surface.

Dots All The Same Size For dots all the same size, dip

into the paint for each dot. Make sure the tool you use has no dried paint on it.

Graduated Dots Load the tool with paint initially, but do not reload for each dot. Figure 6-6 is an example of graduated dots made using the end of a Loew-Cornell® #8 flat brush that was only dipped once in the paint.

When making dots as fillers between flowers, try making graduated dots, placing the largest dots closest to the flower, graduating to the smaller ones farther away from the flower.

Figure 6-6. Graduated Dots Example

Folk Art Design Tools These tools are appropriate for all levels of painters and are used to create evenly spaced dot patterns in various shapes, (hearts, flowers, etc.). When you use them, practice on paper before applying to your actual surface. If you're using bottled acrylics, such as Delta® Ceramcoat®, don't thin the paint. Dip the design tool into the fresh paint and hold the tool straight up and down. Then gently press on your surface and lift straight up.

Bristle End Of Round Brush For painting not-so-perfect round dots, such as those in the center of a flower, use the bristle end of a round brush. Make sure the end is shaped to a point, dip it into the paint, and lightly dab on the surface to be painted.

Doubleloading

A doubleloaded brush carries two different colors at the same time. The colors are loaded at opposite sides of the bristles, then blended across the brush. Technically, any brush can be doubleloaded, however, the flat brush is most commonly used. The angle (rose petal) brush is also used, especially for painting roses.

1. Put two different colors of paint on your palette in separate piles. For practice, make one color light and the other dark.
2. Stroke one edge of the brush back and forth to fully load that side of the brush with the light color of paint.
3. Now load the other side of the brush with the dark color in the same manner described in step 2. Be sure to leave a space between the two colors, since this is the area where the blending will occur.
4. Now turn the brush so the wide edge of the bristles touches the palette. Stroke it back and forth until the colors blend into each other and there is color all the way across the bristles.

5. A properly doubleloaded brush is ready to use on your surface when: (1) the paint is blended all the way across the bristles, and (2) you have a dark color on one side, medium color in the middle, and a light color on the opposite side.

Dressing a Brush

This is done by loading a brush with paint or medium and stroking the bristles back and forth on a palette until they are filled. There should be no globs of paint or medium on the sides.

Dry Brushing

This technique is used in one method of applying highlights or shading to your paintings. It is also very effective for creating grass, fur, Santa's beard., etc. Because it's hard on brushes, it's best to save your old flat brushes for this technique.

1. Put a dab of paint (no water added) on your palette and work the brush back and forth through the paint. The brush needs to be fully loaded.
2. Pat the brush on a paper towel to remove almost all of the paint.
3. When the excess paint has been removed from the brush, apply it to your surface with a light touch.
4. **Shading/Highlighting.** To create shading or highlights, work the brush back and forth or in a "slip-slap" motion. For a rounded highlight, for example on a ball, use the "slip-slap" motion and keep the center of the highlight in mind as you apply it. Though you should paint the strokes in all directions, you still need to keep this center point in mind. The effect should be subtle with no visible start or stop lines.

Hint: For effective highlights, dry brush in a color close to the color of the area being highlighted. Then change to a lighter color and repeat the process, then an even lighter color, until you have achieved the effect you want. As you change to the next lighter color, make the highlight a bit smaller than the previous one, while still maintaining the center of the highlight as your focal point. This helps you achieve more subtle highlights.

5. **Fur/Grass, etc.** Load the brush the same as previously described, but just swish the brush on the surface in graceful lines to simulate the look of fur, grass, etc. Think "free and easy" as you paint to get the most realistic effect.

Edging

This is a very useful technique to help you neatly paint the edges of some objects in a contrasting color. Using Petifours, (described in Chapter 1), makes this task quick, neat, and easy.

Wait until all the decorative painting has been completed, dried, and any remaining transfer lines erased. Let's use a jewelry box for an example. The narrow, one-inch side edge of the lid is a good candidate for the contrasting color technique.

1. Use a soft, wide, flat brush and apply two coats of brush-on water-based varnish to all areas of the box *except* the narrow edge you'll be painting a different color. Allow each coat to dry before applying the next. The varnish is applied first so that if you should accidentally get some paint where you don't want it, it can be easily removed. If you should get some varnish on the narrow edge, gently and quickly wipe it off with a slightly dampened paper towel. Avoid getting any water on the newly varnished surface.
2. When the varnish has dried, you're ready to paint the edge. To do this, dip the Petifour sponge into water to soften it, then squeeze out all excess water. The top, yellow portion of the Petifour folds in the middle to make a convenient handle. Dip the Petifour into unthinned paint and paint the edge. For best results, apply several thin coats, rather than one thick one. The shape of the Petifour sponge makes it very easy to get neat, sharp edges.
3. Once the edge is painted to your satisfaction and any problem areas taken care of, allow the surface to dry completely, then apply two or three more coats of varnish to all areas.

Faux Finishes

The word "faux" is the French word meaning false or fake. Faux finishes are decorative backgrounds created to simulate the appearance of wood grain, marble, etc. They are described in this chapter under the specific name, such as: Marbleizing, Marbleizing With Plastic Wrap, Sponging, etc., and they are easy to do.

Flecking

This technique is also referred to as flyspecking, spattering, or sometimes splattering. It's used to put tiny specks of paint on a surface either before or after doing the decorative painting. When to do it depends on whether you want specks on top of your decorative painting or just on the background. For a softer, almost smeared appearance, the area may be dampened slightly with water first before flecking. Flecking is most commonly done, however, on a dry background.

1. Make sure any previously applied paint is completely dry.
2. This technique can be messy, so spread newspapers around your work area and wear clothing that you don't mind getting paint on.
3. Mix paint with water until it becomes an inky

consistency.

4. Have a damp cloth or baby wipes handy in case you don't like the way the flecking is turning out. As long as your surface is completely dry before you fleck it, mistakes should wipe off easily when the flecking is still wet. Don't rub too hard–all you want to remove is the flecking, not any painting underneath.

5. There are several ways to fleck. Whichever way you choose, experiment on your palette first before applying to the actual surface. These four things will greatly influence the way your flecking turns out.

+ Paint consistency
+ Working distance from the object (4 inches to about a foot)
+ Pressure applied to tool
+ How quickly you move the flecking tool around over the surface. (Staying in one area for too long will cause over-flecking.)

Hint: When you're about to fleck a finished painting, you may worry about ruining the newly painted area. To ease your mind, apply one coat of brush-on water-based varnish to the area to be flecked and allow it to dry, then do the flecking. If you don't like the results, or would prefer one area of the design to remain unflecked, (such as a face), quickly wipe off the flecking in the problem areas with a dampened paper cloth. The varnish will protect your other painting. When the flecking is completed and has dried, apply two or more coats of varnish.

Flecking Methods

Fan Brush Dip the fan brush in the paint/water mixture and give it a flick toward a paper towel to remove any excess paint. Using the chisel edge, gently stroke the bristles of the fan brush across the handle of some other large brush (such as a 3/4" flat brush).

As the bristles clear the handle, they will spring back rapidly, throwing flecks of paint on the surface. Wipe the excess paint/water mixture off the handle every so often to avoid drips. Adjust the distance from the surface to suit you.

An alternate method is to tap the handle of the fan brush against another brush handle.

Spatter Brush This tool is designed for flecking and consists of a coarse bristled brush resembling a bottle brush. The brush has a wooden handle equipped with a pin that lies next to the ends of the bristles.

Dip the ends of the bristles in thinned paint. Hold the wooden spindle in one hand with the pin away from you. Hold the wire handle in your other hand and position the bristles against the wire pin. With the brush over the area to be flecked, rotate the wire handle in a clockwise direction.

For heavy flecking, the pin should touch all of the bristles. For lighter flecking, adjust the wire handle so that fewer bristles contact the pin.

Toothbrush Dip a clean, dry toothbrush in the paint/water mixture. Experimenting over a paper towel, gently run your finger, craft stick, or palette knife along the bristles. (Moving across the bristles toward your body keeps most of the paint away from you.) Adjust the distance from the towel and the pressure on the toothbrush until the specks look about the size you want them. Then do it on your actual surface.

Floats/Floating

Floating is often used as another name for "side-loading." However, there are artists who use the words "float" and "sideload" as two different techniques. Therefore, when using a pattern book, read the general instructions (usually found at the beginning of the book) to learn what the artist really means. Throughout this book, floating and sideloading will mean the same thing.

In general, beginners will be introduced to a smooth float. In shading or highlighting, the float will be one, continuous application of color. However, as painting skill increases, the pat-blended float should be learned. Though the brush is loaded the same way, this float is choppy, and "patted" onto the areas requiring shading or highlighting. Instead of one smooth, continuous application of color, there are many small, choppy ones.

Floating gives depth to your painting by adding shading and highlights, and is one of the most valuable techniques for the acrylic painter. Although it can be a bit frustrating to learn, don't become discouraged. Good floating technique is worth learning because it will enhance all of your paintings.

A flat brush is most commonly used for floating. However, there are times when an angle (rose petal) brush comes in handy. If you use an angle brush, put the paint on the side with the longest bristles.

Use the largest brush you can for the size of design you're painting. Your floats will look better because there are more bristles on which to blend. The result is softer, better blended floats.

Floating Versus Doubleloading Floating is similar to "doubleloading." The difference between the two is this:

+ Doubleloading has different colors of paint on opposite sides of the bristles. The colors blend all the way across the bristles.
+ Floating has paint on one side of the bristles only and plain water (or extender) on the opposite side. The paint does not blend all the way across the bristles.

The Ideal Float This is what you should aim for, and it applies to whatever type of float you'll be doing. A good float will have a gradual fading across the bristles of paint color to clear water or extender. There will be no sharp lines of paint. *Gradual fading* are the key words.

1. Use a fresh puddle of paint, clean water (or extender), and a clean, flat, or angle brush. Use as wide a brush as possible for the area to be floated.
2. Dampen the brush. It should be wet, but not dripping. Blot bristles on a paper towel to remove the excess water.
3. Relative to the color of the area you are floating:

♦ Shading is done with a *darker* color.
♦ Highlighting is done with a *lighter* color.

4. Gently touch one corner of the edge of the bristles against the edge of the puddle of paint. Stroke the edge (only) of the bristles back and forth through the paint. This is more effective than dipping the brush in the paint because when you dip, you tend to get too much paint on the bristles.
5. Now, work the brush back and forth on a small, clean area of your palette (no more than 1 or 2 inches) to blend the color. Stroke back and forth as many times as necessary to get a gradual fading from paint color to clear water. (This could take 15-20 strokes.) No more paint should be added to the brush during the blending process.
6. When you are ready to apply floats to your actual painting surface instead of the practice one, have a baby wipe or slightly dampened paper towel handy. This can act as your "security blanket." If the float isn't good, quickly wipe it off before it has a chance to dry. Rub gently so you don't remove any of the basecoating underneath the float.

Correcting Floating Mistakes

1. If your float isn't dark enough, don't redo it until the first float has dried. Then re-float the area.
2. If it looks totally wrong, quickly wipe it off before it has a chance to dry.
3. If the float is too dark, and it has already dried, try re-floating on top of it with your basecoat color.

Types of Floats

Listed below are some of the types of floats used in decorative painting. I've given an example of how each type might be used. Needless to say, there are any number of ways to use them to create the feeling of dimension in your paintings.

Back-to-Back Floats These are also called "flip floats," "reverse floats," or "ribbon floats." With this technique,

there are two floats, back-to-back. They make wonderful highlights on ribbon.

Paint the first float. Rotate your brush and paint the second float close to the first one, so that the paint from each float touches. As you look at the floats, the paint will be in the middle, the water will be on the outside edges.

In Figure 6-7 below, the broken lines indicate the floats. The arrows indicate the direction in which the water is facing for the two floats.

= = = = = = = ↕ = = = = = =

Figure 6-7. Back-to-Back Floats

Tornado This is a set of floats. Each is made with the water facing in the same direction, and "walking the color" out. They are very effective in creating dimension in flower petals, or folds in clothing. Start with the longest line. Place the next float slightly above and a little shorter than the first one. Continue this sequence until the floats form a triangular or "tornado" shape.

The broken lines in Figure 6-8 indicate where the paint is in each separate float. The arrow indicates the water direction of each float.

Figure 6-8. Tornado Float

Double Sideload This is a float that has two colors loaded on one side of the brush. Prepare a float using the same color as the area to be floated. Work it out on your palette. Then run the same side of the brush you just prepared into a lighter or darker color (depending on whether you're shading or highlighting).

This technique is an excellent way to create soft looking floats. It's important to gradually move up (or down) in value when shading or highlighting. The double sideload is one technique to use that makes it easier to create the gradual value changes desired.

Pat-blended Floats As mentioned earlier in this section, these are small, choppy applications of floated color. Begin the floats where you want the most intense shading or highlighting. Pat them in and gradually "walk the color" away from this area *without* reloading your brush. When you don't reload, the color application automatically diminishes in strength. By the time you've finished walking out the color, only the original basecoat will

remain. Although the strokes are choppy, the end result is not. There will be no sharp color changes, merely a gradual fading of color.

"Pat-blended" floats, when combined with layering, glazing, and tinting techniques, enable you to emulate the wonderful look of oil paintings while using acrylics. The proper placement of shading and highlights is another subject entirely, and is briefly described in this chapter under "Contrast," and also "Layering."

Problems

There are three problems I can almost guarantee you will encounter when you first try a float. (To be honest, even experienced painters occasionally encounter the same problems, especially if they're painting in a hurry.) You will either have too much water on your brush, too little water, or you will get too harsh a line of paint. These are common and expected problems we have all encountered. Only practice will eliminate them.

Too Much Water If there's too much water, you will have a watery mess on your surface. Remove the float, clean your brush, blot it more this time, and start over again.

Too Little Water If there's too little water, the paint won't blend from dark to clear. Just add a little more water to the brush bristles on the side without paint, and re-blend on your palette.

Paint Creates a Line You didn't load your brush properly and/or didn't work the paint across the bristles by stroking enough times on your palette. Wipe off the float, clean your brush, and start over.

Flyspecking See "Flecking."

Full Load

This refers to fully loading your brush with paint. The consistency of the paint will vary depending on the type of stroke you will be doing. See Chapter 5 for more details.

Gold Leafing

This method uses the traditional gold leafing sheets. For a newer method of gold leafing, see the "Gold Leafing With Renaissance Foil" category later in this chapter.

Gold leafing adds an elegant appearance to your painted creations. Imitation gold leaf sheets are very fragile, have no right or wrong side, and are packaged with paper separators. Handle them by the paper separator or use waxed paper.

Supplies Imitation Gold Leaf Sheets, Old World Art Gold

Leaf Adhesive Size, plastic disposable craft gloves, waxed paper, sponge brush, brush-on water-based varnish, Red Iron Oxide acrylic paint, soft rag. If you plan to antique you will also need Norwegian Painting Medium and Burnt Umber Oil Paint.

1. Basecoat the surface to be gold leafed in Delta® Ceramcoat® Red Iron Oxide (or an equivalent color). Make sure the coat is applied smoothly. Allow 1 hour or more to dry.
Note: Although Red Iron Oxide is the traditional color for basecoating, other colors can be used.
2. Because gold leaf can become tarnished from residue from lotion soaps, hand creams, etc., wash your hands with *plain* soap (such as Ivory®) before proceeding.
3. Use a sponge brush and apply a light coat of Old World Art Gold Leaf Adhesive Size. Avoid creating puddles as these will show through the gold leafing. If you are working on large objects, work small areas at a time. The adhesive is a milky color when it's first applied. When it becomes totally clear, proceed to the next step.
4. Carefully take out a gold leaf sheet. Put a piece of wax paper on top of it, then put your hand on top of the waxed paper. The warmth of your hand should cause the gold leaf to cling to the wax paper.
5. Apply gold leaf to the sticky surface, patting it into place. When the area is well covered, remove the wax paper. Make sure there are no gaps. You want gold on the entire area.
6. Repeat step 5 until all areas to which you applied the adhesive are covered.
7. Allow to dry for at least 6 hours, more if the weather is humid.
8. Use a clean, soft rag and rub the gold leaf, always going in the same direction. Don't use paper towels because they tend to stick to the surface. All excess flakes of gold leaf should now be removed. There should be some fine cracks or spots that have the basecoat showing through to give it an "old world" appearance.
9. Skip this step if you want to antique your project. Instead, refer to "Antiquing Note" that follows. If you don't want an antiqued surface, finish your project by applying several coats of brush-on water-based varnish.

To Antique Gold Leafing

1. Seal the surface with a light coat of water-based varnish. Allow it to dry thoroughly.
2. Prepare antiquing mixture by mixing the following with a craft stick:

 ◆ 2 tbsp. Norwegian Painting Medium
 ◆ 1 tiny dab of Burnt Umber Oil Paint (about 1/2" to 3/4" length as it comes out of the

tube).

Add more Norwegian Painting Medium if you want a lighter color; add more oil paint if you want a darker color. It's easier to start light and get darker.

3. Brush the antiquing mixture on the gold leafed area with a sponge brush and then immediately, wipe it off using a clean soft cloth. Rub gently until the surface is the color you want. This step can be repeated until you have just the effect you want to create.

4. Allow the surface to dry at least 24 hours, then varnish with several coats of brush-on water-based varnish, allowing each coat to dry before applying the next.

Gold Leafing with Renaissance Foil

This is a newer, less messy gold leafing technique using Delta® Renaissance Foil. The foil is attached to a thin layer of Mylar so it doesn't float around as regular gold leafing sheets do. The Renaissance Foil line includes Sealer, Base Coat, Adhesive, and Antiquing.

Choices (1) For regular antique gold, use Gold Foil, Italian Red Base Coat, and Baroque Brown Antique. (2) For Verdigris copper, use Copper Foil, Aegean Green Base Coat, and Patina Green Antique. (3) For burnished Silver, use Silver Foil, Pewter Gray Base Coat, and Silver Tarnish Antique.

Supplies Renaissance Foil, Sealer, Adhesive, Base Coat color of your choice, Antique color of your choice (optional), soft lint-free cloth.

1. Seal the surface with Renaissance Foil Sealer. Allow to dry completely.

2. Basecoat the area to be gold leafed. You may use either the Base Coat formulas that were intended to be used with the Foil, or regular acrylics.

3. When the base coat is dry, apply two coats of the adhesive. The adhesive is cloudy when first applied but dries clear. Apply the first coat. As soon as the first coat looks clear, apply the second coat of adhesive.

If you want gold dots, or comma strokes, apply the adhesive in dot shapes or comma strokes and then proceed to Step 4.

4. When the second coat of adhesive is clear, apply the foil *shiny side up*. Press it against the surface that's been coated with adhesive. Use an eraser tip or similar object to press it into the little nooks and crannies.

5. For heavier coverage, repeat steps 3 and 4.

6. When gold leafing is completed, seal with Renaissance Foil Sealer, then antique if desired.

7. Varnish with your choice of products.

Highlight

This is an area of your design that appears to be receiving the most light. Highlights can be added by floating or dry brushing with a color lighter than the basecoat. (Refer to Chapter 7, "Color Choices", for suggested highlight and shading colors for a given basecoat color. Also see the "Floats/Floating," "Layering," and "Dry Brushing" techniques in this chapter.)

Ink and Scrub See "Pen and Ink."

Lace Backgrounds[7]

It's easy and fun to create beautiful lace backgrounds using paper doilies. Although you can also use fabric lace, this technique gives the details for using paper doilies. Whenever I see a pretty doily, I buy it and put it in my collection for future use.

Supplies Paper doily, Delta® Stencil Spray Adhesive, brush-on water-based varnish, stencil brush, and stylus.

1. Prepare the paper doily by punching out and discarding any clinging paper from the cut-out sections. A stylus works well for this. Be careful not to tear the doily when you do this.

2. To make the doily stronger, varnish one side with brush-on water-based varnish. Allow it to dry, then do the same to the other side.

3. For the purpose of these instructions, let's say you want to paint a blue box with a white doily on the lid. Base the box blue everywhere *except* the top. Since you want a white doily, the top must be painted white. Allow the paint to dry thoroughly.

4. Lightly spray the reverse side of the doily with Delta® Stencil Adhesive. Do this in a well ventilated area. For best results, hold the spray can at least 6-8 inches away from the surface. If you spray too heavily, you'll get globs of adhesive on your surface that will cause problems later. Allow the spray to dry at least 5 minutes.

5. Carefully position the treated doily (adhesive side down) on the surface where you want the doily design. Press it firmly into place. Check to make sure it is positioned to suit you.

6. Use a stencil brush and pick up the blue paint you used for basecoating the sides and bottom of the box. Tap the brush on your palette to remove most of the paint. If there's too much paint, there's the chance of it seeping under the doily. Carefully pounce the brush up and down in all the cut-out areas of your doily, being careful not to tear it.

Note: If you prefer, a sponge may be used instead of a stencil brush.

Once the cutouts are covered with paint, use a large

flat brush to paint blue from the edges of the doily out towards the top edges of the box. This will most likely take two coats of paint, so don't be tempted to peak underneath the doily just yet. At this point, the entire top of the box and the cutouts on the doily should be painted blue. Apply second coat of paint if necessary.

7. When you have adequate coverage, carefully remove the doily by pulling it straight up. Do this within 5 minutes to keep the doily from sticking to the paint. If you smudge something, you can touch it up. You will now have a blue box with a white doily design on top.

8. When the paint is dry, transfer the design you want to have on the doily, and do your decorative painting.

9. Seal your completed painting with the varnish of your choice.

Layering

As the name implies, this technique involves applying multiple layers of paint to your painting. These layers are used to add shading and highlighting, and when properly applied, they add realism, and dimension to your design. Layering also enables you to create a more textured appearance.

Layering can be as simple as adding a float of color on top of a basecoat. This is usually the first type of layering a beginner will learn. (See "Floats/Floating" in this chapter.) For the more experienced painter, the process is more involved, and extremely effective. For example, instead of one shading color, you might layer on three or more.

First Value Dark This is the first shading color. It is *slightly* darker than the basecoat and should cover the largest area. For example, if you were shading a petal, this would cover about two-thirds of it.[8] Use this to separate objects.

Second Value Dark This is slightly darker than the first shading color. It goes *inside* the first shading area and covers less space.

Third Value Dark This is the darkest shading color. It is placed inside the second value dark areas and should cover only the smallest areas such as triangular areas and other tiny "nooks and crannies."

Highlights are also built up gradually, with the first one covering the largest area. The second light value needs to be placed within the boundaries created by the first light, covering a smaller area. Each subsequent step up in value covers a smaller area. Here are instructions for one method of layering:

1. Basecoat the pattern. Some designs call for full coverage, others call for simply a "wash" of color. Whichever you use, try to get smooth, even coverage.

2. Once the basecoat has dried, work in small areas at a time, (for example one leaf or small flower). Here you have a few options, that are a matter of personal preference:

- ✦ Dampen the area with water or extender and allow enough time for it to penetrate, then apply shading or highlights. You will have more time to work with the paint when you use extender.
- ✦ Dip your brush first into extender, blot on a paper towel, then work the paint into the bristles for a float. Again, the extender will give you more time to work with the paint.
- ✦ Don't dampen the surface first. Simply make standard floats using water only, no extender. The paint will dry faster than it does for the first 2 methods, because no extender is used.

3. Use "pat-blended floats" to apply shading and highlighting. Be careful not to over blend. If the paint starts to grab, stop, wait for it to dry, then repeat.

4. Multiple layers may be added...the more you add, the more depth you create. However, it is important to let each layer dry before proceeding to the next.

These instructions are a brief and simplified description of a technique well worth learning, especially for those who want to create the feeling of realism formerly accomplished only with oil paints.

Line Trim

This is a very easy way to paint straight line trim on straight edges. Scotch® Magic™ Transparent Tape is used to mask the areas to be lined. The ideal time to apply line trim is after all other painting has been done and a coat of varnish has been applied. In this way, any line trim mistakes may be easily removed.

Areas to be masked must be *completely* dry. Apply the tape. Run your fingers along the edges to press them down firmly, making sure there are no raised edges. Paint the trim, and then carefully remove the tape. Do this immediately. Don't leave the tape on any longer than you have to, because there's a risk of pulling off the paint underneath.

If paint is applied too heavily, there will be a noticeable ridge after the tape is removed. Therefore, a light coat of paint is preferable.

TECHNIQUE

Marbleizing[9]

Marbleizing is a method for creating a marble-like appearance on a given surface. The following describes an easy way to create a beautiful, realistic "marble" surface. No special materials are needed. At the end of the basic instructions, colors are given for painting mauve marble.

Supplies McCloskey's® wood sealer (or your favorite), sponge brush (optional), paper towels, regular bottled acrylic paints.

1. Sand wood. Wipe with a tack cloth. Seal with McCloskey's Wood Sealer, and allow it to dry for 24 hours.
2. Sand with fine grade sandpaper and wipe with a tack cloth.
3. Basecoat the area to be marbleized with 2-3 coats of paint. You need good coverage. Allow it to dry between coats.
4. Place the surface to be marbleized in a horizontal position. It must lie flat when you do the next step.
5. Dampen a sponge brush or large flat brush with water and dampen the area to be marbleized. The surface should look shiny but not dripping. Make sure all areas are dampened evenly.
6. Dip a paper towel in water, then squeeze out most of the water. Whenever you use the towel for this step, it should always be: (1) slightly dampened with water, and (2) softly wadded up. Dip it into the first color and dab here and there over the dampened surface. Allow the basecoat color to show through. Remember that you will be doing this same step with other colors, so you want to save room for them to show through as well.

You may find that some areas appear too dark. If this is the case, simply take a dampened towel, squeeze it until it's almost dry, and dab over the dark spot until it suits you. If an area appears too light, simply apply more paint in the same way.

7. While the area is still wet, take a fine liner with slightly thinned paint and paint vein lines *using the same color as you used in step 6*. Think of a road map as you paint these. You wouldn't want to get on a road going nowhere, so the veins should be long lines that twist and turn going all the way from where they start to the edge of the area you're marbleizing. Make some smaller veins that radiate from the main veins as well. Adjust the pressure you apply to the brush so some areas will have wider lines than others. Refer to Figure 6-9.

Figure 6-9. Veining

8. Repeat steps 6 and 7 for each of the successive colors.
9. Once you have finished applying the different colors, take a close look at your work. If some areas appear too dark, you may dampen the area and apply one of the lighter colors on top.
10. When dry, varnish with 2-3 coats of J.W. Etc. Right Step™ Satin Varnish. If you have marbleized one part of your piece and plan to do other decorative painting on another area, be sure to varnish your marbleized area before proceeding. This will make it easy to wipe off any paint smears that might find their way onto your "marble."
11. For that extra touch, wax the completed piece with Goddard's Paste Wax. Make sure the varnish has dried *at least* 24 hours before doing this. Waiting longer is even better. Dip fine steel wool into the wax and rub the surface briskly. Allow it to set for a few seconds, then buff with a soft towel. Not only will this give a very rich looking glow to your piece, but it gives it added protection.

Use of Colors in Marbleizing

Normally, 3-4 colors are used in marbleizing. One of the colors may be the same as the basecoat. In the following example, the value of the color is shown in parentheses and numbered from #1 (the lightest color) to #4 (the darkest color).

For example, let's assume you want a mauve color of marble and are using DecoArt™ paints. You would first base the area to be marbleized in Dusty Rose (value #2). You would then dab on the color and paint vein lines in the following order:

Step	Color & Value
1	Mauve (value #3)
2	Rookwood Red (#4)
3	Dusty Rose (#2)
4	Buttermilk (#1)

TECHNIQUE

Remember that you marbleize and vein with the *same* color before going to the next one.

The order in which you apply the different colors will change depending on the color of marble you wish to create. One thing remains generally true: the second step is *usually* done with the darkest color, and the last step with the lightest color.

Marbleizing Walls[10]

The same method described above for marbleizing small pieces can be done on walls with just a few minor changes which are described below.

Supplies Latex paint, large sponge (about 4" X 10"), regular bottled acrylics, paper towels, J.W. Etc. Right-Step™ varnish (satin or gloss).

1. Base the wall to be marbleized with a standard latex paint. Allow to dry completely.
2. Work 3 foot areas at a time. Do *not* dampen the surface first as you do with smaller pieces. Dampen both a large sponge and a paper towel. Squeeze out excess water. Use the paper towel to dab on the first color, then feather the color out with the sponge. Don't pick up any extra water on the sponge. Because you are working on a vertical surface, you need to be careful to avoid drips.
3. Use a liner brush and make vein lines as described in step 7 of the previous "Marbleizing" category. When you start to marbleize the next section of the wall, connect the vein lines so they continue on. The veining looks more natural if it doesn't stop at the end of each section you're marbleizing.

Paint less vein lines on walls than you would on smaller surfaces because it is more pleasing to the eye. If some of the veining appears too heavy, gently blot out the area with the damp sponge. Wash the sponge out well between color changes.
4. Repeat steps 2 and 3 for each of the successive colors.

Note: If some of the marbleizing appears too dark, dab on some of the Latex paint you used as a basecoat in these areas.
5. When marbleizing is completely dry, varnish with 2-3 coats of J.W. Etc. Right-Step™ Satin or Gloss varnish.

Note: For information on available pattern packets that incorporate this method of marbleizing, (including one that gives color breakdowns for creating a variety of marble shades), send $1.50 to: "Designs From Charles Johnson," Box 4092 GSS, Springfield, MO 65808, telephone (417) 887-5524. Charles created this method and teaches it throughout the country.

Marbleizing with Plastic Wrap[11]

This is another way to create a faux finish that resembles marble. It's quick and easy to do, making it ideal for a beginner.

1. Basecoat the area to be marbleized in your choice of color. Apply as many coats as needed to cover.
2. Add a little water to a different color of paint. Brush a thin coat on top of the dried basecoat. Cover the wet paint with plastic wrap. Move the plastic wrap around a bit and create some wrinkles in it. Now, carefully move your hands across the plastic and force some of the paint up into the wrinkles.
3. Peel off the plastic wrap immediately. Paint must not have a chance to dry before it is removed.
4. Dry completely, then varnish as desired.

Paper Toweling[12]

This is a method used to create interesting backgrounds and is suitable for small objects.

1. The surface should be basecoated first and allowed to dry.
2. Apply a coat of thinned paint on top of the basecoat, and while still wet, put heavily textured paper towels on top of this, with the textured side down.
3. Lay a flat object, such as a book, on the paper towel just long enough to absorb the moisture. Carefully remove the paper towel. The result will be a textured surface in a two-color pattern.
4. Allow to dry completely, transfer the pattern, and do the decorative painting.

Pen and Ink

This is also referred to as "Ink and Scrub." This technique involves first inking the pattern on your surface, then applying paint later. Commonly, oil paints are used in this technique and are scrubbed in with a stipple brush. However, acrylic paints can also be used, and it is the acrylic method that I will describe.

The following instructions are for doing pen and ink on wood.

Supplies Fine grade sandpaper, tack cloth, Jo Sonja's® All-Purpose Sealer, black extra-fine point water-proof pen, Saral® transfer paper, water-based varnish.

1. Sand the wood, wipe with tack cloth, then seal.
2. Sand again using a fine grade sandpaper. Tack.
3. Basecoat the surface in your choice of colors. Use as many coats as necessary for good coverage. Allow each coat to dry before applying the next. If needed, sand with #400-600 wet/dry sandpaper (use it dry) in between

coats.

4. Transfer all pattern lines using Saral®, or a similar transfer paper. Standard graphite paper might repel the ink.

5. Neatly ink all pattern lines using a black, water-proof, extra-fine point marker (or a Rapidograph® Pen filled with *water-proof* ink). This is very important. If the ink isn't water-proof, it will run when you apply the acrylic washes or the varnish.

Even if the pen says it's water-proof, test the ink on paper first, wait a minute or two, then dampen the inked paper with water. If the ink runs, don't use that pen.

6. When all pattern lines have been inked, allow the ink to dry thoroughly, then erase any remaining transfer lines.

7. Thin the paint with water. (A bubble palette works well here.) "Wash in" the areas within the pattern lines. Shading and highlighting are done with floats.

8. Varnish finished painting with several coats of brush-on water-based varnish.

Note: This procedure may also be done by applying the washes first, then inking the pattern lines when the paint has completely dried.

Pickling

This technique is used to give wood a pale, "washed" color with the wood grain showing through.

Delta® Ceramcoat® Pickling Method.

This can be done on raw (unsealed) wood or on a previously stained piece.

Supplies Delta® Ceramcoat® Water-Based Satin Varnish, Delta® Ceramcoat® Acrylic Paint (White or color of choice), wide brush, jar with lid, clean rag, fine grade sandpaper, tack cloth.

1. If you are using raw wood, sand it well until it's as smooth as possible. Then wipe it with a tack cloth.

2. Mix 2/3 cup Delta® Ceramcoat® Water-Based Satin Varnish with 1/3 cup Delta® Ceramcoat® White acrylic paint (or the color of your choice for a tint) in a container with a lid. Shake well.

For smaller pieces reduce the amounts, keeping the ratio of 2 parts varnish to 1 part acrylic paint.

3. Apply to the surface using a wide, flat brush, covering no more than a two to three foot area at a time. Wipe it off with a cloth, leaving some of the paint in the cracks or edges.

4. Allow the surface to dry at least an hour, then sand lightly. Step 3 may be repeated as many times as desired. Just be sure to wait the hour in between coats.

5. Transfer the pattern and do decorative painting.

6. Varnish finished surface with several coats of Delta® Ceramcoat® Water-Based Varnish.

Pickling with White Lightning™

This method is one of my favorites. Because it's easy to do and I found the results to be consistently good, I recommend it for beginners as well as experienced painters.

Supplies J.W. Etc. White Lightning™, sea sponge, acrylic paints in your choice of colors, sponge brush, J.W. Etc. Right Step™ varnish (satin or gloss).

1. Sand the wood, then tack.

2. Seal wood by applying one coat of White Lightning™ using a sponge or wide, flat brush. Allow it to dry. (I usually wait 30 minutes or so.)

3. For small objects, put about a tablespoon of White Lightning™ on your palette. Tint it by mixing in a drop or two of your favorite color of acrylic paint.

4. Dampen a sea sponge, then squeeze out all excess water. Dip the sponge into the mixture you created in step 3 and apply it to the wood using long, flowing strokes that go with the grain.

Work from edge to edge to avoid stop marks. If you want a deeper tint, add more paint; for a lighter one, add more White Lightning™.

I sometimes even dip the sponge in a tiny bit of straight paint. If you do this, just make sure there is still White Lightning™ in your sponge. If it looks too dark once it's on the surface, turn the sponge over and quickly wipe off the paint.

5. Sometimes it's nice to add a second color. I wait for the first application to dry (about 20 minutes or so) then repeat steps 3 and 4 using a contrasting color.

6. When the pickling has dried, you have an interesting basecoat for decorative painting or you can leave it as is.

7. Varnish with several coats of water-based varnish.

Resist Technique on Wood

Although the resist technique is usually considered to be a fabric painting technique, there is now a product that allows you to use the resist technique on wood. This technique uses products from Delta's® Home Decor/Ceramcoat line.

The Resist Technique on wood involves outlining a pattern with Delta® Stain Resist. When a transparent stain is applied over the Stain Resist, the stain color will not adhere to the resist lines. For best results, use a simple outline pattern when you first try this technique.

Supplies The following Delta® Home Decor/Ceramcoat® products: Stain Resist, Color Wipe (or a piece of lint-free

cloth), Gel Wood Stains (or Pickling Gels) in your choice of colors, and varnish of your choice.

1. Sand the wood, but *don't* seal it.

2. Transfer the pattern lightly. The Resist is transparent, so heavy transfer lines will show through. I find blue Chacopaper® works best because it dissolves when liquids are applied to it.

3. Remove the outer cap from the bottle and snip off the tip of the nozzle. The more of the nozzle you cut off, the thicker your lines will be.

4. Gently squeeze the bottle and apply the Resist to the transfer lines. Resist has a tendency to bubble. If you get a bubble in it, tap the tip of the applicator on the bubble to pop it. (I use a stylus to pop bubbles and to smooth the lines.) If this doesn't work, wait 5 minutes and then pop the bubbles.

If you accidentally get some Resist where you don't want it, wipe it off with a Q-tip® and water. Let the area dry before you add more resist to it.

5. Stain Resist looks cloudy as it comes out of the bottle, but it will dry clear. When Resist has been applied to the entire design, and it has dried clear, you are ready to stain your project.

Note: Drying time is 30 minutes to one hour, depending on the thickness of the lines and the humidity in your area.

6. The Home Decor/Ceramcoat® Gel Wood Stains are transparent and very little color is required to tint the wood.

Note: If you wish to create your own color of wood stain, mix Delta® Ceramcoat® acrylic paints with Neutral Gel in a 50/50 ratio. (See "Neutral Gel" category in this chapter for more uses for this product.)

7. Wipe the stain on using a Home Decor Color Wipe or a piece of lint-free cloth. Wipe with the grain. If you want a gradual blend of more than one color, wipe on the first color, then place the second one right next to the first. Gently blend the two colors together.

Gel Stains may also be applied with a brush. This works well when you want to keep the color in a given area.

8. Remove any excess gel stain that accumulates on the Resist lines. If the stain color has begun to dry on the Resist, it's easily wiped away. Moisten a piece of Color Wipe (or rag) with water and gently wipe it off the Resist lines.

9. Shading and dimension will be achieved automatically because the stain will accumulate on both sides of the Resist lines.

10. If you want to deepen a stain, or add more shading, allow the first layer of stain to dry, then add a second application of color.

11. When the Gel stain is completely dry, varnish it with several coats of Home Decor/Ceramcoat® Matte, Satin, or Gloss Varnish. Allow each coat to dry thor-

oughly between applications.

Scruffing

This is a "dry brush" technique (sometimes called "scuffing") that is used for applying shading and highlighting, or for creating a flowing, yet irregular look needed for things, such as beards, horse manes, etc. See "Dry Brushing" for more details. To simulate beards, etc., use longer, more flowing strokes than you would for creating highlights or shading.

Shading

Shading is most often done with the floating technique; however, dry brushing is also used. To shade an area, a darker color than the basecoat is applied. It provides depth to your painting, and, when combined properly with highlighting, brings your painting to life.

See the "Contrast," "Dry Brushing," "Layering," and "Floats/Floating" categories in this chapter for more details. Also refer to Chapter 7, Color Choices, for suggested shading and highlighting colors for a given basecoat color.

Sideloading See "Floats/Floating."

Spattering See "Flecking."

Sponging[13]

Though sponges are also used for stippling, this particular technique is used in creating an easy-to-do faux finish.

Supplies Natural sea sponge, acrylic paints.

1. Basecoat the surface if desired. This can be done on wood that has been sealed, but otherwise left natural. Allow the basecoat, if any, to dry completely.

2. Pour one or more colors of paint into separate piles on your palette. If you basecoated your surface first, use contrasting colors. It's up to you how many different colors to use. I suggest you start with two colors–one lighter and one darker than the basecoat.

3. Wet the sea sponge and squeeze it until all excess water has been removed.

4. Dip the sponge into the paint colors at random and gently dab onto your surface. The more sponging, the softer your surface will look.

Note: Sea sponges are found in many craft stores and sometimes in cosmetic departments. They are filled with irregular sized holes which makes them useful for doing the sponging technique. I suggest you use a piece no larger than 2 to 3 inches wide unless you're sponging large

areas. The smaller sponge seems to give you better control as you dab the paint on the surface.

Staining (Wood)

Staining is one method to use when you want wood grain showing on your completed project. Wood pieces that will be stained should be chosen with care.

Before you decide to stain the wood, take a close look at the surface. If there are any joints, glue was most likely used in these areas. When stain is applied, it will not absorb properly in these areas and there will be a noticeable line. Even after heavy sanding to remove the excess glue, the line will probably still show.

If there are nail holes and you fill them with wood filler, this can also cause problems. The stain may be a different color in these areas, or may not be absorbed at all.

If you have any of the above situations, you can:

1. Basecoat the wood instead.
2. Stain the wood anyway, placing the pattern so that the decorative painting covers the problem areas.
3. Antique the finished project so the areas are barely noticeable.

With these thoughts in mind, you can decide whether "to stain or not to stain." Here are two of my favorite methods of staining.

Staining with J.W. Etc. Acrylic Wood Stains

This is a quick and easy way to stain wood and achieve beautiful results. This water-based stain is available in 6 natural wood tones plus blue. Colors may be mixed to produce new colors or diluted with J.W. Etc.'s Right Step™ varnish to achieve lighter colors. Cleanup is easy with soap and water. The following method incorporates recommendations by the manufacturer of J.W. Etc. products.

Supplies J.W. Etc. White Lightning™ or Right-Step™ matte varnish, J.W. Etc. Acrylic Wood Stain, soft lint-free cloth, #400 wet/dry sandpaper (use it dry), piece of brown paper sack without print, sponge brush or soft, wide flat brush.

1. Sand the wood with #400 wet/dry sandpaper until smooth, then wipe with a tack cloth.
2. Seal the wood. If you use White Lightning™, shake the bottle well before using. I prefer to apply this with a sponge brush, although a wide, soft brush works well too. When you seal with White Lightning™, the color of the stain will appear lighter than it will if you use the varnish.

If you use the Right-Step™ varnish, roll the bottle on

a table top to mix it completely before applying it to your surface. I recommend applying this with a soft, wide, flat brush.

Whether you use White Lightning™ or varnish, cover all areas of the wood, even those you don't plan to decorate.

3. Sand with #400 wet/dry sandpaper, (use it dry), then wipe with a tack cloth.
4. Thoroughly mix the stain because there is often some settling. Wooden popsicle/craft sticks work well for stirring and can be discarded after use.
5. Use a soft brush and apply the stain to the wood piece. If you're staining a small piece, you can apply stain to the entire piece and have time to wipe it off before it dries.

However, if you're staining a large piece, work on smaller areas such as one side at a time. If a little stain spills over to an area you'll be doing later, quickly wipe it off.

6. If you like the way the stained wood looks at this stage, stop at this point and allow it to dry. However, if you applied the stain too heavily and have some drip marks here and there, take a lint-free cloth and wipe the excess stain off while it is still wet. I like to rub with the grain.

7. If your stained wood isn't dark enough to suit you, repeat steps 5 and 6 as soon as the area is dry to the touch.

8. Allow to dry for about 30 minutes. If the wood grain was raised noticeably during the staining process, sand *very lightly* with #400 wet/dry sandpaper. If, however, the wood still feels smooth, you need only to sand it lightly with a piece of plain, brown paper sack. Remember, the key words here are to *sand lightly*.

9. Wipe with a tack cloth. Your stained wood is now ready for your decorative painting.

Staining and Sealing—Jjo Sonja Method[14]

You are staining and sealing in one step with this method.

Supplies Jo Sonja's® All-Purpose Sealer, Artists' Colors, sandpaper (fine grade), tack cloth, Retarder (optional), and Jo Sonja's® Polyurethane Water-Based Varnish.

1. The wood doesn't have to be sealed first. Leave it in its raw form. Sand lightly to remove any rough spots. Tack.
2. Pour about 1-1/2 tablespoons All-Purpose Sealer onto your palette. To this, add about 1/2 teaspoon Artists' Colors. (Use any color you want. For a fruitwood stain, mix equal parts of Brown Earth and Raw Sienna.)

Note: These are only approximate proportions. For a darker stain, use more paint; for a lighter one, use less.

3. Mix the sealer and paint together with a palette knife.

4. Open time of the stain can be extended by adding Retarder to the above mixture. This is added if you are in a hot, dry area, and want to be able to work the stain for awhile. Add just a few drops at first. If you find the stain is drying too fast, add more Retarder.

5. Apply the stain mixture with a "slip-slap" motion. Every so often, smooth out the stain, going with the grain.

6. When the area is covered with stain, take a soft lint-free cloth and wipe off the stain, going with the grain of the wood.

7. Here is a hint from Jo Sonja and David Jansen. Some woods, such as pine, soak up more stain on the end grains and become very dark. To help control this, dip your brush in Retarder and paint the end grain area before applying the stain. This keeps a lot of the stain from soaking into the wood.

8. When the stain is dry to the touch, sand lightly, tack, then transfer your pattern and do your decorative painting.

9. Seal the finished, dry painting, with Jo Sonja's® Polyurethane Water-Based Varnish.

Stenciling with DecoArt™ Fashion Tape™

This is a lot of fun for beginners as well as more advanced painters. The tape has stencil cutouts in a variety of patterns. The removable adhesive on the tape adheres to fabric and most other surfaces. Here are basic instructions for using the tape on fabric and solid surfaces.

On Fabric

1. Lightly spray an appropriate size piece of plastic-covered cardboard with Stencil Adhesive. (This will keep the fabric from moving around when you paint it). Allow the cardboard to dry about 5 minutes before positioning your fabric on it. If you're painting a shirt, secure it on a cardboard shirt form. I recommend covering all areas of the piece that won't be painted with a piece of plastic trash bag to protect against accidental paint splatters.

2. Cut the tape to fit the area you'll be stenciling. Remove the backing from the cutouts on the tape first. Place these on a piece of waxed paper as they can be used for reversed stenciling. (You put the cutout, such as a heart, on the fabric and paint around it.)

Next, remove the remaining backing and place the tape (sticky side down), on the area to be stenciled.

3. Secure all edges of the stencil to the surface to be painted so paint won't bleed underneath the stencil cutouts. To do this, place a paper towel on top of the tape and rub the edges in place, using your hand or a brush handle.

4. Areas to be stenciled should lie flat when you apply the paint.

5. Paint can be applied by using fabric scrubber brushes or your regular soft-bristled synthetic brushes.

6. Always start painting on the tape and brush onto the surface to be painted. Never brush from the fabric onto the stencil tape because there's a chance that you will lift the tape and get some bleeding under the stencil edges.

7. If you're painting with DecoArt™ fabric paints, use of a wet-on-wet technique is recommended for applying the paints. Do one area of the stencil at a time. Basing, shading, and highlighting should be done while the paint is still wet. When the fabric paints dry together, they bond to the fabric. They will not bond if allowed to dry before additional applications.

8. When the stenciling is completed, you can either leave the tape on until the paint has dried or remove it immediately. However, remove the painted fabric from the cardboard backing as soon as possible to avoid the risk of sticking caused by the Stencil Adhesive Spray. *Don't leave Fashion Tape attached to any surface longer than 2 hours.)*

9. Have a piece of wax paper handy. Slowly peel off the tape, and place it, sticky side down, on the wax paper. This will prevent it from sticking to itself and will make it possible for you to use it again. You may reuse the tape immediately. If there is still some wet paint on it, blot it off with a paper towel while it's on the wax paper. When I want to save the tape for future use, I leave it on the wax paper and store it in an envelope.

On Solid Surfaces (Such as Wood)

1. Prepare the surface as required. For example, seal wood, sand, then tack. When dry, paint with 2 coats of acrylic paint. When dry, apply one coat of water-based varnish and allow that to dry completely (overnight). You're now ready to start stenciling.

2. Refer to steps 2-4 under "Fabric".

3 Apply paint using a soft-bristled synthetic brush. Always start painting on the tape and brush onto the surface to be painted. Never brush from the surface onto the stencil tape because there's a chance that you will lift the tape and get some bleeding under the stencil edges.

4. Paint with either a wet-on-wet technique or apply the base color to each stencil area, allow it to dry, then float in the shading and highlights.

5. When the stenciling is completed, you can either leave the tape on until the paint has dried, or remove it immediately. *(Don't leave the Fashion Tape attached to any surface longer than 2 hours).*

6. Refer to step 9 under "Fabric".

Note: For more information and design ideas for using Fashion Tape, look for these books at your local craft store: "Shimmering Fashions" by Sandy Aubuchon, and "Fabulous Fun With Fashion Tape" by Doxie Keller.

Stenciling with Stencil Magic® Paint Creme

Delta® Stencil Paint Creme is concentrated, permanent color that is suitable on virtually any surface. Though it is an oil-based product, it is non-toxic. While it may look like a solid cake of paint, it is creamy when applied to the stenciling surface. This paint is not suggested for garments or fabrics, such as children's clothing where harsh detergents or constant washing is needed.

The instructions that follow provide basic information on using the Stencil Paint Creme on fabric, walls, and wood.

Supplies Delta® Stencil Magic® Paint Creme, stencils, stencil brushes, Delta® Stencil Adhesive Spray, Stencil Magic® Brush Cleaner, Delta® Stencil Palette (optional), Delta® Home Decor/Ceramcoat® Wood Sealer (if you're painting on wood). For non-porous surfaces, such as enamel walls, Stencil Magic® Top Coat or spray varnish of your choice. See details in step 4 under "Painting on Walls" in this section.

General Instructions That Apply to All Surfaces

1. To prepare the stencil, place it face down on newspapers and spray it lightly with Delta® Stencil Adhesive Spray. Keep the spray away from furniture, carpet, etc. Allow the sprayed stencil to dry about 5 minutes before using. Spraying too heavily will cause excess adhesive to stick to the surface. Also, if the stencil is used while the adhesive is still wet, it will stick to the item being stenciled.

Place the stencil with the adhesive side down on your surface. Use Stencil Magic® Brush Cleaner, baby oil, or mineral spirits to remove any residue.

2. The Creme is "self-sealing," which means it forms a film over the top of the paint each time it is stored. Before applying color, remove the protective film by rubbing the top surface of the paint cake with a paper towel. The Creme will be the consistency of lipstick.

3. Apply paint to the stencil brush directly from the jar, and use a separate brush for each color family. To load the brush, either tap it on the surface of the Paint Creme, or turn the brush about 1/4 turn while touching the paint. Stencil Paint Creme colors are intermixable and a little of this paint goes a long way.

4. Use a circular motion when applying the Creme to the surface. Avoid using a stippling motion as this will make it look splotchy. Brush lightly for a blush of color or layer more on for solid coverage. Because it dries slower than water-based acrylic paints, blend and mix colors right on the stenciling surface.

5. When painting on dark surfaces, you need to apply an undercoat of white Creme before applying the desired color to obtain best coverage.

6. When you finish an area, check your painting to see that everything is complete, then carefully remove your stencil.

7. Clean brushes with Stencil Magic® Brush Cleaner. An alternate method is to clean them with baby oil. Pour baby oil on a paper towel, then rotate the brush on the towel to release most of the paint. Then wash the brush with dish washing soap and warm water. If the brush seems to open up like a mop when it is washed, wrap a rubber band around the bristles and allow it to air dry. Stubborn Paint Creme can be removed with mineral spirits.

8. To clean the stencil, pour baby oil on a paper towel and wipe the Paint Creme off. Stencils may also be cleaned with Stencil Magic® Brush Cleaner. Clean stencils before paint dries on them because paint will be more difficult to remove after it has dried.

9. Don't apply acrylic liquid glitter on top of the Stencil Paint Creme–it is not compatible because the Creme is oil based. The rule is, you may apply oil paint *on top* of acrylic paint, but *not* vice versa.

Painting on Fabric

1. Pre-wash the fabric before painting, using a mild detergent. (This means clothing or other items that will require laundering. If you're painting on a canvas tote, for example, it does *not* need to be pre-washed.) Don't use fabric softeners.

2. Follow steps listed under General Instructions.

3. Be aware that oil from the Creme "wicks" out on the fabric, especially if you load your brush too heavily. This doesn't show on darker surfaces, but it will show on lighter ones. To remedy this problem, use a little less paint on lighter surfaces.

4. Place your painted fabric where it won't be smeared and allow it to dry.

5. Remove fresh painting errors from fabric by pressing a piece of masking tape on the area. Peel it off. Do this several times and the paint should come off.

If the masking tape method didn't remove the error, apply a little oven cleaner, then launder it. (If you must do this, I suggest you test a small, inconspicuous area of the fabric with oven cleaner first.) Remember not to launder the painted fabric until it has cured 10-14 days.

6. Fabrics painted with Stencil Paint Creme may be worn after 24 hours (when it's dry-to-the-touch). Allow fabric to dry 10-14 days before washing. Wash in cool water using a mild soap (such as Ivory Snow®) that doesn't contain any powdered bleach. Do not use detergents.

Painting on Walls

1. Walls painted first with flat wall paint are the most ideal for stenciling. However, semi-gloss and high-gloss surfaces will also give good results.

TECHNIQUE

2. Follow steps listed under General Instructions.

3. It will take at least 3-5 days for the Stencil Paint Creme to dry, but allow 2 weeks for it to be completely cured. Heavier applications will take longer. Spray with Stencil Magic® Top Coat to speed drying time. Avoid spraying too heavily as Paint Creme will run.

4. To protect stenciling done on walls, you may elect to spray the stenciled area with a spray-on varnish. This will also shorten the drying time. Make sure you purchase one with the same sheen as your wall—i.e. for flat wall paint, use a matte varnish. Delta Stencil Magic® Top Coat (varnish) is available in a satin finish only. Therefore, if you're painting on flat or gloss walls, you should consider using another brand of spray-on varnish.

The sprayed surface will appear dry to the touch. However, avoid rubbing the area because the paint will still be wet underneath. After 2 weeks, spray with another coat of the same varnish.

Note: I don't recommend using acrylic brush-on water-based varnish because acrylics are *not* compatible with oil-based products when placed *on top of* them.

5. Somewhere down the road, there may be a time when you'd like to remove the stenciling from your walls. To do this, spray the design with Fantastic® and use a little liquid Comet® to scrub it off. If you have varnished on top of the stenciling, you'll have to scruff up the surface a bit before you use the Fantastic®, etc. You could also wash the walls with a strong solution of TSP®. Make sure you rinse the walls thoroughly before applying any more paint.

Painting on Wood

1. Sand well and tack. Apply Wood Sealer, and allow to dry. Sand and tack again.

2. Follow steps listed under General Instructions.

3. Remove painting errors from wood with a Q-tip® dampened with baby-oil or turp.

4. If possible, place your painted object where it won't be smeared, and allow it to dry.

5. Varnish with a product that is compatible with oil-based paints. (Brush-on water-based varnishes are not compatible with oils.)

Stippling

Stippling is a technique where either a scruffy brush, a sponge, or a stiff fabric brush is pounced up and down on a surface. It is used to paint shrubbery, fur, etc. There are several ways to do it, depending on what effect you want to create. Stippling gives a textured look where it is applied. There are many applications for this technique.

You decide what brush to use by the effect you want to create:

Stiff Round Fabric Brush This works well for stippling in flower centers. However, the effect is a little too precise for creating the appearance of fur or hair.

Old Flat Brush Save your old flat brushes. They will be perfect for stippling fur.

Sponge A natural sponge (found in make-up departments), or a piece of kitchen sponge will do the trick for this type of stippling. This method is used to create a soft, subtle look with no harsh lines.

How to Stipple

1. If you're using a brush, it should be dry. For sponges, soften them first by rinsing in water, then squeezing well to remove all excess moisture.

2. Dip the brush or sponge into fresh paint (no water). Pounce it up and down on your palette to remove excess paint. When there are no longer heavy globs of paint on your palette, apply it to your surface.

Example Let's say you are stippling fur on a teddy bear. The bear should already be basecoated and the paint totally dry. The stippling tool should carry very little paint on it. This way, when you pounce it up and down on the teddy bear, some of the basecoat will show through. This makes it look like fur.

Tack Cloth, Use Of[15]

A tack cloth is very effective in removing sanding residue. Tack cloths are treated with ingredients that attract dust. Some contain wax, others don't.

It is important to remember that wax is not compatible with paint; it keeps paint from adhering properly. Therefore, it's best to look for tack cloths that are wax-free. However, if you do use one that contains wax, or you're not sure what ingredients are in the one you have, following these instructions may help you avoid problems.

1. Make sure you completely unfold the cloth and use it in a "soft wadded" manner. Using the tack cloth folded (as it comes from the package), tends to transfer more of the wax where it is concentrated along the fold lines.

2. Wipe the surface *gently* with the tack cloth.

Tinting Plaster Castings

This technique is used to create the wonderful, soft, transparent look of the "Precious Moments" Figurines on bisque, plaster, and ceramic.

Supplies Soft Tints™ Matte Sealer & Glaze, Soft Tints™ in your choice of colors, lint-free rags, and Gloss Soft Tint™ Glaze (optional).

1. Seal with Matte Sealer and Glaze.

2. Apply the tints by using a soft-bristled brush. They do not need to be diluted because the paint is transparent.

3. Immediately wipe the tints off in the areas you wish to create highlights. No floating of color is necessary to create highlights and shading with this technique.

Alternate Method: You may thin the tints with water and apply washes of color to the surface first. For a more transparent glaze, use Soft Tint™ Clear instead of water. When dry, brush on undiluted Soft Tints™ and wipe them off as desired to create shaded undertones.

4. Allow to dry completely and finish with either 2 coats of Matte Glaze & Sealer or for the glass-like appearance of fired ceramics, apply 1 coat of Soft Tints™ Gloss Glaze.

Tipping

Tipping can be done with any brush. The brush is fully loaded with one color of paint, then, just the tip of the hairs is touched into a different color. Touch your brush on your palette to remove excess paint, then make your stroke. This stroke will look streaky and is very effective for flower petals and leaves.

Transparent Color See "Wash."

Undercoating

This technique is used when you are painting a light pattern onto a dark surface. If, for example, you want to paint a lemon on a dark background, you would first paint the lemon with white. Then, when that has dried, paint it yellow. As with basecoating, it is advisable to apply several light coats of the undercoat color, allowing each coat to dry. It helps to work from the middle out to avoid creating ridges of paint on the outer edges.

Varnishing

There are many types of varnishes available. They offer four possible finishes–matte (no shine), satin (a soft glow), semi-gloss (a light shine), and gloss (a bright shine). The satin finish is most commonly used for decorative painting.

Though spray varnishes are very popular, I prefer using a brush-on water-based varnish because: (1) it's convenient to use because cleanup is done with soap and water; (2) you don't have a problem with excessive fumes; (3) it doesn't yellow with age as oil-based products do, (4) it's better for the environment, and (5) it may be used indoors in all types of weather. (Because of the fumes, it's preferable to use sprays outside.) I suggest you try both types and decide for yourself.

To Varnish with Brush-on Water-based Varnish

1. Allow the paint to cure on the finished project at least overnight before varnishing, especially if there is a lot of texture to your painting (such as dots, etc.) If possible, wait several days to give the paint time to cure.

2. Before varnishing, remove all remaining transfer markings. Use a kneaded rubber eraser to remove graphite markings and water for Chacopaper®. Also, take a final look to see if you need to do any touch-up work.

3. Because instructions will vary with the varnish you choose, read the package instructions first.

4. Put some varnish on your palette. Though it is sometimes applied with a sponge brush, I recommend using a large, flat brush (3/4 to 1-inch) because I think you get smoother coverage.

Whichever brush you use, make sure it is completely dry. A damp brush will cause streaking with some brands. If the flat brush has been reshaped with soap, it needs to be rinsed out and allowed to dry before using for varnishing.

5. Apply varnish just as you would a basecoat, using light coats, and waiting for each coat to dry before applying the next. Apply the varnish with a flowing motion to get the smoothest surface possible. To minimize brush marks, avoid reworking areas.

6. Varnish in a well-lit area so that you can see if you are getting complete coverage and can correct any drips, smears, or remove hairs or dust particles that may have found their way into the freshly applied varnish. These problems should be corrected before the varnish has dried.

7. For beginners, varnishing will probably be a new procedure. Here are more specific directions to help you. Let's say you are varnishing a trivet.

 a. Varnish the side edges first, working towards the top. If you drip some on the top, quickly remove it. If it's allowed to dry, it will create a ridge.

 b. Keep the back free of varnish because once the top and sides are varnished, the trivet will sit with the back part down until it dries. If you should get some varnish where it doesn't belong, it's easily removed with a damp paper towel or a baby wipe, as long as it hasn't dried.

 c. When the top and sides have dried to the touch, apply another coat to the same areas. Apply as many coats as you want, but make sure each coat has dried before applying the next. I usually use between 3 and 5 light coats of varnish. If the item will get heavy use, more coats will offer better protection.

 d. Now varnish the back. Make sure you don't get any varnish on the sides and top. If you do, quickly remove it before it dries.

Since this example is a trivet, the back would not

need as many coats as the top and sides. However, there are no set rules. Decide for yourself how many coats to use, depending on what you are varnishing.

8. If you see any bubbles or hairs in the dried varnish that you didn't catch earlier, lightly sand with extra fine sandpaper before you apply the last coat of varnish. Use a gentle touch. All you want to remove is the unwanted particle and a little varnish, not the painting.

Note: I highly recommend using a Dry-It™ Board (described in Chapter 1). As soon as a coat of varnish has been applied, put the object on the board. The tiny points on the board don't damage newly varnished (or painted) surfaces.

To Varnish with Spray Varnishes

1. Read all instructions and warnings on the can first. If the weather is warm enough, spray outside when possible. Avoid breathing the fumes.
2. The can of varnish, the object to be varnished, and the room should be about the same temperature.
3. For best results, set your object on a piece of cardboard, which you can use as a turntable. The object being sprayed should be in a horizontal position or at a slight angle to minimize drips and should be at waist level. Set it on blocks (paint caps work fine), so no edges will touch the cardboard. This prevents paint buildup around the edges of your project. [16]
4. The spray tip should be held 12-14 inches from the surface to be varnished. Start and stop the spraying off the surface to avoid drips. Apply a fine mist of spray, moving the can from side to side, slightly overlapping successive strokes.
5. When the first coat is dry, more coats may be applied in the same manner.
6. For pieces that won't receive a lot of wear, three coats are usually adequate. However, for items that will be heavily used, more coats will provide better protection.
Note: When you apply the spray too heavily, it causes drips or puddles. Make sure you mist lightly for best results.

Walking Color

This refers to making several, shape-following strokes, (usually floats), that gradually move away from the original stroke.

1. Load a flat brush for a float. See "Floats/-Floating" for complete instructions for doing this technique.
2. Make one float, following the contour of the area to be floated. Water (or extender) will be on one side of the brush, paint on the other. Be consistent in the placement of water or paint. If you started "walking" the color

with the water facing away from the area to be shaded, continue doing so throughout the procedure.
3. Make another float right above the first one, following the shape of the original float.
4. Repeat step 3 and move still farther away from the original float, continuing this until you have the desired effect. There shouldn't be any harsh lines where the floats meet. They should just "melt" into each other, creating the impression of depth in your painting.

Note: A "tornado" is an example of a float made by "walking the color," however in this procedure each float is a little smaller than the previous one. See "Floats/Floating" for more information on tornadoes.

Wash

This is also referred to as "transparent color." Washes vary in intensity depending upon the ratio of paint to water. For a more transparent color, use more water. For a heavier color, add more paint.

1. Mix a little paint and water (or extender) on your palette. The mixture may appear too light for you, however, it will look darker on your painting surface.
2. Use the biggest flat brush you can to fit the area to be washed. This lessens the chance of getting streak marks. Fully load it with the thinned paint.
3. Paint in one direction. I usually start at the top and make vertical strokes downward. Avoid reworking areas you just washed. If you don't think it looks dark enough, wait for the first wash to dry, then redo it.
4. If you do get a streak, brushing in the opposite direction of the streak will often remove it. You need to do this before the streak has dried.

Note: Some artists lightly dampen the surface with water before applying the washes. If you choose to do this, remember the key words are *"dampen lightly."*

Watercolor with Acrylics[17]

Of all the classes I've taken, some of the most enjoyable were those in which the "Watercolor With Acrylics" technique was used. Acrylics are thinned with water and basecoating is applied with washes, shading is applied with floats, and highlights are created by leaving the watercolor paper showing through. In the following technique, the finished painting is outlined with thinned paint using either a Crow Quill Pen or a fine liner brush.

The following instructions are for painting a design (such as flowers), on a 9" X 12" piece of watercolor paper. If you will be painting a larger or smaller pattern, you may need to adjust the brush sizes. For specific information on watercolor paper, refer to Chapter 1.

Supplies 125-140 lb. cold-pressed watercolor paper, (such as Arches, or Grumbacher Society Watercolor Paper #7185-2), cardboard the same size as the paper (optional), Robert Simmons #5 Aquatip round brush (or equivalent), #10 or larger flat brush, Hunt's Crow Quill Pen or a fine liner (i.e. Bette Byrd #6/0 Scroller, or Robert Simmons S-51 Sable Blend 2/0), kneaded rubber eraser, bubble palette, distilled water (optional), small plastic squirt bottle (available in cosmetic departments) in which to keep clean water, Krylon® Matte Fixative Spray, regular acrylics.

1. Use a large flat brush and dampen the entire piece of paper with clean water. This dissolves and softens the sizing and also keeps the paint from grabbing. Allow the paper to dry completely.

I like to secure the paper to a piece of cardboard using masking tape. This makes it easier to manipulate as you're painting. This is an optional step.

2. Transfer the pattern very lightly using a soft, lead pencil. You should barely be able to see the transfer lines. One way to accomplish this is to tape your pattern on a sunny window, place the watercolor paper on top of the pattern, then trace it. Another way is to use a light box, or if you have a glass-top table, put a lamp under it and use it as a light table. Avoid using standard graphite paper because it will repel the paint.

3. **Highlights.** Before you begin your painting, decide where the highlights will be placed, because the white of the watercolor paper becomes the highlights. This takes some getting used to since most of us are accustomed to applying highlights later in the painting process.

When a highlight will be at the end of a petal for example, there is no need to be concerned that the petal will seem to disappear at the tip because everything will be outlined with thinned paint.

4. Put a dab of paint in one reservoir of the bubble palette. Gradually add water to the paint and mix it until it resembles tinted water. The small, plastic squirt bottle makes adding the water less messy.

Test your paint on a scrap of paper. If it's too dark, add more water; if it's too light, add more paint. When in doubt, it's better to be on the light side because you can always heavy up the color later. However, if it's too dark, that's another story.

5. When you're painting, always keep a clean paper towel handy to blot any errors you might make. If you move fast enough, they can be removed by dabbing them off with the towel. Also keep a clean, damp flat brush close by. This can be used to dampen areas before painting and also can be used to quickly wipe off painting mistakes.

6. **Initial Tinting (Or Basecoating).** Paint in sections–that is, an area that is enclosed by lines, such as one petal, one leaf, etc. To prevent paint from grabbing, and to get more even coverage, pre-moisten large areas with clean water, (distilled water works even better). Use your flat brush for this and apply the water within the pattern area so the paper is damp, but not dripping. Small areas do not need to be pre-moistened.

As you apply color in the pre-moistened areas, always work from a wet area into a dry one because this will help you avoid creating streak marks.

If you're painting flowers or leaves, pull the strokes in the same direction as the flower or leaves would grow (i.e. from the base outward). Work from one side of the area to the other, remembering to keep the highlight area free of paint. If you accidentally get paint where your highlight should be, you may be able to remove it by either blotting the area with a paper towel or brushing it off using a clean brush dipped in water.

Dip the round brush in the thinned paint. "Wick-out" your brush by dabbing it once on a paper towel before applying the paint to the surface. Basecoat all areas of your design using this method.

7. **Shading.** Shading is applied with floats of colors. Refer to "Floats/Floating" in this chapter. Use either a flat or angle brush. Make the shading light to start with. If the area was basecoated with thinned Gypsy Rose, for example, your first shading would be done with floats of the same color. If you wish to deepen the shading, gradually apply floats in slightly darker values until you have achieved the desired effect.

8. **Highlights (revisited).** Hopefully, you have left watercolor paper showing through so your highlights are already taken care of. However, if this isn't the case, in small areas, additional highlights can be reapplied by floating with white or an off white with a little yellow added to it.

Another way to give more contrast is to deepen your shading to make it appear as if the highlights were stronger.

9. **Liner Work.** Line all pattern areas using the lightest color possible for a given area. Avoid too much contrast, because the paler the liner work, the softer the finished painting will look.

Liner work is done using thinned paint and either a Crow Quill Pen or a fine liner brush. For instructions on how to use the pen, refer to "Crow Quill Pen, Use of," in this chapter.

10. **Cleanup.** Allow your painting to dry completely, then erase all pencil lines with a kneaded rubber eraser. Mistakes can be gently scraped off with the flat edge of an X-Acto knife or you can lightly float over them with white paint to cover up the spot.

11. You may choose to spray your painting lightly with Krylon® Matte Fixative Spray for a little added protection. Frame as desired.

For a list of pattern packets that use this technique,

send a stamped, self-addressed envelope to Carolyn Phillips, 5416 Temple City Blvd., Temple City, CA 91780. Indicate that you are interested in using the "watercolor with acrylics" technique because Carolyn has a variety of packets available.

Summary

You have now become acquainted with a number of decorative painting techniques. Before you go any farther, try to find time to practice some of them–especially floating. This technique can make a world of difference in how your finished project looks.

TECHNIQUE

COLOR CHOICES

Making color choices is an important factor in helping you create special pieces that harmonize with your decor and reflect your tastes. This is true whether your decorative painting skills are at a beginning, intermediate, or advanced level. Each one of us has our own favorite colors. Sometimes the patterns we like will be designed using our favorites—sometimes not. This is when making color choices comes into play.

There are Color Choice Guides included in this chapter for five brands of bottled acrylics—Accent®, DecoArt™, Delta®, FolkArt®, and Wally R.™. Each guide is divided into nine different color categories. I suggest a number of possible basecoat colors in each category, along with what I feel would be a good shading and highlighting color for each. Some brands have fewer colors than the others. In these cases, there will be fewer listings in each color category.

This chapter is *not* about color theory. Rather it is intended to help you if you want to change colors in a design. I've written it especially for beginners, in the hope that it will take some of the mystery out of substituting colors.

The brands listed above have anywhere from 128 to 233 different colors. It was not my intent to list shading and highlighting colors for every one of them. Instead, this chapter is intended to help you get started making some basic color choices. For your convenience, I've included a form at the end of this chapter. Feel free to photocopy it and use it to jot down your own color combinations. Hopefully, you will add many of your own combinations to the Guides included.

Basic Information

The following pointers are intended to help you in both using the Color Choice Guides and in creating your own color combinations.

✦ There are times when the best highlight is as easy as simply adding white to your basecoat color. (This is also quite economical!) Be careful, however, because if you add too much white, your highlight might look chalky. If this happens, wait for the first highlight to dry, then apply a *light* wash of the basecoat color on top of the highlight. This should help remove the chalky appearance.

When I've indicated to mix the basecoat color with white, start by mixing approximately *2 parts of the basecoat color with 1 part of white.* Keep in mind that acrylics dry darker than they appear when they are wet.

Wait until your highlight has dried before you decide whether or not to lighten (or darken) it. There is no problem in floating on top of another float as long as you wait for the first one to dry.

✦ The shading color you use can change the effect created by your basecoat. To see what I mean, paint a 2" x 2" strip with Delta's® Salem Blue on a piece of paper or a manila folder. When it's dry, shade one side with Colonial Blue and the opposite side with Manganese Blue. Notice how the side shaded with Colonial Blue looks much greener than the one shaded with Manganese Blue. Try the same thing using Delta's® Pumpkin. Shade one side with Red Iron Oxide and the other with Bright Red. Red Iron Oxide tends to tone down the Pumpkin color while Bright Red makes it appear much brighter. The color you choose should be influenced by the effect you are trying to create.

✦ Occasionally, I suggest using another brand of paint for a highlight or shading color because I didn't feel there was an appropriate color in the brand being covered.

✦ Here's a hint to help you when you have trouble deciding if your shading or highlighting is strong enough. Wait for the paint to dry *completely*, then slightly dampen the surface by gently brushing on a small amount of clean water. The dampened surface will give you an idea of what it will look like when it's varnished. Gently remove the excess water by quickly blotting it off with a paper towel.[1]

✦ Highlighting on reds can be especially tricky. Unfortunately, adding white to the basecoat doesn't generally make a good highlight with reds. When you add white to most reds, you get pink. Maybe you'll like the effect, or perhaps you'd prefer a different color. For this reason, I have generally recommended orange or coral tones for the highlights on reds in the Color Choice Guides. With reds especially, there will be times when the first application of the highlight won't look strong enough. If this happens, just wait for the first highlight to dry, then reapply it.[2]

♦ Generally, beginners start off using only one highlight and one shading color. Learning about second and third value darks (shading) and lights (highlights) comes later (usually at the intermediate painting level). Therefore, with a few exceptions, the Color Choice Guides in this chapter offer suggestions for only one highlight and one shading color for a given basecoat color. This will give the less experienced student a starting place without the need to have an in-depth discussion on the proper use of color.

How to Use this Chapter

To keep this as simple as possible, I chose not to limit the color categories by adhering exactly to those color families found on a color wheel. Frankly, it can be confusing, especially to those of you who haven't taken color theory classes. For example, where would you place "mauve" on the color wheel? Do you know its color family? To use this chapter, you don't need to know the answers to these questions. Simply look in this chapter under the category "Pinks/Mauves/Purples".

Let's say you want to paint a design from a pattern packet or book—a little girl in her best party dress, carrying a basket filled with flowers. The pattern instructions indicate the dress is yellow, and the flowers in the basket are yellows and oranges. The designer has given you the basecoat, shading, and highlighting colors to use. You, however, want the girl to have a blue dress with a basket filled with pink flowers. Here's what to do:

1. Choose the brand of paint you want to use and turn to the Color Choice Guide for that brand.
2. Choose the appropriate Color Category for your needs. The nine different ones are listed in alphabetical order. They were chosen with one thing in mind—to make things simpler for you. They are:

Black/Gray	Pink/Mauve/Purple
Blue/Turquoise/Aqua	Red/Burgundy
Brown/Beige/Tan	White/Neutral
Green	Yellow/Gold
Orange/Flesh/Peach	

3. Select the colors you want to use and have fun.

Keep in mind that there are *many* different possibilities when choosing shading and highlighting colors. Those listed in the Color Choice Guides suit my tastes and are commonly used, but you may find other combinations you prefer.

Use these Guides as a starting point only. I encourage you to experiment and see what looks good to you. Learning about color is a wonderful adventure, and soon you'll find your own favorite color combinations.

How Was this Information Compiled?

I looked through all my decorative painting books, magazines, class notes, and pattern packets. When I found color combinations I felt would be appropriate for this chapter, I jotted them down. Next, I looked at all the color swatch cards I made up for creating the color conversion charts. I sorted them by color category and came up with my own favorites. I painted samples of each combination and reviewed each one with my friend who is an experienced teacher and designer.

Remember, we all perceive colors differently, and as I mentioned earlier, there are a number of different color combinations that you could use that would be just as effective as those I'm including in this chapter.

Tips on Using Color in a Design

The following tips are for those of you who want to delve a little bit deeper into the use of color in a design. If you'd rather not get too involved in this subject right now, wait to read this in the future.

We'll still use the little girl with the basket of flowers as our example.

Read the designer's instructions carefully and find out in what additional areas of the design the yellows and oranges (the colors of the dress and flowers) are located. You might find some cases where the colors are mixed with another color (probably to lessen their intensity).

Since you're changing to pinks and blues, you need to consider if these same areas would be appropriate for a touch of pink or blue.

Why is this necessary? Using a touch of all the colors found in your focal point area, (even if they are less intense or muted), tends to pull things together in the design. You don't need to use large amounts of these colors—a tint on a leaf or ribbon may be all you need to help tie things together.

In this particular design, we'll assume the little girl with the basket is the focal point. The brightest, most intense colors should be used in this area. This is where you want people to look first. Less intense, or muted values of the focal point colors should be used in areas outside the focal point. The farther away you progress from this area, the less intense and more muted the colors should be.

Do You Know How to Make a Color less Intense?

Earlier, I mentioned that colors need to be less intense as you move away from the focal point. If you want to learn how to do this in the most effective way, find time to study some color theory; it will be very helpful. I highly recommend the book *"The ABC's of Color—Keeping It Simple"* by Barb Watson. I've read this book and was also fortunate to have taken one of Barb's color theory

seminars. She has the ability to make color theory easy to understand.

Although I'm not going to go into the specifics, here are some of the ways to make a color less intense: Add black, gray, or an earth color. Add the complementary color at the same value. The above mentioned book covers this in detail.[3]

Summary

Don't be afraid to experiment as you paint. Change colors to suit your tastes and try adding some of your own extra touches to the designs you're painting. Though all your attempts might not be successful, some of them will, and just making the effort to spread your wings and try new things will help you grow as a decorative painter.

Color Choice Guides

ACCENT®

See "Basic Instructions" found at the beginning of this chapter.

Brand & Color Category	Basecoat	Shade	Highlight
Accent®: BLACK/GRAY	April Showers	Stoneware Blue	Real White
	Real Black	None	Soft Gray or Nevada Turquoise*
	Soft Black	None	Soft Gray or Nevada Turquoise*
	Soft Gray	Soft Black	Real White

Black is often highlighted with gray when you want to achieve a neutral effect. However, Nevada Turquoise is also very pretty. You might consider using this if it will coordinate with the other colors in your design.

Brand & Color Cateogory	Basecoat	Shade	Highlight
Accent®: BLUE/AQUA/ TURQUOISE	Clear Blue	Ultra Blue Deep	Clear Blue + Real White
	Indian Sky	Monet Blue	Real White
	Larkspur Blue	Windsor Blue	Larkspur + Real white
	Marina Blue	Nevada Turquoise	Marina Blue + Real White
	Monet Blue	Ultra Blue Deep	Monet Blue + Real White
	Nevada Turquoise	Chesapeake Blue	Marina Blue
	Sapphire	Windsor Blue	Sapphire + Real White
	Soldier Blue	Liberty Blue	Stoneware Blue
	Stoneware Blue	Soldier Blue	Lt. Stoneware Blue

Brand & Color Category	Basecoat	Shade	Highlight
Accent®: BROWN/BEIGE/ TAN	Burnt Umber 2437*	Raw Umber	Tumbleweed
	Light Tumbleweed	Golden Oxide	Blonde
	Raw Sienna	Burnt Umber 2613*	Tumbleweed
	Raw Umber	Real Black	Sweet Chocolate
	Sweet Chocolate	Raw Umber	Tumbleweed
	Tumbleweed	Raw Sienna	Golden Harvest

Accent® has two Burnt Umbers (and two Burnt Siennas) in their line. For this reason, I've included the product numbers so you'll know which one I'm referring to.

CHOICES

Brand & Color Category	Basecoat	Shade	Highlight
Accent®:	Forest Green	Black Green	Lt. Yellow Green
	Green Olive	Pine Needle Green	Green Olive + Real White
	Holiday Green	Deep Forest Green	New Leaf
GREEN	Lt. Yellow Green	Forest Green	Lt. Yellow Green + Real White
	New Leaf	True Green	New Leaf + Real White
	Pine Needle Green	Black Green (Delta)	Lt. Yellow Green
	Prairie Green	Black Green	Village Green
	Seafoam Green	Avon on the Green	Lt. Seafoam Green

Brand & Color Cateogory	Basecoat	Shade	Highlight
Accent®:	Apricot Stone	Dark Flesh	Light Flesh
	Coral Blush	Cottage Rose	Light Flesh
	English Marmalade	Pennsylvania Clay	Peaches 'n Cream
ORANGE/FLESH/	Light Flesh	Medium Flesh	Real White
PEACH	Medium Flesh	Dark Flesh	Lt. Flesh
	Peaches 'n Cream	Dark Flesh	Lt. Peaches 'n Cream
	True Orange	Vermilion	Sunkiss Yellow
	Vermilion	Pure Red	Sunkiss Yellow

Brand & Color Category	Basecoat	Shade	Highlight
Accent®:	Dioxazine Purple	Real Black	Wild Heather
	Fuchsia	Burgundy Deep	Painted Desert
	Painted Desert	Rose Blush	Real White
PINK/MAUVE/	Purple Canyon	Eggplant	Wild Hyacinth
PURPLE	Roseberry	Rose Garden (FolkArt)	Rose Cloud (Delta)
	True Purple	Real Black	Purple Canyon
	Victorian Mauve	Mauve (DecoArt)	Victorian Mauve + Real White

Brand & Color Category	Basecoat	Shade	Highlight
Accent®:	Apache Red	Burgundy	Painted Desert
	Burgundy	Fingerberry Red	Apache Red
	Holiday Red	Fingerberry Red	Apache Red
RED/	Jo Sonja Red	Barn Red	English Marmalade
BURGUNDY	Napthol Red Lt.	Barn Red	English Marmalade
	Pueblo Red	Fingerberry Red	Coral Blush
	Pure Red	Barn Red	Vermilion

Brand & Color Category	Basecoat	Shade	Highlight
Accent®:	Adobe Wash	Warm Neutral	Real White
	Antique White	Tumbleweed	Adobe Wash
WHITE/NEUTRAL	Real White	April Showers*	None
	Warm Neutral	Butter Pecan (FolkArt)	Adobe Wash

White may be effectively shaded with a variety of colors. Try one that coordinates with the other colors in your design. For example, for blues try Lt. Stoneware Blue, for greens, Lt. Village Green, etc.

Brand & Color Category	Basecoat	Shade	Highlight
Accent®:	Cactus Flower	Pure Yellow	Real White
	Dijon Gold	Golden Oxide	Sunsational Yellow
	Golden Harvest	Golden Oxide	Sunsational Yellow
YELLOW/ GOLD	Sunkiss Yellow	Tumbleweed	Lt. Cactus Flower
	Sunsational Yellow	Dijon Gold	Lt. Cactus Flower
	Yellow Light	Golden Harvest	Adobe Wash
	Yellow Ochre	Tumbleweed	Golden Harvest

DECOART™

See "Basic Instructions" found at the beginning of this chapter.

Brand & Color Category	Basecoat	Shade	Highlight
DecoArt™:	Charcoal Gray	Ebony (Lamp) Black	Charcoal Gray + Snow White
	Ebony (Lamp) Black	None	Charcoal Gray or Desert Turquoise *
BLACK/GRAY	Gray Sky	Slate Gray	White Wash
	Neutral Gray Toning	Ebony (Lamp) Black	Dove Gray
	Slate Gray	Slate Gray + Ebony (Lamp) Black	Gray Sky

Black is often highlighted with gray when you want to achieve a neutral effect. However, Desert Turquoise is also very effective. You might consider using this if it will coordinate with the other colors in your design.

Brand & Color Category	Basecoat	Shade	Highlight
DecoArt™:	Baby Blue	Wedgewood Blue	White Wash
	Blue Haze	Blue Haze + Ebony Black	Ice Blue
	Blueberry	Midnite Blue	Salem Blue
	Country Blue	Blue Violet	White Wash
BLUE/AQUA/ TURQUOISE	French Gray/Blue	Uniform Blue	French Gray/Blue + Snow White
	Indian Turquoise	Blue Green	White Wash
	Sapphire	Ultra Blue Deep	Baby Blue
	Uniform Blue	Prussian Blue	French Gray/Blue
	Wedgewood Blue	Prussian Blue	Wedgewood Blue + Snow White
	Williamsburg Blue	Uniform Blue	Williamsburg Blue + Snow White

CHOICES

Brand & Color Category	Basecoat	Shade	Highlight
DecoArt™:	Dark Chocolate	Ebony (Lamp) Black	Sable Brown
	Mink Tan	Lt. Cinnamon	Toffee
BROWN/BEIGE/ TAN	Mississippi Mud	Dark Chocolate	Toffee
	Sable Brown	Dark Chocolate	Cashmere Beige
	Sand	Sable Brown	White Wash
	Toffee	Mink Tan	Sand

Brand & Color Category	Basecoat	Shade	Highlight
DecoArt™:	Avocado	Midnite Green	Olive Green
	Bluegrass Green	Viridian Green	Sea Aqua
	Colonial Green	Teal Green	White Wash
	Deep Teal	Black Forest Green	Desert Turquoise
	Hauser Medium Green	Hauser Dark Green	Hauser Lt. Green
GREEN	Holly Green	Black Forest Green	Bright Green
	Jade Green	Light Avocado	Jade Green + Snow White
	Light Avocado	Plantation Pine	Olive Green
	Olive Green	Avocado	Yellow Green
	Sea Aqua	Bluegrass Green	Sea Aqua + Snow White
	Teal Green	Teal Green + Ebony (Lamp) Black	Colonial Green

Brand & Color Category	Basecoat	Shade	Highlight
DecoArt™:	Base Flesh	Shading Flesh	Flesh (Hi-Lite)
	Blush Flesh	Country Red	Peaches & Cream
	Cadmium Orange	Georgia Clay	Tangerine
ORANGE/FLESH/ PEACH	Coral Rose	Country Red	Coral Rose + Snow White
	Flesh (Hi-Lite)	Shading Flesh	Snow White
	Medium Flesh	Shading Flesh	Medium Flesh + Snow White
	Peaches & Cream	Blush Flesh	Buttermilk
	Pumpkin	Red Iron Oxide	Yellow Light

Brand & Color Category	Basecoat	Shade	Highlight
DecoArt™:	Baby Pink	Brandy Wine	Snow White
	Boysenberry	Deep Burgundy	Boysenberry + Snow White
	Dusty Rose	Brandy Wine	White Wash
PINK/MAUVE/ PURPLE	Gooseberry Pink	Rookwood Red	Gooseberry + Snow White
	Lavender	Dioxazine Purple	Lavender + Snow White
	Mauve	Cranberry Wine	Mauve + Snow White
	Raspberry	Burgundy Wine	Raspberry + Snow White
	Spice Pink	Boysenberry	Flesh (Hi-Lite)

CHOICES

Brand & Color Category	Basecoat	Shade	Highlight
DecoArt™:	Brandy Wine	Russet	Brandy Wine + Snow White
	Burgundy Wine	Cranberry Wine	Spice Pink
	Cadmium Red	Rookwood Red	Tangerine
RED/	Calico Red	Rookwood Red	Coral Rose
BURGUNDY	Country Red	Rookwood Red	Coral Rose
	Red Iron Oxide	Russet	Shading Flesh
	Russet	Ebony (Lamp) Black	Shading Flesh
	True Red	Rookwood Red	Pumpkin

Brand & Color Category	Basecoat	Shade	Highlight
DecoArt™:	Antique White	Sable Brown	Buttermilk
	Buttermilk	Antique White	Snow White
WHITE/NEUTRAL	Desert Sand	Sable Brown	Snow White
	Sand	Mink Tan	Snow White
	Snow (Titanium) White	Gray Sky*	None

Snow White may be effectively shaded with a variety of colors. Try one that coordinates with the other colors in your design.. For example, for pinkstry "Baby Pink," for blues, "Baby Blue," etc.

Brand & Color Category	Basecoat	Shade	Highlight
DecoArt™:	Antique Gold	Terra Cotta	Yellow Ochre
	Cadmium Yellow	True Ochre	Snow White
	Lemon Yellow	True Ochre	Snow White
YELLOW/	Moon Yellow	True Ochre	Taffy Cream
GOLD	Pineapple	Cadmium Yellow	Snow White
	Taffy Cream	Cadmium Yellow	Snow White
	True Ochre	Terra Cotta	Taffy Cream
	Yellow Ochre	Antique Gold	White Wash

NOTE: The full name for "Snow White" is "Snow (Titanium) White".

DELTA®

See "Basic Instructions" found at the beginning of this chapter.

Brand & Color Category	Basecoat	Shade	Highlight
Delta®:	Black	None	Quaker Gray or Colonial Blue*
	Bridgeport Gray	Adriatic Blue	Drizzle Gray
	Cadet Gray	Hammered Iron	White
BLACK/GRAY	Charcoal	Black	Quaker Gray
	Drizzle Gray	Bridgeport Gray	White
	Hippo Gray	Charcoal	Cadet Gray
	Quaker Gray	Hippo Gray	White

Black is often highlighted with gray when you want to achieve a neutral effect. However, Colonial Blue is also very pretty. You might consider using this if it will coordinate with the other colors in your design.

Brand & Color Category	Basecoat	Shade	Highlight
Delta®:	Adriatic Blue	Dark Night Blue	Lavender Lace
	Avalon Blue	Midnight Blue	Salem Blue
	Blue Heaven	Copen Blue	Blue Mist
	Bonnie Blue	Midnight Blue	Blue Mist
	Cape Cod Blue	Nightfall Blue	Lavender Lace
	Colonial Blue	Avalon Blue	Colonial Blue + White
	Copen Blue	Navy Blue	Blue Heaven
BLUE/AQUA/	Denim Blue	Midnight Blue	Blue Jay
TURQUOISE	Lavender Lace	Liberty Blue	White
	Nightfall Blue	Charcoal	Tide Pool Blue
	Norsk Blue	Midnight Blue	Blue Haze
	Periwinkle Blue	Ultra Blue	Blue Mist
	Salem Blue	Manganese Blue	Blue Mist
	Turquoise	Emerald Green	Tropic Bay Blue
	Wedgewood Blue	Midnight Blue	Blue Mist

Brand & Color Category	Basecoat	Shade	Highlight
Delta®:	Autumn Brown	Burnt Umber	Flesh Tan
	Dark Brown	Walnut	Autumn Brown
	Flesh Tan	Palomino Tan	Lt. Ivory
	Golden Brown	Spice Brown	Maple Sugar Tan
BROWN/BEIGE/	Light Chocolate	Spice Brown	Flesh Tan
TAN	Maple Sugar Tan	Golden Brown	Light Ivory
	Mocha Brown	Brown Iron Oxide	Maple Sugar Tan
	Raw Sienna	Burnt Umber	Maple Sugar Tan
	Spice Brown	Walnut	Spiece Tan
	Spice Tan	Spice Brown	Maple Sugar Tan

Brand & Color Category		Basecoat	Shade	Highlight
Delta®:		Avocado	Gamel Green	Lt. Yellow Green (Wally R)
		Christmas Green	Black Green	Lima Green
		Deep River Green	Black Green	Jade Green
		Emerald Green	Pthalo Green	Turquoise
		Forest Green	Black Green	Leaf Green
		Green Sea	Alpine Green	Green Sea + White
		Jade Green	Deep River Green	Turquoise
	GREEN	Kelly Green	Hunter Green	Lima Green
		Leaf Green	Dark Forest Green	Apple Green
		Leprechaun	Forest Green	Pale Mint Green
		Salem Green	Black Green	Blue Wisp
		Seminole Green	Black Green	Apple Green
		Stonewedge Green	English Yew Green	Ivory
		Wedgewood Green	Dark Forest Green	Apple Green
		Woodland Night Green	Black Green	Rainforest Green

Brand & Color Category		Basecoat	Shade	Highlight
Delta®:		AC Flesh	Bambi Brown	White
		Bittersweet Orange	Tangerine	Luscious Lemon
		Caucasian Flesh	Red Iron Oxide	Medium Flesh
		Coral	Adobe Red	Rosetta Pink
		Deep Coral	Tompte Red	Pink Angel
		Desert Sun Orange	Burnt Sienna	Fleshtone
		Fleshtone	Caucasian Flesh	Lt. Ivory
	ORANGE/FLESH/	Fleshtone Base	Bambi Brown	White
	PEACH	Island Coral	Cayenne	Queen Anne's Lace
		Medium Flesh	Caucasian Flesh	Santa's Flesh
		Nectar Coral	Deep Coral	Santa's Flesh
		Pumpkin	Red Iron Oxide	Yellow
		Rosetta Pink	Caucasian Flesh	Santa's Flesh
		Tangerine	Burnt Sienna	Bittersweet Orange
		Western Sunset Yellow	Medium Flesh	Queen Anne's Lace

CHOICES

Brand & Color Category	Basecoat	Shade	Highlight
Delta®:	Bouquet Pink	Candy Bar Brown	Pink Frosting
	Dusty Mauve	Candy Bar Brown	Sachet Pink
	Dusty Plum	Dusty Purple	Dusty Plum + White
	Dusty Purple	Charcoal	Napa Wine
	Fuchsia	Black Cherry	Hydrangea Pink
	Gypsy Rose	Burgundy Rose	Indiana Rose
	Hydrangea Pink	Dusty Mauve	White
	Indiana Rose	Gypsy Rose	Gypsy Rose + White
PINK/MAUVE/	Lavender	Purple	Lavender + White
PURPLE	Lilac Dusk	Grape	Lilac Dusk + White
	Napa Wine	Vintage Wine	Lilac Dusk
	Normandy Rose	Gypsy Rose	Queen Anne's Lace
	Pink Angel	Adobe Red	Santa's Flesh
	Pink Frosting	Pink Quartz	White
	Pink Quartz	Dusty Mauve	Pink Frosting
	Rose Cloud	Rose Mist	Rose Cloud + White
	Rose Mist	Candy Bar Brown	Rose Cloud
	Sachet Pink	Dusty Mauve	Pink Frosting
	Wisteria	Vintage Wine	Lilac Dusk

Brand & Color Category	Basecoat	Shade	Highlight
Delta®:	Adobe Red	Tompte Red	Coral
	Bright Red	Candy Bar Brown	Rouge
	Fiesta Pink	Tomato Spice	Nectar Coral
	Fire Red	Mendocino Red	Tangerine
RED/	Maroon	Candy Bar Brown	Bright Red
BURGUNDY	Mendocino Red	Candy Bar Brown	Tomato Spice
	Red Iron Oxide	Burnt Umber	Bright Red
	Rouge	Tompte Red	Rosetta Pink
	Tomato Spice	Candy Bar Brown	Persimmon
	Tompte Red	Burgundy Rose	Deep Coral

Brand & Color Category	Basecoat	Shade	Highlight
Delta®:	Antique White	Trail Tan	White
	Ivory	AC Flesh	White
WHITE/	Lt. Ivory	Quaker Gray	White
NEUTRAL	Old Parchment	Spice Tan	Lt. Ivory
	Sandstone	Lichen Gray	White
	White	Drizzle Gray*	None

*White may be effectively shaded with a variety of colors. Use one that coordinates with the other colors in your design. For example, for pinks try "Pink Frosting," for blues "Tide Pool Blue," etc.

Brand & Color Category	Basecoat	Shade	Highlight
Delta®:	Antique Gold	Raw Sienna	Pineapple Yellow
	Bright Yellow	Antique Gold	White
	Butter Yellow	Golden Brown	Lt. Ivory
	Crocus Yellow	Antique Gold	White
YELLOW/	Custard	Crocus Yellow	White
GOLD	Empire Gold	Pigskin	Crocus Yellow
	Luscious Lemon	Antique Gold	White
	Pale Yellow	Raw Sienna	White
	Pineapple Yellow	Antique Gold	White
	Straw	Golden Brown	Pineapple Yellow

FOLKART®

See "Basic Instructions" found at the beginning of this chapter.

Brand & Color Category	Basecoat	Shade	Highlight
FolkArt®:	Barnwood	Dark Gray	Vanilla Cream
	Black	None	Gray Flannel
BLACK/GRAY	Dove Gray	Charcoal Gray	Wicker White
	Medium Gray	Dark Gray	Light Gray
	Light Gray	Medium Gray	Wicker White
	Gray Flannel	Dapple Gray	Wicker White

Brand & Color Category	Basecoat	Shade	Highlight
FolkArt®:	Amish Blue	Slate Blue	Dove Gray
	Bavarian Blue	Indigo	Bavarian Blue + Wicker White
	Bluebell	Bluebonnet	Wicker White
	Coastal Blue	Azure Blue	Coastal Blue + Wicker White
	Denim Blue	Payne's Gray	Amish Blue
	French Blue	Paisley Blue	French Blue + Wicker White
	Icy White	French Blue	Wicker White
	Light Blue	Ultramarine	Wicker White
	Light Periwinkle	Brilliant Blue	Lt. Periwinkle + Wicker White
BLUE/AQUA/	Porcelain Blue	Heartland Blue	Wicker White
TURQUOISE	Slate Blue	Navy Blue	Amish Blue
	Summer Sky	Teal Green	Summer Sky + Wicker White
	True Blue	Prussian Blue	True Blue + Wicker White
	Turquoise	Viridian	Aqua Bright

CHOICES

Brand & Color Category	Basecoat	Shade	Highlight
FolkArt®:	Acorn Brown	Chocolate Fudge	Warm White
	Almond Parfait	Acorn Brown	Taffy
	Chocolate Fudge	Licorice	Acorn Brown
	Cinnamon	Rusty Nail	Portrait Medium
BROWN/BEIGE/ TAN	Coffee Bean	Burnt Umber	Acorn Brown
	Country Twill	Chocolate Fudge	Vanilla Cream
	Honeycomb	Coffee Bean	Country Twill
	Linen	Coffee Bean	Warm White
	Nutmeg	Burnt Umber	Teddy Bear Tan
	Teddy Bear Brown	Burnt Umber	Acorn Brown
	Teddy Bear Tan	Raw Sienna	Buttercrunch

Brand & Color Category	Basecoat	Shade	Highlight
FolkArt®:	Aspen Green	Wrought Iron	Robin's Egg
	Bayberry	Old Ivy	Lemonade
	Fresh Foliage	Sap Green	Fresh Foliage + Warm White
	Grass Green	Thicket	Fresh Foliage
	Green	Hunter Green	Kelly Green
GREEN	Green Meadow	Wrought Iron	Fresh Foliage
	Mystic Green	Shamrock	Mystic Green + Warm White
	Old Ivy	Wrought Iron	Fresh Foliage
	Robin's Egg	Bluegrass	Robin's Egg + Wicker White
	Teal Green	Wintergreen	Summer Sky
	Thicket	Wrought Iron	Clover

Brand & Color Category	Basecoat	Shade	Highlight
FolkArt®:	Apricot Cream	Portrait Dark	Georgia Peach
	Autumn Leaves	Rusty Nail	Tangerine
	Dusty Peach	Peach Perfection	Warm White
	Peach Perfection	Cinnamon	Georgia Peach
	Persimmon	Huckleberry	Tangerine
ORANGE/ FLESH/PEACH	Portrait Medium	Portrait Dark	Dusty Peach
	Promenade	Rusty Nail	Dusty Peach
	Pure Orange #628*	Christmas Red	Tangerine
	Red Orange	Rusty Nail	Tangerine
	Skintone	Portrait Dark	Dusty Peach
	Tangerine	Pure Orange #628*	Lemon Custard

*FolkArt® has two Pure Oranges in their line. For this reason, I've included the product number so you'll know which one I'm referring to.

Brand & Color Category	Basecoat	Shade	Highlight
FolkArt®:	Berries 'n Cream	Rose Garden	Delicate Rose
	Cherokee Rose	Raspberry Wine	Cotton Candy
	Cotton Candy	Cherokee Rose	Portrait Light
	Delicate Rose	Rose Chiffon	Wicker White
	Fuchsia	Burnt Carmine	Pink
	Heather	Purple Passion	Heather + Wicker White
	Hot Pink	Magenta	Pink
	Lavender Sachet	Periwinkle	Wicker White
	Orchid	Red Violet	Wicker White
PINK/MAUVE/	Pink	Magenta	Sweetheart Pink
PURPLE	Plum Chiffon	Burnt Carmine	Pink
	Plum Pudding	Burnt Carmine	Rose Pink
	Potpourri Rose	Raspberry Wine	Berries 'n Cream
	Purple	Dioxazine Purple	Heather
	Rose Blush	Rose Garden	Delicate Rose
	Rose Chiffon	Raspberry Wine	Berries 'n Cream
	Rose Pink	Raspberry Wine	Rose Pink + Wicker White
	Strawberry Parfait	Primrose	Sweetheart Pink
	Sweetheart Pink	Raspberry Sherbet	Portrait Light

Brand & Color Category	Basecoat	Shade	Highlight
FolkArt®:	Barnyard Red	Dark Brown	Poppy Red
	Brick Red	Huckleberry	Poppy Red
	Burgundy	Burnt Carmine	Primrose
	Calico Red	Alizarin Crimson	Poppy Red
	Cardinal Red	Alizarin Crimson	Primrose
	Christmas Red	Huckleberry	Pure Orange #628
RED/	Holiday Red	Alizarin Crimson	Primrose
BURGUNDY	Huckleberry	Chocolate Fudge	Portrait Dark
	Maroon	Burnt Carmine	Primrose
	Napthol Crimson	Alizarin Crimson	Pure Orange #628
	Poppy Red	Napthol Crimson	Primrose
	Primrose	Calico Red	Pink

CHOICES

Brand & Color Category	Basecoat	Shade	Highlight
FolkArt®:	Taffy	Linen	Wicker White
	Tapioca	Clay Bisque	Wicker White
WHITE/NEUTRAL	Vanilla Cream	Butter Pecan	Warm White
	Warm White	Vanilla Cream	Wicker White
	Wicker White	Dove Gray *	None

*Wicker White may be effectively shaded with a variety of colors. Use one that coordinates with the other colors in your design. For example, for pinks try "Cotton Candy," or for blues "Light Blue," etc.

Brand & Color Category	Basecoat	Shade	Highlight
FolkArt®:	Buttercream	Lemon Custard	Wicker White
	Buttercrunch	Yellow Ochre	Taffy
	Buttercup	Yellow Ochre	Taffy
	English Mustard	Nutmeg	Buttercup
YELLOW/ GOLD	Harvest Gold	English Mustard	Buttercup
	Lemonade	Sunny Yellow	Wicker White
	Moon Yellow	Yellow Ochre	Wicker White
	School Bus Yellow	Harvest Gold	Wicker White
	Sunny Yellow	Harvest Gold	Wicker White
	Yellow Ochre	Raw Sienna	Buttercup

WALLY R.™

See "Basic Instructions" found at the beginning of this chapter.

Brand & Color Category	Basecoat	Shade	Highlight
Wally R.™:	Black	None	Dove Gray or Breezy Turquoise*
	Dove Gray	Rhino Gray	White
	Pelican	Pilgrim Gray	White
BLACK/GRAY	Pilgrim Gray	Caspian	Pelican
	Rebel Gray	Iron Clad	White
	Rhino Gray	Soft Kohl	Rebel Gray
	Soft Kohl	Black	Dove Gray

*Black is often highlighted with gray when you want to achieve a neutral effect. However, turquoise is also very pretty. You might consider using this if it will coordinate with the other colors in your design.

Brand & Color Category	Basecoat	Shade	Highlight
Wally R.™:	Aegean Blue	Kohl Blue	Misty Blue
	Breezy Turquoise	Pacifica	Breezy Turquoise + White
	Caspian	Velvet Night	Santa Fe Blues
	Dover Blue	Phantom Blue	Santa Fe Blues
BLUE/AQUA/	French Blue	Kohl Blue	French Blue + White
TURQUOISE	Hawaiian Green	Pthalo Green	Aqua
	Heavenly Blue	Sapphire Blue	Misty Blue
	Nordic Blue	Kohl Blue	Gray Dawn
	Pacifica	Kohl Blue	Big Sky
	Phantom Blue	Soft Kohl	Delft Blue
	Sapphire Blue	Blazer Blue	Heavenly Blue
	Wedgwood Blue	Kohl Blue	Misty Blue

Brand & Color Category	Basecoat	Shade	Highlight
Wally R.™:	Brown Sugar	Warm Brown	Chamois
	Cappucino	Warm Brown	Chamois
	Chamois	Brown Sugar	Tusk
	Creamy Beige	Sonora	Tusk
BROWN/BEIGE/	Dark Brown Sugar	Raw Umber	Nutmeg
TAN	Jamocha	Brown Iron Oxide	Chamois
	Milk Chocolate	Warm Brown	Creamy Beige
	Nutmeg	Burnt Umber	Creamy Beige
	Raw Sienna	Burnt Umber	Chamois
	Warm Brown	Raw Umber	Cappucino

Brand & Color Category	Basecoat	Shade	Highlight
Wally R.™:	Blade	Ivy	Pippin Green
	Blarney	Terrestrial Green	Mellow Marsh
	Deep Sea	Kohl Green	Lichen Green
	Forest Night	Kohl Green	Emeraude
	Green Olive	Bay Leaf	Lt. Yellow Green
	Holly Green	Kohl Green	Spring Green
GREEN	Irish Green	Erin Green	Spring Green
	Lichen Green	Kohl Green	Pamadour Green
	Moss	Kohl Green	Pippin Green
	Sage	Shrub	Sweet Cream
	Terrestrial Green	Kohl Green	Blade
	Tranquil Green	Solvang	Tranquil Green + White

CHOICES

Brand & Color Category	Basecoat	Shade	Highlight
Wally R.™: **ORANGE/FLESH/ PEACH**	Cashmere Rose	Chimney	Cherub
	Cherub	Spiced Peach	Cherub + White
	Desert Tea	HB Medium Flesh	Corn Flower
	Duck Bill	Fresh Tangerine	Juicy Lemon
	Fresh Tangerine	Burnt Sienna	Duck Bill
	HB Medium Flesh	Spiced Peach	Corn Flower
	Peachee	Red Pepper	Corn Flower
	Pumpkin	Red Iron Oxide	School Bus Yellow
	Santa Fe	Burnt Sienna	Skin Tone
	Skin Tone	Spiced Peach	Tusk
	Spiced Peach	Red Iron Oxide	HB Medium Flesh
	Warm Beige	Doeskin	White

Brand & Color Category	Basecoat	Shade	Highlight
Wally R.™: **PINK/MAUVE/ PURPLE**	Cameo Pink	Carnation	White
	Carnation	Winter Wine	White
	Faded Rose	Rose Dawn	Faded Rose + White
	Grecian Rose	Cinnabar	Grecian Rose + White
	Hortense Violet	Brandy	Pink Begonia
	Lavender	Purple	Lavender + White
	Maiden's Blush	Chimney	Maiden's Blush + White
	Mulberry	Soft Kohl	Plum Wine
	Opal	Rose Dawn	Corn Flower
	Pink Begonia	Velvet Plum	Pink Begonia + White
	Plum Wine	Brandy	Pink Begonia
	Rose Dawn	Aztec	Faded Rose
	Terra Rosa	Winter Wine	Cameo Pink
	Zinfandel	Cinnabar	Cameo Pink

Brand & Color Category	Basecoat	Shade	Highlight
Wally R.™: **RED/ BURGUNDY**	Bing Cherry	Cinnabar	Toluidine Red
	Chimney	Valentine	Cashmere Rose
	Cranberry	Cinnabar	Ripe Tomato
	Festive Pink	Ripe Tomato	Rouge
	Fire Truck Red	Cranberry	Fresh Tangerine
	Red Iron Oxide	Burnt Umber	Toluidine Red
	Ripe Tomato	Cinnabar	Tropicana
	Toluidine Red	Cinnabar	Tropicana
	Tropicana	Valentine	Cherub
	Valentine	Aztec	Deep Coral (Delta®)

Brand & Color Category	Basecoat	Shade	Highlight
Wally R.™:	Cotton Candy	Taupe	White
	Creamy Beige	Cappucino	Tusk
WHITE/	Desert Sand	Sterling Gray	White
NEUTRAL	Sweet Cream	Warm Beige	White
	Tusk	Dove Gray	White
	White	Pelican*	None

*White may be effectively shaded with a variety of colors. Use one that coordinates with the other colors in your design. For example, for pinks try "Cameo Pink," for blues "Delft Blue," etc.

Brand & Color Category	Basecoat	Shade	Highlight
Wally R.™:	Banana Cream	Yellow Oxide	White
	Caribou	Brown Sugar	Sweet Cream
	Cotton Seed	Raw Sienna	White
YELLOW/	Hansa Yellow	Yellow Oxide	White
GOLD	Juicy Lemon	Yellow Oxide	White
	Lemon Meringue	Sungold	White
	Spun Gold	Tigereye	Sungold
	Sungold	Yellow Oxide	White
	Yellow Oxide	Raw Sienna	Banana Cream

CHOICES

My Color Choices

Brand & Color Category	Basecoat	Shade	Highlight

Brand & Color Category	Basecoat	Shade	Highlight

Brand & Color Category	Basecoat	Shade	Highlight

Brand & Color Category	Basecoat	Shade	Highlight

CHOICES

Feel free to copy this form and use it to record your favorite color combinations.

Chapter 8

WHERE TO FROM HERE?

If you have read this book from the beginning, you should now have a good knowledge of the basics of decorative painting. Where do you go from here?

This is a "bits and pieces" chapter that offers suggestions on how to learn more about decorative painting plus a few miscellaneous tidbits that I think you will find helpful.

Painting from Pattern Books

There are beautiful pattern books available that provide you with a wide variety of patterns, pictures, and instructions for projects to paint. To an experienced painter, they can be a real delight. However, to a beginner, most of them can be a little frustrating or intimidating, because they usually offer only scanty instructions.

To an experienced painter, these scanty instructions pose no problem at all. As long as there is a good color picture of the project and a pattern, they're ready to paint. Unfortunately, this is not the case for a beginner–they need more information. There are ways for a beginner to work from pattern books, and I'd like to share some of the things I've learned with you.

In addition to the project instructions in the pattern book, I recommend that you:

1. Read the general instructions that are usually found in the beginning of the pattern book. These are basic instructions that describe how the artist does certain techniques. Remember, decorative painting is not an exact art, so artists don't always do things the same way or call things by the same name.
2. Look up the surface and techniques in this book and read the in-depth information provided. If you don't understand a word, look for it in the glossary.
3. Refer to the color picture in the pattern book because observing the shading and highlights and other details will make the instructions more understandable.
4. Refer to the pattern that is (hopefully) marked for shading. Some authors mark patterns for highlighting as well, which is even better.

Typical Instructions

The instructions shown below in bold print are similar to what you might expect to see in a pattern book. Following the bold print is an explanation of what to do. The pattern is for a simple wooden bow cutout.

"Sand, tack, seal" What you're to do in this step is to prepare the wood for painting. So, look in Chapter 3—Surfaces, of this book under "Wood, New" for in-depth instructions. Look in Chapter 6—Techniques, under "Tack Cloth" for instructions on how to use one.

"Base bow Bright Red" Base, or basecoating is a technique described in Chapter 6. To refresh your mind on how to properly do this, reread "Basecoating."

"Shade bow with Red Iron Oxide, highlight with Tangerine" This is the step that will probably throw you. You need to put contrast into your painting by applying shading and highlights.

Study the color picture in the pattern book carefully to see which areas look lighter and which look darker. The phrase "Pictures are worth a thousand words" definitely applies here. Reread "Contrast" in Chapter 6. Remember the simple basics are:

> Dark to the back
> Medium in the middle
> Light in the front

Refer to the picture and/or the pattern for placement of shading. Remember that floating is the most commonly used technique for applying shading and highlights. (Some pattern books will refer to floating as "sideloading.") Therefore, reread "Floats/Floating" in Chapter 6—Techniques.

"Varnish" This technique is described under "Varnishing" in Chapter 6. Reread this section. It will take you step-by-step through the varnishing process. A variety of varnishes are listed in Chapter 1.

Other Considerations

Having to do so much reading before you actually start painting probably sounds like a lot of work, and frankly, it is–but it's not something you'll need to do for very long. The more projects you paint, the easier it will be. The basic techniques will soon come to you automatically and you'll be able to understand instructions found in pattern books without any problems.

Here is what a beginning painter should look for when purchasing pattern books (besides, of course, the beautiful designs):

1. Good color pictures that show the details clearly.

If the picture is too small to see details, it will make things a lot more difficult.

2. Patterns that are marked for shading. This will usually be indicated by dots or fuzzy lines in the areas to be shaded. Refer to Figure 8-1 below. Notice that Pattern A has no shading, so it's not much of a help to a beginner. Pattern B will help you a lot more than Pattern A because it shows you where the shading is supposed to go.

3. Look for simple patterns. For example, ones using dots, crosshatching, comma strokes, etc. are very appropriate for beginners. Avoid multi-petal roses and other more complicated patterns until you've had more painting experience. Many lovely flowers can be painted easily using simple strokes.

4. Purchase a book where projects are painted in your medium. Beginning acrylic painters may be easily confused if instructions are given for painting the projects with oils or watercolors. Once you have more experience, however, you should be able to convert these project to acrylics.

LEGALITIES OF USING PATTERNS IN PATTERN BOOKS OR PACKETS

Pattern books and packets are created to help you paint a particular design. They are copyrighted, however, the painting you paint from them is yours. I think you should be aware of some of the "do's" and "don'ts" concerning use of these patterns.

1. *Do* sign your work, even though you didn't design the pattern. You painted it, so your name belongs on the painting, not the name of the pattern designer.[1]

2. *Do* feel free to sell the objects you painted from the patterns in the book.[2]

3. *Do* mix and match patterns from other pattern books if you want to.[3]

4. **Don't** photocopy anything from a pattern book unless it is *for your own use*. If you want the pattern smaller, it's a lot easier to reduce it on a photocopy machine than with the grid system.[4]

5. *Do* make sure that the copyright notice (name, etc.) on the pattern appears on your photocopy.[5] In other words, don't cover up the notice so it won't appear on the copy.

6. **Don't** make copies for friends or students because doing so is an infringement of copyright laws.[6] If you want to teach the project and photocopy patterns for each student, you must write to the author or publisher of the book and obtain written permission, unless permission is given in the book itself.

Classes

One of the more obvious ways to learn decorative painting is to take classes. Local craft stores, as well as the Adult Education programs in the colleges and junior colleges are a good place to look for decorative painting classes. If they are available in your area, I suggest you enroll. It's a great way to learn, besides being a lot of fun.

Keep in mind that most people paint better at home than they do in class because they're more relaxed. Because of this, they paint slower or make more mistakes in class and are often unable to finish the project during class time. Don't allow this to defeat you. Keep a positive attitude and just do the best you can. Don't worry if the person sitting next to you paints better than you. For some reason, this is often the case. I think it's just another example of "Murphy's Law in Action," so don't worry about it.

With almost all of the classes I've taken in the past 7 years, I have been very fortunate to have teachers with wonderfully positive attitudes. It seemed no matter how badly I did something, they could show me a way to fix it. When I asked them to critique my work, they did it honestly and tactfully, telling me the good and bad points about it. Constructive criticism given with a kind attitude is the best way to learn. If you don't know what you're

PATTERN A, WITHOUT SHADING

PATTERN B, WITH SHADING

Figure 8-1. Shading Versus No Shading on Patterns

doing wrong, you can't fix it.

However, if you ever find yourself in a situation where this is not the case, and the teacher is negative and has a way of making you feel absolutely stupid, remember to have faith in yourself. Do the best you can and never allow anyone to discourage you.

Benefits of Taking Classes

1. By watching a teacher paint, you'll get a better idea of how to do it yourself.

2. If you have difficulty with a certain technique, the teacher can watch you paint and tell you what you're doing wrong.

3. You will have an opportunity to meet people who share your interest in painting.

4. You can observe how individuality comes into play. Though each student is usually painting the same project, no two projects look the same. How others change their color schemes or add extra flourishes to a pattern gives you ideas you might want to try.

5. The encouraging words of both the teacher and students help you to persevere, even when you become discouraged.

6. If time allows, at the end of the class, you may choose to ask the teacher to critique your piece.

Remember, don't ask unless you want to hear the bad as well as good points.

Taking Notes

To get the most out of your classes, I suggest you take some notes whenever possible, especially if the teacher doesn't provide them for you. However, I've learned from experience, that if you get "carried away" and spend too much time on note taking, you won't be able to keep up with the class. Believe me–this is very frustrating.

Find a happy medium. Jot down main points you might forget later. Develop a system that you consistently use for marking your patterns for shading and highlighting. You can quickly do this and you'll find the marked-up pattern a big help when you work on the project at home.

For example, you might mark areas to be highlighted with "X"s and shading with dots or zig-zagged lines. If an area is to be floated, you might consider marking an arrow to indicate the direction the water should face on your brush (or the paint, if you prefer). If it isn't clear by watching the teacher demonstrate, don't be afraid to ask.

Write the source of your pattern either on the tracing or your notes. If you can't figure out how to paint a certain stroke, ask the teacher if he or she would be willing to paint one for you on a piece of tracing paper. You can then attach it to your notes and refer to it later.

If the project involves mixing some colors, put a sample of the color on a piece of paper and jot down the

mix recipe so you'll be able to recreate the color again.

Once you've developed your own system for taking quick and efficient notes, you'll be able to spend most of your class time painting—and this is important.

Taking Pictures

Having a picture of the teacher's painted sample is very helpful, especially if you don't have a copy of the book the pattern came from. Some teachers make pictures available to students for a small charge. If they don't, ask if you may take your own picture of the sample to keep with your notes.

Taping the Class

Though not very practical for classes where you actually paint (because the teacher doesn't talk continually), taping is helpful in lectures where you don't paint. A small, battery-operated tape recorder is perfect for these situations. Taping the lecture, along with taking notes, is a good way to keep from missing any important points. However, do ask the speaker if he or she has any objection to your doing this.

No Classes in Your Area?

If no classes are available in your area, you might want to consider traveling to a seminar. Though this can be costly, both in time and money, it's a way for you to benefit from a class room experience. Members of the SDP (Society of Decorative Painters) have an opportunity to take classes with the top people in the industry. More information on the SDP is provided later in the chapter.

Videos

More and more decorative painting videos are available, and they are an excellent way to learn about painting from a professional—in your own home, at your own pace, and at your convenience.

Videos are often advertised in decorative painting magazines. The description of the video generally mentions whether oil, watercolor, or acrylic paints are used. For beginners especially, I suggest you purchase videos that deal with the medium in which you are interested. For example, if you paint with acrylics, you'll get a lot more out of the video if the artist is demonstrating with acrylics.

Though you won't have the benefit of the teacher's personal critique of your work or the encouraging words of class members, you will be able to watch an expert and see how the painting comes together. Videos also give you the chance to play portions over and over. If you're having trouble with a certain step, you can keep watching it until you understand how to do it.

Some sources for decorative painting videos are:

Charles Johnson Charles demonstrates his marbleizing technique on the video entitled "Victorian Faux Finish." The project is a trunk with a faux finish on the front and sides. The top has a lid with a design of Victorian roses and lace. To order the video, send $11.95 (which includes postage and handling) to "Designs From Charles Johnson," Box 4092 GSS, Springfield, MO 65808. His phone number is (417) 887-5524. This video is also available through DecoArt (product number DAS41).

DecoArt The DecoArt "U-Can-Do..." Video Library™ has a number of excellent, reasonably priced videos available featuring top artists in the field. These half-hour, full color, professional quality video tapes (VHS format only), provide you with easy, step-by-step painting instructions using DecoArt™ acrylic paints.

Also available are videos by both Enid Hoessinger and Melinda Neist which can help you learn how to master the multi-loading technique. For ordering information, write to DecoArt, PO Box 360, Stanford, KY 40484.

Donna Bryant-Waterson The following two videos will help you learn more about how to create realistic paintings using acrylic paints: "Yes, It's Acrylic: Bountiful Harvest", which is a step-by-step approach to painting round objects using Donna's bronzing powder technique; and "Yes, It's Acrylic: Wild Rose Tray", which is a step-by-step approach to painting 5-petal flowers and leaves.

Her "Roses, Roses, Roses" video is a step-by-step guide in painting beautiful roses on fabric using Accent® Elegance™ dyes. Her "Florals on Fabric" video provides step-by-step instructions for a variety of techniques for painting home decor items, wearables, or gifts. Each video includes color selections and step-by-step designs.

To order the videos, write to Donna Bryant-Waterson, Donna Bryant Publications, 3817 Cozy Drive, Wichita, KS 67220. Telephone (316) 682-6867.

Jackie Shaw Studio For a catalog of over 100 books and videos available, send $1.00 to Jackie Shaw Studio Inc., 13306 Edgemont Rd, Smithsburg, MD 21783. Telephone (301) 824-7592.

Jo Sonja Product Video Jo Sonja and her son, David Jansen have worked with Chroma Acrylics Inc. to produce an excellent video called "A Guide for the Use Of Jo Sonja's® Artists' Colors and Mediums." If the video is not available at your local craft store, write directly to Chroma Acrylics for information. Their address is 205 Bucky Drive, Lititz, PA 17543. The phone number is (800) 257-8278.

Plaid Enterprises, Inc. The Plaid "View 'n Do™" videos cover a wide range of subjects, such as: Painted Finishes, Watercolor with Acrylics, Fabric Painting, to name a few.

Also available are companion videos to two books I recommend in this chapter: "Open Your Eyes to Color" (Plaid #71001), and "Painting With Metallics" (Plaid #70015). Refer inquiries to Plaid Enterprises, PO Box 7600, Norcross, GA 30091, or call (404) 923-8200.

Thurmond Ltd. Vi Thurmond is noted for her beautiful, realistic paintings of animals. If this subject interests you, send a stamped, self-addressed business-size envelope to Vi Thurmond, Box 35394, Des Moines, Iowa 50315-0304, and ask to receive a complete brochure of available videos.

Barb Watson, MDA Barb has a companion video to her book "*The ABC's of Color, (Keeping it Simple)*". Working through the book and watching the video will give you a wonderful insight into the wonderful world of color. To order the video, send a check or money order for $31.95 (this includes shipping) to Barb Watson, PO Box 1467, Moreno Valley, CA 92556 or call her for more information at (909) 653-3780.

PBS and Cable Television

Check your local PBS and cable stations. There are some excellent programs demonstrating decorative painting: "Creative Living With Crafts" (TNN), Jackie Shaw's "Creative Painting" (PBS), Tulip's "Fashion Painting Step By Step" (PBS), and "The Magic of Tole Painting With Priscilla Hauser" (PBS). Priscilla's program includes some projects in oils and some in acrylics. If these aren't available in your area, ask the station if it's possible to add them to their schedule.

Inquiries

Don't be afraid to ask questions–it's a great way to get answers you might not be able to find on your own. If you have a question about a product, write to the manufacturer. There's a good chance they will answer. Most decorative painting magazines encourage questions from readers and have a column just for the purpose of answering these questions.

When you write a letter and request a personal response, show your consideration by including a stamped, self-addressed envelope. You will be asking someone to take their time to answer your question. It's only fair to save them the cost of the postage and envelope. Also, by saving them the time of addressing an envelope, you have a greater chance of getting a response.

Suggested Reading—Books

Craft stores and many mail order companies carry a wide variety of project and instructional books. I think it's helpful to read books by a number of different authors on

a given subject. As I mentioned in an earlier chapter, there are variations in the way painters do things. For example, I've described various techniques in my own words. Reading how someone else describes them will be different. The combination of different descriptions can help pull everything together for you.

Books and magazines are a great source of information. The following list describes some of those I've found helpful. Remember, this list is only the tip of the iceberg.

ABC's of Color (Keeping it Simple), by Barb Watson. This is an excellent reference book that explains color theory in a simple, easily understood manner. I encourage you to take time and work through the book. (A companion video of the same name is also available). You will be surprised how much you'll learn about color theory. Write to Barb Watson, P O Box 1467, Moreno Valley, CA 92556 or call her for more information at (909) 653-3780.

Animal Life-Like Paintings, (Plaid Publication #8873), by Sharron England. This is a wonderful book for anyone who would like to learn how to paint animals using a few easy techniques. There are instructions for painting 17 animals using either FolkArt® Pure Pigment Colors™, or oils. Instructions are provided for painting on wood, canvas, and fabric.

Beginning Lessons in Acrylics, (Plaid Publication #8667), is a good reference and project book for beginners. Included are 10 lovely projects by four very talented ladies: Marty Lambeth-Robson, Ginger Edwards, Bette Byrd, and Brenda Jansen. Information is given on painting brush strokes, creating special effects using the deerfoot brush, painting terminology, supplies, and preparation for painting.

Beginner's Guide to Freehand Decorative Painting, (Publication #40) by Jackie Shaw. There is a wealth of information in this book. Some of the subjects covered are: arranging your painting work area conveniently; keeping paints fresh; brush care; color mixing theory; painting easy stroke designs; brush stroke basics; stripping old paint and finishes; simple faux finishes; finishing techniques, antiquing and glazing.

The Big Book of Decorative Painting, by Jackie Shaw. Jackie has written many wonderful books, but she's even outdone herself with this beauty! This 336-page book is a must for every decorative painter. As described on the cover, it will teach you *"how to paint if you don't know how—and how to improve if you do"*. Jackie provides excellent instructions on a variety of subjects: learning to mix color, lettering, brush control, brushstrokes, blending with acrylics, surface preparation, developing painting

skills, to name just a few. My favorite section of the book explains how to paint a variety of flowers in three different levels–"quick and easy", intermediate, and advanced. There are similar sections for painting fruits and vegetables. There are numerous wonderful color plates throughout the book that I know you will find very helpful. If you can't find this at your local craft store, write to the Jackie Shaw Studio, 13306 Edgemont Rd, Smithsburg, MD 21783.

Brush Manual, by Loew-Cornell®. If you want to learn more about brushes, this is the book for you. It delves into the subject of brush making, how to choose the proper brush, describes the various Loew-Cornell® brush lines, brush shapes and their uses, brush care, terminology, and it provides charts that tell you which brush is most appropriate for a number of different projects. Not only does it recommend which brush to use, but it tells you why. If you can't find this locally, write to Loew-Cornell, 563 Chestnut Avenue, Teaneck, NJ 07666. Telephone (201) 837-7070.

Create Your Own Masterpiece... This is the title for a series of books on how to paint song birds and water fowl on amazingly realistic resin castings. An example is "Painting the Black-Capped Chickadee" by Jon Jones & George Kruth, with Bob Guge, four-time world champion in miniatures as the featured artist. These are not your standard type of decorative painting books, however, they are definitely a "must-see" for those of you who would like to try painting realistic birds and water fowl. The step-by-step instructions and color photos are excellent. For books, castings, and related materials, contact Georgetowne Inc., 121 Bashford Drive, Coraopolis, PA 15108. Telephone (800) 947-6690.

Faces Made Easy, by Jillybean. This is a fully illustrated guide to drawing and painting faces and hair. The step-by-step instructions, which include how to paint a face to look younger or older, makes this an invaluable addition to your library. If you can't find this in your local craft store, write directly to: Jillybean, 722 West 66th Street, Suite 250, Richfield, MN 55423, or phone (612) 867-2127.

Flower Studies and Techniques, by Susan Abdella. This is a series of project/instructional books that have beautiful projects to paint as well as providing you with information on how to paint a variety of flowers. The flowers covered in Volume 1 are: wild roses, violets, tulips, forget-me-nots, morning glories, and a study of leaves. Volume 2 provides step-by-step instructions for painting red poppies, cornflowers, daisies, poppies, buttercups, and pink roses. All of Susan's books have excellent instructions and beautiful color pictures

WHERE TO

Folk Art With Enid, by Enid Hoessinger. This book is a guide to learning the "Multi-Loading Brush Technique" for both right and left-handed people. Step-by-step instructions and lovely color work-up sheets guide you as you learn to paint a variety of flowers. Though this is mainly an instructional book, there are also projects included.

Freehanding With Jackie–Borders, Second Edition, by Jackie Shaw (Publication #9). This is one in a series of Jackie's books on the fundamentals of freehanding. You will find over 260 ideas for borders for all painting media. I enjoy it because it gives me ideas on borders I can add to a design to enhance it. This is a great reference book to have in your library.

Guide to Stenciling, by Nancy Tribolet. This Delta publication provides a wealth of information on stenciling tools, techniques, paints, and surfaces, as well as giving you design ideas. I know you will enjoy this book, whether or not you've stenciled before, because it gives you up-to-date information and is written so that it's easy to understand.

How To Do Your Own Wood Finishing, by Jackson Hand. This provides in-depth information on wood finishing and describes such things as surface preparation, types of stains and varnishes, stripping wood, etc. This is especially appropriate for those interested in restoring furniture for decorative painting. I found this "treasure" at my local library.

Index of Decorative Painting, The, (Publication #84). This helpful publication will enable you to locate books and patterns to suit your needs, style, and tastes. It contains four sections for cross reference: Author Index, Book Index, Pattern Index, and Publisher Index.

Introduction to Silk Painting, (Publication # 33), by Jackie Shaw. This describes how to do the Resist, Watercolor, Salt techniques, and stenciling and batiking on silk using DEKA®-Silk Paints. The color pictures, along with the instructions, will be a real help for those interested in silk painting.

Jackie's Brush Stroke Workbook, (Publication # 39), by Jackie Shaw. The workbook format and the color pictures make this a very convenient and effective way to practice brush strokes. A sheet of Magic Paper is included in the book so all you need for practice is 3 brushes, paint, and water.

Jackie's Freehanding Seminar, Book 1, (Publication #24) by Jackie Shaw. In addition to showing how to paint a variety of brush strokes, there are color pictures that show

how these strokes can be transformed into flowers, cats, birds, (without using a pattern). It describes how to create the feeling of form and dimension with crosshatching. Other subjects covered are designing made easy; developing, nurturing, and sustaining creativity; and finishing techniques.

Melinda's Folk Art, Volumes 1 and 2, (Jackie Shaw Publications #100 and #102), by Melinda Neist. These are excellent books for those who want to learn the "Multi-Loading" painting technique. The volumes are progressive, so it's important to start by working through Volume 1 because this is where the basic strokes and how to paint them are described. When you've learned them, move on to Volume 2 for even more information and projects. The projects included in both books are absolutely beautiful. Melinda's instructions are easy to understand, and it's a real adventure learning to paint so many flowers and leaves with only one, round brush.

Open Your Eyes to Color, (Plaid Publication #8864), by Pat Clarke, MDA. Even though you may balk at the thought of learning color theory, it really will help you in your decorative painting. This book is an excellent way to get started on color theory by painting a floral wreath as you learn, using FolkArt® Pure Pigment Colors™. There are also a number of projects included that help reinforce color theory as you paint. A companion video of the same name is also available, (Plaid #71001).

Painting With Pure Pigments—An Artist's Guide, (Plaid Publication #8740), by Pat Wakefield, MDA. This is a resource book for acrylic painting techniques and color theory featuring FolkArt® Pure Pigment Colors™. There are 10 painting projects included as well as some very useful information on color theory such as mixing colors, changing color intensity, etc. The color pictures included are excellent.

Priscilla Paints... There are a number of books in this series. All of them are excellent instructional/project books by Priscilla Hauser. The *Tole & Decorative Painting Book I* provides basic information on decorative painting as well as patterns, step-by-step worksheets and instructions on how to paint a variety of flowers, leaves, and ribbons. Look for this and other books in the series at your local craft store.

Rose Foundations, by Susan Abdella. This book is a favorite of mine because it provides the reader with palettes and instructions for painting blended roses in a variety of colors. Susan takes the mystery out of painting roses. There are color work-up sheets showing the development of the roses step-by-step. The "Color Placement Maps" are marked for shading, highlighting,

and tints. If you can't find this locally, write to Susan Abdella Publications, 420 Marilyn Lane, Redlands, CA 92373.

Rose Petals Stroke by Stroke, by Susan Abdella. Though this book does contain lovely projects, what I feel you'll find invaluable are the color worksheets and instructions for painting pink, white, yellow, and red roses. If you can't find this locally, write to Susan Abdella Publications at the address shown under "Rose Foundations".

Sponging–A Beginner's Guide, (Plaid #8335), by Susan Goans Driggers. This informative book provides complete instructions and color pictures for using Plaid's French Wash® Sponging Paint described in Chapter 1.

Steps to Better Drawing, (Plaid Publication #8729), by Helen Roberts. As you grow in your decorative painting, you may want to broaden your horizons and design some of your own patterns. This book provides step-by-step instructions in learning basic drawing techniques. Mastering these basic techniques will improve your painting. My guess is that it will also give you more confidence in your ability to create your own designs.

Sweet & Tender Watercolors With Acrylics, (Plaid #8646), by Donna Spiegel. The "watercolor with acrylics" technique remains quite popular and this book provides 15 adorable projects to paint using this method. The concise instructions and color worksheets will make painting these projects fun and easy.

Sweet Faces Simply, (Plaid Publication #8735), by Pat Clarke. This is a must for anyone who wants to learn the fundamentals of painting faces. Besides teaching you the basics, there are lovely projects for you to paint, applying your newly learned skills.

Victorian Designs, by Charles Johnson. This lovely book is one you'll want to add to your library, especially if you want to do projects using Charles' method of marbleizing described in Chapter 6. It contains information on painting furniture as well as a variety of smaller projects. This is available directly from the author. Send $11.45, (which includes postage and handling), along with your name, address, and phone number to "Designs From Charles Johnson," Box 4092 GSS, Springfield, MO 65808. His phone number is (417) 887-5524.

Victorian Gingerbread, by Charles Johnson is a book that will delight those of you who are looking for patterns for painting Victorian homes and such with all the "gingerbread" trim. This should be available at your local craft store or through Viking Folk Art Publications, Inc., 1317 8th St., S.E., Waseca, MN 56093.

Victorian Lace & Roses, by DeLane Lange. The patterns in this book are beautiful, but even more important to me, is the color worksheet showing how DeLane paints roses. It shows the step-by-step method she demonstrates in the DecoArt™ video entitled "Roses DeLane's Way." If you can't find this book locally, write to DeLane Patterns Inc., 2206 East Evans Road, Ozark, MO 65721, phone (417) 887-8717. The video is available directly from DeLane or from DecoArt™. (See "Videos" category earlier in the chapter for more information on purchasing DecoArt™ videos.)

Magazines

There are decorative painting magazines that offer you up-to-date product and supplier information, describe new techniques, include specialty columns that answer consumer questions, and original designs with painting instructions, patterns, and color pictures. Here are a few recommendations:

Artist's Journal This is a Jo Sonja Folk Art publication. It includes a variety of projects by leading artists with full instructions and color pictures. In addition, every issue brings you entertaining, educational features designed to provide tools for personal artistic growth. To order the magazine, write to The Artist's Journal, PO Box 9080, Eureka, CA 95501.

Decorative Arts Painting (Formerly Decorative Arts Digest) This magazine features painting projects with complete instructions and pictures, general information, book reviews, new product, seminar, and video information, and much more. Write to Decorative Arts Painting, PO Box 7520, Red Oak, IA 51591-0520, or call (800) 444-0441.

Decorative Artist's Workbook This is an excellent publication that is devoted exclusively to decorative art. There are four or more original projects in each issue, including all the needed instructions and step-by-step color worksheets. Address your inquiry to "The Decorative Artist's Workbook," PO Box 3284, Harlan, IA 51593. Telephone (800) 333-0888.

Decorative Painter, The This is discussed in depth in this chapter under "Society of Decorative Painters."

Let's Paint! This is DecoArt's™ wonderful publication that is packed full of a variety of projects in each issue, all using DecoArt products. (A recent issue had over 20 projects!) It offers you information on how to use new DecoArt™ products as well as the more familiar ones. You won't find pages of advertisements in this magazine, and when there is an ad, it is for DecoArt products only.

WHERE TO

It may be purchased over the counter in craft stores or by subscription. Write to: Let's Paint!, DecoArt, PO Box 360, Stanford, KY 40484, or phone (606) 365-3193.

PaintWorks This is another magazine featuring projects from well-known artists, product information, questions and answers, and seminar information. Write to Paint-Works, PO Box 388, Mt. Morris, IL 61054-0388.

Tole World This includes painting projects with instructions and colored pictures, special features such as Getting a Start in Line Art, Tole Show & Seminar Calendar, Bookshelf, and one of my favorites "Shutter Studies". This is filled with valuable information for decorative painters. Write to Tole World, PO Box 52995, Boulder, CO 80322-2995.

Society of Decorative Painters

What is it? The SDP, (Society of Decorative Painters), formerly referred to as the National Society of Tole/Decorative Painters (NSTDP), is a wonderful organization. There are approximately 28,000 members spread all across the United States, most provinces in Canada, and 27 foreign countries. Anyone can join and the members range from beginning painters and decorative artists to manufacturers and distributors of decorative art supplies.

Organized on October 22, 1972 with 22 members, the popularity of this organization is evident when you consider how much the membership has grown. The members share a common interest—decorative painting. They are very willing to share their knowledge with fellow members, and this spirit is one of the things that makes the organization so successful.

Chapters The SDP has over 227 affiliated Chapters. By writing to the SDP office, you can get a list of chapters located near you. Though SDP members don't have to join a local chapter, doing so is a good way to expand your knowledge of decorative painting.

I belong to the Orange County Tole/Decorative Painters in California. I have learned a great deal from the classes I've taken through this group as well as the members themselves. In addition to being educational, it's been a lot of fun. I encourage you to join a chapter near you.

The Decorative Painter This is the magazine that is one of the benefits of SDP membership. In addition to product information and articles, leading artists design the painting projects in the magazine. All projects are pictured in color, with full-size patterns and clear instructions. This magazine helps to keep you up-to-date on what's happening in the decorative painting field.

Conventions

Each year, the SDP holds a national convention. For the convenience of its membership, the locations change from year to year. The convention and trade show are truly a "Disneyland for adults."

It's amazing how much you can learn during convention week, and how much fun you can have doing it. Here are some of the things the SDP convention has to offer you.

Classes Attending the SDP convention gives you the opportunity to take classes with some of the top teachers in the field. In many cases you will be meeting and learning from the published artists whose project books you may have purchased. No matter what your painting level—beginning, intermediate, or advanced—there are classes for you. I found the teachers to be very patient and helpful.

Class members have varied years of painting experience. It's not uncommon to find a student who has only painted a year or so sitting next to one who has painted for 10 years. However, to get the most out of the class, sign up for one that is appropriate for your painting level.

In addition to having a completed, or semi-completed project to take home from each class, you will receive a certificate signed by each of your instructors, which makes a very nice souvenir.

Demonstrations These are informal and offer you the chance to watch artists paint and explain their style and techniques. Attendance is held on a first-come, first-served basis.

Seminars These are an excellent way to learn about various aspects of decorative painting. Unlike classes where you actively participate, seminars offer you a chance to just sit, listen, and take notes (if you feel so motivated). SDP provides speakers who are experts in the field. I met SDP members who attend the convention simply for the seminars, trade show, and casual demonstrations—never attending a class where they actually paint.

Socializing In addition to all the educational benefits, the convention provides a chance for you to meet people from all over our country and foreign ones as well. No matter what your homeland is, everyone attending convention has at least one thing in common—they all share an interest in decorative painting. There are special events planned where you can meet the SDP leaders. I learned many helpful hints in casual conversations with members I had never met before. This makes the social part of the convention educational too.

Trade Show Manufacturers come from all over the

country to display their decorative painting products. This is probably the best place to see what is available for our craft—all under one roof. Many artists and companies wait to release their new books or supplies at convention. This just adds to the feeling of excitement.

Attending the trade show gives you an opportunity to talk to some of the manufacturers or their representatives to get accurate information on using their products.

You will be able to pick up all sorts of information on supply sources, get a variety of catalogs, and even get free samples from some suppliers. There are demonstrations so you can see first hand how to use the various products, and "Make-It, Take-its" where you work under the supervision of a manufacturer's representative to complete a specific project. Unless you have iron willpower, you won't be able to leave the trade show without spending money. I learned from experience that you need one extra suitcase just to carry your newly purchased "treasures" home with you.

Certification The SDP also provides an opportunity for its members to receive their certification as a CDA (Certified Decorative Artist), or MDA (Master Decorative Artist).

It takes a lot of work to achieve the honor of certification. However, in conversations I've had with members who competed, they were quick to say that it was definitely a good learning experience and well worth the effort.

If you are a beginner, you have quite a bit more painting to do before you are ready to attempt this. However, it is another valuable benefit offered by SDP membership. If you are interested, the SDP will provide information on the process.

How to join the SDP Write to Executive Director, SDP, PO Box 808, Newton, KS 67114 or call (316) 283-9665 for membership information. Membership is from January to January, no matter when you join, and dues are payable for the entire year.

Designing

Though it may seem remote to you now, if you continue painting, I think there will be a time when you'll want to design your own patterns. For those who are able to draw easily, the step to designing is made pretty naturally. To those of us who are still drawing stick figures that resemble the ones we drew as children, it takes more effort.

I feel the first step potential designers should take is to learn to draw, if they can't already do so. Several years ago I took a class from Doe Bush, a friend of mine who is a wonderful portrait artist. She told us that anyone can learn to draw, and recommended a book to help us reach that goal. When she said this, my first thoughts were "no way, not me!" But being the inquisitive type, I bought the

book anyway. Needless to say, I've been so impressed with it that I wanted to tell you about it in case you aren't aware of its existence.

The book is *Drawing on the Right Side of the Brain* by Betty Edwards. It is available in many book stores, but if you can't find it, contact the publisher, Jeremy P. Tarcher, Inc., 5858 Wilshire Blvd., Suite 200, Los Angeles, CA 90036. The book contains "before" and "after" pictures drawn by average students. The "before" pictures look very much like my own drawings...awful. The "after" pictures are another story completely. As I looked at them, I found it difficult to believe the same student had drawn both the "before" and "after" pictures. After reading the book and talking to students who have studied the methods described in it, I was convinced. I can learn to draw...and so can you.

For those of you who aspire to designing, here are some other ideas to help you get started. They are "Pearls of Wisdom" that some of my favorite designers shared with me.

1. You're more likely to be inspired when you are in an aesthetically pleasing atmosphere. So try designing in a room or other place in which you feel comfortable.

2. Start simply. If you like to paint flowers, create a simple pattern using the flowers you like to paint most. Look at a vase of flowers you might have around and try positioning the flowers on your pattern the same way as the arrangement.

3. Start collecting pictures, pieces of wallpaper, lace, fabric, photographs, etc. of things you like and try incorporating them in your own designs.

4. Remember the hints that you learned in taking classes or reading books and try to apply them to your design. (Examples—shading and highlighting techniques).

5. Learn about color theory and the basic principles of using color. Refer to the "Suggested Reading" and "Videos" section of this chapter for reference material.

6. Choosing your color scheme can be simplified by using color charts of the paint type you plan to use. Bobbie's Tru-Color™ System (described in Chapter 1 under "Tru-Color™ System Discs"), is one such product.

7. If you're a flower lover and receive seed and bulb catalogs, save the color pictures of the flowers you like. You can actually trace the flower from the picture. I did this for my design in Figure 4-2 in Chapter 4. With the tracing and the color picture you have from the catalog, you are now ready to add extra flourishes, such as ribbons, lace, curlicues, etc., that express your "special touch."

8. You now have a design. Decide what you want the background to be and paint it in that color. There is an easy way to see how your other colors will look on top of it. Just paint part of the design on clear plastic or acetate with your chosen colors. Then, place the painted acetate on top of your background to see how the colors

look together. This will save your actual project surface and give you greater freedom in deciding what colors look best.

9. Don't let fear of failure keep you from designing. If you never try, you'll never design. No one has to see your designs but you. It's just like learning to play the piano. When you're a beginner, it usually sounds awful. (I speak from experience...I teach piano.) Only time and practice enable you to achieve your goal—creating something of beauty.

10. If you're having trouble getting your design work off the ground, the Dover Pictorial Archive Series may help. These are books that provide copyright free patterns that you may use in your designs. There are patterns for holidays, animals, people, flowers, borders—some in color, some in black and white.

When you use them, try to change the patterns so you will—slowly but surely—be stretching your own creative potential until you can design without the aid of this type of crutch.

If you progress to the point where you want to publish these designs, no more than ten may be used in the same publication or project without permission. To request a catalog, write or call:

Dover Publications, Inc.
31 East 2nd Street
Mineola, NY 11501-3582
(516) 294-7000

Conclusion

I sincerely hope that this book will make learning decorative painting easier for you. In closing, I want to encourage you again that you can learn if you have a strong desire to do so. Then add patience, perseverance, and a positive attitude, and you will surely succeed. As you are learning, just relax and enjoy the beauty of this very special art. I wish you the best of luck as you reach for this new horizon.

WHERE TO

GLOSSARY

This glossary contains a short description of commonly used decorative painting terms.

Acrylic Canvas A type of artists' canvas that is prepared with a polymer primer for better adhesion and compatibility with acrylic paints.

Acrylic Paint A water-based paint that is available in either bottles, jars, or tubes.

Adhesion The ability of paint to stick to a surface.

Alkyds A type of paint. Unlike oil paints that traditionally have a linseed oil base, alkyds have a resin base. The main difference between them is the binder–alkyd resin in alkyds. They may be used just as oil paints, although alkyds dry faster.

Angular Shader Another name for a "rose petal brush."

Antiquing A technique usually done after decorative painting has been completed that makes an object look old and darkened with age.

Back-to-Back Floats Also known as "Flip," "Reverse," or "Ribbon Floats." There are two floats placed right next to each other. The paint side of the brush goes in the center, so where the two floats meet, the paint sides of each stroke touch, and the water sides face the outside edges.

Basecoating This means: (1) Painting an entire object with a color of paint before it is decorated, or (2) Filling in a specific area with paint as you would do in a color book. Occasionally it is referred to as "color book" painting.

Batiking A method used in hand painting fabrics, where areas not to be dyed are coated with wax.

Binder A compound that is used to suspend color pigments in paint.

Bisqueware Smooth surfaced ceramic bisque objects that are fired in a kiln once. They cannot be fired after painting and are not suitable for food storage. Sometimes referred to as "Ceramtole."

Blending The combination of colors, or a color and water or medium (as for floats) to achieve a softened, subtle appearance.

Blot In decorative painting, this is most often used to mean gently pressing a brush against a paper towel to remove excess moisture.

Brights Short, hard-bristled brushes. Also called "Chisel Blenders."

Bristles Brush "hairs." Either natural, synthetic, or a blend of the two.

Brush Mix Random mixing of two or more colors on a palette using brush bristles.

Bubble Palette A plastic plate with bubble-shaped depressions on the surface. Especially useful when painting with thinned acrylics for watercolor designs.

CDA This is the abbreviation for "Certified Decorative Artist," an honor given by the Society of Decorative Painters.

Calico Dots Uniformly spaced dots in groups of threes or fours.

Cat's Tongue Refers to a brush more commonly known as a "filbert" or "oval."

Ceramtole Another name for "bisqueware."

Chisel Blender A square ended brush with short bristles. Used for blending and shading. Also called "Brights."

Chisel Edge Narrow edge of bristles on flat or angle brushes. This is the part of the brush that would touch a surface first if you held it in a vertical position with the bristles facing down.

Chroma Also referred to as "intensity". Refers to the brilliance (or dullness) of a color.

Color Book Painting A synonym for "basecoat." It refers to painting areas of your design before you do the detail work.

Complementary Colors Those directly opposite each other on the color wheel; i.e. red and green.

Consistency Thickness (of paint).

Contrast Color variations in your painting which create a sense of depth through proper placement of light, medium, and dark colors.

Conversion Chart A guide to help you pick equivalent paint colors from different brands.

Corner Load Paint is loaded onto only one corner of the brush, then blended on the palette to remove all excess paint and create a gradual blend from paint to nothing. Also used by some artists to mean the same thing as sideloading or floating.

Crackle A technique used to create an aged, cracked appearance on a painted surface.

Crosshatching A type of liner work that forms crisscrossed lines.

Curing Time The time it takes for paint, varnish, etc. to go through its chemical reactions to reach its final, stable state.

Curlicues Fine, curvy lines that twist, circle, and turn any way you want them to. Used to enhance a finished painting. Make excellent tendrils for grape leaves. Sometimes referred to as "tendrils."

Dab Using a brush or sponge in a gentle, up and down motion to apply paint to a surface.

Detail All the techniques used to bring a painting to life, such as shading, highlighting, dots, etc.

Diamond Dusting A technique where an iridescent, sparkly, glitter-like substance is added to a painted object.

Dirty Brush This term is used when you carry more than one color of paint on your brush. The colors aren't mixed together. The brush is patted on a paper towel, then another color is picked up.

Distressed Wood Wood that has been damaged in such a way that it gives it an aged, well-used appearance.

Dolly Parton Hearts Hearts formed initially by placing two dots right next to each other, then pulling a line from

each dot to form a "V."

Dots A painting technique done by using a stylus, end of a brush, or some other device to make round, decorative additions to your painting.

Double Dip Dipping the tip of a fully loaded brush into a contrasting color.

Double Loading Filling your brush with two different colors, each on an opposite side of the bristles.

Dragging A technique used to create a streaked, linear, wood grain effect by dragging a notched brush or sea sponge across a freshly glazed surface.

Dressing A Brush The process of filling brush bristles with paint or medium.

Dry Brushing A technique in which a dry brush, almost free of paint, is used to stroke in highlights and shading. Also referred to as "scruffing" or "scuffing."

Dry-It Board A flat, plastic surface with fine sharp points on one side. Ideal for drying newly painted or varnished surfaces because the fine points do not damage the wet surface.

Dry To The Touch Refers to paint when it has reached the stage where the solvent has evaporated out of it. Regular acrylic paint will have lost its sheen: however, the acrylic gloss enamels maintain their sheen even when dry. Paint will no longer feel cool to the touch. This is not to be confused with "cured" paint, where paint has reached its final, stable state.

Dusty Brush A large, full brush with very soft bristles. Also referred to as a "Mop" Brush.

Earth Tones Also referred to as "Earth Colors". The most common ones are: Burnt Sienna, Burnt Umber, Raw Sienna, Raw Umber, & Yellow Ochre.

Extender A product added to paint to slow its drying time or to vary the transparency of paint. Retarder is the same type of product made by a different manufacturer.

Faux Finishes "Faux" means false or fake in French. These are decorative backgrounds that simulate the look of marble, wood, etc..

Ferrule The metal part of a brush that holds the bristles in place.

Flecking Applying specks of paint that has been thinned with water to a surface. Synonyms are "flyspecking," "spattering," and "splattering."

Flip Floats The same as "back-to-back" or "ribbon" floats.

Float A technique used to apply shading and highlights. One side of a flat or angle brush is loaded with paint, the other with water or extender. Also known as side-loading.

Focal Point The center of interest - the first thing the eye should see in a painting.

Force Dry Methods used to speed up the drying process of paints. Examples are directing the heat from a hair dryer on a newly painted surface, or placing the surface in direct sunlight. When using a hair dryer, do not get it too close to your surface and use only the lowest setting.

Free Handing Painting directly onto a surface without using a pattern.

Full Load Refers to a paint brush that is completely filled with paint.

Gesso A creamy acrylic primer which is effective as a sealer on wood and other surfaces.

Glaze The application of a transparent color over a painted background.

Gloss Refers to a highly polished, glass-like finish.

Gold Leaf Thin sheets of beaten gold that are used to embellish a decorated object.

Grain The markings in wood that go in a particular direction. To go with the grain, means follow the same direction of the wood grain when varnishing, etc.

Graphite A gray-black color of transfer paper.

Grit Usually used to refer to the texture of sandpaper—whether coarse, fine, ultra-fine. etc.

Gutta Serti A generic name which applies to solvent and rubber-based resists.

Hairs Another name for brush bristles.

Heat Set Applying heat to fabric to set the paint. Most commonly done with an iron.

Heel (of Brush) This refers to the part where the bristles go into the ferrule.

Highlight Lightening an area of your painting to bring it forward so that it looks as if this area is receiving the most light.

Hue Color name, i.e. red, green, etc.

Ink and Scrub A procedure where the surface is inked and then paint is scrubbed in with a stiff brush. Also referred to as "Pen and Ink."

Intensity Refers to the brightness or dullness of a color. Words often used to describe intensity are "muted", "grayed", "toned", "vivid", "harsh", etc.

Layering Building up areas of a painted surface by using several applications of paint. It gives depth to your painted surface.

Liner Work Painting done using a liner brush. Paint is diluted with water or extender, bristles are twirled to a fine point. Examples of liner work—crosshatching, curlicues, and outlining.

Load The process of filling your brush with paint.

Lost and Found Areas "Lost" areas of your painting are those that are close to the same value as the background so that they seem to become lost in the background. "Found" areas are either lighter or darker in value than the background so they are clearly seen and tend to stand apart from the background.

MDA This is the abbreviation for "Master Decorative Artist," the highest level of certification awarded by the Society of Decorative Painters.

Magic Brush Refers to a #3 round, sable brush created by the Royal Brush Company. It was designed to be used for the Multi-Loading Technique.

Matte A dull finish having no gloss.

Medium Refers to products that are added to or combined with paint that change its consistency, drying time, etc. Also refers to the various materials used in art, such as

oil or acrylic paints.

Metal Primer A product used on metal to prevent rusting and to provide a surface to which paint easily adheres.

Mop Brush See "Dusty Brush."

Mommie Indicates the weight of silk. The smaller the number, the lighter the silk. The larger the number, the heavier the silk.

Multi-Loading Technique This wonderful European technique (often referred to as "Austrian Florals"), involves loading at least three colors on a round brush and using 13 basic brush strokes to create many beautiful flowers, leaves, etc. With this method, you are able to achieve several color variations in one single brush stroke.

NSTDP The abbreviation for the "National Society of Tole and Decorative Painters," which is now referred to by its shortened name "The Society of Decorative Painters," ("SDP"). The membership is comprised of people who enjoy decorative painting, no matter what their painting level.

Opaque Occurs when no background can be seen through the paint; light cannot pass through or penetrate the color.

Open Time The amount of time before paint dries to the touch.

Over Stroke Doing brush strokes on top of an area that has already been painted.

Paint Side Refers to the side of the brush the paint is on when floating color.

Palette A surface on which paints are placed and blended. It also refers to the range of paint colors used in a given design.

Pattern The line drawing of a design that will guide you in your painting.

Petifours Small, square sponge applicators used for banding the sides of boxes, picture frames, etc.

Pickling A technique used to give wood a pale, "washed" color with the wood grain showing through.

Pigment A dry, insoluble substance, usually pulverized, which, when suspended in a liquid, becomes a paint, ink, etc.

Pitch A darkened area in wood caused by sap that can bleed through the decorative painting if not properly sealed.

Polliwog Stroke Another, less commonly used name for the comma stroke.

Porous Contains pores or openings that permit liquids to sink in. Example–brick is a porous surface.

Pounce See "Stippling."

Prep Short for "Preparation", this is the work done to a surface before painting it; i.e. sanding, sealing, etc.

Primary Colors Red, yellow, and blue. Located an equal distance apart on the color wheel. They are pure colors that can't be made from other colors.

Prime To apply the first coating, color, or preparation to a surface.

Ragging A technique used to create a crinkly wood-grain effect by pouncing a rag up and down on a freshly applied glaze.

Rake A brush with bristles that are thinned and uneven at the ends. Used for painting fur, hair, grass, etc.

Raw Metal Metal that hasn't been painted or primed.

Raw Wood This is wood as it comes from the woodcutter. It hasn't been sealed or finished in any way.

Renaissance Foil A new product used to achieve the appearance of gold leaf without using the traditional gold leaf sheets that tend to be a bit messy.

Resist A product and/or technique. It involves outlining a pattern on fabric (or wood) with a substance called "Resist", that contains paints in one specific pattern area, keeping them from bleeding through to other areas of a design.

Retarder A medium used to slow down the drying time of paint. Also used in place of water to obtain more fluid strokes. Same type product as extender.

Reverse Floats Same as "back-to-back," "flip," or "ribbon floats."

Ribbon Floats Synonym for "reverse," "back-to-back, or "flip" floats.

Rosemaling Norwegian decorative art styles, such as Hallingdal, Valdres, Rogaland, and Telemark.

Round Refers to a type of brush where round, full bristles form a fine point at the end.

Salt Technique A silk painting method where dry salt is placed on wet dyes to create a starburst effect.

Saral® A brand name for a wax-free transfer paper.

Scuffing Same as "Scruffing," or dry brushing. A dry brush is dipped in paint, all excess paint is removed, then highlighting or shading is scuffed or dry brushed on the surface.

Sealers Protective compounds applied to painting surfaces before and after painting which prevent chemical reactions between paints and surfaces on which they are applied.

Secondary Colors Orange, green, and violet. Created by mixing two Primary colors together.

Shade/Shading A technique used to darken certain areas of your painting.

Shaders Another name for flat brushes.

Sideloading Also known as floating. A technique used for applying shading and highlights. A flat brush is most often used–one side has paint, the other has water (or a product such as Extender).

Silk Screening A stencil fabric painting process in which colors are forced onto the material to be painted through the meshes of a silk or organdy screen.

Sizing A substance manufacturers put on brush bristles to help them maintain the desired shape as it travels from the factory to you.

Slip-Slap Motion Refers to moving a brush in a crisscross motion (the brush strokes form X's) as opposed to repeatedly going in the same direction.

"Soft Hand of Fabric" A statement used in fabric painting to indicate that the painted fabric remains as soft after it has been painted as it was before the painting was done.

Solvent A mixing component used to turn a solid color into

a liquid. Some common ones are water (in acrylics), oil (in oil-based paints), acetone, turpentine, lacquer thinner, and mineral spirits.

Spattering The same as "flecking," "splattering," or "fly-specking."

Spotter A fine-pointed brush with short bristles. Effective for fine detail work.

Squiggles These are random strokes (like doodles), used to enhance a design, such as commas, teardrops, tendrils, etc.

Sta-Wet Palette A container used to keep paints moist. It has a snap-on lid that seals in the moisture, enabling paints to remain fresh for long periods of time.

Stencil For decorative painting purposes, these are most commonly made of thin, flexible plastic that has a design cut out of it. When placed on a surface, paint is applied to these cut-out areas to create a painting.

Stick A less commonly used term for a brush handle.

Stippling Pouncing brush bristles (or sometimes a sea sponge) up and down on a surface. Very little paint is in the brush or sponge. Excellent for creating the impression of fur and impressionistic style flowers.

Style The personal touch that you give to your painting that makes it recognizable as being distinctly yours.

Stylus A tool used in decorative painting to make dots or to transfer a pattern onto a surface.

Tack Using a cloth to remove sanding residue. Some pattern books spell it "tac."

Tacky Refers to paint that is only partly dry and is still sticky to the touch.

Tendrils Also called curlicues. These are very fine lines that curve and circle randomly.

Tertiary Colors Red Orange, Yellow Orange, Red Violet, Blue Green, Blue Violet, and Yellow Green. Made by mixing a Primary color with an adjacent Secondary color on the color wheel.

Textile Medium A product for fabric painting that is mixed with regular acrylic paints to assist in proper absorption. This is also added to some brands of fabric paints or dyes to thin the paint for doing watercolor designs, liner work, etc.

TextureRefers to the body of the paint itself as it appears on a surface. Heavily textured effects can be accomplished by layering fresh paint on top of already dried paint, adding a thickener to the paint, or by using thicker tube acrylics.

Tinting Applying just a hint of color to a surface. The area is first dampened with water. Paint is then lightly patted or floated in for a suggestion of color. Also sometimes referred to as adding white to a color on your palette.

Tipping Dipping a brush that has been fully loaded in one color then just touching the tip of the bristles in a different color.

Tole Painting Historically, this meant painting on tin surfaces. Today "tole" is used as a shortened version of "Tole/Decorative Painting" which is done on a variety of surfaces.

Tooth Refers to the roughness of the surface on which you are painting. A surface with tooth is one that has enough roughness that paint adheres well.

Tornado A series of floats that form the shape of a pyramid.

Tracings Patterns that have been transferred to tracing paper then used for applying a design to a surface.

Translucent Permitting light to pass through, but diffusing it so that anything on the opposite side is not clearly visible.

Transparent You can see through the paint. Water (or a clear medium) is added to the paint to create this appearance. A wash creates a transparent color, for example.

Transparent Color Another name for "wash."

Undercoat A thin basecoat of paint (or gesso) that is applied to a surface before any other color is applied. This is especially helpful when you are painting a light object on a dark background.

Value How light or dark one color is in relationship to another.

Viscosity The thickness or thinness of any liquid. In decorative painting terms, a paint that is high in viscosity is thicker than one that is low in viscosity.

Walking the Color Making several strokes that gradually move away from the original one. Very effective when done as floats.

Wash A transparent application of color. Acrylic paints are thinned with water then applied to a surface to create a slight tint of color. When applied to unpainted wood, the grain shows through the color. This effect is called "pickling."

Water Side Refers to the side of the brush the water (or extender) is on when floating color.

Wet-on-Wet To immediately blend colors together once they have been applied to your surface, without allowing time for a color to dry before blending into the additional color.

Wick-Out A term used in the "Watercolor With Acrylics" technique. After thinned paint is loaded in a brush, the tip of the brush is barely touched to a paper towel before it is used on the actual painting surface.

BIBLIOGRAPHY

Chapter 1—Supplies
[1] National Art Materials Trade Association (NAMTA), *Sales Training Manual Number 5, Brushes*, (1986), p. 4.
[2] Ibid., p. 7.
[3] Ibid., p. 9.
[4] Ibid., p. 8.
[5] A previously unpublished "Pearl of Wisdom" from Joanne Haymen.
[6] A previously unpublished "Pearl of Wisdom" from Debra Garner of Delta Technical Coatings, Inc.
[7] Nancy Tribolet, *Guide to Stenciling*, (1994), p. 3-4.
[8] Pat Wakefield, *Beginner's Guide to Watercoloring with Acrylics*, (Plaid #8461), p. 4.

Chapter 2—Paints
[1] Helping Artist Newsletter, *Sandy Says...*, Winter 1993/94, p. 3.

Chapter 3—Surfaces
[1] Pearl Kent, "Gator Shoes," *Creative Painting USA*, (April 1989), p. 15.
[2] Susan Fouts, "Hilary Holstein," *Creative Painting USA*, (May 1989), p. 13.
[3] Patt Bell, "Let's Think About Christmas!," *Tole World*, September/October 1988), p. 31.
[4] Sandy Aubuchon, *Creative Crockery*, (Plaid #8208), p. 2.
[5] Karen Sheppard, a previously unpublished "pearl of wisdom."
[6] Video—"A Guide to the Use of Jo Sonja's Artists' Colors & Mediums," Chroma Acrylics.
[7] Noreen Burgess, a previously unpublished "pearl of wisdom."
[8] Ginger Edwards, "Ask the Masters," *Decorative Artist's Workbook*, (February 1993), p. 23.
[9] John Rajanen, Liquitex Product Seminar, September 16th, 1989.
[10] Susan Jill Hall, Diane Meyer, Margaret Wilburn, "Three Santas," *The Decorative Painter*, (October 1988), p. 59.
[11] Priscilla Hauser, *Magic of Decorative Painting*, 2nd ed., (1983), p. 30.
[12] Judi Krause, *Timeless Treasures*, (Plaid #8363, 1988), p. 11.
[13] Sharon L. Rachal, *Decorative Arts Digest*, (January 1989), p. 35.
[14] Jeani Valentine, "Rock Art," *Tole World*, (July/August 1991), p. 62.
[15] Kathy Whitmire, "Back to School," *Tole Painting USA*, (September 1987), p. 11.
[16] Jill Hodges, *Color Steps™: Restore & Restyle Your Shoes*, Plaid View 'n Do Video #27, (1992)
[17] Barb Every, "Victorian Wearable Art," *Tole Painting USA*, (June 1988), p. 8.
[18] Ibid., p. 9.
[19] Jackie Shaw, *Introduction to Silk Painting*, (1986), pp. 2-12.
[20] Ibid.
[21] Pat Keck, "You've Tole'd Us...," *Tole Painting USA*, (June 1988), p. 52.
[22] William D. Crawley, M.D., "Winter Holly," *The Decorative Painter*, Issue No. 2, (1991), p. 55.
[23] Jo Sonja Chatterbox Newsletter (Summer 1988).
[24] Linda Kortz, "The Care & Feeding of Metal Toleware," *CrafTrends*, (June 1988), p. 31.
[25] Mary Ellen Radtke, a previously unpublished "pearl of wisdom."
[26] Kim Mauro, "Umbrella Fellas," *Tole Painting USA*, (September 1987), p. 25.
[27] Jackson Hand, *How to do Your Own Wood Finishing*, 6th ed., (1972) Popular Science Publishing Co., New York, pp. 10-15.
[28] Jennette Brice, "Painting Wood Resin Figurines," *CrafTrends*, (June 1988), p. 30.
[29] Shirley McCollum, *With Love Pattern Packets*, (1994).

Chapter 4—Pattern Transfer
[1] Sherry C. Nelson, "Sherry Says," *Decorative Arts Digest*, (October 1988), p. 11.
[2] Rosemary West, "Developing Skills," *The Decorative Painter*, (December 1988), p. 18.
[3] Nancy Hornberger, a previously unpublished "Pearl of Wisdom."
[4] Jackie Shaw, *Introduction to Silk Painting*, (1986), p. 5.

Chapter 5—Brush Strokes
[1] Jackie Shaw, *Jackie's Brush Stroke Workbook*, (1987), pp. 6, 7.
[2] Midge Mjos, *Different Strokes—The Pocket Painter*, (Pamela Publications, 1988), p. 48.
[3] Edna Snyder and Susan Abdella, *FolkArt Foundations, Volume I*, (1984), p. 11.
[4] Priscilla Hauser, *Magic of Decorative Painting*, 2nd ed. (1983), p. 10.
[5] Jackie Shaw, *Jackie's Brush Stroke Workbook*, (1987), pp. 6, 7.
[6] Ibid.
[7] Ibid., p. 8.
[8] Ibid.
[9] Ibid., p. 9.
[10] Ibid.
[11] Ibid., p. 8.
[12] Ibid., p. 9.
[13] Ibid.
[14] Ibid.
[15] Ibid., p. 11.
[16] *Different Strokes—The Pocket Painter*, p. 48.
[17] *Jackie's Freehanding Seminar, Book 1*, p. 12.

[18] *Magic of Decorative Painting*, p. 11.
[19] *Jackie's Freehanding Seminar, Book 1*, p. 8.
[20] Ibid., p. 7.
[21] *FolkArt Foundations*, p. 11.
[22] Ibid., p. 10.
[23] *Jackie's Freehanding Seminar, Book 1*, p. 8.
[24] Ibid.
[25] Created by Jo Sonja Jansen.
[26] *Jackie's Freehanding Seminar, Book 1*, p. 12.
[27] Ibid., p. 7.
[28] Ibid., p. 11.
[29] Ibid., p. 12.

Chapter 6—Techniques
[1] Jackie Shaw, *Beginner's Guide to Freehand Decorative Painting*, (1987), p. 54.
[2] Jeanne Grace and Beverly Woodbury, *Guide to Decorative Painting Terms, Tools, Techniques*, (1988), pp 28-29.
[3] Jo Sonja and David Jansen, *A Guide for the Use of Jo Sonja's® Artists' Colors and Mediums*, Video produced by Chroma Acrylics, Inc.
[4] Ibid.
[5] Carolyn L. Phillips, "Spring Bouquet in Basket," (pattern packet), (1988).
[6] *Beginner's Guide to Freehand Decorative Painting*, p. 51.
[7] Notes taken during Judy Nutter Seminar, "Bird and Blossoms on Stenciled Doily Background," (1981).
[8] Donna Bryant, *Shower of Flowers*, (1992), p. 8.
[9] Charles Johnson, *Victorian Designs*, (1987), p. 8.

[10] Charles Johnson, a previously unpublished "Pearl of Wisdom."
[11] *Beginner's Guide to Freehand Decorative Painting*, p. 49.
[12] Ibid., p. 47.
[13] Ibid., p. 48.
[14] *A Guide for the Use of Jo Sonja's® Artists' Colors and Mediums*
[15] Charlene Greenberger, CDA, "Backgrounds," *The Decorative Painter*, (June 1988), p. 26.
[16] Beth Browning, "Window Shopping," *Decorative Arts Painting*, (May/June 1994), p. 59. (originally shown in "A Closer Look," newsletter, by Krylon).
[17] Carolyn Phillips, "Mother's Rose," (pattern packet), 1989

Chapter 7—Color Choices
[1] Shirley McCollum, a previously unpublished "Pearl of Wisdom."
[2] Ibid.
[3] Barb Watson, *The ABC's of Color—Keeping It Simple*, (1992), pp. 21-23.

Chapter 8—Where To From Here?
[1] Sherry C. Nelson, "Sherry Says," *Decorative Arts Digest*, (October 1988), p. 11.
[2] Ibid.
[3] Ibid.
[4] Ibid.
[5] Ibid.
[6] Ibid.